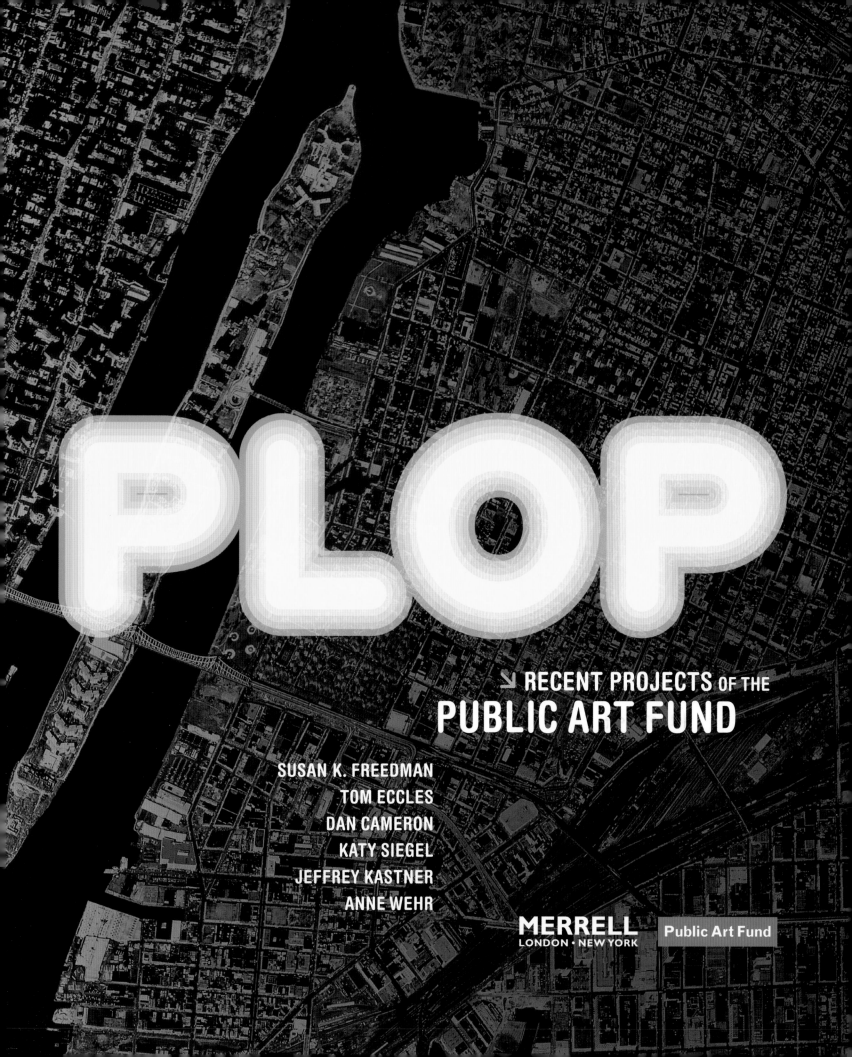

PLOP

↘ RECENT PROJECTS OF THE
PUBLIC ART FUND

SUSAN K. FREEDMAN

TOM ECCLES

DAN CAMERON

KATY SIEGEL

JEFFREY KASTNER

ANNE WEHR

MERRELL
LONDON · NEW YORK

Public Art Fund

CONTENTS

When the Public Art Fund began in 1977, its original mission was to provide artists with the institutional support to show their work in New York's public spaces. Without such an organization, the daunting bureaucratic, legal, and financial demands on individual artists made the possibility of exhibiting beyond the gallery or museum a challenging, if not all but impossible, proposition. Since those pioneering days, the Public Art Fund has played a leading role in defining and redefining how artists can meaningfully interact with the city's residents and the architectural environment. At the heart of that activity there has been a consistent belief that contemporary art can be understood and appreciated by the widest possible audience and, as such, that it can enhance our experience of the urban environment.

This book is not a history of the organization but a contemporary survey of some of our most recent projects. In the mid-1990s, the Public Art Fund made a strategic shift in the way we work with artists. In many cases projects began with the simple invitation to an artist to make a project in New York City, and we were deeply involved in the evolution of the work from conception through realization. The Public Art Fund frequently undertook the role of producer, a partnership with artists that allowed for expansive projects in a field notorious for frustrating compromises. The mid-1990s marked a period of decreasing government funding for the arts and in particular the elimination of individual artist grants by the federal government. In response we created "In the Public Realm," a program which provides direct support to emerging artists to develop works at sites of their own choosing. In doing so, artists were invited and encouraged to challenge people's expectations of the kinds of sites and projects that are usually considered appropriate for public art. Concurrently with this activity, the Public Art Fund has worked consistently with artists who might least be expected to make work in a public context. The results, as documented here, have provided a remarkable survey of contemporary art within the streets and parks of New York City.

The process of realizing each individual artist's vision has been an exhilarating one, particularly when we have overcome seemingly insurmountable obstacles in order to bring a work to fruition. In every case our projects have been made possible through the collaboration of many partners, from neighborhood groups to the owners of major New York real estate, from individuals within a particular community to members of city government and business leaders. We have worked with hundreds of fabricators, craftspeople, technicians, installers, and riggers, whose ingenuity and dedicated efforts have allowed us to change, if temporarily, the physical and social environment of New York. I am proud to have led the organization through this dynamic period alongside my colleague and friend Tom Eccles, who has provided the curatorial vision for our projects and has been a constant source of enthusiasm and inspiration. Each and every staff member has made their own invaluable contribution to these complex and demanding initiatives. This book is testimony that a dedicated, small staff can achieve great things. Above all, my thanks to the artists themselves for their extraordinary works and enduring commitment. It is a legacy that my mother, Doris C. Freedman, who founded the Public Art Fund, could not have foreseen, but of which I know she would have been proud.

I AM FOR AN ART
THAT EMBROILS ITSELF
WITH THE EVERYDAY CRAP
AND STILL COMES
OUT ON TOP.

Claes Oldenburg, 1961[1]

AS THE ARTIST IS
PART OF THE PUBLIC
PUBLIC ART IS ART
FOR YOURSELF

Lawrence Weiner, 2001[2]

"Plop art," a term coined by architect James Wines,[3] is just one of many epithets used to locate a certain practice of public art, common in the late 1950s and 1960s, in which often-less-than-distinctive Modernist sculpture was sited in front of often-less-than-memorable Modernist buildings, much to the chagrin of the wider public. It was in reaction to this practice that new genres of public art emerged throughout the 1970s and 1980s, spearheaded in the United States by the National Endowment for the Arts and increasingly ubiquitous Percent for Art programs, which commissioned artists to create works for federal, state, and city buildings.[4] With every new approach to contemporary public art practice, whether it was "site-specificity," "community-responsiveness," or the "integration of art and architecture," each twist and turn on the evolving paradigm pulled public art further away from the artist, and ever more into a set of programmatic requirements that effectively eviscerated the vitality of the art itself. The use of the term "Plop" in the title of this book of recent Public Art Fund projects is, of course, an ironic gesture, coopting a derogatory term for public art to suggest, I hope, that the projects commissioned by the Public Art Fund in the past few years have occupied the territory of "public art" while challenging, to varying degrees, many of the underlying assumptions for commissioning artists in the urban environment.

 The Public Art Fund is an independent, not-for-profit organization, not a government agency. Its funding comes primarily from private sources, and all the projects have a deliberate relationship with New York City. The forty-nine projects in this book cover a period of almost ten years, although most were realized between 1998 and 2003. They are the products of a commissioning strategy that has always considered the practice of public art to be an activity fully consistent with the type of contemporary art practices seen in museums, galleries, or the artist's studio. Enabling the artist to move outside the studio and into the public realm, the Public Art Fund has presented a bold and, at times, challenging series of projects at sites throughout New York City. These interventions into Walt Whitman's "mad, mettlesome, extravagant city" are distinctly urban, and conceived of as a dialectic between the physical, social, and psychological power of the built environment; individual voices raised among the city's eight million inhabitants.

 Most members of the art community understand public art to be problematic. It is now almost de rigueur for commentators to begin their

↘ TOM ECCLES

PLOP

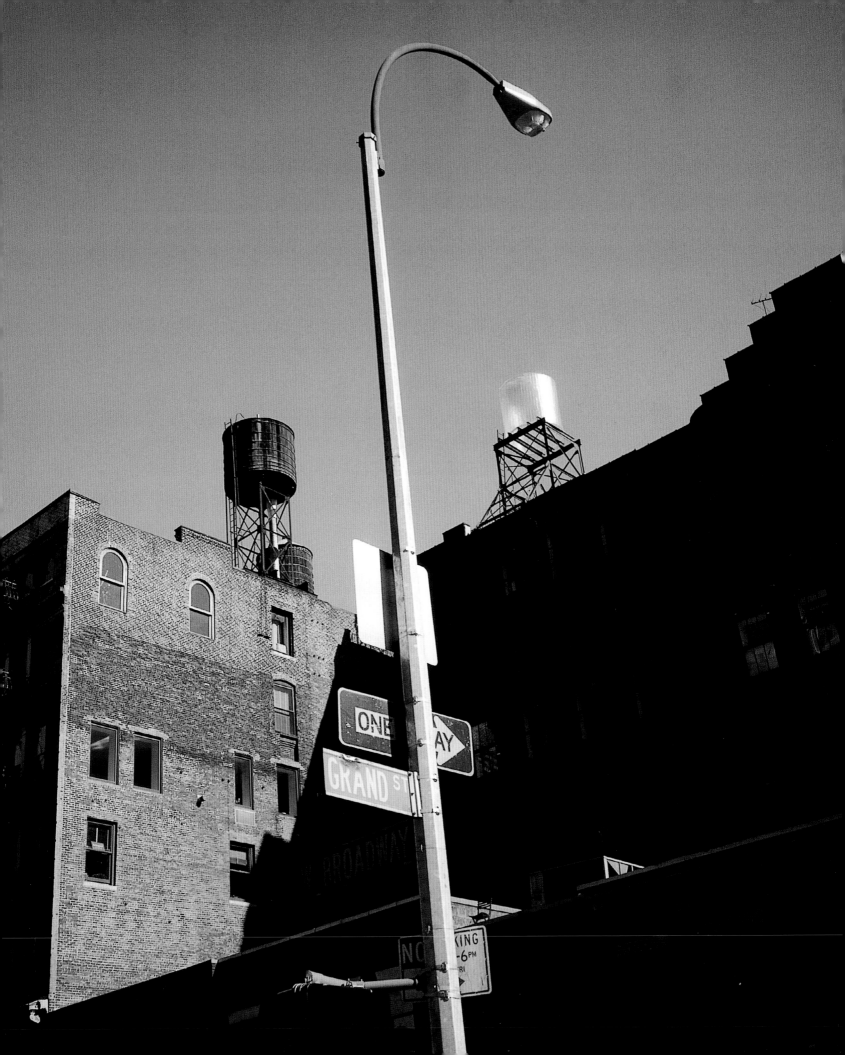

review with the disclaimer that most public art is bad or worse; that it is in some sense inherently "compromised," that the artistic gesture itself is necessarily restricted by the conditions set upon the artist, that in the public arena even a good artist can go bad.[5] I don't aim to challenge that position, because I more or less agree with it. Rather, I hope to show that, given a different focus, artists can participate in the public life of the city in ways as complex and critical as that which we find in any contemporary museum or gallery.

My experience with the Public Art Fund began at a moment of transition. The 1980s were clearly over. A signature program of the Public Art Fund during that period had been an ongoing series of artists' "statements" on the Spectacolor Board in Times Square. Initiated by artist Jane Dickson in 1982, the "Messages to the Public" series, which began with Keith Haring and included Jenny Holzer's first L.E.D. (light-emitting diode) sign works and more than eighty artists' projects, ended on September 1, 1990, with the Board's removal and replacement with updated technology (essentially a giant television screen). This format—creating a structure within which numerous artists could participate—had been further developed by Holzer for *Sign on a Truck* during the 1984 presidential election campaign, and she extended its participatory format to include on-the-street interviews with passersby. The Public Art Fund followed the artists' lead with billboards by the Guerrilla Girls, subway posters by General Idea, and bus shelters by Barbara Kruger, among others.

In 1989, the Public Art Fund sponsored Felix Gonzalez-Torres's first billboard work, which was installed in Sheridan Square to mark the twentieth anniversary of the Stonewall rebellion in the West Village. Something in that quiet, poignant list— *People with AIDS Coalition 1985 Police Harassment 1969 Oscar Wilde 1895 Supreme Court 1986 Harvey Milk 1977 March on Washington 1987 Stonewall Rebellion 1969*—presented a new strategy, an alternative aesthetic; a poetic yet critical pebble dropped into the ocean of New York's cacophony. Plop. This nonlinear inventory of dates significant to the Gay Rights movement before and after the Stonewall riot "refuses narrative closure," as curator Nancy Spector observed: "Gonzalez-Torres utilized one of the most public forms of advertising to speak of the socially disenfranchised in a manner that required each viewer to construct the work's meaning from his or her own cultural memory."[6]

On the night of March 15, 1989 (in the same month that Gonzalez-Torres's billboard was installed), demolition crews working for the federal government cut Richard Serra's *Tilted Arc* into three pieces and removed it from Federal Plaza in Lower Manhattan. In retrospect it seems astonishing that the controversy surrounding this great work should have continued from its installation in 1981 for almost an entire decade.[7] For a few years after its removal, the words of Richard Serra—"I don't think it's the function of art to be pleasing Art is not

PAGE 9:

RACHEL WHITEREAD
Water Tower, 1998
Cast resin
Rooftop at West Broadway and
Grand Street, SoHo, Manhattan

TOP:

KEITH HARING
Untitled ("Messages to the Public"
series), 1982
L.E.D. (light-emitting diode) sign
in Times Square, Manhattan

BOTTOM:

JENNY HOLZER
Untitled ("Messages to the Public"
series),1983
L.E.D. (light-emitting diode) sign
in Times Square, Manhattan

democratic. It is not for the people."[8]—became a kind of rallying cry for what was wrong with public art, particularly in New York City where the Dinkins Administration was promoting greater inclusiveness and recognition of community diversity.

Serra's insistence that the potential relocation of this work equaled its destruction did, however, establish the hegemony of site-specificity as a paradigm, one that was most fully explored outside New York by curators Kasper König and Klaus Bußmann in Germany, James Lingwood in Britain, and Mary Jane Jacob in the United States.[9] Their well-documented exhibitions, unlike permanent commissions for public buildings, had in common the fact that their temporary nature, built around a particular time frame or festival, allowed the artist to investigate the history and conditions of a particular site.

The recent history of the Public Art Fund was shaped in part by the destruction of another great work, Rachel Whiteread's *House*, a concrete cast of an East London row house commissioned by James Lingwood at Artangel in 1993.[10] *House*, described by the London newspaper *The Independent* as "one of the most extraordinary public sculptures to have been created by any English artist working this century,"[11] was always intended as a temporary intervention but generated such intense passions (both for and against) that the desire to keep the work up for an extended period became the focus of a national debate, and its demolition, under the direction of councilman Eric Flounders, was widely seen as a brutal act of cultural vandalism.

A few months after *House* had been pulled down, we invited Rachel Whiteread to make a work for New York City. Rather than beginning with a site (and a budget), the invitation was open, allowing for an extended period of investigation, the opportunity for Whiteread to propose almost anything. Our idea was essentially to invert the commissioning process, to reconsider an organization's role in terms of an artist's vision and the needs of their proposed project, rather than asking the artist to work within a given set of design parameters.

As it turned out, Whiteread's ultimate decision to cast a clear resin water tower that would sit upon the rooftops of SoHo radically changed the way the Public Art Fund conceived of its relationship with artists. The unprecedented scale of the undertaking brought about the need to create a partnership with the artist from conception, through fabrication, installation, and presentation. Surprisingly unspectacular, yet mesmerizing in its ability to capture changing light, *Water Tower* (1998) challenges many of our assumptions about public art and its possibilities. As a work of public sculpture, it eschewed the city's streets to find an unlikely space where only those who sought it out would find it. It kept its distance, deliberately removed from the viewer below. For those who visually stumbled upon it, the work was as anonymous and unassuming as the other water tanks whose rooftops it shared. While undoubtedly present in

TOP:

JENNY HOLZER
Sign on a Truck, 1984
Diamond Vision television, truck,
audio-visual equipment
Grand Army Plaza, Manhattan

MIDDLE:

BARBARA KRUGER
Untitled (Bus Shelter), 1991
Various locations around
New York City

BOTTOM:

FELIX GONZALEZ-TORRES
Untitled, 1989
Billboard at Sheridan Square,
Manhattan

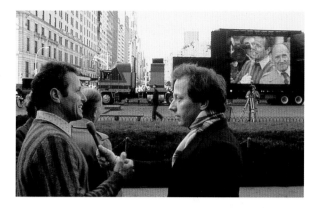

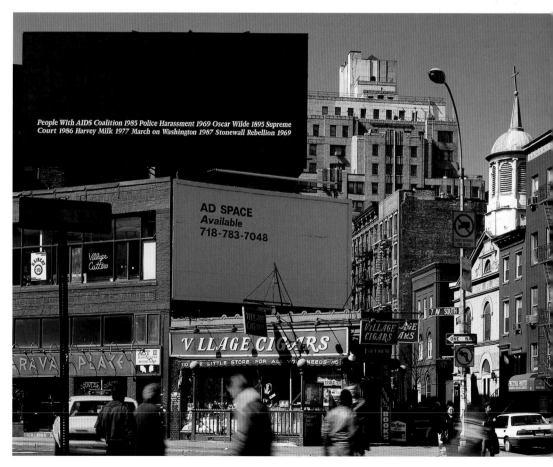

physical terms, it had an ephemeral quality, constantly changing with the light conditions and all but disappearing at night. Activating its surrounding architecture, *Water Tower* seemed to absorb the city's history and materiality, providing a humanizing counterpoint to the encroaching commercialization of public space and public walls. It was, in effect, an enigmatic vanishing point of sculpture in the twentieth century.

Leading up to this time, the Public Art Fund had already expanded its commissioning process to invite artists from beyond New York City to investigate sites of their choosing for temporary installations. The first such project, Christian Boltanski's *Lost: New York Projects* (1995), transformed sites in four landmark buildings (a Lower East Side synagogue, a Harlem church, a corridor of the New-York Historical Society, and the waiting room of Grand Central Terminal) into potent experiences of individual and collective loss and resurrection. For six months Boltanski collected New York's lost property, mountains of second-hand clothing, the tape-recorded memories of Lower East Side children, and the entire possessions of an anonymous apartment dweller for installations that represented New Yorkers through a pseudo-anthropology of past and present. Although Boltanski's audio installation at Eldridge Street Synagogue was a new work, *Lost* also functioned as a multi-site retrospective for Boltanski, recontextualizing previous works into New York

settings. *Inventory,* for example—the work he presented at the New-York Historical Society—was first created in 1973 at the Kunsthalle Baden-Baden, and *Lost Property,* in Glasgow, a year prior to its New York reincarnation. Both became intimate portraits of New Yorkers through the accumulation of their objects (either saved or lost).

The fact that Boltanski, who is not a resident of the city, could make such poignant works grounded in their respective neighborhoods provided a stark contrast to the predominant philosophy within the public art community in New York, of commissioning local artists for local settings. After *Lost,* the Public Art Fund continued to broaden its reach, both by inviting more non-New York based artists to propose projects and by extending the way in which these projects were integrated with the city. In 1996, Alexander Brodsky, a Russian artist who had participated in the Muscovite Paper Architects group in the 1980s (known for their extravagant and unrealizable submissions for state-run competitions), selected the disused track of the Canal Street subway station at Broadway for an installation of rudimentary gondola-like boats floating in a water-filled tank. The resulting sculptural passageway, more Vietnamese than Venetian, was a dark existential theater in the bowels of commuter hell. Ilya Kabakov's *Monument to the Lost Glove* (1997), a mysterious red resin glove surrounded by eight lecterns engraved with the accounts of fictional passersby, sited on the traffic

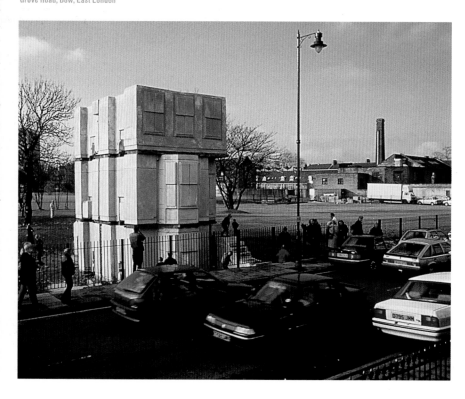

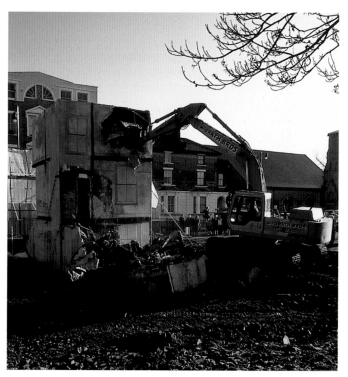

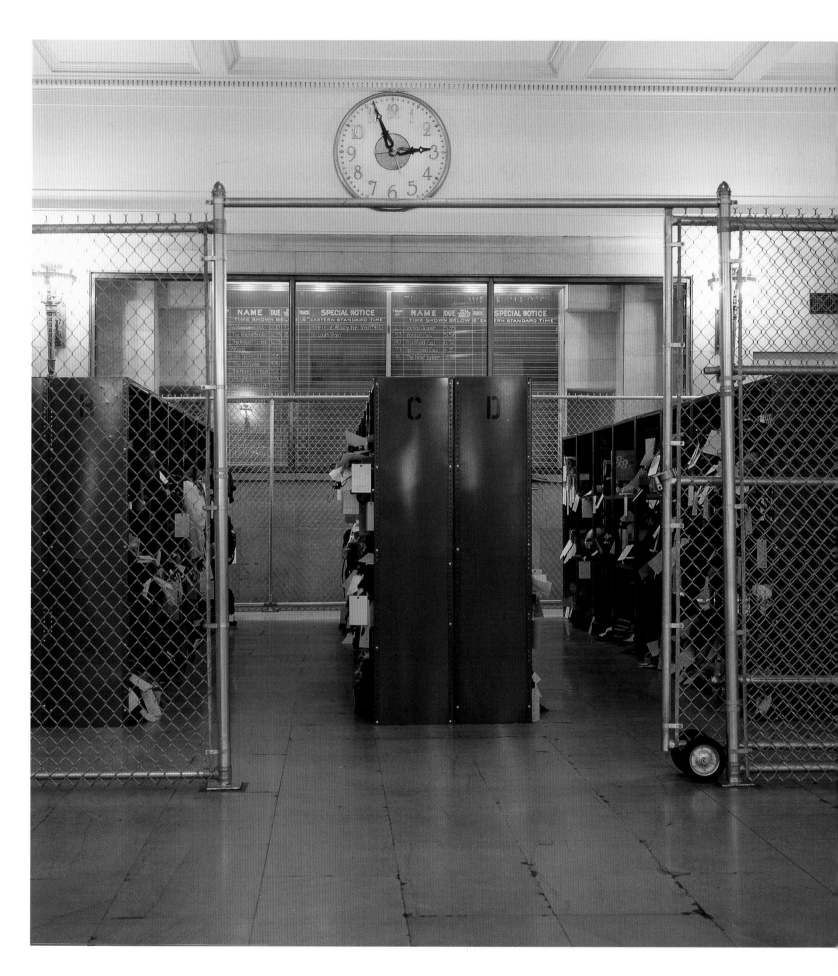

triangle in front of the Flatiron Building, further demonstrated a new curatorial confidence in the ability of sometimes difficult artworks to sustain the interest of the viewer.

Incrementally, through these and other projects, the Public Art Fund moved toward a new operating model. More "producer" than public art manager, we became integrally involved in identifying potential locations, fixing budgets, raising funds, and solving a wide array of technical problems raised by the artists invited to address the city as a site for their work. Providing political, organizational, and technical support, obtaining the necessary permits, and securing bureaucratic approvals are all elemental steps in the realization of the artist's vision. A further shift occurred as the Public Art Fund developed a curatorial model—selecting and inviting artists to work with, rather than the more familiar panel process—a natural enough evolution but one that was in its time quite a radical departure. Not only did this lead to the removal of a certain kind of bureaucracy, it also established an unusual level of partnership with the artists selected and a

commitment on the part of the organization to realize their individual vision.

These projects also changed the correspondence between "sites" and artistic practice. While each work clearly "fit" its selected site, none of the works presented was precisely "site-specific" in the sense of directly referring to its location—or in the sense intended by Richard Serra, that removal meant destruction. In Whiteread's case, *Water Tower* was removed from its West Broadway rooftop and donated to the collection of The Museum of Modern Art in midtown Manhattan; many of the installations documented here have now been resited or reconfigured for other locations. Artists were also more likely to investigate a site typologically rather than historically. That is, the works temporarily gave the spaces they occupied a new meaning, but were not centered upon a specific local history or identity, in contrast to the prevailing public art practice, which often renders the commission as something of an archeological dig.

Over the three years that *Water Tower* was in development, the Public Art Fund's program evolved

into a diverse range of commissioning roles, incorporating large and small-scale projects by both internationally known and emerging artists at disparate sites throughout the city. The ability to move among a range of activities with an almost chameleon-like structure allowed for a freedom to work with artists that is rare among contemporary art institutions.

One program in particular, "In the Public Realm," has provided an important forum for emerging artists to push the institutional and conceptual boundaries of the Public Art Fund. Begun in 1996, "In the Public Realm" was set up in direct response to the elimination of individual artist grants by the National Endowment for the Arts, which had been a cornerstone of John F. Kennedy's vision of federal funding for the arts.[12] Each year, the Public Art Fund commissions proposals from ten emerging artists, who are chosen with complete disregard for the applicability of their work to the public sphere, selecting at least three for realization. This program has provided a significant vehicle for artists to shape our perception of how contemporary art can interface with a broader public. The first project to

BELOW, LEFT:

CHRIS DOYLE
Commutable, 1996
22-karat gold leaf
Williamsburg Bridge, Lower East
Side entrance, Manhattan

BELOW, RIGHT:

PAUL RAMÍREZ JONAS
Every Day, 2001
Flag streamers installed at five
locations in Brooklyn, Manhattan,
and Queens

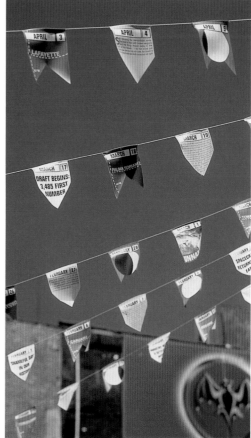

be realized was Chris Doyle's *Commutable* (1996), in which the artist gilded the pedestrian entrance to the Williamsburg Bridge in 22-karat gold. Initially raising the specter of a one-sided "debate" on funding for the arts (*Fox News* for example ran a "You won't believe this! And how much taxpayers' money was spent on this?" segment), Doyle's $7,000 project was soon embraced by a media somewhat surprised by the overwhelmingly enthusiastic response of the public. Maria Elena González's *Magic Carpet/Home* (1999), installed with the help of local residents in a Red Hook housing project, became a center for social activity (birthday parties and barbecues) in a park better known for crack vials and broken bottles. Christine Hill's idiosyncratic *Tourguide?* (1999) office in SoHo drew crowds of wide-eyed tourists and a wedding party from Cleveland, and, after extensive publicity, received numerous requests for flights out of JFK as if Hill were a legitimate travel agent. Paul Ramírez Jonas's *Every Day* (2001) used the multi-colored flags often found outside bodegas, gas stations, and car dealerships to create a personal almanac of historical moments, cultural holidays, and ordinary events that incongruously merged with the vernacular architecture of our daily lives. Olav Westphalen's *E.S.U.S. (Extremely Site Unspecific Sculpture)* (2000), "an artwork that functions equally well in almost any imaginable site at any time," inadvertently reduced drug activity in Tompkins Square Park when locals mistakenly took it for a new instrument of police surveillance.

The term "community" is often invoked as central to successful public art, and it is this idea that Tony Matelli extended in *Distant Party* (1999), an after-hours sound installation in which the sounds of a very happening party emanated from a Chelsea warehouse. At a time of "quality of life" enforcement, Matelli questioned the selection of one set of community values over another—for him, the party crowd was a kind of idealized community, albeit an obnoxious one. The artworks created through the "In the Public Realm" program have to a large degree focused on the social potential of art, often drawing upon the art community itself. Josiah McElheny's *Metal Party* (2001) was a celebration of that community, its continuity, and its history. Many of McElheny's gallery installations have playfully examined the conventions and constraints of museum display, so it was particularly fitting for the Public Art Fund that *The Metal Party* took on an aspect of Bauhaus history that falls outside of traditional museum presentations. With McElheny's "re-creation," the Bauhaus's 1929 *Mettalische Fest*—a gathering that epitomized the school's belief in the promise of modernity and in metal as inherently modern—received a reflective examination that coaxed history back to the present. *The Metal Party* demanded performance not as viewer-spectacle but on a fundamentally participatory level, where the installation became a foil for gathering, dancing, and socializing.

TOP:

OLAV WESTPHALEN
E.S.U.S. (Extremely Site Unspecific Sculpture), 2000
Stainless steel, fiberglass
Tompkins Square Park, Manhattan

BOTTOM:

JOSIAH MᶜELHENY
The Metal Party, November 29, 2001
Viewer-participatory performance
and mixed-media installation
Brooklyn Front, Dumbo, Brooklyn

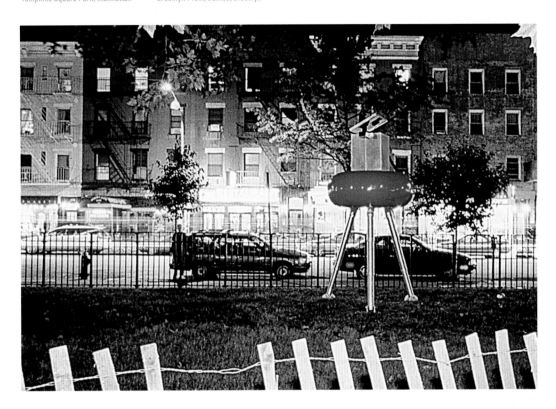

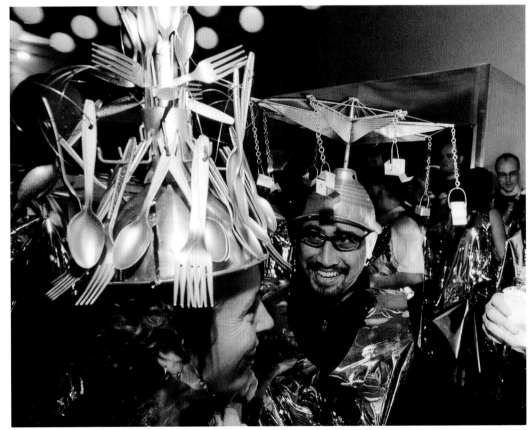

↘

The function of public art is to make or break a public space. On the one hand, it hunts down public spaces, it finds them where none existed before, in the nooks and crannies of privacy (in between buildings, at the edge of buildings); the act of public art annexes territories, into the public realm. On the other hand, it loses public spaces; it takes a space that's ordained to be public, an institutionalized public space, and comes up from under it: the act of public art disintegrates the public space, so that the public can take it with them, on their backs or in their nerves.
—VITO ACCONCI, 1993[13]

In 1967, ten years prior to the founding of the Public Art Fund by Doris C. Freedman, two outdoor exhibitions in New York had a profound influence over the direction of the organization: Tony Smith's installation of ten major sculptures in Bryant Park and the multi-site exhibition *Sculpture in the Environment*, a city-wide show proposed by Irving Sandler, organized by Doris Freedman (with the support of New York City's nascent Department of Cultural Affairs), and coordinated by Sam Green.[14] Both exhibitions demonstrated a new potential for art outside the museum and crystallized a belief in the ability of artists to transform and enhance the physical environment of the city. This was underscored by a clear desire to expand the audience for art beyond the province of a select few. In 1972, Freedman described her vision for public art: "Many works of art provoke scattered grumblings and protests, but this may in itself be a good thing, for the art therefore fulfills one of its functions by encouraging the exchange of ideas and the elicitation of responses and reactions."[15]

The fiscal crises of the 1960s and 1970s had left New York's public spaces in a battered and often neglected state. Doris Freedman, among other civic leaders, championed the idea of nongovernmental groups intervening to save landmarks such as Grand Central Terminal from destruction, and also became involved directly with their improvement. While Special Assistant for Cultural Affairs (within New York City's department of Parks & Recreation) during the *Sculpture in the Environment* show and later as the first Director of the newly created Department of Cultural Affairs, Freedman was a vocal and passionate advocate for artists, helping to establish the Loft Law that legalized artists' housing in SoHo and organizing numerous exhibitions of large-scale sculpture, including the outdoor component of Mark di Suvero's Whitney Museum mid-career retrospective in 1975, bringing his iconic I-beam works to Battery Park in Manhattan, Flushing Meadows in Queens, and elsewhere throughout New York City.

That legacy is most evident in the ongoing program at the southeast entrance to Central Park, named for Doris Freedman after her death in 1981. The Public Art Fund has mounted exhibitions of sculpture at this site on a rotating basis, providing contrasting and comparative approaches to contemporary sculpture, with newly commissioned works as well as existing pieces from private and public collections. In essence, Doris C. Freedman Plaza has become a sculpture garden without walls. The ongoing exhibitions at the Plaza highlight how a programmatic approach to temporary exhibitions can gain acceptance and support where the imposition of one permanent installation would undoubtedly meet with enormous opposition. The temporary nature of these installations permits

the kind of curatorial and artistic freedom so rarely associated with public art. But I would argue that temporality is also one of the central virtues of the Public Art Fund's overall program. It allows artists to address their contemporaries rather than some speculative future generation. These temporary installations can also occupy spaces that, on a permanent basis, even the most ardent supporter of contemporary art would object to.

In 1998 for example, the Public Art Fund joined forces with The Museum of Modern Art to present a major outdoor component to the Tony Smith exhibition. The centerpiece of this effort was undoubtedly Smith's giant *Light Up* (1971) on Mies van der Rohe's Seagram Plaza. Smith's taxi-yellow tour de force put the lie to almost ten years of rhetoric regarding the appropriateness or otherwise of public sculpture. A work dramatically dropped into its site (one Smith had eyed as a possible venue in his own time), *Light Up* was everything that had been rejected by practitioners of public art. It is clearly imperative that a work should have a conspicuous relationship to the architecture in which it is placed, but in contrast to the strategies of integration, juxtaposition of art with the environment can be equally if not more meaningful.

This adoption of juxtaposition as a strategy has found its most dramatic effect at Rockefeller Center, where the Public Art Fund has presented Jeff Koons's beloved *Puppy* (2000), Louise Bourgeois's *Spiders* (2001), Nam June Paik's *Transmission* (2002), and Takashi Murakami's *Reversed Double Helix* (2003). These grand, perhaps flamboyant, installations set against the backdrop of an American architectural icon are unashamedly spectacular, even theatrical. Bourgeois's *Spiders*, for example, become pure "gotham" on this stage set. But the viewer is not a

NEAR RIGHT:

Tony Smith with plywood mock-up for *Night* (1962), for an exhibition of his sculpture in Bryant Park, Manhattan, 1966–67

FAR RIGHT:

Claes Oldenburg, Doris C. Freedman, and Samuel A. Green standing at the site of Oldenburg's *Placid Civic Monument*, Central Park, 1967

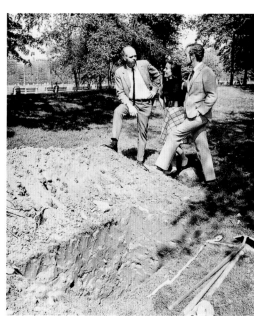

passive recipient. The relationship between the viewer and the work, where both occupy a space to which they have equal claim, is a profound experience and is quite unlike seeing art in a gallery or museum setting, where the works are literally guarded and the viewer deliberately distanced.

Listening to people's comments during the installation and deinstallation of works leads invariably to the conclusion that the experiential difference between the works shown by the Public Art Fund and, say, a museum is not that one is outdoors and the other indoors (an idea that has always struck me as somewhat banal, at any rate), but rather that these public works are experienced *over time*. If the analogy might be made to a private collection, these works do not hang over the fireplace in pride of place but are on the wall leading to the bedroom — seen first thing in the morning and last thing at night. Thus the phenomenology of their presence in one's life is mostly submerged. Over time they become familiar, woven into our lives, not front and center, works whose significance becomes most apparent when they are lost or removed. Thus, in a sense, the Public Art Fund is creating a set of memories that have little or nothing to do with civic pride but rather with personal experience. Viewers of art at museums spend a remarkably small amount of time in front of the works displayed. The incremental nature of experiencing a public work, set as it is within one's daily traverses and preoccupations, makes for a profound engagement with an artist's work over a period of months on a daily basis.

Strangely enough, the fact that a work only reveals itself over time is rarely noted in the critical discourse of public art, so accustomed are we to examining a given thing (no matter how carefully) and then simply moving on. In the spring of 2001,

TOP:

MARK DI SUVERO
Are Years What? (For Marianne Moore), 1967
Painted steel
Prospect Park, Brooklyn, 1976

BOTTOM:

TONY SMITH
Light Up, 1971
Painted steel
Seagram Plaza, Park Avenue, Manhattan, 1998

FOLLOWING PAGE:

LOUISE BOURGEOIS
Maman, 1999
(cast in bronze in 2001)
Bronze
Rockefeller Center, Manhattan, 2001

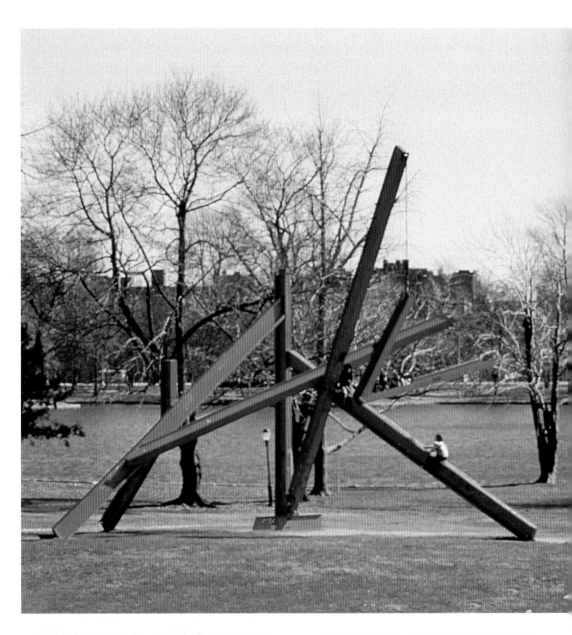

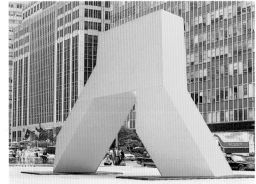

17

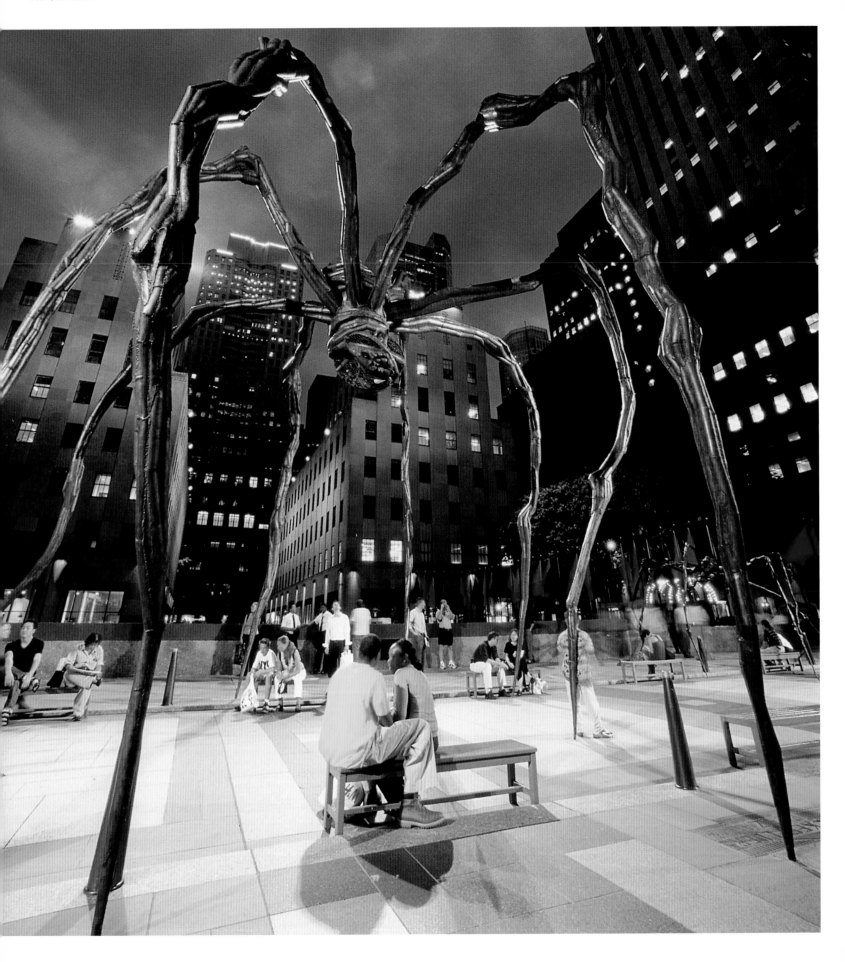

Paul Pfeiffer's *Orpheus Descending*, a project of the "In the Public Realm" program, probed these issues, exploiting temporality in ways that made it literally impossible to experience the work without a heightened sense of the passing of time. As a video installation set in passageways of the World Trade Center, *Orpheus Descending* worked at two speeds— the frenetic to-and-fro of the commuter and the pastoral, if surprisingly busy, life of the chicken coop. Both were equalized, neither one privileged as the backdrop to the other; two quotidian existences that played out in separate universes. Set on a farm in Sullivan County, *Orpheus Descending* documented the life of a flock of chickens. Filmed twenty-four hours a day using three cameras, the silent video of the creatures' lives (played back as though in real time) followed them from incubation through their hatching at around seventeen days and finally to their development into fully grown chickens at seventy-five days. On the seventy-fifth day the sun set for the last time, and the monitors on which the images played returned to their normal routine of Path Train timetables and shopping guides.

Orpheus Descending (the title is taken from Tennessee Williams's 1947 stage play and refers to Orpheus's ill-fated descent into the Underworld to rescue his wife Eurydice) was presented as an uncanny presence, a small window into another world glimpsed out of the corner of one's eye. Pfeiffer established a parallel without any deliberate commentary, yet the chickens under constant surveillance were also a mirror, a kind of Brave New World to which workaday life remained oblivious.

Besides the inherent quality of each given work, public art will only engage its intended audience if the individual is so inclined or interested. This raises the issue of audience and takes us back to Richard Serra's questioning of *who* the artwork is made for. I wouldn't be so dismissive of the wider public. The audience (or expanding the audience), it seems, has been the critical factor in the kind of museum exhibitions that are presented and the artists who are institutionally supported. It would seem to be a critical question for public art but, paradoxically, it is less so than for museums where the tangible financial incentive of entrance fees is essential to their survival. The "public" may be an undifferentiated mass as an abstract concept, but is actually a set of particulars in the concrete. To remove the somewhat proselytizing (and patronizing) impulse from public art liberates it from the need to *please* everyone, or anyone for that matter. Rather, an organization can support a series of propositions by artists and argue for the right of artists as individuals to be heard; that, in a sense, the distinctive nature of visual art can and should play a prominent role in the cultural life of the city, and ultimately accessibility to that activity is not the exclusive domain of the privileged few. In response to the question of what public art is, artist Siah Armajani says: "It is not about the myth of the artist but it is about civicness. It is not to make people feel diminished and insignificant, but it is to glorify them.

It is not about the gap between culture and public, but it is to make art public and artists citizens again."[16]

While corporate advertising seems to be able to take up endless amounts of public space with a constant stream of advertising, the space available for any meaningful public dialogue is greatly diminished. The power of the artworks presented often results from the simple fact that it is so rare to find articulate individual voices that engage the intelligence and natural inquisitiveness of the passerby. While the installations are generated from the artists' own vocabulary and maintain a certain density as artworks—unlike advertising, which can immediately be decoded to reveal a single proposition (buy me!)—the projects in their city locations are "open texts" that invite many possible readings and individual perceptions. This humanistic philosophy presents artists and their art as significant participants in the public life of the city. In this context, artists become (often unintentionally) important advocates for democratic values, maintaining the belief that public land is an arena for public life. Patricia Phillips roots this very American philosophy back into the idea of "the commons": "the physical configuration and mental landscape of American life." She goes on to write: "The commons was frequently a planned but sometimes a spontaneously arranged open space in American towns, but its lasting significance in cultural history is not so much the place it once held in the morphology of the city as the idea it became for the enactment and refreshment of public life— its dynamic, often conflicting expressions … . The philosophical idea of the commons is based on dissent, transition, and difficult but committed resolution; this legacy remains current even as the space and memory of the commons are diminished."[17]

If there has been a guiding principle to the Public Art Fund's program, it has been to realize artists' projects that would not have been possible without our support, and to do so without changing or reshaping the artists' vision, in environments where one would least expect them. It is rare, indeed, for individuals to transform, even temporarily, the architecture of the city. This book documents the work of forty-six artists who did just that.

NOTES

1. Claes Oldenburg, "I Am For an Art," in *Environments, Situations, Spaces*, New York (Martha Jackson Gallery) 1961; reprinted in an expanded version in Claes Oldenburg and Emmett Williams (eds.), *Store Days: Documents from The Store (1961) and Ray Gun Theatre (1962)*, New York (Something Else Press) 1967, pp. 39–42.

2. Florian Matzner, *Public Art: Kunst im öffentlichen Raum*, Ostfildern, Germany (Hatje Cantz Verlag) 2001, p. 402.

3. The term "Plop art" came out of a group discussion at the art and architecture studio SITE (Sculpture in the Environment) Projects in 1969.

4. For further discussion of the recent history of public art, see in particular Suzanne Lacy's introduction, "Cultural Pilgrimages and Metaphoric Journeys," in S. Lacy (ed.), *Mapping the Terrain: New Genre Public Art*, Seattle (Bay Press) 1994, pp. 19–47 and Tom Finkelpearl's essay, "Introduction: The City as Site," in T. Finkelpearl, *Dialogues in Public Art*, Cambridge MA (MIT Press) 2000.

5. For example, Jerry Saltz began a review of Rachel Whiteread's *Water Tower* by saying: "Most public art is shit. The reasons for this are many, but the fact remains indisputable—which makes Rachel Whiteread's *Water Tower* all that more remarkable" (*Time Out New York*, August 6–13, 1998, p. 52), and Michael Kimmelman wrote in *The New York Times* that "It seems grumpy and possibly beside the point to say that on the whole outdoor art is bad. So I won't mention it" (*The New York Times*, August 8, 2003, p. E1).

6. *Felix Gonzalez-Torres*, exhib. cat. by Nancy Spector, Santiago de Compostela, Galicia (Centro Galego de Arte Contemporánea) 1996, p. 23.

7. On April 24, 1980, the year before *Tilted Arc* was completed, the Public Art Fund installed Richard Serra's *Rotary Arc* at the St. John's Rotary at the Lower Manhattan entrance to the Holland Tunnel. It remained at that site until 1987, with little community disapproval. For a wider discussion of Serra's *Tilted Arc*, see American Council for the Arts, *Public Art, Public Controversy: The Tilted Arc on Trial*, New York (ACA Books) 1987 and Harriet Senie, *The Tilted Arc Controversy: Dangerous Precedent?*, Minneapolis (University of Minnesota Press) 2001.

8. Quoted on PBS website accompanying the WGBH television series *Culture Shock* (www.pbs.org/wgbh/cultureshock).

9. For more information see Klaus Bußmann and Kasper König, *Skulptur Projekte in Münster*, Cologne (DuMont Buchverlag) 1987; Klaus Bußmann, Kasper König, and Florian Matzner, *Contemporary Sculpture: Projects in Münster*, Stuttgart (Verlag Gerd Hatje) 1997; Gerrie van Noord (ed.), *Off Limits: 40 Artangel Projects*, London (Merrell Publishers) 2002; *TSWA 3D*, exhib. cat. by James Lingwood, Tony Foster, and Jonathan Harvey, Newcastle, Belfast, and Glasgow, 1987; Mary Jane Jacob, *Places with a Past: New Site-Specific Art at Charleston's Spoleto Festival*, New York (Rizzoli) 1992; and *Culture in Action: A Public Art Program of Sculpture Chicago*, exhib. cat. by Mary Jane Jacob et al., Seattle (Bay Press) 1995.

10. See James Lingwood (ed.), *Rachel Whiteread: House*, London (Phaidon Press) 1995.

11. Andrew Graham Dixon, "This Is the House that Rachel Built," *The Independent*, November 2, 1993, p. 25.

12. "I see little of more importance to the future of our country and our civilization than full recognition of the place of the artist. If art is to nourish the roots of our culture, society must set the artist free to follow his vision wherever it takes him." John F. Kennedy, 1963 (quoted on the institutional chronology page of the National Endowment for the Arts website, www.nea.gov).

13. Vito Acconci, *Making Public*, The Hague (Stroom hcbk) 1993, p. 16.

14. See Irving Sandler, *Sculpture in the Environment*, New York (New York City Administration of Recreation and Cultural Affairs for the Cultural Showcase Festival) 1967. For a discussion of the *Sculpture in the Environment* exhibition, see Suzaan Boettger, *Earthworks: Art and the Landscape of the Sixties*, Berkeley (University of California) 2003, pp. 1–9.

15. Quoted in *Ten Years of Public Art: 1972–1982*, New York (Public Art Fund) 1982, p. 6.

16. Matzner 2001, p. 106.

17. Patricia C. Phillips, "Temporality and Public Art," in Harriet Senie and Sally Webster (eds.), *Critical Issues in Public Art: Content, Context, and Controversy*, New York (HarperCollins) 1992, p. 299.

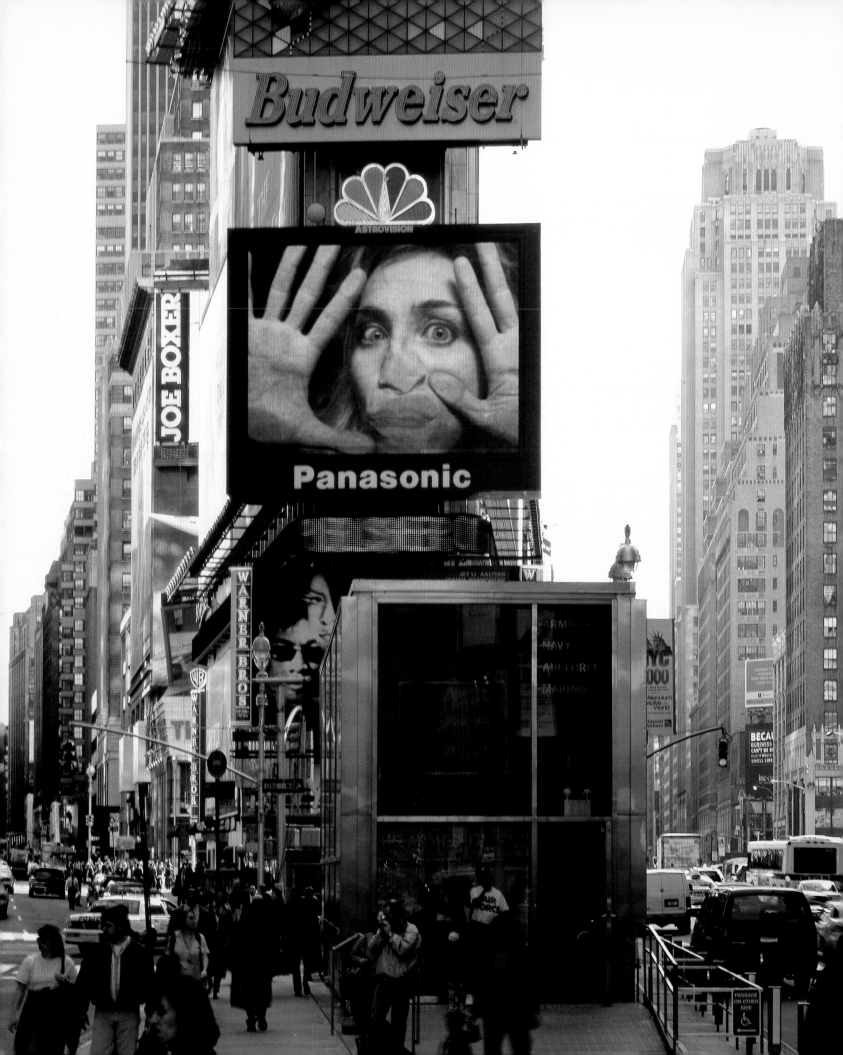

While there are many ways of viewing art, not all of them require voluntary participation on the viewer's part. Much as our experience of architecture or nature is not always dependent on a conscious decision to go out and look at either one, so the encounter with art need not be restricted to those occasions when we choose to go to a museum or gallery. On the contrary, it is entirely conceivable that, by catching us unawares, art can have an impact that might not be possible in an environment where one has consciously prepared for what one is going to see. Being immersed in a fast-paced cosmopolitan urban environment, on the other hand, tends to heighten one's perceptions of space and time, so that aspects of the mundane are occasionally transformed into something more compelling than they might at first appear. Most of us have experienced moments when our gaze has been caught by a structural or incidental detail of urban life that might have always been there, but which appears more striking or emblematic by the mere fact that one day it suddenly seems to stand out from its surroundings. Such encounters run against the grain of our day-to-day routine, reminding us that the privilege of being part of a metropolitan center includes the underlying knowledge that there is infinitely more richness of experience at hand than one can possibly find the time to process adequately.

The activities of the Public Art Fund, which has increasingly set for itself the challenge of transforming the outdoor spaces of New York City into one of the liveliest sites for contemporary art in the world, have developed somewhat along these lines. No matter where one happens to be in Manhattan, for example, chances are that the Public Art Fund has gotten there first, and has at one time or another converted it into a surprise encounter with a work of art, experienced by millions of viewers from all walks of life. This is quite distinct from the "white cube" experience that one normally associates with indoor art venues, where the success of the encounter is predicated on having one's attention fully absorbed by the art on display, to the deliberate exclusion of all surrounding elements of the visual environment. By contrast, the projects organized by the Public Art Fund do not compete with or blend into the city for which they have been conceived. Rather, they augment the unfolding panorama of city life, reminding us that art is a part of our lives, not something that can only be indulged in when the manifold duties of quotidian life have been fulfilled. In fact, to experience the dynamic presence of artistic creation in tandem with the surrounding spectacle of a great metropolis enables the one to amplify the other, giving us a glimpse into the public sphere as a massive collaborative project, in which we are all, simultaneously, authors and audiences together.

↘ DAN CAMERON

CITY OF WONDERS

For readers who do not readily equate the phrase "contemporary art" with the mental image of "millions of viewers," the challenge set by the Public Art Fund is profound. In a world that too readily accepts that the audience for new art totals, at most, in the low tens of thousands, the implicit premise behind the Public Art Fund's activities is that contemporary art can be, or should be, for everyone. Not only does this notion fly in the face of the barely concealed elitism of the Modernist avant-garde, it also challenges a much more fundamental notion of city life: that the visual spectrum belongs to us all. In most of Manhattan, where the continuous visual bombardment of outdoor advertising, public signage, and architectural grandiosity conspires

to rob us of any sense of agency in what we perceive, such a claim might well be met with skepticism and disbelief. Most of us would no sooner presume ownership in the public spaces of our city than we would in the sky above our heads or the waterways surrounding us on all sides. And yet, if we examine these feelings of passivity more closely, they contain little if any logical rationale. Half a century ago, when neon was still new, television in its infancy, and billboards a harbinger of unlimited consumer prosperity, it would have been nearly impossible to see what we instantly recognize today as a visual glut of banality, sensationalism, and greed. And as more and more of our treasured outdoor spaces are sold off to the highest commercial bidder, we have

become understandably, but no less regrettably, mute in the face of what amounts to the wholesale robbery of our shared vistas. Whereas Times Square was once the pinnacle of sensory overload (and a worldwide attraction for being so), it has now established the standard for visual pollution to which the rest of the city seems to aspire.

Within the context of these observations, it might be tempting to think of the Public Art Fund's activities as a sort of radical reclamation project, dedicated to reconfiguring the daily commute, the leisurely stroll, and the crosstown errand as adventurous forays into the heady domain of artists and their perception-challenging schemes. However, such a characterization, while attractive in both its scope and magnanimity, overlooks the fact that, instead of proposing to scrap the current, overcrowded system in favor of something more populist in nature, the Public Art Fund aims to augment what we already agree is way too much visual information with just a little bit more. Although this may seem contradictory, the discussion that follows, based on the projects of selected artists and the rationales underpinning their development, is predicated on the idea that art represents a very different level of visual engagement from advertising, or traffic signs. Where art and New York City are concerned, "a little bit more" might, in fact, stand for a critique of what already exists, an insight into the environment surrounding it, an island of beauty in an ocean of ugliness, or even a direct challenge to the unrelenting spectacle in favor of something even more attention-grabbing. By utilizing a variety of distinct approaches to presenting art in the ultimate urban setting, the Public Art Fund invites us to experience the city as the ideal platform for realizing our own dreams: a place that is always new, always vital, and always unexpected.

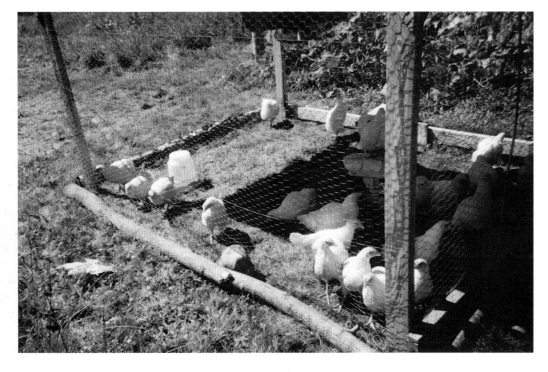

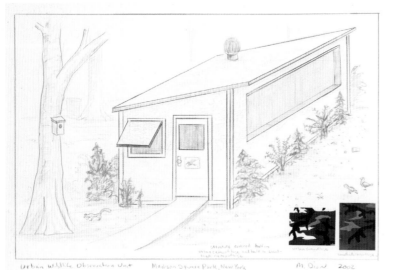

ABOVE:

Photograph of site of
Paul Pfeiffer's *Orpheus
Descending*, 2001

LEFT:

MARK DION
Drawing for *Urban Wildlife
Observation Unit*, 2002
Colored pencil and mixed
media on paper

PAGE 20:

PIPILOTTI RIST
Open My Glade, 2000
Video presentation
One-minute segments shown on
NBC Astrovision by Panasonic,
Times Square, Manhattan

By 1968, the sculptor Robert Smithson had developed the dialectical structure for the "non-site," an artwork consisting, in essence, of a slice of nature displaced and relocated within the gallery confines. Although the non-site by itself remains only a minor part of Smithson's immense contribution to sculpture, the underlying dialectical structure has become so important to current conceptions of art-making that it is hard to imagine a time when it did not exist. Within the scope of the Public Art Fund's vast range of successful projects, one sees traces of the non-site principle in a large number of endeavors. There is a significant difference, of course, between a planned encounter with an arrangement of dirt or rocks in a gallery or museum and happening upon a work of contemporary art in a public space, but the broader effect is surprisingly similar. Smithson's original premise was that the dialectical structure presupposed a spatial referent—nature—that could not be accessed at the same time as the gallery, so the artwork was understood as occurring in a space somewhere between what could be seen and what

could not. In the examples shown here, nature is also the key point of departure, but not in a form that is necessarily hidden or removed. As often as not, nature is also a fundamental part of the cosmopolitan experience, but the artist's function is to remind us that perceiving nature's role in an overly constructed environment requires an extra stimulus to both the eye and the intellect.

In Paul Pfeiffer's *Orpheus Descending* (2001), for example, untold thousands of commuters at the World Trade Center became unwitting witnesses to the incubation, hatching, and growth cycle of a generation of chickens that were being bred in an upstate New York farm over the course of seventy-five days. For the artist, the video image of animal life unfolding in a rural zone more than a hundred miles away, transported to one of the busiest commuter concourses in the world, became a reminder, in quasi-spectacle form, of a world inherently foreign to the professional experiences of most passing viewers. But Pfeiffer was also sensitive to the overlapping allegories that his work employed: the early-morning urban commute and the beginning of a day on the farm, or the struggle of the baby chicks to orient themselves to their environment and the sleep-deprived struggles of stress-filled workers to adjust to their schedules. Similarly, when Mark Dion set up his *Urban Wildlife Observation Unit* (2002) at Madison Square Park, he was conscious of the sheer incongruity of encountering, in plain sight, in one of New York's most pristine and manicured small parks, the type of blind used by hunters or conservationists when observing wildlife. These structures, which are usually located well out of the range of vision, emphasized the degree to which all of us unconsciously edit out the experience of nature in our daily perceptions of urban space. At the same time, it called attention to the fact that nature is no less present in a large city than in the wilderness, and that only a degree of focused attention is required to perceive how animal and plant life alike thrive in abundance in the interstices between street, sidewalk, and architecture.

One of the strategies most successfully employed by many artists participating in the Public Art Fund is subterfuge or camouflage, which in this context can be defined as the effort to conceal a work of art from the viewer in such a way that its discovery, accidental or intentional, borders on the revelatory. In many cases, the work itself poses as a fragment of the urban environment that is so predictable as to be passed over unthinkingly by an overwhelming majority of prospective viewers. One of the most provocative of these was Ilya Kabakov's *Monument to the Lost Glove*, a 1997 sculpture consisting of a red resin glove attached to the traffic triangle that frames the intersection of Broadway and Fifth Avenue in front of the Flatiron Building. Using an unabashedly mundane example of the sort of minor mishap that has no doubt affected nearly every New Yorker who ventures on to the streets in winter, Kabakov's project singled out a "representative" lost

glove to suggest that even this banal event deserved a kind of memorial. His point was that for most of us, such small incidents are quickly forgotten, because they typify the category of unimportant phenomena that have no rightful place alongside the daily mantra of success through perseverance that frames the internal narratives of most hard-working New Yorkers. Although *Monument to the Lost Glove* was of necessity a temporary homage, Lawrence Weiner's *NYC Manhole Covers* project (2000) was intended to enter the fabric of New York street life in a way that will outlast all of us. Using the same materials and processes employed by manufacturers of these quintessentially New York emblems, Weiner had twenty of them cast and inscribed with a text, "IN DIRECT LINE

WITH ANOTHER & THE NEXT." Installed at numerous points in downtown Manhattan, the works can only be seen if inspected closely, something that very few pedestrians are able or inclined to do.

A variation on the strategy of urban subterfuge is the blending of projects into the landscape so that either they are all but invisible to the passerby or they stand out because of their successful mimicry of the surroundings. For the Whitney Museum of American Art's 2002 Biennial Exhibition, two temporary projects created for Central Park typify this approach in different ways. Roxy Paine's *Bluff* (2002), a full-scale replica of a 50 foot high (15.2 m) tree made entirely from stainless steel, duplicated the gracefully arching branches of a poplar or elm,

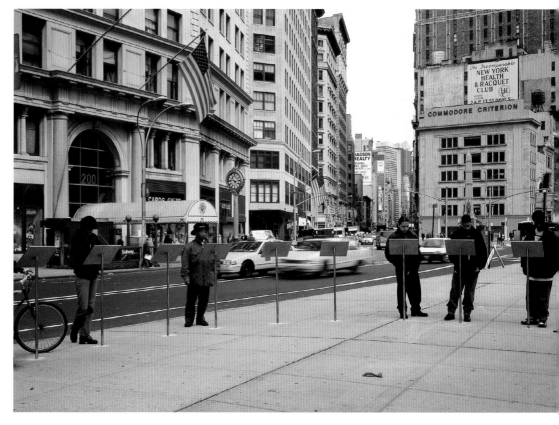

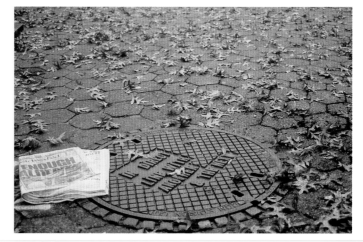

but its metallic surface gleamed spectacularly in the sun. Using metal plates embedded in the earth for support, *Bluff* combined a slender trunk, 2 feet (60 cm) in diameter, with cantilevered branches constructed from varying widths of stainless steel rods and pipes, the latter weighing 6000 pounds (2721 kg). Although by day the work stood out dramatically from its surroundings, during dusk, nighttime, and early morning it blended almost imperceptibly into its environment, revealing its unusual material only when the first rays of sunlight began reflecting off its steel surface. At the other end of the spectrum was a project by Brian Tolle, titled *Waylay* (2002), in which the artist submerged different mechanisms under the surface of the Lake in Central Park, near Bow Bridge. The mechanisms produced splashes, some quite subtle and others much stronger, in the surface of the lake, creating the sensation that some natural phenomenon was taking place. Although on first encounter it may have been possible to explain the splashes away as a fish snapping at an insect, or a pebble being dropped from above, the more one stood on the bridge witnessing the splashes, the more inexplicable they seemed. Without the benefit of an identifying label or other clue immediately nearby, the knowledge that an artist had manufactured these splashes as a way of disrupting our expectations of nature would have been the last thing to occur to most passersby.

Perhaps the best-known and most celebrated of the urban subterfuge projects undertaken by the Public Art Fund is Rachel Whiteread's 1998 project *Water Tower*, which was created on the rooftop of a typical SoHo former industrial building, where it remained for several months. Fascinated by the ubiquitous nature of these towers throughout the Manhattan skyline, the British sculptor was equally drawn to the fact that their distinct location on the roofs of buildings makes them all but invisible to most New Yorkers, who unthinkingly accept them as part of the skyline. As a backhanded tribute to human nature's tendency to blot out the most apparent thing in its sight line, once it has been accepted that the thing itself is not meant to attract attention, Whiteread cast one of them in a translucent polyester resin, then placed it in exactly the location that one would expect to see (or not see) the real thing. The resulting visual play on the twinned aspect of the visible and the invisible resulted in a countless number of double takes, even from those who knew of the existence of the work and had a general idea of how to find it. Even after it had been publicly recognized as sculpture, *Water Tower* retained a peculiar ability to slip in and out of one's visual attention, almost like a ghost that occupies a precise location at one instant and then just as suddenly vanishes without a trace.

Another approach favored by many artists who have collaborated with the Public Art Fund consists of a form of simulation of the everyday.

This tactic, which is similar to that of urban subterfuge, originates from the premise that people often disregard aspects of normal daily life that do not appear to be too far out of line with convention. In the most successful instances, the artist's ability to capture and expand upon an element of so-called "normalcy" requires a certain capacity for surrounding their endeavors with an air of legitimacy. Christine Hill, an American artist who has often worked in real-life situations in a public manner, collaborated with the Public Art Fund and the SoHo gallery Deitch Projects to establish a series of regularly scheduled walking tours under the name of *Tourguide?* (1999). The project, which lasted the entire summer tourist season, was in fact a functional tour service, with the main exceptions being that the sites visited were not generally included as part of a tourist itinerary—a typical McDonalds, for example, or the site of a defunct stationery store—and were highlighted by personal anecdotes told by the tour guides. Rather than function from the authoritative position of the "local expert," Hill chose to emphasize aspects of New Yorkers' lives that directly provoked conversation from and between the members of the tour, enabling them to share in the responsibility for the enjoyment of the experience. Anissa Mack, a young New York artist who has often created works that reflect aspects of life in small-town America, developed a project during the summer of 2002

BELOW, LEFT:

ROXY PAINE
Bluff, 2002
Stainless steel
Central Park, between the
Mall and the Sheep Meadow

BELOW, RIGHT:

CHRISTINE HILL
Tourguide?, 1999
Performance and storefront
installation at Deitch Projects, 76
Grand Street, Manhattan

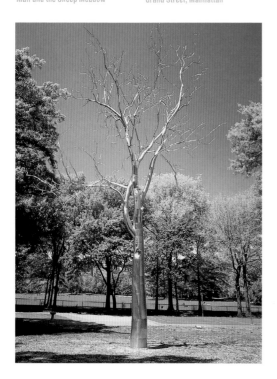

called *Pies for a Passerby*. Operating out of a simulated cottage on the steps outside the Brooklyn Public Library, Mack spent her days baking apple pies from scratch. As each pie was finished, she would place it on a window shelf, luring passersby into an open-ended situation in which they could smell the pie, eat it, steal it, or simply engage the artist in conversation.

At times the simulation of the everyday can have unexpected consequences, particularly in a congested urban environment in which a broad range of personalities converge within the same space. Tony Matelli, a New York artist known for his hyperrealistic figurative sculptures, developed a project in 1998 for the Public Art Fund's renowned series of younger artists' commissions at Brooklyn's MetroTech Center, with the self-explanatory title *Stray Dog*. Fabricating a life-size sculpture of a seeing-eye dog, Matelli then sited it adjacent to a busy pedestrian walkway within the park in such a way as to immediately attract the attention of passersby, some of whom, not knowing the dog was fake, presumably became concerned for its well-being.

One of the most difficult challenges inherent in the kind of programming that the Public Art Fund organizes centers on the question of the general public's openness to new art, as well as the tendency for programs like this one to shy away from projects that might provoke a misunderstanding on the part of the average New Yorker. Accordingly, since the most common precedent for these endeavors is found in the model of the Calder-in-the-plaza or the Botero-in-the-park, perhaps the most revealing aspect of the Fund's recent history is the way it has collaborated with artists whose profile with the general public is much higher than average. Perhaps the best-known example of recent years is Jeff Koons's *Puppy*, a work that was first shown in Arolsen, Germany, as part of a Documenta-related *Salon des refusés* in 1992, but remained largely a rumor to New York viewers until the Public Art Fund presented it at Rockefeller Center during the summer of 2000. Of all the public artworks seen in New York over the past decade, none has been as widely embraced by both the public and the art establishment as *Puppy*, in large part thanks to Koons's own longstanding commitment to bridging the gap between middle-class taste and the remnants of the artistic avant-garde. Standing 40 feet (12 m) in height and supporting 25 tons (25.4 tonnes) of soil, which in turn gives life to more than seventy thousand flowers of numerous varieties, *Puppy* belongs to a category of public art that can be loosely defined as a form of counter-spectacle. A counter-spectacle is one that aspires to a visual impact that rivals—in potential if not reality—the sheer perceptual force continuously unfolding within the mega-theater represented by virtually every point in Manhattan.

Although few artists working today might be considered the equal of Jeff Koons in such an aspiration, there are a number of examples of successful Public Art Fund projects that might also be classified as counter-spectacles. One might further elucidate this category as a public manifestation that asks nothing more of the viewer than that he or she respond in the same way to it as they would if, say, they were suddenly to come upon an unannounced free concert by the Rolling Stones. In other words, the possibility of working on a large public scale represents, for these artists, the chance to make a convincing argument that visual art does not take a back seat to any other form of creative activity today, be it a fashion show, movie premiere, or rock concert. For example, the use of the NBC Astrovision by Panasonic in Times Square, which is unquestionably the most widely viewed screen on the planet, is a perfect demonstration of how an artist's video, such as Pipilotti Rist's *Open My Glade* (2000), requires only the massive scale of such a venue to literally halt thousands of pedestrians in their tracks. Rist's work, which combines certain of the production values of professional filmmaking with the avant-garde credentials of her predecessors, is a kind of hybrid art form, one that can be as easily enjoyed by the average household viewer as by an elite audience of art sophisticates. The deliberate confusion that was no doubt experienced by much of the audience for *Open My Glade*—owing at least in

part to the gathering of crowds of young people at the same place to be part of the background for MTV's *Total Request Live* show—speaks to the possibility that contemporary art has only begun to find its possible audience.

The unannounced occupation of urban spaces frequented by large numbers of pedestrians is an important part of the counter-spectacle strategy, even when this occurs in such a way as to reach only those who exhibit a certain degree of curiosity about their surroundings or who merely happen to be in the right place at the right time. Paul McCarthy's *The Box*, presented in 2001 in the lobby of a corporate office building on Madison Avenue, happened to occur within an environment that was already familiar to many passersby as a space where sculpture was sometimes presented. However, the difference between McCarthy's project and the occasional Calder displayed as part of the backdrop for a lunchtime break could not have been more pronounced. As the title suggests, *The Box* is a massive wooden construction, and its interior measurements correspond to those of the artist's studio. Containing every tool, object, artwork, and piece of furniture in the studio, located in the same position as when McCarthy conceived the work, the room has been rotated ninety degrees so that each surface radically changes its orientation: the walls become the floor and ceiling, and vice versa. For the viewer of the work, this drastic state of disorientation,

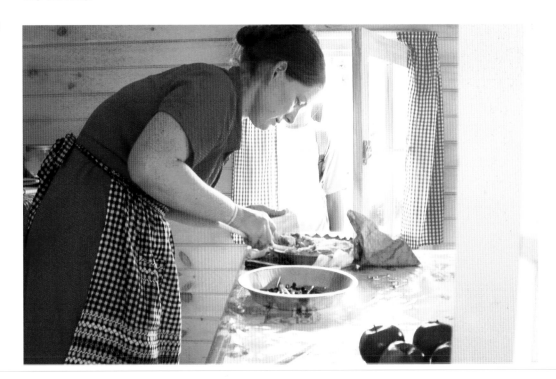

combined with the everyday appearance of the space as a whole, was an unsettling glimpse into a world literally turned on its side, but in which every component retains its "normal" position.

Among the many outdoor projects produced by the Public Art Fund, perhaps none has been as fully enveloping in its sense of disorientation as Tony Oursler's *The Influence Machine*, which was presented at Madison Square Park over thirteen nights in October 2000, the last showing taking place on Halloween. *The Influence Machine*, a co-commission with Artangel of London, and unquestionably the artist's most complex work to date, took the form of a number of projections on to smoke, trees, and the surrounding buildings, as well as a sophisticated sound track and score produced especially for the occasion. To create the work, Oursler undertook a dedicated period of research into the remarkable social legacy surrounding the early years of technological developments, when a fuzzy boundary lay between the worlds of scientific invention and paranormal activity. Exploring the complex realm of human presence through the nineteenth and early twentieth centuries, *The Influence Machine* deployed giant ghostly faces projected on to natural and ephemeral spaces—as well as a knocking fist and a

talking lamppost—to rekindle remnants of human fears associated with the disembodied human form. Playing off the supernatural undertones of Halloween, the complex sound track incorporated voices speaking in fragmented narratives, radio feedback, knocking sounds associated with seances, a glass harmonica, and other unexpected sounds. By combining spectators' nostalgic identification with narratives of now-antiquated technologies, and the often-unspoken present-day anxiety over the hegemony of new information and communication technologies, Oursler accomplished the unusual task of reviving our fears of the unknown, whether these emanate from the spirit world or from our own laptop computers.

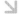

Of all the histories evoked by the many artists who have contributed over the past ten years to the Public Art Fund's programs, none is as poignant as the stories of those individuals who have come to New York from faraway cultures and fought to establish themselves as a part of their adopted society. Indeed, the deepest social bonds cherished by all New Yorkers involve the constant reforging of those links between New York's colorful immigrant past and its present-

day status as home to millions of foreign-born individuals striving to make a new life for themselves. French artist Christian Boltanski's 1995 project *Lost: New York Projects*, which took place simultaneously at Grand Central Terminal, the New-York Historical Society, the Eldridge Street Synagogue, and the Church of the Intercession in Harlem, employed the complex and evocative presence of personal property and narratives to refer to the memory of the countless individuals who left their past lives behind in order to begin new ones. Although virtually all of the objects chosen and displayed by Boltanski were taken from the present, the mere presence of their accumulation in sites of history, worship, and transit became a metaphor for the vast majority of people whose adventures ended in, or were marked by, tragedy, hardship, and loss. As with his well-known photographic works documenting thousands of anonymous people, many of whom disappeared in the furnace of the Holocaust, Boltanski's *Lost* reminded present-day New Yorkers—many of whom are direct descendants of those pioneers who risked everything in the name of freedom and opportunity—that history moves in cycles, and that today's poor but hard-working immigrant is tomorrow's embodiment of a vision made reality.

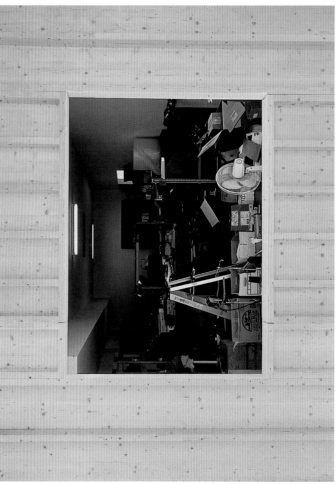

FAR LEFT:

TONY MATELLI
Drawing for *Stray Dog*, 1998
Mixed media on paper

NEAR LEFT:

PAUL McCARTHY
The Box (detail), 1999
Mixed-media installation
590 Madison Avenue, Manhattan, 2001

OPPOSITE, TOP:

TONY OURSLER
The Influence Machine, 2000
Video, sound, and mixed-media installation
Madison Square Park, Manhattan

OPPOSITE, BOTTOM:

NAVIN RAWANCHAIKUL
I ♥ Taxi, 2001
Mixed-media installation
Madison Square Park, Manhattan

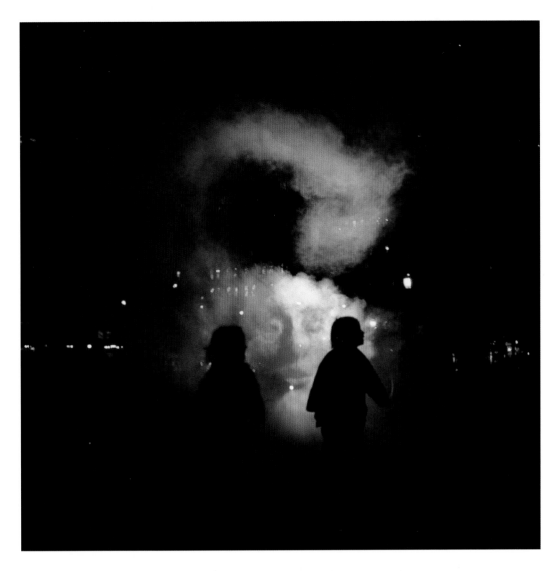

Thai artist Navin Rawanchaikul's *I ♥ Taxi*, a 2001 homage to the contemporary New York taxi driver, produced a similar effect for those relatively few New Yorkers who were able to experience it directly. Originally planned as a public work involving hundreds of cabbies, each of whom would volunteer to let the artist transform their vehicle into a kind of moving shrine to the power of private entrepreneurism, *I ♥ Taxi* ended up being produced in a highly truncated version, due to the Taxi and Limousine Commission's last-minute refusal to participate. As is well known to New Yorkers and visitors alike, the overwhelming majority of taxi drivers in the city are foreign-born, and in that sense each yellow cab cruising for a fare represents a present-day manifestation of the dreams of success and liberty that Boltanski's project poetically evoked from history. For Rawanchaikul, the idea that every New York cabbie plays the part of a driver's-seat philosopher, extolling wisdom and information along with getting their passengers from one place to another, is a significant resource that relatively few New Yorkers appreciate as such. By inviting us to "see" this resource as something that deserves not to be passed over, Rawanchaikul encourages us to celebrate not only diversity and opportunity but also humanity in its most universal state. As the artist reminds us in the booklet accompanying his project, many important artists and statesmen did their time behind the wheel of a cab, and each time we hail a cab, we are embarking on an active collaboration between someone else's dreams of fulfilment and our own.

Because of its almost uncanny ability to capture the present and future dimensions of New Yorkers' aspirations, Rawanchaikul's contribution to the Public Art Fund's remarkable trajectory makes it one of the most successful at lending narrative form to the ideals on which this program is founded. Although few New Yorkers lack for signs in their visual environment to remind them of their own ambitions, rarely if ever does the opportunity come up to explore the common purposes that bind us together. At a moment in its tumultuous history when life in New York has become more precious than many of us can remember, the fact that we now occasionally stop in our tracks, struck by the wonder of the great metropolis surrounding us, is itself a kind of gift. To be able to do so in a way that also sensitizes us to how multitudes of others engage in a parallel experience goes beyond what mere civic awareness can bring. For this kind of transcendence to occur in a meaningful way requires the kind of psychic intervention that only art can produce, and the Public Art Fund has scored an unparalleled triumph over the past decade by making sure that this possibility exists for anybody who merely opens their eyes to see it.

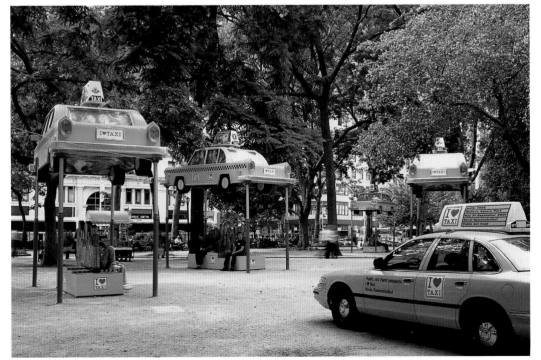

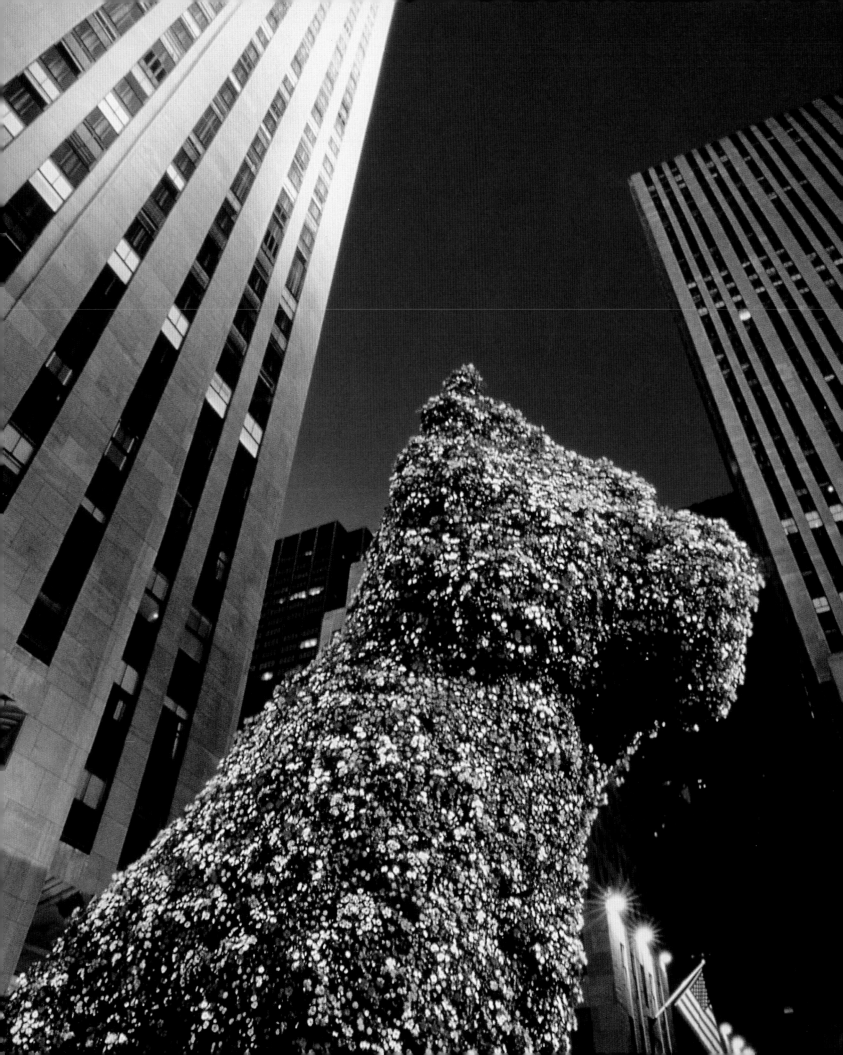

PUPPY LOVE

↘ **KATY SIEGEL**

Recently I went to The Metropolitan Museum of Art to see an exhibition of drawings by Leonardo da Vinci. Each time I neared one of the small, exquisitely fine works, someone wielding one of the magnifying glasses ingeniously marketed by the museum ducked in front of me or, after a few seconds, pushed me aside as their Acoustiguide impelled them forward. I would catch a glimpse of a beautiful Leda or angel or Madonna, and then she would disappear.

After leaving the Leonardo show, I headed to another exhibition in the Met, a mid-career retrospective of German photographer Thomas Struth. Less crowded than the other exhibition, it was still full of people. But here the crowd did not bother me. For one thing, the size of Struth's pictures let me see them easily. Even if parts were occasionally obscured by the heads, backsides, and strollers of passersby, I could fill in the missing bits in my head; thanks to the smooth uniformity of photography, there were no surprises of texture or handling in the missing passages. And strikingly, many of the photos themselves reflected my experience: they showed crowds of art lovers in the Sistine Chapel, in the Louvre, at a lecture on Delacroix. In these photographs, Struth pictures the viewers his mode of picture-taking accommodates.

The comparison is unfair, of course. The Leonardo show was unusual, featuring the private sketches of the world's most famous artist. Still, it was perhaps only an extreme example of a common phenomenon: the blockbuster exhibition. And even apart from thronged shows like *Matisse/Picasso* (The Museum of Modern Art, 2003) and *Manet/Velázquez* (The Metropolitan Museum of Art, 2003), museums have, as many have remarked, become increasingly popular destinations, featuring shops, restaurants, and, most recently, stunning, adventurous architecture—not to mention wine and cheese parties, jazz nights, and children's workshops. Run like businesses, counting on ticket sales to replace public funding, and genuinely wanting to make art available to more people, museums have become more and more crowded, thanks also to the return of the upper middle class from the suburbs to the cities of America, the rise of international tourism, and perhaps even simple population growth.

Not surprisingly, this has affected the kind of art that museums show. There is, of course, the familiar complaint that motorcycles, Italian suits, and celebrity portraits are replacing real art as the subject of exhibitions in our modern box populi. And that Impressionist painting shows spring up with the annual regularity of crabgrass. Museums are also increasingly engaged in exhibiting, buying, and even producing or commissioning contemporary

art for several reasons. Older art—even older modern art—is scarce (they are not making any more Leonardos or Picassos, although someone digs one up now and then in a basement), difficult to borrow, and expensive to acquire. Contemporary art is relatively inexpensive, particularly at the beginning of an artist's career, when the right investment can pay off big later on. Because museums and contemporary art have become so intertwined, the changing conditions of the museum affect the art that gets exhibited and talked about, and even the ways in which ambitious artists make art.

Why begin an essay on public art in the museum rather than by rehearsing the history of public art? Historians and critics—both academic and journalistic—usually consider the category of public art as separate from art proper, as having its own history, conventions, and functions, as well as its own artists and audiences. But this separation is misleading, particularly today—public art exists within and in relation to the larger category of art, a situation that current public art, particularly that organized by the Public Art Fund, makes very clear.

Traditionally, discussions of public art have centered around the question of what "the public" wants. Giant steel sculptures? Portraits of people in the community? Replanted gardens and more user-friendly landscaping?[1] The most obvious problem with the question is that modern definitions of "the public" tend to be abstract, ignoring social particularities such as employment, race, gender, religious affiliation, neighborhood, class, even citizenship. When critics, artists, and even politicians talk about "the public," they are usually trying to guess what the "average" person thinks about art, how to appeal to them, or what attitude to strike in relation to them, without asking what an average person might be—average in income, race, or gender? When journalists *do* name the average person, they often designate a hypothetical or real working-class skeptic (that favorite figure of conservative populists and well-meaning art people alike).[2] Aside from such specific agendas as ridiculing either art or the public, this is also a tactic to avoid specific discussions of the public's composition and potentially conflicting interests.

This idea of the public is related to the contrast of public with private as it has developed in modern

PAGE 28:

JEFF KOONS
Puppy, 1992
Stainless steel, soil, flowering plants
Rockefeller Center, Manhattan, 2000

BELOW:

THOMAS STRUTH
Stanze di Raffaelo II,
1990–92
C-print

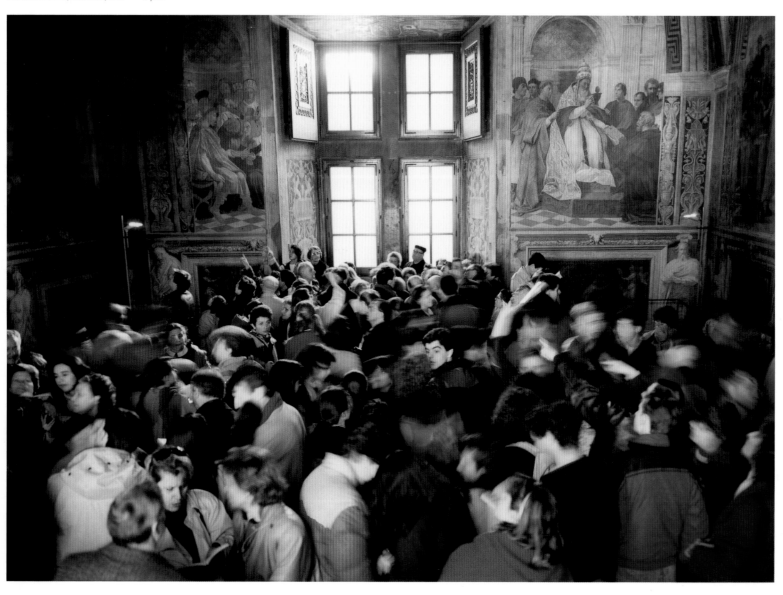

society since the eighteenth century. "Public" is, in theory, opposed to particular "private" interests—it is the realm of the citizen, represented by the state (the *Republic*). Public is therefore contrasted with commercial enterprise. In practice, the common interest is represented by public-spirited individuals: the civic, humanist aristocrats of the eighteenth century or the intellectual, politically charged avant-garde of the twentieth century. Their role was to act, theoretically, in the best interest of the many.

As part of this ideal, the museum was invented in Europe in the eighteenth century as a public institution, for the public. (In the United States, characteristically, museums were created by groups of private citizens.) The idea was that the museum would educate that public and uplift them, expressing higher values, offering a transcendent and moral experience that was outside of the everyday, commercial interests of getting and spending.

Oppositions between public and private have been confused by the trend toward privatization of public institutions, from water supplies to mail service to museums. Today we might say museums are less "public," in that they are less concerned with trying to be higher than or separate from everyday commercial life.[3] As discussed above, the museums are filled with shops, restaurants, and movie theaters. Museum officials often speak about this redesign and repositioning in the name of the public and increasing accessibility. Because museums have moved closer to the commercial entertainment condition that characterizes most of contemporary cultural life, they are also *more* public in that they aim to draw broader audiences, not just the specialist art lover.

The pressure to define "public" is especially acute when considering the history of public art.[4] That history, considered as the story of public art's current incarnation, is relatively short, stretching back to the new wave of public sculpture that appeared in the 1960s, commissioned by various city governments, local booster groups, and the National Endowment for the Arts' "Art in Public Places" program. Thought of more broadly, of course, the history stretches back much further. Monuments to rulers, war heroes, politicians, and religious heroes have formed an integral part of European and Asian cityscapes for thousands of years; in the United States, their history begins in the late eighteenth century, when politicians debated whether celebrating heroic individuals in monumental sculptures and paintings betrayed the values of the republic.[5]

But art as art, rather than as commemorative of individual persons or civic themes, is relatively new in the public realm. The first outdoor sculptures in the United States of this nature tended to be semi-abstract, biomorphic works by such well-known artists as Pablo Picasso and Alexander Calder. Although the works were initially controversial, being derided by local newspapers, they often became symbols of a city's civic pride, sophistication, and

economic well-being. Calder's *La Grande Vitesse* even provided the logo for Grand Rapids, Michigan, appearing on the city stationery and the sides of sanitation trucks.[6] The success of these commissions gave rise to a profusion of abstract sculptures that—like jewelry or turds,[7] depending on your point of view—adorned government and corporate Modernist buildings. In the late 1970s and 1980s this kind of work gave way to projects that were site-specific in responding to a particular location's topography (such as Richard Serra's notorious *Tilted Arc*, 1981). Moving away from the autonomous object, such artists as Scott Burton and Athena Tacha (who made public art almost exclusively) reconfigured the architecture and landscaping of public space to allow for greater harmony as well as accessibility.

The history of public art since the 1960s can be seen as a series of rejections of previous answers to the question "What does the public want?" (or "What is good for the public?"). Site-specific artists reject the generic quality of earlier abstract sculpture; urban-space artists reject the high-handed, Modernist uselessness of the site-specific sculpture; socially inclined artists reject the uncritical gentrification of the space shapers. Today, artists working with the Public Art Fund have responded to all of these various kinds of public art with art that is an implicit or explicit critique of the genre's conventions and uses.

The monumental tradition is still the dominant one and is, with its outdated formal qualities and questionable politics, a favorite target for artists. Ilya Kabakov installed *Monument to the Lost Glove*

KEITH EDMIER
Emil Dobbelstein and Henry J. Drope, 1944, 2002
Bronze and granite
Doris C. Freedman Plaza,
Central Park, Manhattan

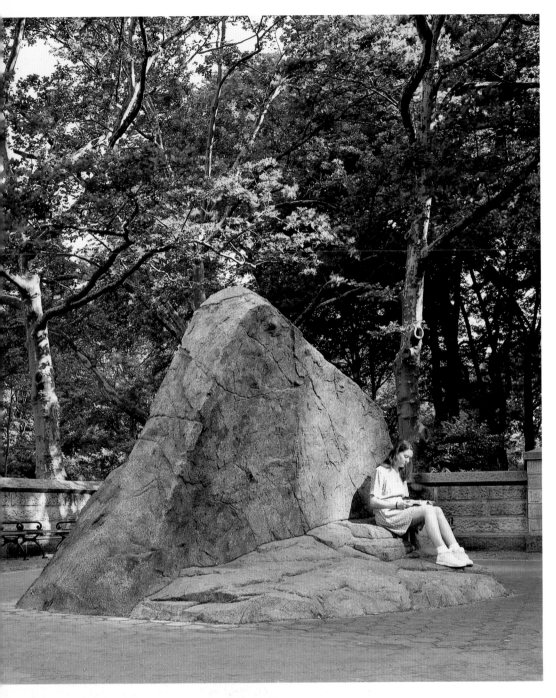

in the Flatiron District in 1997, using the memorial form to commemorate a distinctly unheroic, unmonumental subject: a single red glove lying on the sidewalk. His monument silently asked passersby to stop and consider the kind of small moment that any city dweller can relate to but usually overlooks unthinkingly, lending the glove something of the anonymous universality of the tomb of the unknown soldier. In Do-Ho Suh's *Public Figures* (1998) at MetroTech Center in Brooklyn, hundreds of tiny men and women who look like toy soldiers stretch their arms above their heads, holding up a traditional monumental sculpture pedestal. In the absence of any crowning figure, the hero of the sculpture becomes Everyman. Still more specifically, Keith Edmier took on the subject of the war memorial in *Emil Dobbelstein and Henry J. Drope, 1944* (2002), statues depicting his two grandfathers in their service uniforms. Although done in a conventional figurative style, the statues, of men who were not heroes in the conventional sense, are much smaller than the older memorials in Central Park that portray bristling men on horseback, poised for action.

Other artists turn gentle irony on the more recent history of public art, in particular the idea of the site-specific work of sculpture responsive to the community. Olav Westphalen's *E.S.U.S. (Extremely Site Unspecific Sculpture)* (2000) was a compact, abstract work easily moved from place to place, mocking art that "investigates" the history or physical requirements of a space. In 1999, Andrea Zittel's *Point of Interest* was placed in Doris C. Freedman Plaza, usually a site for more traditional monumental sculpture, such as the bronze female figure by Willem de Kooning that had been on view there just a few months before. On the one hand, Zittel created a generic lump of terrain—a "point of interest" that in fact is *not* interesting, without formal or historical importance. In its insistent recognition of the needs of the tourists who are the main users of the location as a place to rest or picnic or for children to play on, Zittel's piece shared the functionality of the chairs and tables by Scott Burton in *Urban Plaza South* (1985–86), located nearby in midtown Manhattan around the UBS Paine Webber building. On the other hand, by rejecting Burton's conventional furniture forms, Zittel's lumpy land spill allows for more free-form social uses than the businessman's thirty-minute lunch. She manages to undermine the contrast between a critical, site-specific practice that questions the intended use of urban spaces and what some critics perceived as the lowbrow, development-friendly art of someone like Burton.[8]

In their interactive projects, Mark Dion and Christine Hill both adopt and mock the position of the artist as anthropologist, as expert researcher of his or her specific site. Sliding into the role of guide, each artist explores and explains his/her respective sites: Dion takes Madison Square Park and the subject of its "wildlife"; Hill, as a tour guide, explores New York City.

ABOVE:

ANDREA ZITTEL
Point of Interest, 1999
Concrete and steel
Doris C. Freedman Plaza,
Central Park, Manhattan

LEFT:

SCOTT BURTON
Urban Plaza South, 1985–86
51st Street at Sixth Avenue,
Manhattan

Both setups are humorous, with Dion giving natural-ist information on rats and squirrels rather than more exotic creatures, and Hill offering weird semi-fictional tours, filled with offbeat facts and bizarre versions of historical landmarks. Both projects comment ironically on the desire to educate "the public" central to art in the museum and outside it.

Very little of the art commissioned by the Public Art Fund adopts the artistic practice of the 1970s and 1980s, in which artists used graphic design and advertising strategies to instruct or exhort the public about the government, AIDS, homelessness, feminism, or other hot political issues. Barbara Kruger's 1997 project, a bus running from Queens to Manhattan covered with various exhortations and warnings couched in her signature stern and portentous terms, is a rare vestige of 1980s public address. More successful, because less sweeping and abstract in its address, *The Invisible City* (1999), by the team of Grennan and Sperandio, used subway "ads" and comic books to depict the jobs and lives of night-shift workers, rendering them visible to the majority of people who work and ride the subway during the day.

In a larger sense, the Public Art Fund itself implicitly criticizes past public art in its choice of artists and projects. Rather than facilitating research, decorating buildings, landscaping downtrodden neighborhoods, or commemorating political events, both the Director and the President of the Public Art Fund have declared that the aim of the program is to bring the best contemporary art

to new locations outside the museum, "exposing diverse audiences to the art of our time."[9] And the Public Art Fund has undeniably become one of the most important forums for cutting-edge art in New York City—something that could not have been said about any of its government-funded or civic predecessors. Public art has gone through phases of decoration, monument, civic classiness, tough intellectual art, specific historical investigations, user-friendly art. Now it is just regular art, like that in the museums or galleries.

But this reflects as well the changing nature of "regular" art itself in response to contemporary conditions. New genres of art have emerged that take advantage of the availability of museums to contemporary artists. First and foremost is installation art, work designed to occupy large spaces, and initially thought too "difficult" to sell. European museums and *kunsthalles* played a major role in the development of installation art in the 1960s and 1970s, as did certain US institutions.[10] Ilya Kabakov's work is found almost exclusively in museums, not only because of its scale but also because of the content—for one piece, he took over a whole floor of the Pompidou Center in Paris to explore his experience of Russian history. Of course, nothing is actually too hard to sell, and the work of Jason Rhoades and Matthew Barney, which is both multi-media and enormous, proved commercially marketable in the mid-1990s, as well as having a museum presence. The genre of institutional critique—art that analyzes the museum and its

social function—from Hans Haacke to Fred Wilson and Andrea Fraser, also depends on the institution as a foil, and today, as a sponsor, as the critical reading of one's own museum becomes a must-have accessory.

Similarly, the rise of film and video creates new conditions for the relationship between the viewer and the artwork. Famously, Walter Benjamin and Siegfried Kracauer championed film as a medium that accommodated a mode of distraction, the modern urban mode of perception. The film and video installations ubiquitous in museums today allow the viewer to pass in and out of darkened rooms, paying partial attention, rarely seeing an entire piece from beginning to end, regardless of narrative or non-narrative content. In this sense, we might contrast the work of someone like Pipilotti Rist with that of Mark Rothko, which requires attention and concentration for the viewer to win any real experience from it, or at least the kind of experience the artist intended. But even painting, long the province of "real" art, private and commercial, resistant to the public, made for contemplation, shows up in the walk-in paintings by such artists as Matthew Ritchie, Fabian Marcaccio, and Michael Majerus—enormous in scale or even constructed for a specific location—that relies on and caters to the institution of the museum, its specific architecture.

Benjamin's idea that, after the novel, the cinema provided a form of representation demanded by the crowd—a picture of itself—brings us back to

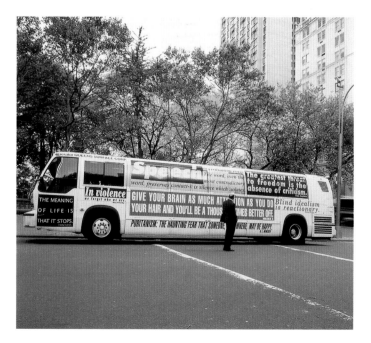

the work of Thomas Struth.[11] His photographs often depict crowds in public settings, often specifically in various art meccas, such as The British Museum or a cathedral, reflecting the social experience of viewing the work in these places. We might also think of the relatively new genre of art that attempts to create an interactive social space, using architecture, food, design, and various performance modes to place the crowd inside the art. Both Rirkrit Tiravanija and Maurizio Cattelan created projects for New York's MoMA in the mid-1990s that use the spectator actively. In *Untitled (Playtime)* (1997), Tiravanija set up a small version of a Modernist glass house, loaded with paper and scissors and glue and paint, and various other "craft" materials; visitors, children and adults alike, were invited to make their own art. Cattelan, a bit more sardonic, paid an actor dressed in a sailor shirt and Capri pants to sport a giant papier-mâché Picasso head of the kind usually spotted at Disney World, and greet visitors to the museum. Both projects were intended at once to make the museum more accessible and to subvert its traditional purpose.

Finally, we might say that not only the form but also the content of art has responded to the popularity of the museum. The absorption of popular culture by high art has reached some kind of ironic saturation point, as Jeff Koons and Takashi Murakami have taken such subjects as stuffed animals, cartoons, and flowers, and made them so central to their art practice that their art itself has become part of the larger, dominant culture, available in editions, planters, key chains, handbags, and T-shirts.

Of course, as noted above, public art and museum art were never precisely opposed to each other. But during the nineteenth century, museums were disengaged from contemporary art, which was seen as the purview of the commercial gallery or dealer, the realm of privately owned art as opposed to art for the public. During the past fifty years, public art was not exactly opposed to museum art but rather had different functions, and so obeyed different conventions of scale and attention. Now that museum art can mean *contemporary* art, as well as work that is large, site-specific, and distracting, the distinction between these two kinds of art is withering, and their shared connection with the world of private commerce is becoming clear and central, rather than limited and shameful.

It is in this situation that the Public Art Fund operates, looking away from the tradition of public art. It is committed to commissioning and bringing the best art of the moment to a wider audience, rather than art specifically addressed to an imaginary "public." How can it do this? By inviting the most interesting avant-garde artists, such as Francis Alÿs, Takashi Murakami, and Vik Muniz, as well as eminences like Paul McCarthy, Louise Bourgeois, and Dan Graham, and up-and-coming young artists like Tony Matelli. Of course, when the city of Chicago

TOP, LEFT AND RIGHT:

RIRKRIT TIRAVANIJA
Untitled (Playtime)
(overhead and interior views),
1997
Mixed-media installation at
MoMA, New York

MIDDLE:

MAURIZIO CATTELAN
Untitled, 1998
Performance at MoMA, New York

RIGHT:

PABLO PICASSO
Chicago Picasso, 1967
Steel
Chicago

asked Pablo Picasso to make a public sculpture in 1963, it also chose him because he was the most famous artist—the best—in the world. The difference is that Picasso had won his reputation for difficult, cerebral art made at the small-scale standard for his historical moment, while today's Public Art Fund-supported artists in their museum and gallery work *already* have a practice that is often large-scale, sometimes humorous, full of popular culture references, and made for a distracted crowd.

Most obviously, much of the work produced for the Public Art Fund tends to the monumental, particularly the work installed at Rockefeller Center, a large open space typically crowded with tourists, surrounded by enormously tall buildings. This is the site of Koons's *Puppy* (2000), Bourgeois's *Spiders* (2001), Nam June Paik's *Transmission* (2002), and Murakami's *Reversed Double Helix* (2003), all 30 feet high (9 m) or more, built to be visible to the passing throngs. But even the massive scale of these works does not set them apart from art in museums: it is interesting to note that Koons's *Puppy* has primarily been exhibited in front of museums, and that London's Tate Modern accommodated Bourgeois's *Spiders* inside its vast hall. Muniz's wrapping of the Brooklyn Academy of Music with a gigantic photographic blowup of candy-decorated gingerbread (2002) and Rist's video at Times Square (2000) are answers to similarly enormous, crowded spaces, addressing the viewer as part of a mass in distracted viewing.

The crowd makes an appearance as a subject in many Public Art Fund projects. Vanessa Beecroft's performance *VB42/Intrepid: The Silent Service* (2000) arranged a number of Navy men and women in quasi-military formation on the deck of the USS *Intrepid.* For his *Modern Procession* (2002), Francis Alÿs organized a parade from MoMA's permanent home in Manhattan (which had just closed for renovation) to its temporary location in Queens, MoMA QNS. The march included people who worked at the museum, hangers-on, extras carrying various art "icons" (including a palanquin bearing Kiki Smith), and a Peruvian band. Two works use the crowd or gathering found at a party: Josiah McElheny's *Metal Party* (2001), which re-creates a famous Bauhaus gathering in the 1920s, and Tony Matelli's *Distant Party* (1999), which broadcasts across Chelsea from hidden loudspeakers the sounds of a party to which the listener is obviously not invited (the quintessential New York social experience). Metaphorically, the crowd also has a melancholy presence in Christian Boltanski's *Lost Property* (1995), a collection of items from Grand Central Terminal's lost-and-found department.

The public is present also through the incorporation, celebration, and playful distortion of everyday experiences, the kinds of objects and activities available to anyone: food, the weather, nature. Tobias Rehberger made it snow in Madison Square Park in the middle of summer for his *Tsutsumu N.Y.* (2001), turning an ordinary

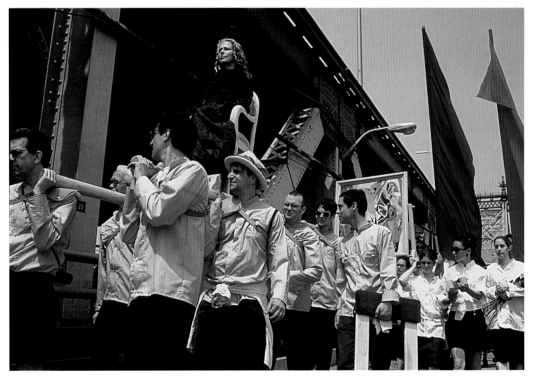

occurrence—snow—into a special, rarefied pleasure. In *Waylay* (2002), Brian Tolle used pipes inserted into the pond at Central Park to create a series of sudden splashes, like those made by jumping fish or skipping rocks. Perhaps most charmingly, Anissa Mack made a cottage on the plaza in front of Brooklyn Public Library, setting it amid the plaza's monumental arch and other commemorative architectural structures so typical of nineteenth-century public art. Every day she baked pies in this archetypal sweet little house, a sort familiar to Brooklynites only from cartoons, old movies, and fairy tales. She placed the pies on the windowsill to cool, inciting people walking past to grab a pie and run, like Tom Sawyer or characters on the Andy Griffith show. All of these also require the presence of a crowd to be activated. Their primary content is a pleasurable experience, although all of them to some extent inflect that pleasure with melancholy by emphasizing the actual absence and artificiality

MARTIN CREED
Work No. 203: Everything is going to be alright, 1999
Neon
Installation view in
Clapton, East London

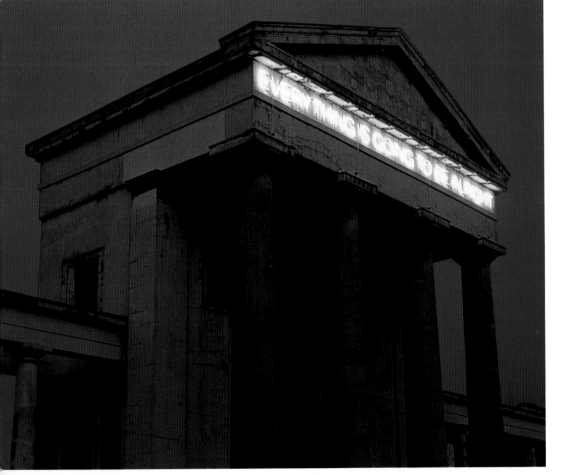

of the things—nature, homemade food—they offer.

Does this shift in art generally toward more public social experiences, subjects, interests, forms, make a difference in its actual reach or appeal? The Public Art Fund does not want to dumb down art, to make it "accessible" through condescending choices or explanations. In the battle between experience and education, they come down on the side of experience (although they have excellent brochures as well), preferring to put the art out there and let people come across it and react as they will. But the changing content and form of the art do suggest a wider audience. Although the evidence for such discussions is always only anecdotal, it is worth looking at anyway. The popularity of Mack's pastry piece surprised even the artist, drawing competing pie swipers—everyone from children to art insiders—from around the neighborhood, and even a lady from Queens, who wanted to know what time she had to get there to get the first pie.[12] A piece that

Martin Creed made for 42nd Street, a neon sign reading "Everything is going to be alright," was originally done for Clapton, a working-class neighborhood in East London, where its soothing (and slightly ominous) message proved so popular that residents asked it be made permanent.[13]

My personal anecdote comes from an art history class I teach at Hunter College in Manhattan, part of the City University of New York. Everyone on the faculty gives one lecture to the huge, four-hundred-person freshman survey class, and mine is on art since 1970. Most of the students are just fulfilling a requirement, and they are fresh out of high school—self-centered, super cool, and focused on the following week's final exam. One semester, after an hour of explaining why Richard Serra's slabs and Ana Mendieta's nude performances qualify as art, I reached art at the present moment, and Jeff Koons's *Puppy* appeared on the screen. Four hundred voices sighed "aaaaawwww" in unison. Many of them had seen it at Rockefeller Center, and even if they had not, the projected slide was enough to provoke a love reaction. This is an amazing accomplishment for a piece of art.

What does it mean? The public art of the past—say, the religious frescoes and public statuary of rulers made in the Renaissance and still visible all over Italy—delivers clear messages. The doge is strong and benevolent, and Venice will defeat other city-states; the Medici are the most powerful family in Italy both intellectually and militarily; Christ died for our sins. And the messages are clear, in part because they were being sent to well-defined publics: citizens of a particular city, people who attended a particular church, and still more particular groups such as guild members and social classes. Things are not so simple for contemporary art at the beginning of the twenty-first century.

Its goal seems to be the modest one of niceness—a moment of cuteness or humor or sweetness or humanity or specialness. If this art is monumental, it is in size, rather than ambition. It attempts to make life more bearable—it is nice and fun, and more people probably like it than like the paintings of Robert Mangold. This art undoubtedly eschews the seriousness, the *terribilità* of someone like Rothko, the sense of an alternative to the common culture provided by earlier avant-garde art. Older modern art offered the *promesse de bonheur*, while this art seems to say, the happiness we can have is already here. Or it can be found in slight, wondrous adjustments of what exists—snow in summer, the country in the city.

Art now responds to the condition of the crowd not only in being visible but also in being at our level—it says, as Jeff Koons insists, that you are okay the way you are, that you do not need to improve or uplift yourself.[14] The thing you like is *already* great. This attitude marks the end of an earlier idea of "culture"—the idea that bourgeois society is about turning money and capitalism into something higher. The fact that art no longer has to

be uplifting is a real change, made gradually and fitfully, since 1960.

We might see the *Puppy* as an interesting twist on the Afghan hound Picasso designed for Chicago. City fathers in 1967 still thought that the best art of the time was not only European but semiabstract, and so difficult and uplifting; its initial rejection by the public was to be expected. Koons's art is not about being fancy and European; rather, now even Europeans want to be free and wacky and commercial and American (and perhaps Japanese now as well). Koons, like Picasso, is a museum artist, but while Picasso played dumb for occasional effect (some suggest his sculpture actually depicts his wife and dog in a compromising position), Koons plays dumb brilliantly all the time.

Don't get me wrong. I don't mean this story of contemporary art and art institutions to be an Adornian lament about the absorption of art by entertainment. Unlike Theodor Adorno's torchbearers, and like my students, I love the *Puppy*. A certain kind of academic critic might argue that we like the *Puppy* because it is kitsch, easy, and trite, like the other cultural products we are trained to love, just as Anissa Mack does not challenge anyone's social preconceptions. And maybe that critic would be right: this art does not play art's traditional role of education or spiritual uplift. But while the *Puppy* may be fun and nice and temporarily brighten your day, it is the opposite of escapism as far as art is concerned—it is realism. This is art that acknowledges not only the dominant interests and visual experiences of contemporary life but the real life of art in that world—a world where more and more people go to museums, but also where smart people no longer feel bad about liking television, and collectors no longer have to feel guilty about being rich. The traditional contrast between public and private makes less and less sense, as governments no longer even feel compelled to disguise the commercial interests driving the "public" interest. In this world, critics and professors who assert that Barbara Kruger or Marxist art history can change society are indulging in escapism, a pretentious and deluded self-dramatization.

That is not to say art is over. Art is a particular social activity with a particular history, one that is not going away—the most "public" of artists, from Andrea Zittel to Takashi Murakami, pack their objects densely with references to earlier art forms. And unlike kitsch, and like "high" or difficult art, such as the paintings of Gerhard Richter or David Reed, the work by Murakami and Koons is lovely and well made. In finding quality in small pleasures like candy and pie, puppies and nature, artists are looking for something available to everyone that is truly good—like the Simpsons, or a great hamburger or a fuzzy kitten, a snowstorm, or even the play of reflection and translucence found in shop windows echoed in Dan Graham's ostensibly highbrow work. Andy Warhol's perverted version of

this was the hot dog that anyone could buy, the fact that the Queen herself could not order a better Coke than the one you were drinking. He saw democracy with bitter realism, and today, too, there is not only nostalgia but irony when an artist proposes that a puppy or a pie is the best they can offer us.

Rather than a lesson for the many, or a rarefied experience for the singular viewer, much contemporary art wants to make something really good that responds to the crowd. Unlike a small drawing by Leonardo, many of these pieces offer a collective experience—more like Leonardo's *Last Supper* or the frescoes and cathedrals that Struth captures in his photographs, full of the modern faithful worshipping art. But contemporary public art refuses not only transcendent religious experience but also transcendent, high-minded art experiences. The experience is public because the art is scaled or situated for collective enjoyment, in contrast to the individual moments with our cats at home, fondling Hello Kitty merchandise in a store, or eating pie in a bakery. This public art offers a pleasurable, positive experience of being with other people in a crowd, as opposed to the annoyance of being crammed into a subway car at rush hour. The *Puppy* has a populist allure, but unlike the excitement of a fascist rally, it appeals to our best nature, not our worst self-interest.

The kind of art the Public Art Fund presents is public in several senses: displayed in public settings and also geared to the conditions of public life, no longer set aside from the hustle and bustle of everyday concerns, commercial and otherwise. Oriented to the crowd, not just the lone individual who acts as the artist's double (the wealthy collector or the natural aristocrat with nothing but time to contemplate higher realities), this art acknowledges the audience, our presence and our interests. Made not for the ideal viewer that most of us will never be, it treats us as already ideal viewers.

NOTES

1. It is interesting to note that this topic rears its head with great frequency in regard to contemporary art generally—people ask angrily why art has to be so exclusionary, hermetic, opaque, and so on. Strangely, many of the people doing the asking seem to be intellectuals and even art professionals themselves. For example, ArtPace, a foundation in Texas, recently held a symposium titled "Is Anybody Listening?," bringing together art experts to discuss the topic.

2. A *New York Times* write-up of a bulldozer of beautiful Gothic design by Wim Delvoye was clichéd but perhaps not inaccurate in its breakdown of the New York City public: working-class men (who maintain and work at the site), tourists, the occasional informed art lover, and the precocious or open-minded child who can see with his innocent eyes the intrinsic wonder of the object (June 29, 2003).

3. Less public as well simply in that they are largely privately funded in the U.S., and increasingly in European countries which follow that model.

4. I found books written and edited by Harriet Senie, and a collection of essays by Miwon Kwon, to be extremely helpful in thinking about public art. The two authors made many similar points, although from different ideological and generational perspectives. See Harriet Senie, *Contemporary Public Sculpture: Tradition, Transformation, and Controversy*, New York and Oxford (Oxford University Press) 1992; Harriet Senie and Sally Webster (eds.), *Critical Issues in Public Art: Content, Context, and Controversy*, New York (HarperCollins) 1992; Miwon Kwon, *One Place After Another: Site-Specific Art and Locational Identity*, Cambridge MA and London (MIT Press) 2001.

5. Kirk Savage, "The Self-Made Monument: George Washington and the Fight to Erect a National Monument," in Senie and Webster 1992, pp. 5–32.

6. Senie 1992, p. 103.

7. "Turds in the plaza" was coined by James Wines of SITE (Sculpture in the Environment) as a disparaging term for abstract public sculpture, cited in Kwon 2001, note 16, p. 182. Henry Moore said: "I don't like sculpture used as costume jewellery, which is what happens when it is pinned onto a building," cited in Senie 1992, p. 105.

8. Foremost among critics of public art that makes land available for use is Rosalyn Deutsche. See Deutsche, *Evictions: Art and Spatial Politics*, Cambridge MA (MIT Press) 1996.

9. Susan K. Freedman and Tom Eccles, press release by the Public Art Fund, 1998. Other press releases and statements from that year also refer to traditional goals of community involvement and enrichment; more recent statements emphasize artistic innovation and experiment.

10. Raymonde Moulin, "The Museum and the Marketplace," *International Journal of Political Economy*, 25, no. 2, 1995, p. 49.

11. For further information on historical discussions of the crowd by Walter Benjamin, Siegfried Kracauer, and others, see Katy Siegel, *Everybody Now: The Crowd in Contemporary Art*, New York (The Bertha and Karl Leubsdorf Art Gallery at Hunter College) 2001.

12. Andy Newman, "Take These Pies, Please," *The New York Times*, May 31, 2002, p. B1.

13. Holland Cotter, "Surging into Chelsea," *The New York Times*, January 21, 2000, p. E37.

14. "Jeff Koons Talks to Katy Siegel," *Artforum*, 41, March 2003, pp. 252–53, 283.

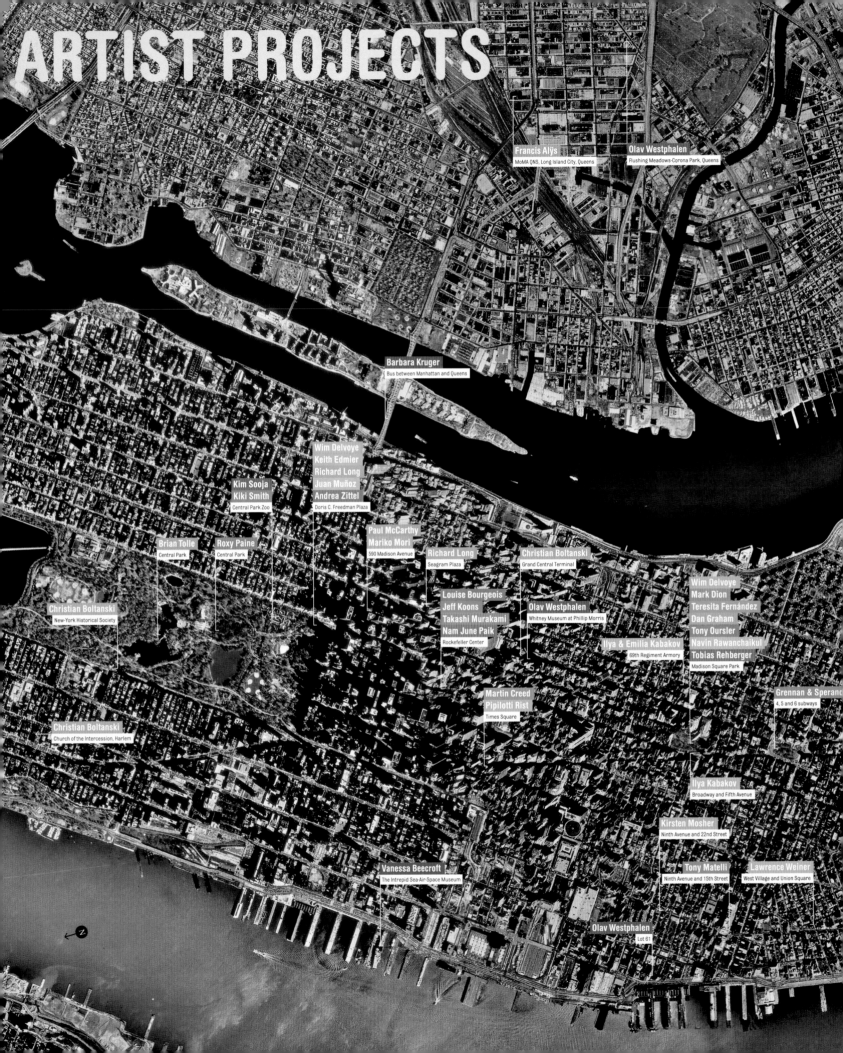

ARTIST PROJECTS

Francis Alÿs
MoMA QNS, Long Island City, Queens

Olav Westphalen
Flushing Meadows-Corona Park, Queens

Barbara Kruger
Bus between Manhattan and Queens

Wim Delvoye
Keith Edmier
Richard Long
Juan Muñoz
Andrea Zittel
Doris C. Freedman Plaza

Kim Sooja
Kiki Smith
Central Park Zoo

Paul McCarthy
Mariko Mori
590 Madison Avenue

Richard Long
Seagram Plaza

Christian Boltanski
Grand Central Terminal

Wim Delvoye
Mark Dion
Teresita Fernández
Dan Graham
Tony Oursler
Navin Rawanchaikul
Tobias Rehberger
Madison Square Park

Brian Tolle
Central Park

Roxy Paine
Central Park

Louise Bourgeois
Jeff Koons
Takashi Murakami
Nam June Paik
Rockefeller Center

Olav Westphalen
Whitney Museum at Phillip Morris

Ilya & Emilia Kabakov
69th Regiment Armory

Christian Boltanski
New-York Historical Society

Grennan & Sperandio
4, 5 and 6 subways

Christian Boltanski
Church of the Intercession, Harlem

Martin Creed
Pipilotti Rist
Times Square

Ilya Kabakov
Broadway and Fifth Avenue

Kirsten Mosher
Ninth Avenue and 22nd Street

Vanessa Beecroft
The Intrepid Sea-Air-Space Museum

Tony Matelli
Ninth Avenue and 15th Street

Lawrence Weiner
West Village and Union Square

Olav Westphalen
Lot 61

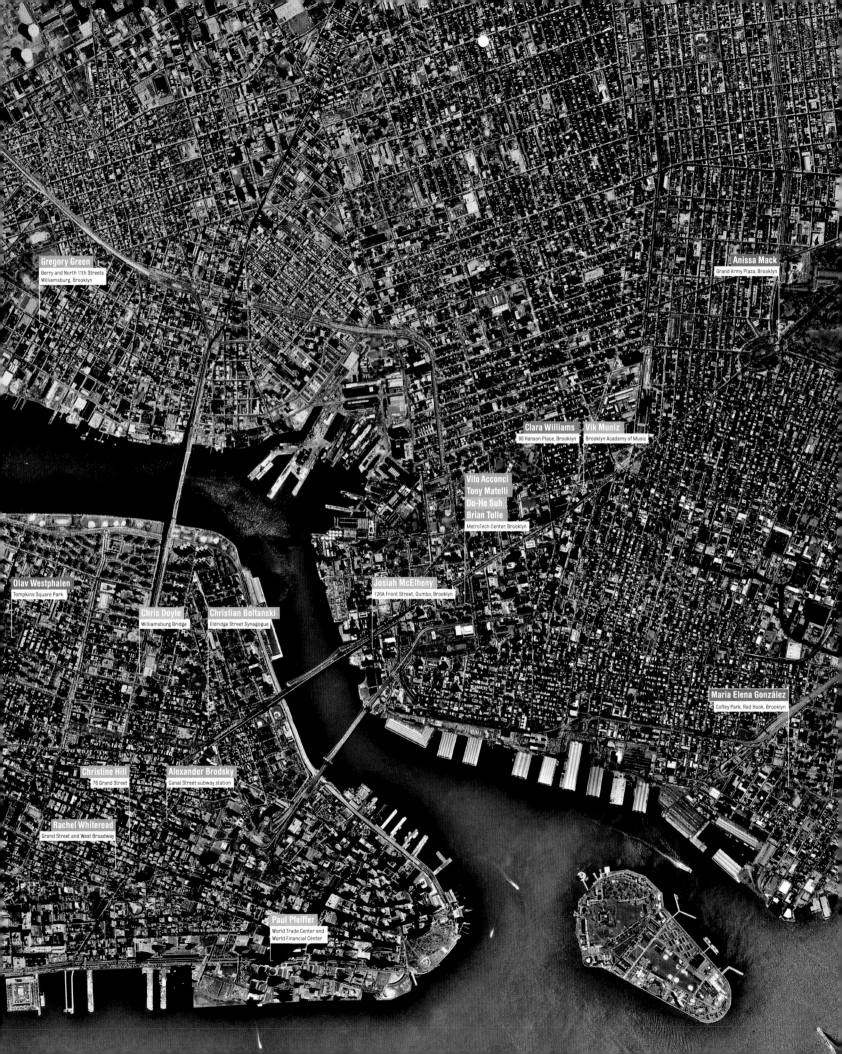

Gregory Green
Berry and North 11th Streets
Williamsburg, Brooklyn

Anissa Mack
Grand Army Plaza, Brooklyn

Clara Williams
80 Hanson Place, Brooklyn

Vik Muniz
Brooklyn Academy of Music

Vito Acconci
Tony Matelli
Do-Ho Suh
Brian Tolle
MetroTech Center, Brooklyn

Olav Westphalen
Tompkins Square Park

Josiah McElheny
126A Front Street, Dumbo, Brooklyn

Chris Doyle
Williamsburg Bridge

Christian Boltanski
Eldridge Street Synagogue

Maria Elena González
Coffey Park, Red Hook, Brooklyn

Christine Hill
76 Grand Street

Alexander Brodsky
Canal Street subway station

Rachel Whiteread
Grand Street and West Broadway

Paul Pfeiffer
World Trade Center and
World Financial Center

Long a leading figure on the New York Conceptual art scene, Vito Acconci has developed a remarkably heterogeneous practice over the last three decades, utilizing sculpture, installation, architecture, text, and performance. What has united all of his different approaches has been a fascination with the diversity of interpersonal relationships, whether physical, social, temporal, or psychological.

For one of the Public Art Fund's earliest forays into its now-familiar home at MetroTech Center, Acconci was commissioned to produce a project for an empty lot at the corner of Flatbush Avenue and Myrtle Promenade in downtown Brooklyn. When he went to survey the location, the artist found that the space was bounded by a pair of existing private gardens, surrounded by chain-link fences to prevent access by the general public. Acconci's response was to adopt the formal language of these adjacent spaces but to invert their sense of exclusivity. Using aluminum fence posts, he created a 4 foot high (1.2 m) labyrinthine environment of paths that connected fifty small seating areas; the rest of the space was then covered with chain-link fence designed to serve as a kind of urban arbor, over which he coaxed climbing plants such as English ivy, Japanese honeysuckle, trumpet creepers, wisteria, and grape vines. Planted in April and left to grow over the course of the summer, Acconci's "garden for the body" created a verdant trellis that met visitors walking into the space at waist height, but seemed to float at eye-level when they sat down in one of the single, double, or triple-seat benches scattered throughout it.

The bucolic horticultural form of *Addition to MetroTech Gardens* might seem at odds with the more flamboyant gestures usually associated with Acconci's practice—this was, after all, the artist whose early performance-related projects included tailing different individuals around New York for twenty-three consecutive days for his *Following Piece* (1969), and who once famously spent several days masturbating beneath a platform in Sonnabend Gallery for his 1972 performance *Seedbed*. Yet since the mid-1980s, his quest to generate conditions for contact between different individuals and groups has increasingly led Acconci in the direction of urban planning, architecture, and public space. Although his proposals for building and design projects often subvert expectations, they also remain fundamentally engaged with issues of social organization and personal boundaries. In his project for the Public Art Fund, the artist brought both of these interests to bear, creating an environment encompassing both communal space for private reflection and private spaces for communal interaction.

Addition to MetroTech Gardens,
1995–96
Chain-link fence and plants
MetroTech Center, Brooklyn,
Fall 1995–Fall 1996

VITO ACCONCI
Addition to MetroTech Gardens

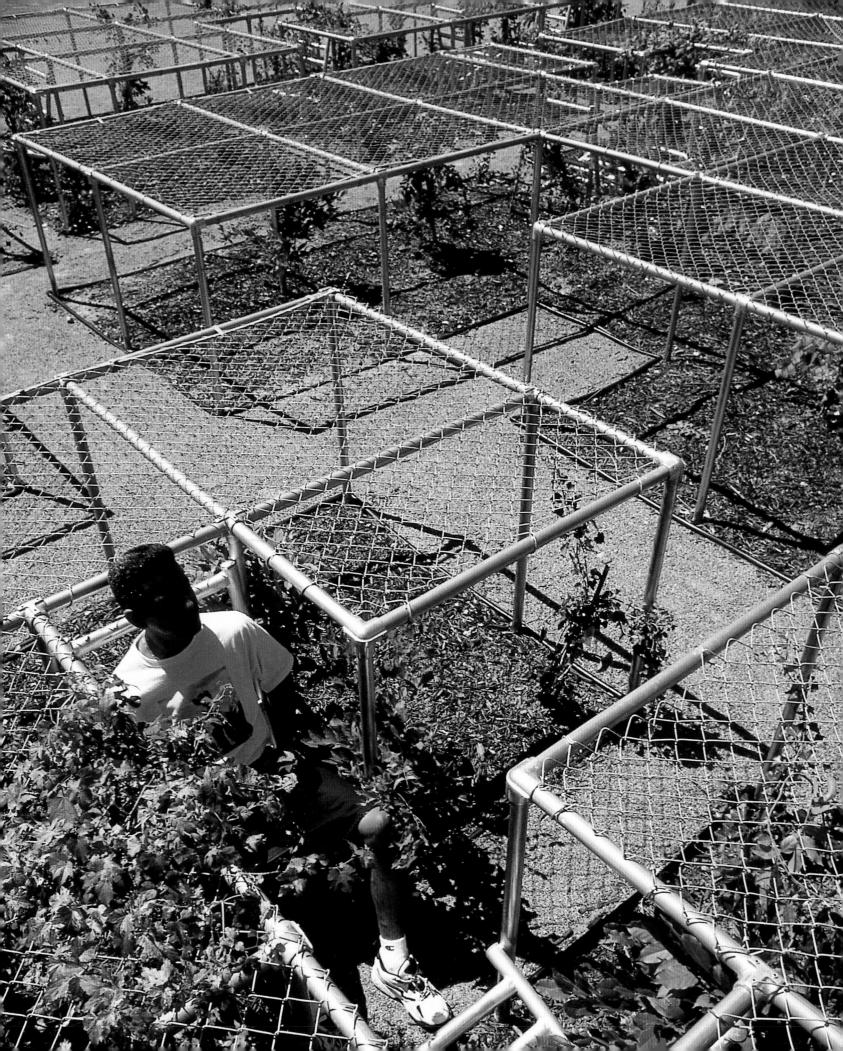

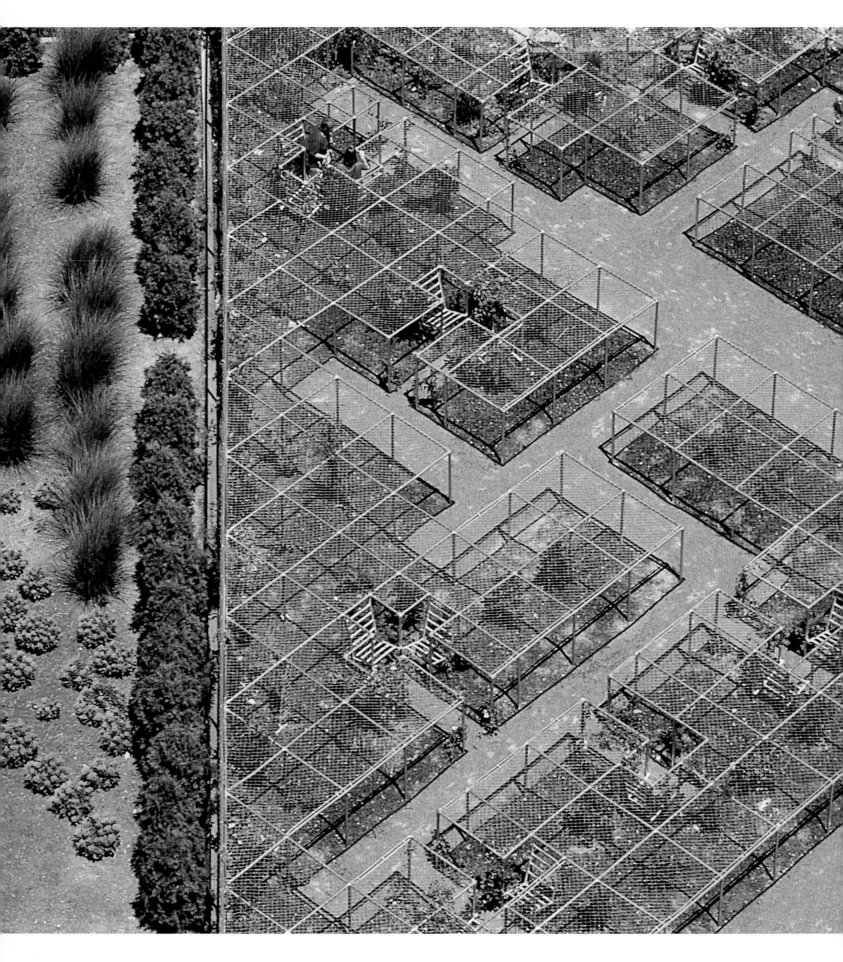

↘ VITO ACCONCI

Born in the Bronx, New York, 1940.

SELECTED EXHIBITION HISTORY

Vito Acconci has recently had solo exhibitions at Milwaukee Art Museum (2002; traveled to Aspen Art Museum, Colorado; Miami Art Museum, Florida; and Contemporary Arts Museum, Houston, Texas); Arnolfini Gallery, Bristol, England (2001); University of the Arts, Philadelphia (1999); and Stroom, The Hague's Center for Visual Arts, The Netherlands (1997). Recent group exhibitions include the Sydney Biennale, Australia (2002); *New Hotels for Global Nomads*, Cooper-Hewitt National Design Museum, Smithsonian Institution, New York (2002); *Into the Light*, Whitney Museum of American Art, New York (2001); *Tele[visions]*, Kunsthalle Vienna (2001); *Video Time*, MoMA (The Museum of Modern Art), New York (2000); *Media City Seoul*, Seoul Biennale (2000); *Out of Actions: Between Performance and the Object, 1949–1979*, Museum of Contemporary Art, Los Angeles (1998); *inSITE97*, San Diego and Tijuana, Mexico (1997); *Rooms with a View: Environments for Video*, Guggenheim SoHo, New York (1997); and *Documenta X*, Kassel, Germany (1997).

FURTHER READING

Celant, Germano, "Dirty Acconci," *Artforum*, 19, Nov. 1980, pp. 76–83

Gintz, Claude, "Vito Acconci: L'impossibilité de l'art public" (interview), *Art Press*, no. 166, Feb. 1992, pp. 10–18

Linker, Kate, *Vito Acconci*, New York (Rizzoli) 1994

Matzner, Florian (ed.), *Public Art: Kunst im öffentlichen Raum*, Ostfildern (Hatje Cantz Verlag) 2001

Moure, Gloria (ed.), *Vito Acconci: Writings, Works, Projects*, Barcelona (Ediciones Poligrafa) 2001

Paparoni, Demetrio, "Vito Acconci," *Tema Celeste*, no. 78, March–April 2000, pp. 56–63

Poggi, Christine, "Following Acconci/Targeting Vision," in *Performing the Body/Performing the Text*, ed. Amelia Jones and Andrew Stephenson, London (Routledge) 1999, pp. 255–72

Taylor, Mark C., *et al.*, *Vito Acconci*, London (Phaidon Press) 2002

Vidler, Anthony, "Home Alone: Vito Acconci's Public Realm," in Anthony Vidler, *Warped Space*, Cambridge MA (MIT Press) 2000, pp. 135–42

Vito Acconci/Acconci Studio: Para-Cities, exhib. cat. by Catsou Roberts, Bristol, Arnolfini Gallery, 2001

LEFT:

Addition to MetroTech Gardens (overhead view), 1995–96

RIGHT, TOP:

Following Piece, October 3–25, 1969 Performance work created for *Street Works IV*, an exhibition of the Architectural League of New York

RIGHT, BOTTOM:

Seedbed, January 1972 Three-week performance/ installation of wooden ramp at Sonnabend Gallery, New York

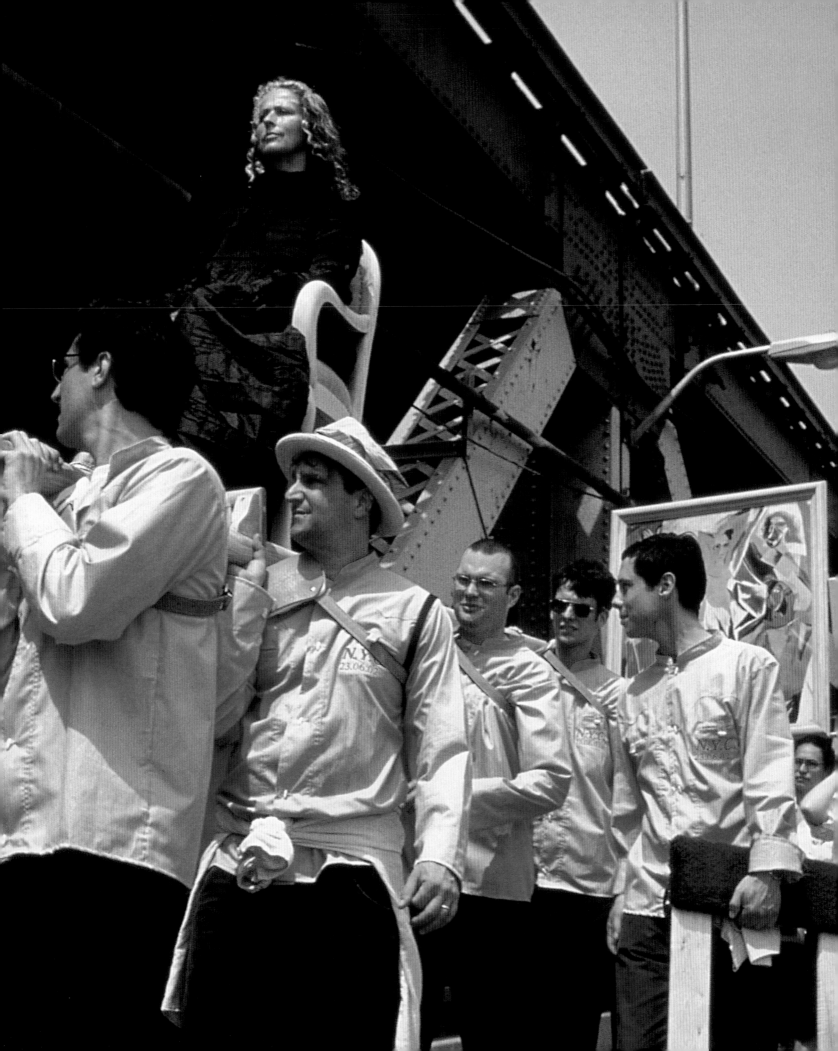

Early Sunday morning isn't a time typically associated with major events in New York's cultural scene but, in keeping with much of Francis Alÿs's canny practice, *The Modern Procession* sidestepped art world conventions in order to both celebrate and critique them. At 8:30 a.m. on June 23, 2002, 53rd Street between Fifth and Sixth Avenues looked like the site of a blockbuster movie shoot, with dozens of volunteer participants donning *The Modern Procession* shirts, a twelve-person Peruvian brass band tuning up, and camera crews reviewing the day's game plan. At 8:50 a.m., two NYPD patrol cars arrived to escort the caravan on its trip through the boroughs. The band began playing a slow, melodic tune (the sort of traditional march that's kept the pace in processions for centuries), the crowd miraculously assembled itself from chaos into coherence, and, at 9 a.m. sharp, *The Modern Procession* was off.

Alÿs had imagined *The Modern Procession* as a relatively straightforward event that would make visible and public the venerable institution MoMA's move from Manhattan to its temporary location in Queens, a renovated stapler factory that shares the block with a greasy-spoon diner and a check-cashing business. As he put it, the project was meant to "welcome MoMA's most sacred icons to the periphery." Replicas of three museum masterpieces—Picasso's *Les Demoiselles d'Avignon*, Duchamp's *Bicycle Wheel*, and a version of Giacometti's *Standing Woman*—were carried atop three wooden palanquins. Alÿs had asked Kiki Smith to be a "living icon" of contemporary art, so she was carried on a fourth palanquin, in the wake of a riderless horse and strewn rose petals. Like *Walking a Painting* (2002)—one of Alÿs's solitary walking works, in which a painting of the 1992 Los Angeles race riots was removed from the gallery wall each day and walked through a neighborhood of the city—*The Modern Procession* literally shrunk the distance between art and public, presenting beloved icons (or at least re-presenting them) as a celebratory and perhaps even healing gesture for a city still suffering the emotional aftershocks of the September 11 attacks.

From his earliest walking action, *The Collector* (1991–92)—in which he pulled a magnetic toy dog through Mexico City, collecting scraps of metal from the city streets—Alÿs has staged casual interventions that interact with and discreetly transform the urban landscape. Although it was more elaborate than most of his street actions, Alÿs noted that *The Modern Procession* remained essential in form: "As in past projects, I tried to maintain a very schematic structure so that the project can travel as a rumor or a story, even while the event or performance is happening." For those who witnessed the procession—many of whom interrupted their Sunday morning schedules to join in, Pied Piper-style—*The Modern Procession* was a chance encounter that lingered as a fanciful afterimage. For those who heard about it later or saw it on the evening news, *The Modern Procession* became an urban fable, and MoMA's move became another vivid New York story layered on top of the city grid.

OPPOSITE:

The Modern Procession,
June 23, 2002
Walk from MoMA, Manhattan,
to MoMA QNS, Long Island City,
Queens

FOLLOWING PAGES:

PAGES 46–47:

Drawing for *The Modern Procession*, 2002
Mixed media on tracing paper and
map of New York City

PAGE 47 TOP:

The Modern Procession in
midtown Manhattan, June 23,
2002

PAGE 47 BOTTOM:

The Modern Procession on the
Queensboro Bridge, June 23, 2002

FRANCIS ALŸS
The Modern Procession

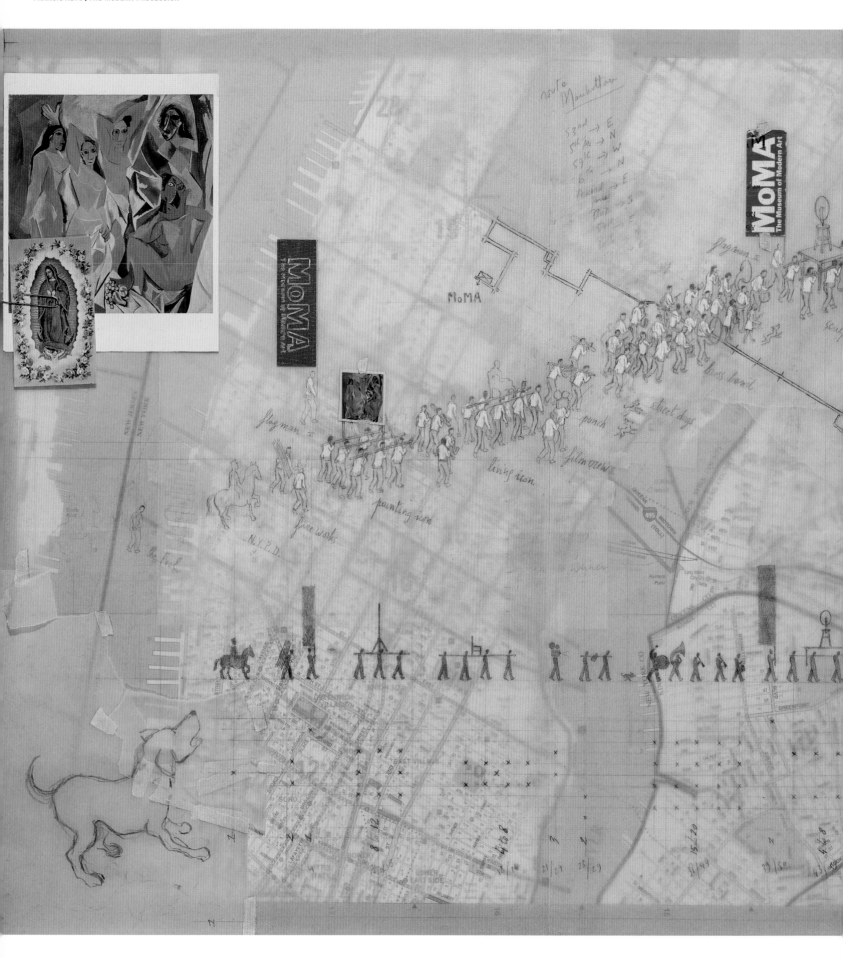

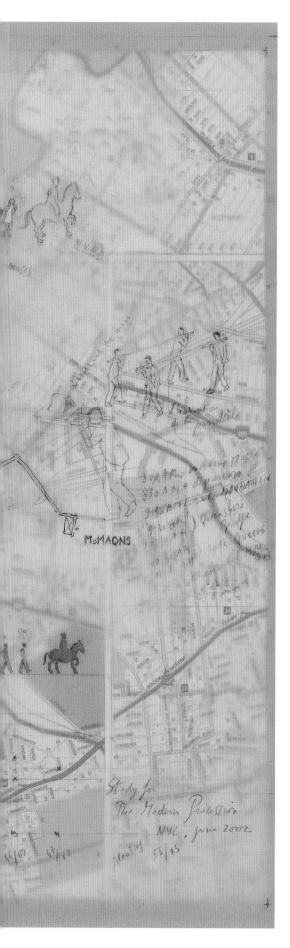

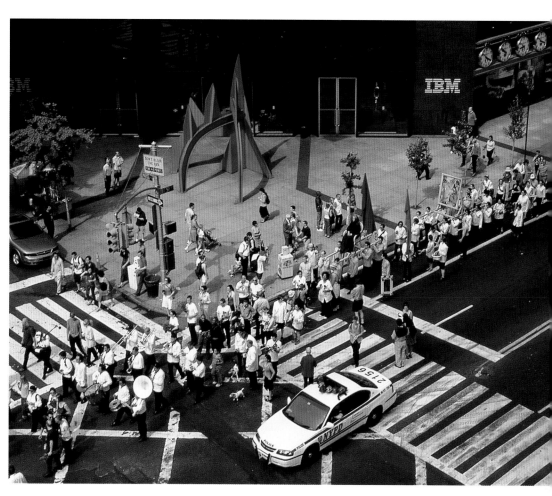

↘ FRANCIS ALŸS

Born in Antwerp, Belgium, 1959.

SELECTED EXHIBITION HISTORY

Francis Alÿs has recently had solo exhibitions at Kunsthaus Zurich, Switzerland (2003); Centro Nazionale per le Arti Contemporanee, Rome (2002); MoMA QNS (The Museum of Modern Art, Queens), Long Island City, Queens (2002); 3rd Lima Bienniale (2002); and Musée Picasso, Antibes, France (2001). Recent group exhibitions include *Twenty Million Mexicans Can't Be Wrong*, South London Gallery (2002); *Mexico City: An Exhibition about the Exchange Rates of Bodies and Values*, P.S. 1 Contemporary Art Center, Long Island City, Queens (2002); *Squatters*, Museu Serralves, Porto, Portugal, and Witte de With, Rotterdam, The Netherlands (2001); 49th Venice Biennale, Italy (2001); *Da Aversida de Vivemos*, Musée d'Art Moderne de la Ville de Paris (2001); *Painting at the Edge of the World*, Walker Art Center, Minneapolis (2001); 7th Havana Biennale (2000); *Mirror's Edge*, BildMuseet, Umea, Sweden (1999); *The Passion and the Wave*, 6th Istanbul Biennale (1999); and Roteiros, 24th São Paulo Bienal, Brazil (1998).

FURTHER READING

Alÿs, Francis, *et al., The Modern Procession*, New York (Public Art Fund) 2004

Alÿs, Francis, Ivo Mesquita, and Bruce Ferguson, *Walks/Paseos*, Mexico City (Museo de Arte Moderno) 1997

Donadio, Rachel, "Goddess Kiki Smith Leads MoMA March," *The New York Sun*, June 24, 2002, pp. 1, 4

Francis Alÿs, exhib. cat. by Cuauhtémoc Medina, Thierry Davila, and Carlos Basualdo, Antibes, Museé Picasso, 2001

Heiser, Jörg, "Walk on the Wild Side," *Frieze*, no. 69, Sept. 2002, pp. 69–74

Hollander, Kurt, *Francis Alÿs: Other Peoples' Cities, Other Peoples' Work*, São Paulo (Galeria Camargo Vilaça) 1995

The Last Clown, exhib. cat. by David G. Torres, Cuauhtémoc Medina, and Mario Flecha, Barcelona, Fundació "La Caixa," 1999

McEvilley, Thomas, *Francis Alÿs: The Liar, The Copy of the Liar*, Guadalajara (Arena Mexico Arte Contemporaneo and Galeria Ramis Barquet) 1994

The Prophet and the Fly, exhib. cat. by Catherine Lampert for the exhibition *Obra Pictória*, Rome, Centro Nazionale per le Arti Contemporanee; Madrid (Turner) 2003

Torres, David G., "Francis Alÿs, simple passant," *Art Press International*, no. 263, Dec. 2000, pp. 18–23

LEFT:

The Modern Procession on the Queensboro Bridge, June 23, 2002

RIGHT, TOP:

The Collector, 1991–92 Performance in Mexico City

RIGHT, BOTTOM:

Walking a Painting, April 29–May 6, 2002 Performance and installation in Los Angeles

In keeping with her conceptually complex practice, Vanessa Beecroft's *VB42/ Intrepid: The Silent Service* involved both meticulously orchestrated activity and the documentation of that activity, a mix of live performance and its physical traces. A major off-site component of the Whitney Museum of American Art's 2000 Biennial Exhibition, Beecroft's project featured one of her trademark posed arrays—in this case, involving some thirty U.S. Navy sailors from the Undersea Warfare Community, attired in their dress uniforms and positioned in ceremonial formation on the deck of the retired aircraft carrier USS *Intrepid*, which now serves as a sea, air, and space museum at its permanent berth on Manhattan's West Side. Dramatically lit and arrayed with the twinkling skyline of the city at their backs, the sailors were then photographed. These images, along with an on-site installation in the interior of the *Intrepid* where films were shown in a scaled-down inflatable reproduction of the Navy SEAL museum in Fort Pierce, Florida, were the physical vestiges of Beecroft's multilayered gesture.

The Italian-born Beecroft has over the last decade established herself as one of the most celebrated, and controversial, artists in contemporary art. She first came to prominence in the mid-1990s with her initial live performances featuring women, both dressed and nude, inhabiting gallery settings for extended periods of time. With their strategically discordant overtones of fashion, Classical figure modeling, and sexual exploitation, these projects—for each of which the artist gave simple production-line titles based on her initials and its number in the progression of her oeuvre (*VB10*, *VB11*, etc.)—were alternately hailed for their deft hybridization of performance and photography and denounced for their objectifying force. As she has continued in her career, Beecroft has quite unapologetically continued to explore these often difficult adjacencies between bodies and images, individuals and groups, sexuality and commerce. Though they are deeply engaged in issues around contemporary media culture and modes of display and consumption, her projects also cast a mordant eye back toward historical notions of the idealized human (usually female) figure in Classical art, at once demystifying and problematizing the relationship of representational identity and physical substance, questioning both depictions of bodies and the identities of bodies they depict.

VB42 represented the most elaborate example to date of Beecroft's increasing interest in expanded gender contexts for her treatments of individual identity and group presence, a part of her practice that first emerged with *VB39/US Navy* (1999), a performance in which she had sixteen San Diego-area sailors stand at attention for long stretches of time within a white museum gallery. With its rigid formality and iconographic resonance, the martial display culture of the military evoked by *VB42* was tailor-made for this new phase of Beecroft's investigations— a gesture that managed to be both critical and sincere in its exploration of the complicated relationships between gender roles, performance, and aesthetics.

Poster for *VB42/Intrepid: The Silent Service*, 2000

VANESSA BEECROFT
VB42/Intrepid: The Silent Service

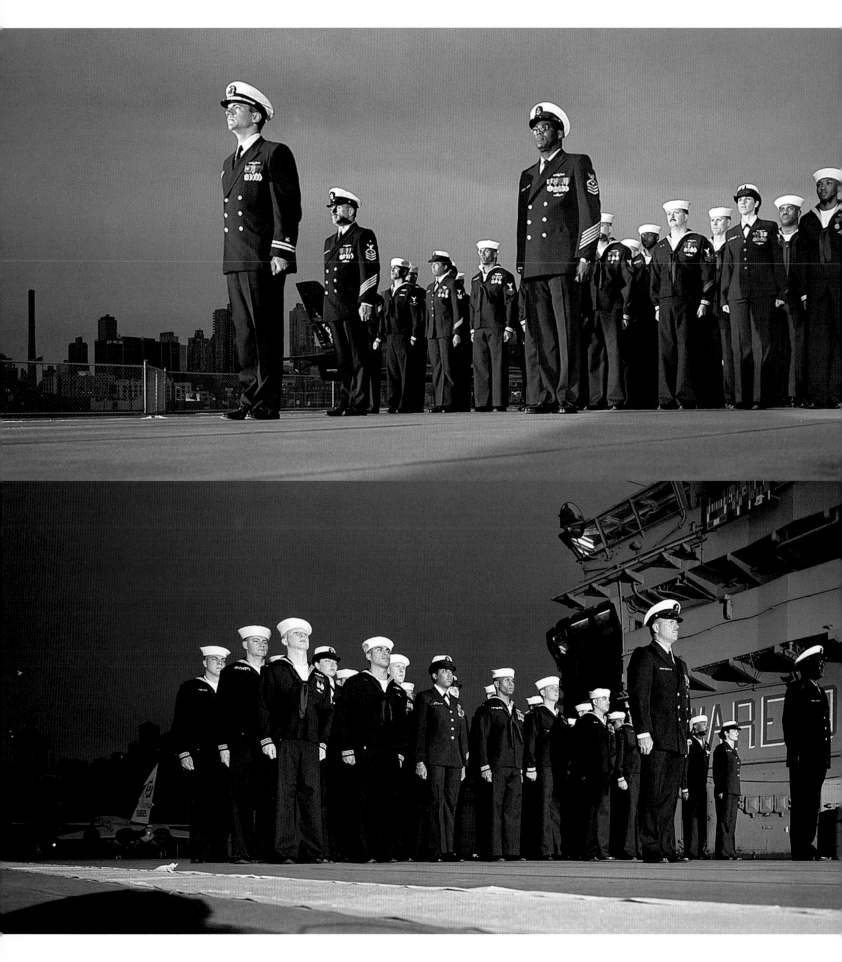

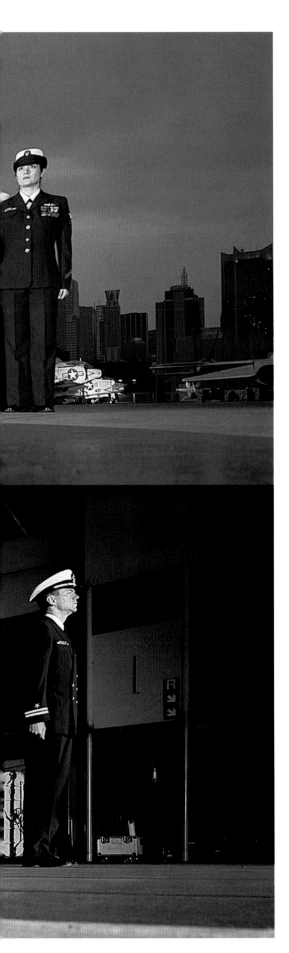

↘ VANESSA BEECROFT

Born in Genoa, Italy, 1969.
Studied at Accademia di Belle Arti di Brera, Milan, Italy (1993), Accademia Ligustica di Belle Arti, Genoa, Italy (1988), and Civico Liceo Artistico Nicolo Barabino, Genoa, Italy (1987).

SELECTED EXHIBITION HISTORY

Vanessa Beecroft has recently had solo projects at Schloss Vinsebeck, Germany (2002); 25th São Paulo Bienal, Brazil (2002); Peggy Guggenheim Collection, Venice, Italy (2001); Museum of Contemporary Art, San Diego (1999); and Solomon R. Guggenheim Museum, New York (1998). Recent group exhibitions include *Lateral Thinking: Art of the 1990s*, Museum of Contemporary Art, San Diego (2002); *Beautiful Productions*, Whitechapel Art Gallery, London (2001); *Collaborations with Parkett: 1984 to Now*, MoMA, New York (2001); 49th Venice Biennale, Italy (2001); *Performing Bodies*, Tate Modern, London (2000); *Wounds: Between Democracy and Redemption in Modern Art*, Moderna Museet, Stockholm (1998); *Heaven: Public View, Private View*, P.S. 1 Contemporary Art Center, Long Island City, Queens (1997); *Truce: Echoes of Art in an Age of Endless Conclusions*, 2nd Biennale, SITE Santa Fe, New Mexico (1997); and 47th Venice Biennale, Italy (1997).

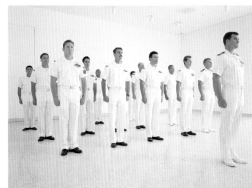

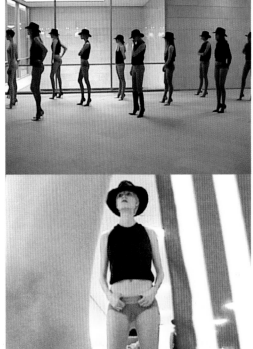

FURTHER READING

Beecroft, Vanessa, *et al.*, *Parkett*, no. 56, 1999, pp. 78–119 (including Norman Bryson, "US Navy Seals," pp. 78–79; Pier Luigi Tazzi, "Parades," pp. 94–96; Keith Steward, "Classic Cruelty," pp. 99–100; Jan Avgikos, "Let the Picture Do the Talking," pp. 106–109)

Grosenick, Uta, and Burkhard Riemschneider (eds.), *Art at the Turn of the Millennium*, Cologne (Taschen) 1999

Hickey, Dave, *VB08–36: Vanessa Beecroft Performances*, Ostfildern (Hatje Cantz Verlag) 2000

Kaplan, Cheryl, "Vanessa Beecroft" (interview), *Smock*, Summer 2000

Leffingwell, Edward, "Vanessa Beecroft Aboard the USS Intrepid," *Art in America*, 88, Oct. 2000, p. 168

Pretty Naked, exhib. cat. by Collier Schorr, New York, Solomon R. Guggenheim Museum, 1998

Shave, Stuart, "Hello Sailor," *I-D Magazine*, no. 198, June 2000, pp. 86–90

Smith, Roberta, "Standing and Staring, Yet Aiming for Empowerment," *The New York Times*, May 6, 1998, p. E2

Thurman, Judith, "The Wolf at the Door," *The New Yorker*, March 17, 2003, pp. 114–23

Williams, Gilda (ed.), *Cream: Contemporary Art in Culture*, London (Phaidon Press) 1998

LEFT:

VB42/Intrepid: The Silent Service, April 20 and 21, 2000
Performance at the Intrepid Sea-Air-Space Museum, Manhattan

RIGHT, TOP:

VB39/US Navy, 1999
Performance at the Museum of Contemporary Art, San Diego

RIGHT, MIDDLE AND BOTTOM:

VB34, 1998
Performance at Moderna Museet, Stockholm

The myriad threads that connect things, places, and memories were woven through Christian Boltanski's sprawling, often elegiac Public Art Fund project, *Lost: New York Projects*. Choosing sites at four different locations around New York in the spring of 1995—the Eldridge Street Synagogue on the Lower East Side, Harlem's Church of the Intercession, the New-York Historical Society on Central Park West, and Grand Central Terminal—the celebrated French Conceptualist used lost or discarded personal effects to generate often deeply moving evocations of presence and absence, both communal and individual.

The four satellite works that comprised *Lost* were all related, yet each employed distinct strategies. At Grand Central, Boltanski's *Lost Property* featured a display built around hundreds of personal effects the artist retrieved from the station's lost and found. Ordered typologically on metal shelves within an enclosure segregated by a chain-link fence, these quotidian possessions left behind by harried commuters suggested both the peripatetic nature of contemporary life and the transience of our relationships to those things with which we furnish it. In *Dispersion*, the work created for Harlem, Boltanski also deployed cast-offs, but with a very different purpose in mind. There, in the nave of the landmark church, he deposited one ton of used clothing, donated by the city's Goodwill Industries. For two dollars, visitors were allowed to fill a paper bag featuring an identifying stamp created by the artist with as many clothes as would fit—a transactional, participatory gesture that evoked not the lost but the found; a gesture of generosity and restitution as perfectly suited to the psychic environment of a house of worship as was *Lost Property* to the bustlingly indifferent precincts of the metropolitan transit hub.

At the Historical Society, the artist took yet another tack with *Inventory*, embracing the museological modes of display consistent with the gallery space by essentially mounting an exhibition of the contents of one anonymous man's New York apartment. Displaying kitchen appliances and furniture, as well as vitrines stocked with the everyday things of his unidentified subject's life, Boltanski produced a pitch-perfect conceptual insertion into an institution whose mission is precisely to document the regular lives of New Yorkers. The final component of *Lost* was its most ephemeral. In the quiet of the Eldridge Street Synagogue—originally built in 1887—Boltanski's *What They Remember* (created in collaboration with writer Leslie Camhi) insinuated an array of tape recorders within the temple seats. On the audio tracks were young children telling stories of the arrival in the U.S. of their immigrant ancestors who were still among the synagogue's congregants. Mixing fact and fiction, and related with charming, youthful indeterminacy, these stories—like all of Boltanski's best work—locate something quintessentially human in the intersection of the pedestrian and the poignant.

Lost Property, 1995
Mixed-media installation
Grand Central Terminal,
Manhattan, May 11–June 10, 1995

CHRISTIAN BOLTANSKI
Lost: New York Projects

TOP:

What They Remember, 1995
Mixed-media sound installation
Eldridge Street Synagogue,
Manhattan, May 11–July 9, 1995

BOTTOM:

Inventory, 1995
Mixed-media installation
New-York Historical Society,
Manhattan, May 11–June 25, 1995

OPPOSITE:

Dispersion, 1995
Mixed-media installation
Church of the Intercession,
Manhattan, May 11–June 10, 1995

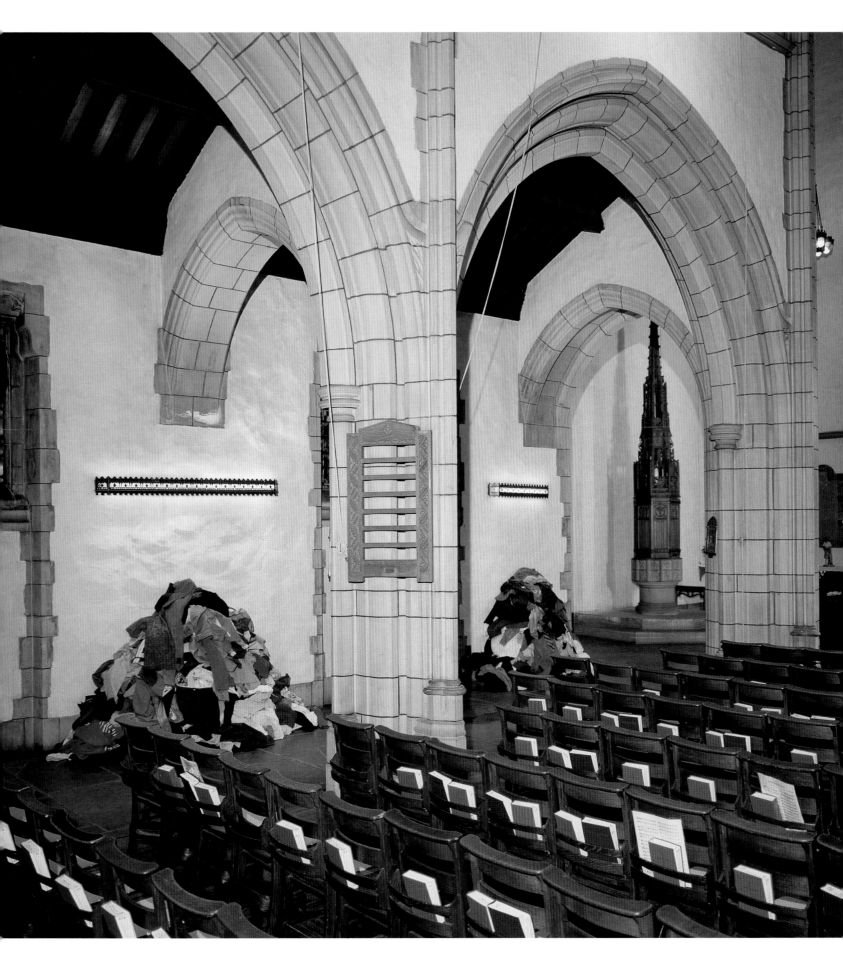

↘ CHRISTIAN BOLTANSKI

Born in Paris, 1944.

SELECTED EXHIBITION HISTORY

Christian Boltanski has recently had solo exhibitions at Palazzo delle Papesse, Centro Arte Contemporanea, Siena, Italy (2002); Jewish Museum, San Francisco (2001); Museum of Fine Arts, Boston (2000); *Dernières Années*, ARC/Musée d'Art Moderne de la Ville de Paris (1998); and Arken Museum for Moderne Kunst, Copenhagen (1998). Recent group exhibitions include *Dialogue Ininterrompu*, Musée des Beaux-Arts de Nantes, France (2001); *Vanitas: Meditations in Life and Death in Contemporary Art*, Virginia Museum of Fine Arts, Richmond (2000); *The Self is Something Else: Art at the End of the 20th Century*, Kunstsammlung Nordrhein-Westfalen, Düsseldorf, Germany (2000); *Zeitwenden*, Kunstmuseum Bonn, Germany (2000); *Diary*, Cornerhouse, Manchester, England (2000); *Circa 1968*, Museu Serralves, Porto, Portugal (2000); *The Museum as Muse: Artists Reflect*, MoMA, New York (1999); *La Ville, le Jardin, la Mémoire*, Villa Medici, Rome (1999); *Premises: Invested Spaces in Visual Arts and Architecture from France, 1958–1998*, Guggenheim SoHo, New York (1998); and *In Visible Light*, Museum of Modern Art, Oxford, England (1997).

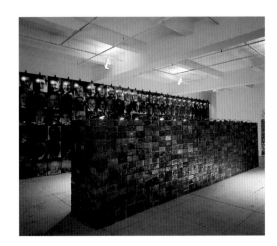

FURTHER READING

Boltanski, exhib. cat. by Danilo Eccher for the exhibition *Christian Boltanski: Pentimenti*, Milan, Galleria d'Arte Moderna Bologna, Villa delle Rose, 1997

Boltanski, Christian, *Christian Boltanski: Reconstitution*, London (Whitechapel Art Gallery) 1990

Boltanski, Christian, *et al., Parkett*, no. 22, 1989, pp. 22–65 (including Didier Semin, "An Artist of Uncertainty," pp. 26–27; Georgia Marsh, "The White and the Black: An Interview with Christian Boltanski," pp. 36–40; Béatrice Parent, "Light and Shadow: Christian Boltanski and Jeff Wall," pp. 60–63)

Camhi, Leslie, "Christian Boltanski: A Conversation" (interview), *The Print Collector's Newsletter*, 23, Jan.–Feb. 1993, pp. 201–206

Cotter, Holland, "Lost, Found, and Somewhere in Between," *The New York Times*, May 26, 1995, p. C26

Demos, T.J., "The Aesthetics of Mourning," *Flash Art*, no. 184, Oct. 1995, pp. 65–67

Gumpert, Lynn, *Christian Boltanski*, Paris (Flammarion) 1994

Rosen, Carol, "Traces of the Dead," *Sculpture*, 18, June 1999, pp. 26–33

Semin, Didier, *Christian Boltanski*, London (Phaidon Press) 1997

Weber, Bruce, "Just Stuff. Just Art? Clutter of 1995 Goes to Museum," *The New York Times*, May 10, 1995, pp. B1, B10

LEFT:

Lost Property (detail), 1995

RIGHT, TOP:

Reserve of Dead Swiss (large), *Reserve of Dead Swiss (small)*, and *174 Dead Swiss*, all 1990 Three mixed-media installations

RIGHT, BOTTOM:

Lumières (blue Pyramid-Claudine), 2000 46 blue lightbulbs, 1 black-and-white photograph

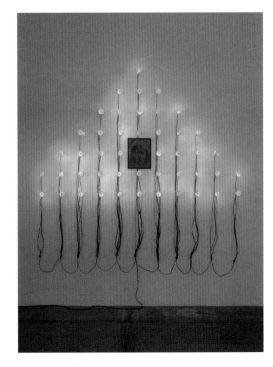

For decades, Louise Bourgeois has spun her memories and personal history into candid, emotionally charged works, fusing artistic exploration and therapeutic purging into one creative act. At Rockefeller Center, her self-examination took center stage with a dramatic installation of three bronze spiders. The two smaller ones—which, at 8 and 15 feet tall (2.4 and 4.9 m), were not actually small by any means—were dwarfed by one 34 foot tall (10.3 m) giantess, *Maman*, whose arching stance spanned virtually the entire width of the plaza. Their legs were gnarled and ropy, but slender: the *Spiders*' had an angular, adolescent bent, while *Maman's* eight legs traced gothic vaults in the air, tapering to an impossibly elegant needle-thin point where they met the ground. Viewers who walked underneath could see *Maman* was carrying a cage-like sac of eggs.

Bourgeois began making sculptures of spiders in the 1990s, although she has said her engagement with the theme dates back to the 1940s. Likening the spider to her own mother, Bourgeois wrote in "Ode to My Mother" (1995), "The friend (*the spider—why the spider?*) because my best friend was my mother and she was deliberate, clever, patient, soothing, reasonable, dainty, subtle, indispensable, neat, and as useful as a spider. ... I shall never tire of representing her." Bourgeois repeatedly returns to the parent–child relationship, and although much of her oeuvre has been made in response to her father (whose long-lasting affair with the family's live-in governess was the formative betrayal of Bourgeois's childhood), the spider appears again and again in her work as a totem of maternal protection. She has also compared the act of drawing to that of a spider secreting thread to make a web—both things, she says, are "organizations of space."

A steel and marble version of *Maman* was first exhibited in London, at Tate Modern's Turbine Hall in 2000 (Bourgeois was the first to show work in that monumental space), and when it was reworked in bronze for Rockefeller Center, it was a grandly personal gesture inserted into a spectacular public arena. Discussing the act of creating art for a public place, Bourgeois recently said: "I am not working for the public. I make what I make, and if the public likes it, so much the better." Protective but imposing, her oversized spiders seemed a fair match for the oversized city. Positioned in front of the grand and iconic Art Deco building at 30 Rockefeller Center, *Maman* and her two spider children were phenomenal beings, part-organic, part-mechanical, and utterly mysterious.

Maman, 1999
(cast in bronze in 2001)
and *Spiders*, both 1996
Bronze
Rockefeller Center, Manhattan,
June 21–September 4, 2001

LOUISE BOURGEOIS
Spiders

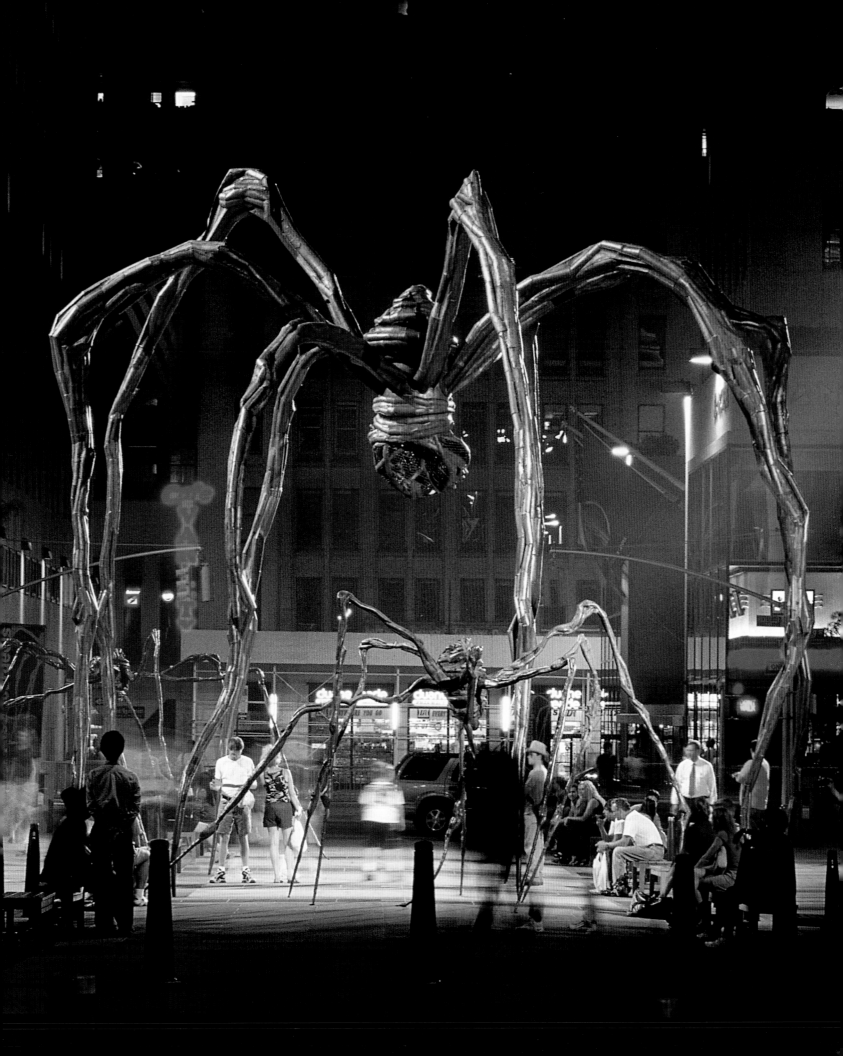

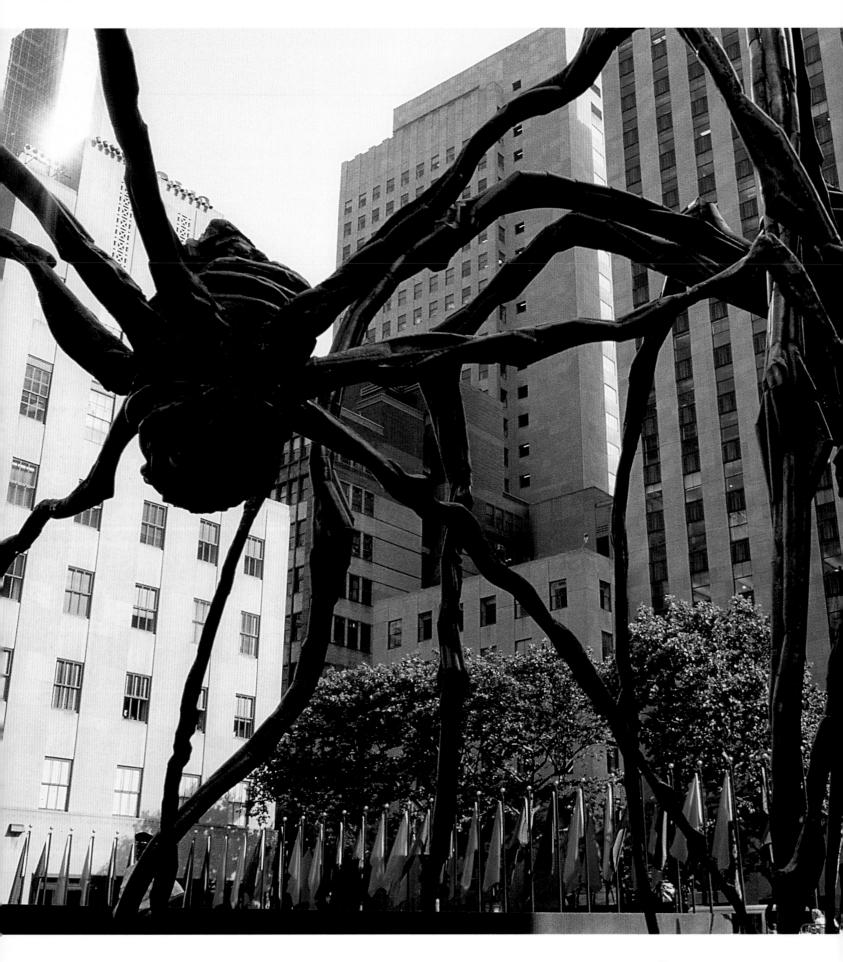

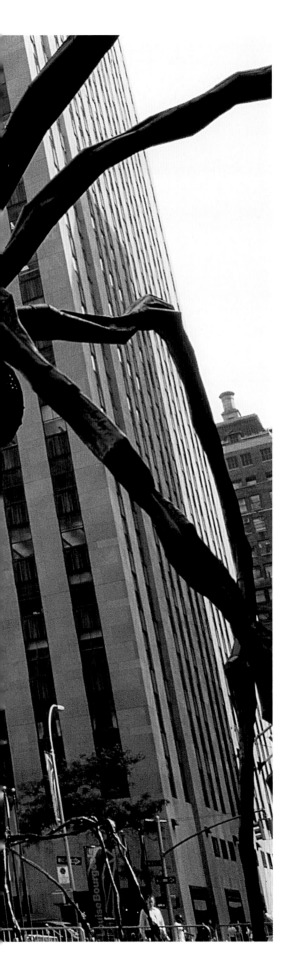

↘ LOUISE BOURGEOIS

Born in Paris, 1911.
Studied at Académie de la Grande-Chaumière, Paris (1937–38), and Ecole des Beaux-Arts, Paris (1936–38).

SELECTED EXHIBITION HISTORY

Louise Bourgeois has recently had solo exhibitions at Whitney Museum of American Art, New York (2003); Kunsthaus Bregenz, Austria (2002); Tate Modern, London (2000); Museo Nacional Centro de Arte Reina Sofía, Madrid (2000); and CAPC Musée d'Art Contemporain, Bordeaux, France (1999; traveled to Foundation Belem, Lisbon; Malmö Konsthall, Sweden; and Serpentine Gallery, London). Recent group exhibitions include *Documenta XI*, Kassel, Germany (2002); *Surrealism: Desire Unbound*, Tate Modern, London (2002); *The End: An Independent Vision of Contemporary Culture, 1982–2000*, Exit Art, New York (2000); *Regarding Beauty: A View of the Late Twentieth Century*, Hirshhorn Museum and Sculpture Garden, Smithsonian Institution, Washington, D.C. (2000; traveled to Haus der Kunst, Munich, Germany); *The American Century: Art & Culture 1900–2000, Part II 1950–2000*, Whitney Museum of American Art, New York (1999); *Looking For a Place*, 3rd Biennale, SITE Santa Fe, New Mexico (1999); 48th Venice Biennale, Italy (1999); *Changing Spaces*, Fabric Workshop and Museum, Philadelphia (1998; traveled to Miami Art Museum, Florida; Arts Festival of Atlanta; Detroit Institute of Arts; and Institute of Contemporary Art, Philadelphia); and 1997 Biennial Exhibition, Whitney Museum of American Art, New York (1997).

FURTHER READING

Acocella, Joan, "The Spider's Web," *The New Yorker*, Feb. 4, 2002, pp. 72–77

Asbaghi, Pandora Tabatabai, Jerry Gorovoy, *et al.*, *Louise Bourgeois: Blue Days and Pink Days*, Milan (Fondazione Prada) 1997

Bourgeois, Louise, Marie-Laure Bernadec, and Hans-Ulrich Obrist, *Destruction of the Father/Reconstruction of the Father (Writings and Interviews 1923–1997)*, London (Violette Editions) 1998

Louise Bourgeois, exhib. cat. by Marie-Laure Bernadac *et al.*, Bordeaux, CAPC Musée d'Art Contemporain; London, Serpentine Gallery, 1998

Louise Bourgeois, exhib. cat. by Frances Morris and Marina Warner, London, Tate Modern, 2000

Louise Bourgeois, exhib. cat. by Eckhard Schneider and Scott Lyon-Wall, Bregenz, Kunsthaus Bregenz, 2002

Louise Bourgeois: Architecture and Memory, exhib. cat. by Jerry Gorovoy, Danielle Tilkin, *et al.*, Madrid, Museo Nacional Centro de Arte Reina Sofía, 1999

Louise Bourgeois: The Early Work, exhib. cat. by Josef Helfenstein, Champaign IL, Krannert Art Museum, 2002

Mahoney, Robert, "Louise Bourgeois: Maman and Spiders," *Time Out New York*, Aug. 23–30, 2001, p. 48

Wallach, Amei, "Louise Bourgeois at 90, Weaving Complexities," *The New York Times*, Dec. 25, 2001, p. E1

LEFT:

Maman with *Spider* (detail), 1999 (cast 2001) and 1996

RIGHT, TOP:

Spider, 1994
Watercolor, pencil, and gouache on paper

RIGHT, BOTTOM:

Spider IV, 1996
Steel

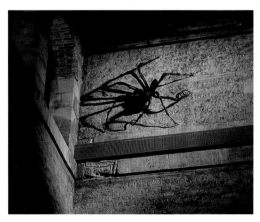

ALEXANDER BRODSKY
Canal Street Subway Project

One of the Public Art Fund projects most fondly remembered by the general public, Alexander Brodsky's 1996 *Canal Street Subway Project* turned a stretch of the city's underground transit system into a Venetian gondola scene worthy of Canaletto. Working in collaboration with New York City's Metropolitan Transit Authority, Brodsky used a 60 foot (18 m) length of tunnel at the Canal Street station in Lower Manhattan that was undergoing renovation to create his illusion for commuters making their way between trains—floating five gondolas constructed from wood, aluminum, and tin in a pool of water 1 foot (30 cm) deep built on to the disused track. Propelled by a wave-making pump system, the boats were populated with the silhouetted figures of merry-making couples who appeared to be floating past a classic Venetian cityscape.

The Russian-born Brodsky is a founding member of the influential group of artists and architects from the early 1980s known as the "Paper Architects"—so called because, under the former Soviet regime, they had to be content with realizing their visions only on paper. Unable to build in the real world, Brodsky and his colleagues (particularly his longtime collaborator, Ilya Utkin) displaced their creativity on to the page with a series of increasingly fanciful architectural schemes. By the late 1980s, they had begun to develop these sketches into three-dimensional sculptural installations, as in their *Portrait of an Unknown Person or Carl Fabergé's Nightmare* (1990), where a Sisyphean figure was depicted pushing an enormous egg across the floor of the gallery, or Brodsky's 1999 solo project *Palazzo Nudo*, an enormous pile of demolished architectural details taken from the Pittsburgh neighborhood where it was shown. Surrounded by a large metal scaffolding and lit by spotlights, the heap of Beaux-Arts ornament—like so much of Brodsky's work—suggested the inevitable decay of the built environment and the impermanence of sociocultural tastes and styles.

The tunnels of the New York City subway system may seem an unlikely location for an artwork, yet in many respects they suit Brodsky's conceptual approach perfectly. Superficially public yet still strictly controlled, this underground network is eminently familiar to the denizens of the five boroughs yet, with its dank passageways and unmarked doors, still full of mystery and even a bit of dread. Brodsky played both on and against these qualities—by putting the "canal" back in Canal Street (where such a waterway indeed once flowed), his *Subway Project* transformed the environment's physical abjection into a stage set for fantasy, weaving a kind of daydream for the often dark spaces beneath the city.

Canal Street Subway Project
(detail), 1996
Mixed-media installation
Canal Street subway station,
Manhattan, October 4,
1996–January 31, 1996

⬎ ALEXANDER BRODSKY

Born in Moscow, 1955.
Studied at Moscow Architecture Institute (1978).

SELECTED EXHIBITION HISTORY

Alexander Brodsky has recently had solo exhibitions at Aedes Gallery, Berlin (2002); Marat Guelman Gallery, Moscow (2000); Ronald Feldman Fine Arts, New York (1999); State Museum of Architecture, Moscow (1997); and Tretjakov Gallery, Moscow (1997). Recent group exhibitions include *Milano Europa 2000: Fine secolo, I semi del futuro*, Padiglione d'Arte Contemporanea, Milan Triennale, Italy (2001); *Working Here: Art at 111*, Community Gallery, Jersey City (2001); and *Seeing Isn't Believing: Russian Art Since Glasnost*, Lamont Gallery, Phillips Exeter Academy, Exeter, New Hampshire (2000).

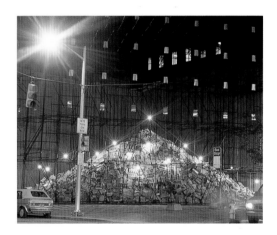

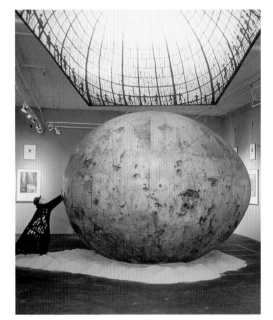

FURTHER READING

Alexander Brodsky and Ilya Utkin, The Portal, exhib. cat. by Alexander Brodsky and Ilya Utkin, Hertogenbosch, European Ceramics Work Center, 1994

Asse, Evgeni, "The Architectural: A Case of Brodsky," *Export*, no. 16, Feb. 2000, pp. 49–64

Brodsky and Utkin, Paper Architecture in the Real World, exhib. cat. by John Weber and Lois Whitmore, Portland OR, Portland Art Museum, 1993

Burke, George, *et al.*, *Palazzo Nero and Other Projects*, Wellington (Wellington City Art Gallery) 1992

Gambrell, Jamey, "Brodsky and Utkin: Architects of the Imagination" and "Brodsky and Utkin Answer," *Print Collector's Newsletter*, no. 21, Sept.–Oct. 1990, pp. 126–32

McLeod, Marion, "Paper Houses," *Performance*, March 9, 1992, pp. 45–46

The Moscow Studio: A Five Year Printmaking Retrospective 1991–96, exhib. cat., Washington, D.C., Corcoran Gallery of Art; Alexandria VA (Hand Print Workshop) 1996

Nesbitt, Lois E. (ed.), *Brodsky and Utkin: The Complete Works*, New York (Princeton Architectural Press) 2003

Ramírez, Anthony, "Venetian Fantasy Still Afloat in a Usually Waterless Canal," *The New York Times*, Jan. 26, 1997, p. CY7

Yung, Sue, "The Physics of Memory: Alexander Brodsky," *Appearances*, no. 24, Spring 1997, pp. 14–17

LEFT:

Canal Street Subway Project, 1996

RIGHT, TOP:

Palazzo Nudo, 1999
Outdoor mixed-media
installation, Pittsburgh

RIGHT, BOTTOM:

BRODSKY AND UTKIN
Portrait of an Unknown Person or Carl Fabergé's Nightmare, 1990
Painted plaster

67

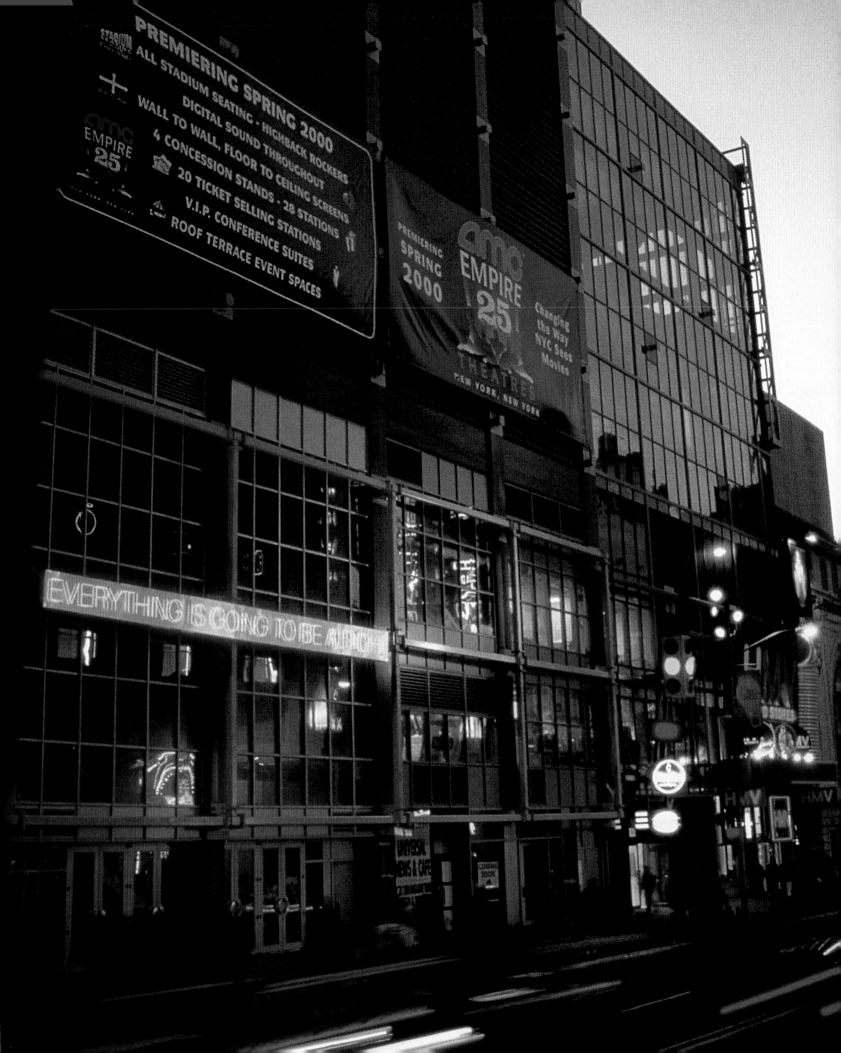

The days before New Year's Eve in Times Square are always a time of frantic activity, but in 1999 the situation reached fever pitch as the annual flocks of event planners and stage crews were joined by 8000 cops and more than a few millennium doomsayers. It was the epicenter of the Y2K panic. There was even a free "prayer station" set up on Broadway. Martin Creed's *Everything is going to be alright*—a neon sign 40 feet (12 m) long scheduled to make its debut in the midst of all of this—was meant to be a calming message offered in the face of possible pandemonium. But high-level security postponed the installation until after New Year's Eve, citing safety reasons—so the switch was flipped on January 4, 2000, instead, a last-minute accommodation that was inadvertently in keeping with the rest of British Conceptual artist Martin Creed's understated, gently subversive oeuvre.

Everything is going to be alright is a pertly reassuring statement, the sort of thing people say when in fact things are not all right at all. In the perpetual daylight of Times Square, where neon signs, flashing ads, and news tickers scramble to grab attention from all quarters, it was an almost monumentally humble gesture. Friendly but anonymous, the words were familiar enough, but incongruous and vaguely unsettling amid all the corporate branding. They had the casual ring of a line from a Bob Marley song, delivered with all the restraint of an emergency public announcement.

This work is Martin Creed's modest answer to the complex problem of making art in a media-saturated society. Like Bruce Nauman's text-based neon works, Creed's sign voiced a private thought to a broad public, but the absurdity of inserting a light-based artwork into the frenzy of Times Square is quintessential Martin Creed. "I want to make things," Creed once said to a journalist. "I'm not sure why ... I think I want to try to communicate with other people, because I want to say 'hullo'." Combining Minimalist strategy and a distinctly un-Minimalist sense of humor, Creed creates engaging art that slips into cracks in our awareness, altering the physical world just enough so that we become conscious of where we are. His best-known piece, *Work No. 201: half the air in a given space* (1998), is another deadpan blend of Minimalism and Pop: a room is filled with party balloons containing exactly half the air in the room. Using next to nothing, Creed makes it apparent that nothing is, in fact, there.

Everything is going to be alright,
1999
Neon sign
42nd Street between Seventh and
Eighth Avenues, Manhattan,
January 4–31, 2000

MARTIN CREED
Everything is going to be alright

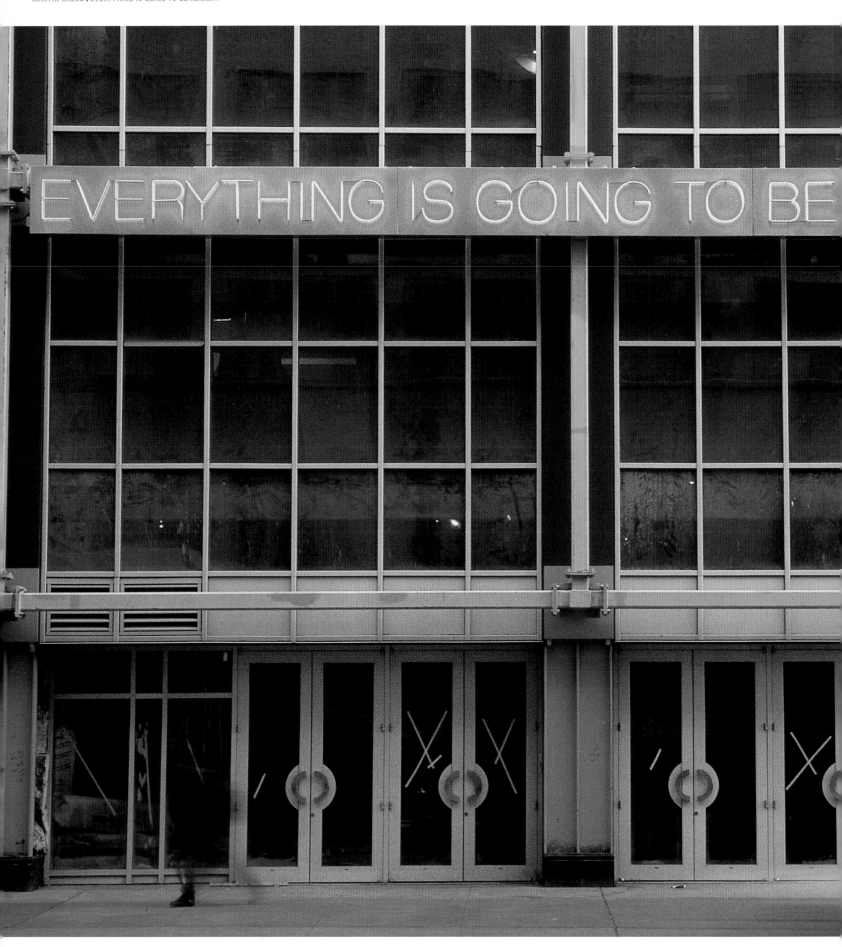

MARTIN CREED

Born in Wakefield, England, 1968.
Studied at Slade School of Fine Art, London (1990).

SELECTED EXHIBITION HISTORY

Martin Creed has recently had solo exhibitions at Wrong Gallery, New York (2002); Micromuseum for Contemporary Art and Culture, Palermo, Italy (2001); Camden Arts Centre, London (2001); Gavin Brown's Enterprise, New York (2000); Tate Britain, London (2000); and Southampton City Gallery, England (2000). Recent group exhibitions include *Strike*, Wolverhampton Art Gallery, England (2002); *My Head Is on Fire but My Heart Is Full of Love*, Charlottenburg, Copenhagen (2002); *Rock My World*, California College of Arts and Crafts, San Francisco (2002); *Tempo*, MoMA QNS, Long Island City, Queens (2002); Turner Prize, Tate Britain, London (2001); *British Art Show 2000*, national touring exhibition organized by the Hayward Gallery, London, for the Arts Council of England (2000); *Searchlight: Consciousness at the Millennium*, California College of Arts and Crafts, San Francisco (1999); *Not Today*, Gavin Brown's Enterprise, New York (1998); 11th Sydney Biennale, Australia (1998); and *Speed*, Whitechapel Art Gallery, London (1998).

FURTHER READING

Buck, Louisa, "Martin Creed," *Artforum*, 38, Feb. 2000, pp. 110–11

Coles, Alex, "Martin Creed—No Entry," *Art/Text*, no. 56, Feb.–April 1997, pp. 38–40

Cotter, Holland, "Surging into Chelsea," *The New York Times*, Jan. 21, 2000, p. E37

Grosenick, Uta, and Burkhard Riemschneider (eds.), *Art Now: 137 Artists in the Rise of the New Millennium*, Cologne (Taschen) 2002

Lillington, David, "Martin Creed," *Metropolis M*, 19, April–May 1999, pp. 46–51

McFarland, Dale, "Don't Worry," *Frieze*, no. 52, May 2000, pp. 66–69

MacMillan, Ian, "I'm Saying Nothing," *Modern Painters*, 13, Spring 2000, pp. 42–45

Mark, Lisa Gabrielle, "Fresh Heir," *C International Contemporary Art*, 63, Sept. 1999, pp. 9–13

Searle, Adrian, "Is This What They Call Pop Art?" *The Guardian*, Jan. 18, 2000, pp. 14–15

Williams, Gilda, "Martin Creed Tabula Rasa," *Art Monthly*, no. 195, April 1996, pp. 22–23

LEFT:

Everything is going to be alright, 1999 (presented 2000)

RIGHT, TOP:

Work No. 201: half the air in a given space, 1998
Balloons in various colors

RIGHT, BOTTOM:

Work No. 142: a large piece of furniture partially obstructing a door, 1996–99
Materials variable

As is often the case with his work, Wim Delvoye's *Gothic* was a strategically orchestrated, highly theatrical collision of what seem to be completely incompatible modes of address. For the project, the Belgian artist fabricated life-size replicas of two Caterpillar excavators, rendering their shapes in delicate Gothic-style filigrees of Cor-Ten steel. Located at two sites in the city during the summer of 2003—one at Doris C. Freedman Plaza in Central Park and another in Madison Square Park, near the Flatiron Building, where it sat near Delvoye's *Chantier*, an expanded array of equally ornamentalized construction equipment, including a concrete mixer and a wheelbarrow— the extravagant machines embodied a host of compelling dichotomies. The exaggeratedly decorative structural forms of the diggers, with their quatrefoil perforations, finial-topped arches, and lacy rosettes, confounded their essential ordinariness; with their unmistakable overtones of church architecture, these emphatically secular apparatuses were somehow made to seem almost sacred.

 Gothic was, in many ways, a perfect outgrowth of Delvoye's studio practice. From early projects, in which the artist decorated unloved objects such as ironing boards and gas canisters with delicate Delftware patterns and heraldic designs, through a more recent series of impossibly lovely "marble" floors whose intricate patterns were made entirely out of slices of cured meats, the artist has consistently probed the boundaries between the historical and the contemporary, the functional and the aesthetic, high culture and low humor. These explorations of the thresholds of use–value found perhaps their most elaborate expression in Delvoye's infamous *Cloaca*, which toured to venues in Europe and the U.S. in 2001 and 2002. A large machine situated within the gallery space, *Cloaca* was concerned with digestion (as the title implies). The enormous alimentary contraption utilized a complex combination of enzymes, bases, and acids to enact a daily cycle of consumption and evacuation—fed by leading local chefs every morning at New York's New Museum of Contemporary Art, it produced "feces" every twenty-four hours.

 Just as *Cloaca* used disparate procedures to create a constellation of inversions between body and machine, between refuse and treasure, Delvoye's overall practice constantly employs carefully pitched contrapositional systems to press viewers into recalibrating their assumptions about what a thing is and what it does. Like the project's closest precedent, his *Cement Mixer* (1999), another heavy machine, in this case made entirely from intricately carved teak, *Gothic* represented a two-way conceptual street—one that created dissonance around the identities of familiar objects, and in so doing challenged the stability of our fundamental expectations about them.

Caterpillar, 2002
Cor-Ten steel
Doris C. Freedman Plaza,
Central Park, Manhattan,
June 27–September 30, 2003

WIM DELVOYE
Gothic

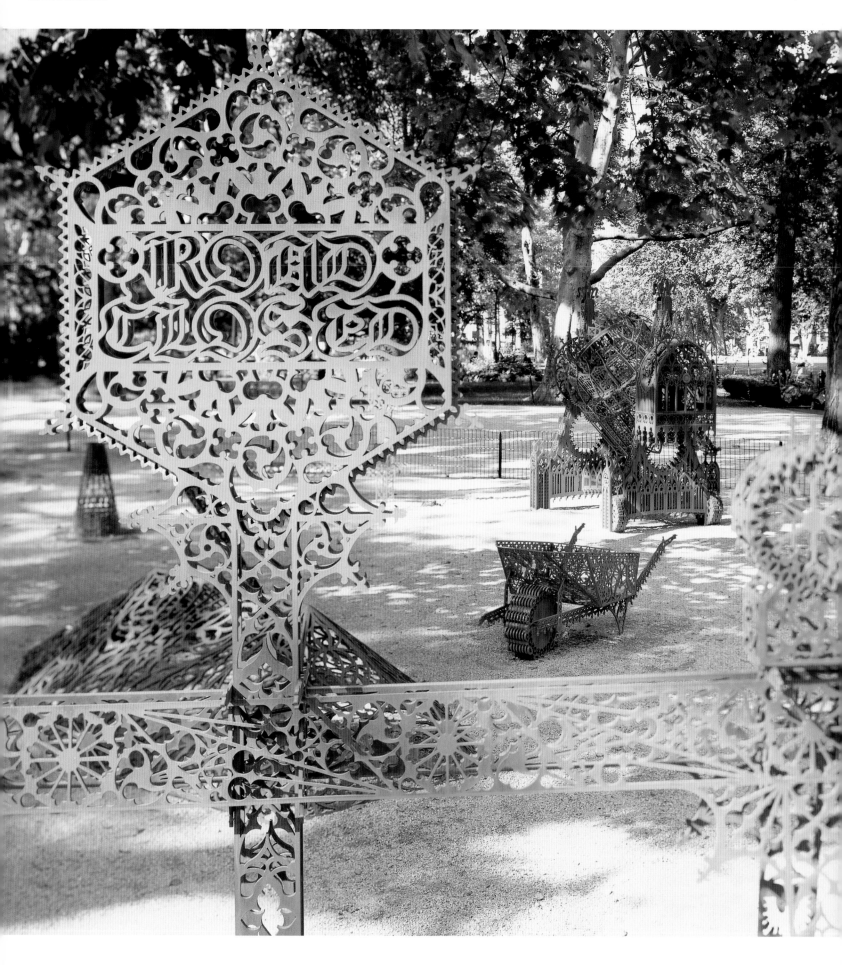

WIM DELVOYE

Born in Wervik, Belgium, 1965.
Studied at Ghent Academy of Fine Arts, Belgium (1980–86).

SELECTED EXHIBITION HISTORY

Wim Delvoye has recently had solo exhibitions at Manchester City Art Gallery, England (2002); Sperone Westwater, New York (2002); New Museum of Contemporary Art, New York (2002); Migros Museum, Zurich, Switzerland (2001); and Centre Georges Pompidou, Paris (2000). Recent group exhibitions include *From Pop to Now: Selections from the Sonnabend Collection*, Tang Teaching Museum and Art Gallery at Skidmore College, Saratoga, New York (2002); *Un art populaire*, Fondation Cartier pour l'art contemporain, Paris (2001); *Sonsbeek 9 – Locus/Focus*, Arnhem, The Netherlands (2001); *Eine Barocke Party*, Kunsthalle Wien, Vienna (2001); *Give and Take*, Victoria and Albert Museum, London (2001); *The World on Its Head: Contemporary Belgian Art from Flanders*, Walter and McBean Galleries, San Francisco Art Institute (2000); *Partage d'Exotismes*, 5th Lyon Biennale, France (2000); *Over the Edges: the Corners of Ghent*, Stedelijk Museum voor Actuele Kunst, Ghent, Belgium; *d'APERTutto*, 48th Venice Biennale, Italy (1999); and Kwangju Biennale, South Korea (1997).

FURTHER READING

Amy, Michael, "The Body as Machine, Taken to Its Extreme," *The New York Times*, Jan. 20, 2002, pp. 37–38

Carr, David, "Wim the Artist and His Steam Shovel," *The New York Times*, June 29, 2003, p. CY5

Delvoye, Wim, *Wim Delvoye: Early Works*, Waregem (Rectapublishers) 2002

Franklin, Catherine, "As Long As You've Got Your Health" (interview), *Art Press*, no. 245, April 1999, pp. 18–23

Grimes, William, "Down the Hatch," *The New York Times*, Jan. 30, 2002, p. F1

Laster, Paul, "XXX-ray Vision," *Time Out New York*, Oct. 17–24, 2002, p. 22

Schouwenberg, Louise, "The Last Seduction," *Frame*, no. 25, March–April 2002, pp. 90–99

Smith, Roberta, "As You Live and Breathe, With, Um, a Couple of Adjustments," *The New York Times*, Feb. 8, 2002, p. E38

Van den Abeele, Lieven, "Everywhere a Tourist: Wim Delvoye's Lively 'Almost Art'," in *The Low Countries: Arts and Society in Flanders and the Netherlands, A Yearbook*, Rekkelm (Flemish–Netherland Foundation) 2000, pp. 165–70

Wim Delvoye: Gothic Works, exhib. cat. by Edwin Carels, Philip Hoare, and Birgit Sonna, Manchester City Art Galleries, 2002

LEFT:

Chantier, 2003
Cor-Ten steel
Madison Square Park, Manhattan,
June 27–September 30, 2003

RIGHT, TOP:

Marble Floor # 91, 1999
Cibachrome print on aluminum

RIGHT, BOTTOM:

Butagaz 51 Shell # 209632, 1987
Gas canister, enamel paint

Installed in a shady, graveled patch of Madison Square Park during the summer of 2002, Mark Dion's *Urban Wildlife Observation Unit* was a small, sturdy box of a building, outfitted with a flip-up service window and painted in greenish-brown camouflage to blend in with its dappled surroundings. Its utilitarian appearance suggested a snack shack or an information booth, but it was, in fact, a field station for the observation and study of urban wildlife: a place to research the pigeons, roaches, rats, squirrels, and other commonplace animals and plants that thrive in New York's intricate, high-density urban ecosystem. Inside, the field station was primly organized and maintained, with glass-enclosed bookshelves full of reference books, a telescope, jarred specimens, and even a diorama of a taxidermied squirrel and pigeon standing among potato-chip wrappers and other elements of their disagreeable "natural" habitat. Using nineteenth- and twentieth-century outposts of scientific exploration as a model, Dion outfitted his observation unit with cedar-plank walls, Roosevelt-era heavy wooden furniture, a free pocket-sized field guide, and an untrained park ranger who, over the course of the summer, learned about New York City's remaining flora and fauna along with everyone else.

In its insistent focus on these compromised bits of nature—usually as invisible to us as gum stains on the sidewalk, and as much an everlasting part of the city—Dion's field station delivered a painfully ironic message. "Madison Square Park is an ecosystem of remarkable impoverishment," he has said. "The park itself is a strange natural island in the city center. Biodiversity is extremely low there."

Like many of his investigative projects, Dion's *Urban Wildlife Observation Unit* amiably operated on parallel, perhaps contradictory, levels. His meticulous examination of one of New York City's best-kept parks can be seen as an optimist's celebration of Mother Nature's ability to thrive in difficult situations, or as an absurd send-up of our modern propensity to categorize and relish the very things we've destroyed or abandoned along the way to modernity. Dion often examines the ways in which we impose order on the natural world, bringing in prized tidbits from outdoors to sort, label, and display in natural history museums, zoos, and the like—and he frequently turns such selectivity on its ear. For *Vivarium* (2002), Dion brought a 22 foot (6.7 m) fallen tree from the woods into the museum, placing it—along with its thriving micro-ecosystem of bugs, moss, and lichen—in a massive vitrine. In *Observation Unit*, Dion concentrated on a three-square-block area of Manhattan, observing the way that humans, plants, and animals coexist in a similarly circumscribed patch of land.

OPPOSITE:

Urban Wildlife Observation Unit, 2002
Mixed-media installation, performance, and field guide
Madison Square Park, Manhattan, July 11–October 31, 2002

FOLLOWING PAGES:

Urban Wildlife Observation Unit (interior installation view and details), 2002

MARK DION
Urban Wildlife Observation Unit

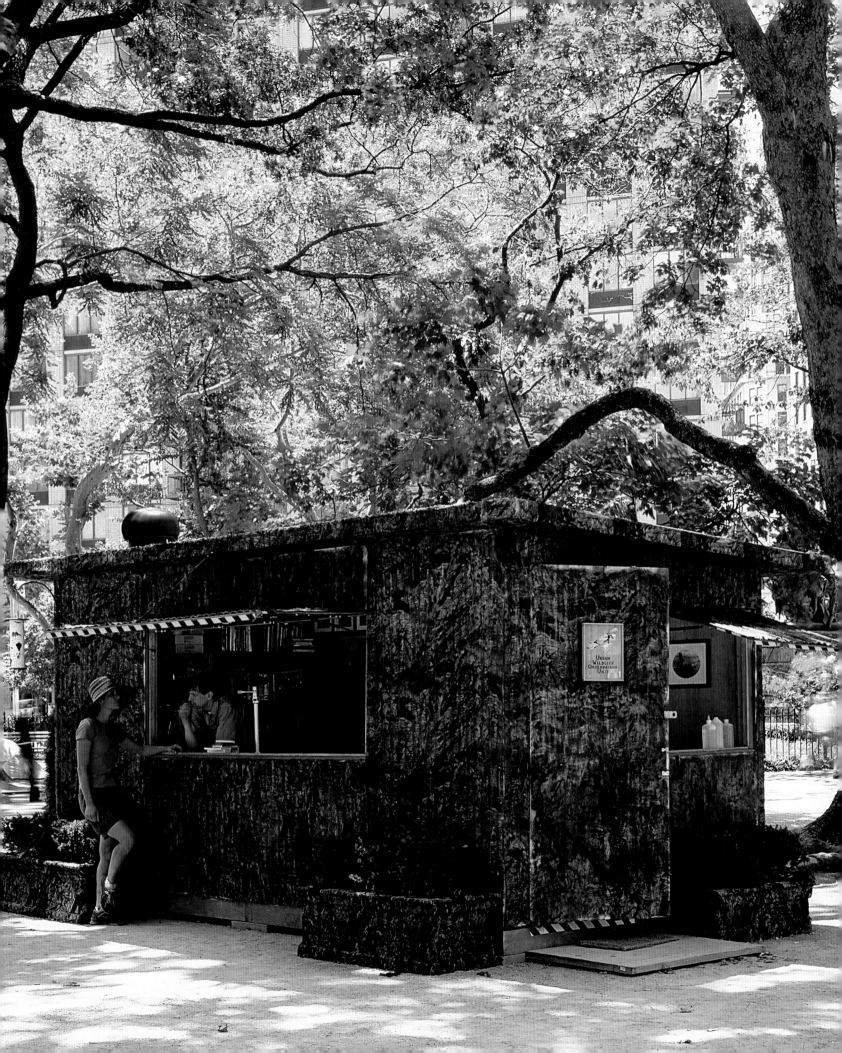

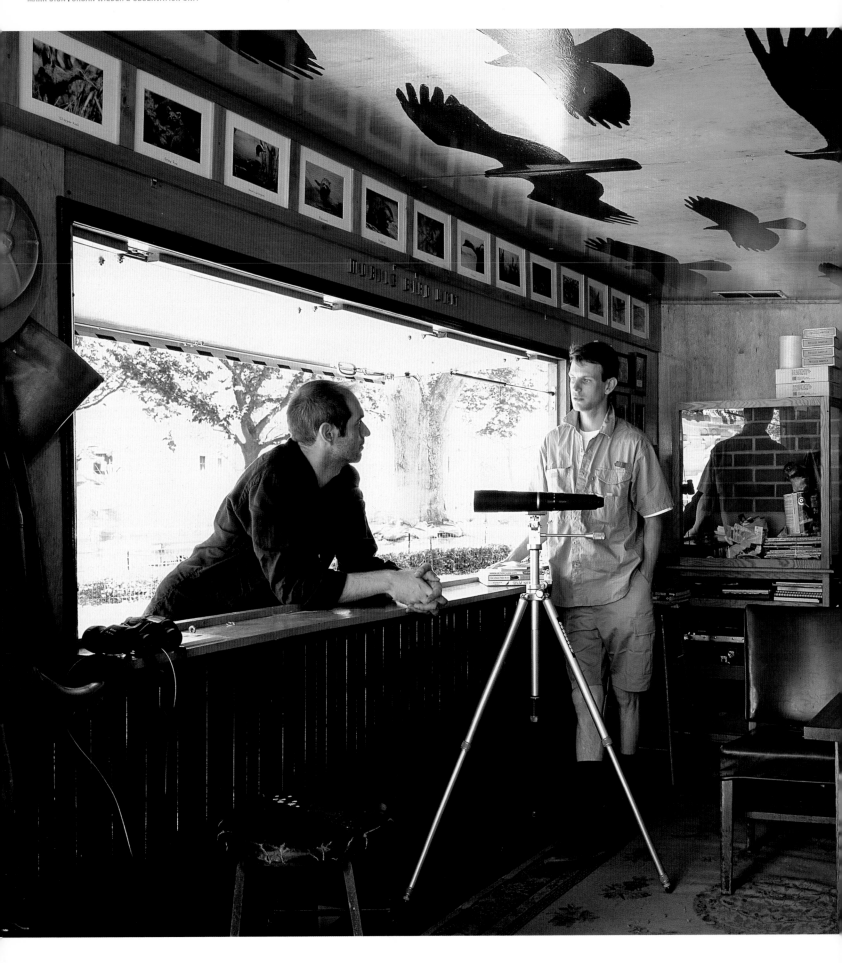

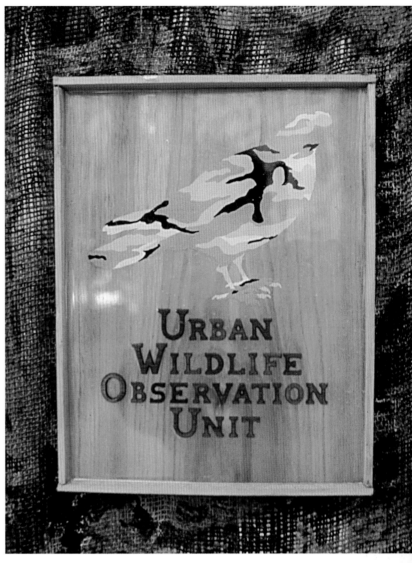

↘ MARK DION

Born in New Bedford, Massachusetts, 1961.
Studied at University of Hartford, Connecticut (Doctor of Arts, 2002), Whitney Museum of American Art Independent Study Program, New York (1984–85), and School of Visual Arts, New York (1982–84).

SELECTED EXHIBITION HISTORY

Mark Dion has recently had solo exhibitions at Aldrich Contemporary Art Museum, Ridgefield, Connecticut (2003); Villa Merkel, Esslingen, Germany (2002–2003; traveled to Bonner Kunstverein, Bonn, and Kunstverein Hannover); Tanya Bonakdar Gallery, New York (2002); American Fine Arts Company, New York (2000); and Tate Gallery, London (1999). Recent group exhibitions include *The House of Fiction*, Sammlung Hauser und Wirth, St. Gallen, Switzerland (2002); *Museutopia*, Karl Ernst Osthaus-Museum der Stadt Hagen, Germany (2002); *Hellgreen*, City Park, Düsseldorf, Germany (2002); *inSITE2000*, San Diego (2000); *Crossing the Line*, Queens Museum of Art (2001); *Ecologies*, David and Alfred Smart Museum of Art, Chicago (2000); *Small World: Dioramas in Contemporary Art*, Museum of Contemporary Art, San Diego (2000); *The Museum as Muse: Artists Reflect*, MoMA, New York (1999); *Carnegie International 1999/2000*, Carnegie Museum of Art, Pittsburgh (1999); and *The National World*, Vancouver Art Gallery, Canada (1998).

FURTHER READING

Coles, Alex, *Archaeology*, London (Black Dog Press) 1999

Dion, Mark, *Ursus Maritimus*, Cologne (Verlag der Buchhandlung Walther König) 2003

The Greenhouse Effect, exhib. cat. ed. Ralph Rugoff and Lisa G. Corrin, London, Serpentine Gallery, 2000

Heidemann, Christine, and Andreas Baur (eds.), *Mark Dion: Encyclomania*, Nuremberg (Verlag für Moderne Kunst) 2003

Mark Dion: Collaborations, exhib. cat. by Zina Davis, Hartford CT, University of Hartford, Joseloff Gallery, 2003

Mark Dion: Drawings, Journals, Photographs, Souvenirs, and Trophies, 1990–2003, exhib. cat. ed. Richard Klein, Ridgefield CT, Aldrich Contemporary Art Museum, 2003

Mark Dion: New England Digs, exhib. cat. ed. Denise Markonish, Brockton MA, Fuller Museum of Art, 2001

Mark Dion: Where the Land Meets the Sea, exhib. cat. by Mark Dion, San Francisco, Yerba Buena Center for the Arts, 1998

Pollack, Barbara, "Animal House," *ARTnews*, 102, Jan. 2003, pp. 108–11

Volk, Gregory, *et al.*, *Field Guide to the Wildlife of Madison Square Park: Mark Dion's Urban Wildlife Observation Unit*, New York (Public Art Fund) 2002

LEFT:

Urban Wildlife Observation Unit (detail), 2002

RIGHT, TOP:

Vivarium, 2002
Maple log, soil, aluminum, tempered glass, wood, ceramic tile

RIGHT, BOTTOM:

Concrete Jungle (The Birds), 1992
Mixed media

The first project ever created through the Public Art Fund's "In the Public Realm" program, Chris Doyle's *Commutable*—a gilded staircase (literally) on the Manhattan side of the Williamsburg Bridge pedestrian walkway—was finished in the late summer of 1996. In the days leading up to its debut, Doyle and a group of assistants spent hundreds of man-hours painstakingly applying more than 11,000 squares of 22-karat gold leaf to the epoxy-covered concrete surface; the result was a beautiful low-key intervention into the urban fabric, one made all the more poignant by its alignment of the precious substance and all its attendant metaphoric associations with a famously neglected precinct of mid-1990s New York City. As Doyle noted at the time about the inspiration for *Commutable*, the bridge had been undergoing renovation for some time leading up to the project, a process that had been suspended by the city after nearby residents complained about the fine flakes of lead-based paint that were dusting their neighborhoods as a result of sandblasting. "I thought it would be nice," Doyle told a reporter, "to give the neighborhood some gold."

Many of Doyle's most memorable projects have been sited in public contexts, and suggest a similar sense of civic empathy. His *Leap* (2000), a series of projections commissioned by Creative Time, depicted people uninhibitedly "jumping" upwards and was shown at extremely large scale for several consecutive nights on the side of 2 Columbus Circle. One of two pieces for an exhibition of his work at the University of Michigan later that same year also involved projections, this time for *What I See When I Look At You*, a work sited on the exterior wall of the school's museum that merged eighteenth- and nineteenth-century portraits from the university collection with images of people videotaped on the campus. In a general sense, *Commutable* can be thought of as a kind of projection as well, one thing laid over another in such a way that both retain some measure of visibility while also exchanging context and content within the given scenario.

Doyle, who trained as a painter but also studied architecture at Harvard in the 1980s, once said in an interview that he was inspired to come out of the studio to work in public space by the need for "connection" with other people. In many ways, *Commutable* represents a kind of apotheosis for several aspects of the artist's background and sensibility—an essentially painterly process, carried out on the very stuff of the built environment and seen by thousands every single day.

Commutable, 1996
22-karat gold leaf
Williamsburg Bridge, Lower East Side entrance, Manhattan,
ongoing since September 12, 1996

CHRIS DOYLE
Commutable

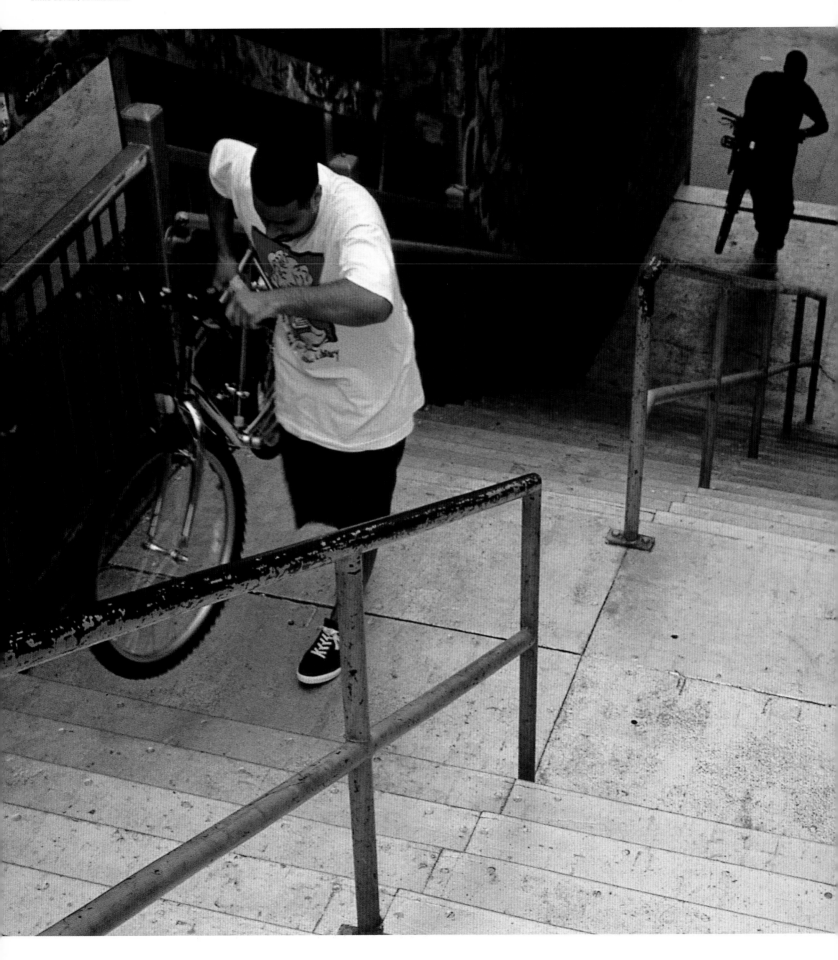

↘ CHRIS DOYLE

Born in Easton, Pennsylvania, 1960.
Studied at Harvard University, Cambridge, Massachusetts (MFA, 1985), and Boston College (BFA, 1981).

SELECTED EXHIBITION HISTORY

Chris Doyle has recently had solo exhibitions at Jessica Murray Projects, Brooklyn (2003); SculptureCenter, Long Island City, Queens (2003); High School of Teaching, Queens (2003); Creative Time, New York (2000); and University of Michigan Museum of Art, Ann Arbor (2000). Recent group exhibitions include *How Deep Is Your Love?*, Jessica Murray Projects, Brooklyn (2003); *American Dream*, Ronald Feldman Fine Arts, New York (2003); *Grotto*, Jessica Murray Projects, Brooklyn (2002); *Heart of Gold*, P.S. 1 Contemporary Art Center, Long Island City, Queens (2002); *EyeStalk*, Smack Mellon Studios, Brooklyn (2002); *5.5*, Real Art Ways, Hartford (2001); *Interval: New Art for a New Space*, SculptureCenter, Long Island City, Queens (2001); *Crossing the Line*, Queens Museum of Art (2001); *Another Day on Planet Earth*, DeChiara Gallery, New York (2001); and *Flock*, Socrates Sculpture Park, Long Island City, Queens (1999).

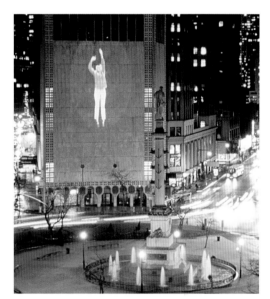

FURTHER READING

Adwan, Rania, "Chris Doyle," *Dazed & Confused*, March 2000

"Chris Doyle, Installation: The Artist's Gild," *New York Magazine*, Sept. 30, 1996, p. 71

Cohen, Billie, "Leap of Faith," *Time Out New York*, April 20, 2000, p. 48

Dover, Caitlin, "Magic Shows: Technology Has Entered Fully into the Realm of Public Art," *Print*, 55, July–Aug. 2001, p. 97

Goldbaum, Karen, "A Conversation with Chris Doyle," *Insight*, Sept.–Oct. 2000, p. 10

Shaw, Lytle, "Chris Doyle: In Private," *Time Out New York*, March 7–14, 2002, p. 66

Smith, Roberta, "Funky Digs with Lots of Space for Performance-Oriented Hipsters," *The New York Times*, Sept. 28, 2001, p. E39

Stevens, Kimberly, "A Lot of New Yorkers with Their Heads in the Clouds," *The New York Times*, April 30, 2000, section 14, p. 8

Weber, Bruce, "A Flight of Fancy: Steps Paved with Gold," *The New York Times*, Sept. 11, 1996, pp. B1, B4

LEFT:

Commutable, 1996

RIGHT, TOP:

Leap, 2000
Video projection at 2 Columbus Circle, New York, organized by Creative Time

RIGHT, BOTTOM:

What I See When I Look At You, 2000
Video projection at the University of Michigan Museum of Art, Ann Arbor

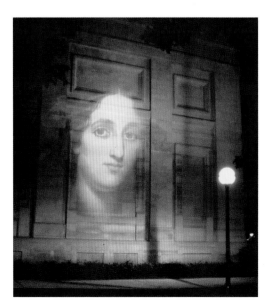

Childhood obsessions, material culture, and one's own irretrievable past—these interwoven fascinations are at the heart of Keith Edmier's figurative sculpture, which ranges from a virginal depiction of his childhood crush, *Jill Peters*, to a rosy-hued portrait of his mother when she was nine months pregnant with the artist, her only son. Although the form and subject of Edmier's recent Public Art Fund project, *Emil Dobbelstein and Henry J. Drope, 1944*, cast it in somewhat sharper focus than these sweetly wistful invocations, it was an equally sentimental journey into the artist's personal history. Emil Dobbelstein and Henry J. Drope were Edmier's two grandfathers, both born in 1916. Both men served in the U.S. Army in World War II but experienced dramatically different fates: Drope, Edmier's maternal grandfather, survived the war and lived until 1995; Dobbelstein, his paternal grandfather, died in a railway accident in 1944 while serving at the Sedalia Army Air Base in Missouri, and Edmier's grandmother later remarried. Edmier never knew about Emil Dobbelstein until he was a teenager, and it wasn't until years later, after months of researching medical and military documents at the Veterans Administration and the Army archives, that Edmier confirmed what he had wondered all along: Emil Dobbelstein's death had been a suicide.

For Edmier, *Dobbelstein and Drope* was the visible culmination of a material trail that included telegrams, newspaper clippings, official documents, and military insignia—all a means to discovering a lost piece of his own past: "The work initially came about not out of a need to make art, but out of a need to find out more about a grandfather I didn't know." To the casual passerby, the work appeared, at first glance, to be nothing more than a conventional war memorial, honoring two veterans of World War II. But Edmier's pint-sized bronze figures, standing just 4 feet (1.2 m) tall on heavy granite bases, looked more like dainty toy soldiers than heroic troops, and the engraved epitaph offered a baffling minimum of biographical information. The work was installed at the entrance to Central Park—home to scores of public statues honoring American generals, famous New Yorkers, and even a heroic dog named Balto—where it continually caused park-goers to stop to investigate the identities of the two soldiers. Using the specificity of his own family, Edmier created a very personal work in the most public of forms, unsettling the finality that memorials are meant to provide with his elegiac acknowledgment of the myriad individual experiences and losses that lie behind every official story.

Emil Dobbelstein and Henry J. Drope, 1944, 2002
Bronze and granite
Doris C. Freedman Plaza,
Central Park, Manhattan,
March 7–May 26, 2002

KEITH EDMIER
Emil Dobbelstein and Henry J. Drope, 1944

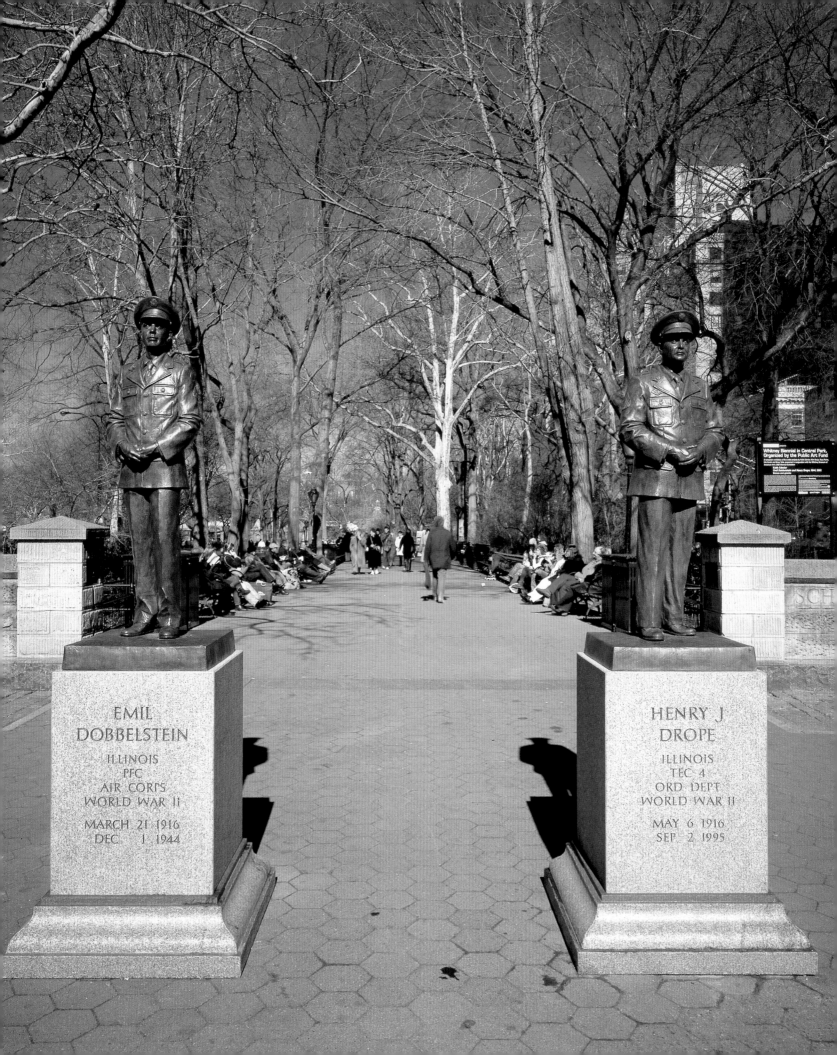

EMIL
DOBBELSTEIN

ILLINOIS
PFC
AIR CORPS
WORLD WAR II

MARCH 21 1916
DEC 1 1944

HENRY J
DROPE

ILLINOIS
TEC 4
ORD DEPT
WORLD WAR II

MAY 6 1916
SEP 2 1995

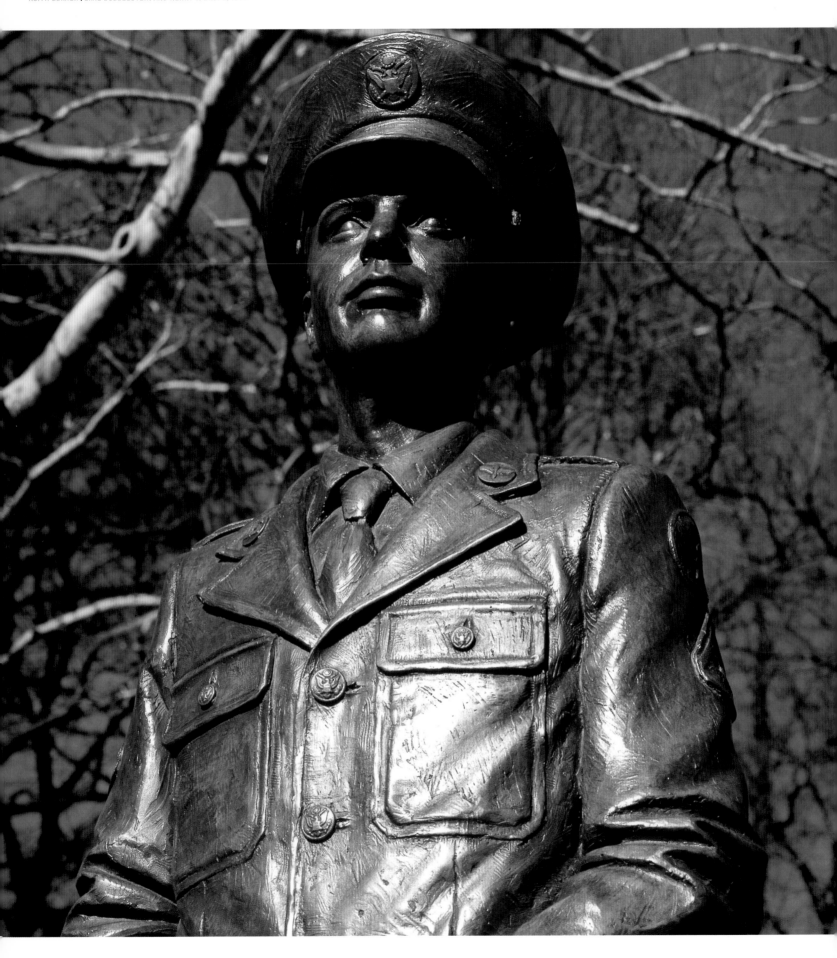

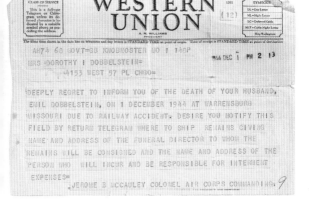

Born in Chicago, 1967.
Studied at California Institute of the Arts, Valencia (1986).

SELECTED EXHIBITION HISTORY

Keith Edmier has recently had solo exhibitions at Los Angeles County Museum of Art (2002); Neugerriemschneider, Berlin (2000); Douglas Hyde Gallery, Trinity College, Dublin (1998); Sadie Coles HQ, London (1998); and University of South Florida Contemporary Art Museum, Tampa (1997). Recent group exhibitions include the 2002 Biennial Exhibition, Whitney Museum of American Art, New York (2002); *The Americans*, Barbican Art Gallery, London (2001); *Casino 2001: 1st Quadrennial of Contemporary Art*, Stedelijk Museum voor Actuele Kunst, Ghent, Belgium (2001); *Age of Influence: Reflections in the Mirror of American Culture*, Museum of Contemporary Art, Chicago (2000); *Fact/Fiction: Contemporary Art That Walks the Line*, San Francisco Museum of Modern Art (2000); *Greater New York: New Art in New York Now*, P.S. 1 Contemporary Art Center, Long Island City, Queens (2000); *Presumed Innocent*, CAPC Musée d'Art Contemporain, Bordeaux, France (2000); *Abracadabra*, Tate Gallery, London (1999); and *Gothic*, Institute of Contemporary Art, Boston (1997).

FURTHER READING

2002 Biennial Exhibition, exhib. cat. by Lawrence Rinder *et al.*, New York, Whitney Museum of American Art, 2002, pp. 66–67

Cotter, Holland, "Spiritual America, From Ecstatic to Transcendent," *The New York Times*, March 8, 2002, pp. E35, E37

Grosenick, Uta, and Burkhard Riemschnieder (eds.), *Art at the Turn of the Millennium*, Cologne (Taschen) 1999, pp. 138–41

Jones, Ronald, *et al.*, *Emil Dobbelstein and Henry J. Drope, 1944*, New York (Public Art Fund) 2002

Jones, Ronald, "Keith Edmier and Richard Phillips," *Frieze*, no. 52, May 2000, p. 98

Keith Edmier, exhib. cat. by Neville Wakefield, Tampa, University of South Florida Art Museum, 1997

Keith Edmier, exhib. cat. by John Hutchinson, Dublin, Douglas Hyde Gallery, 1998

Léith, Caoimhín Mac Giolla, "The Americans, New Art," *Modern Painters*, 14, Winter 2001, pp. 100–102

Smith, Roberta, "Keith Edmier," *The New York Times*, Feb. 27, 1998, p. E38

Zelevansky, Lynn, *Keith Edmier and Farrah Fawcett: Recasting Pygmalion*, New York (Rizzoli) 2002

OPPOSITE:

Emil Dobbelstein and Henry J. Drope, 1944 (detail of Emil Dobbelstein), 2002

LEFT, TOP TO BOTTOM:

Three telegrams sent by Emil Dobbelstein in 1943 and 1944, and a fourth announcing his death

RIGHT, TOP:

Beverly Edmier, 1967, 1998
Cast urethane resin, cast acrylic resin, silicone, acrylic paint, silk, wool, Lycra fabric, cast silver buttons, nylon tights

RIGHT, BOTTOM:

Jill Peters, 1997
Polyvinyl, wax, cotton, rayon, polyester, silicone, human hair

TERESITA FERNÁNDEZ
Bamboo Cinema

Vision, landscape, light: all are central to the work of Miami-born artist Teresita Fernández; all were essential aspects of her 2001 Public Art Fund project, *Bamboo Cinema*. A maze-like sequence of Plexiglas poles 8 feet (2.4 m) high painted with alternating vertical bands of acid yellow and green and set in a series of concentric circles in Madison Square Park, *Bamboo Cinema* mediated both spatial and visual experience. The deeper visitors wandered into Fernández's chartreuse grove, the more the procession of slats stuttered their impressions of the outside world. Yet instead of obscuring perception, *Bamboo Cinema* actually enlivened the senses. Recalling elementary "motion-picture" mechanisms like the zoetrope—in which a long strip of images was placed into a drum-shaped container whose surface was perforated with regular vertical slots; when spun, the images would seem to move due to the "shuttering" effect of the rotating slits—it seemed to animate what was viewed through it.

Like much of the artist's work, *Bamboo Cinema* oscillated in a productive space between sculpture and installation; operating at a basic perceptual level, it enticed both visual engagement and physical interaction. While Fernández's practice has diversified stylistically, she has remained remarkably consistent in her interests, typically working in the essential forms of Minimalism and often utilizing materials with pronounced qualities of reflectivity or translucence. Fernández's gallery-based works inhabit and alter the spaces in which they are sited, destabilizing the boundaries between the built environment and the natural world. Her *Borrowed Landscape* of 1998, for example, was a series of five large cubes constructed from translucent scrims of colored veil and lit from above—the floors of each, inaccessible to viewers but visible through the diaphanous material, consisted of delicate pencil drawings evoking the lyrical geometric structures of European formal garden designs that have often informed Fernández's work. The complex large-scale combinations of volume, color, and light shifted for visitors as they moved through the space, producing a kind of simulated landscape architecture for the contemporary age, one punctuated by Fernández's subtle drawn intimations of the Classical landscape tradition that inspired it.

Fernández has often commented on the necessity of viewer interaction, what she calls the "circuit that completes the work"; her most successful projects create a kind of experiential immersion in pervasive, totalized environments that fundamentally reorder perceptions of space for those who occupy them. *Bamboo Cinema* successfully translated this experience into the public sphere, recontextualizing the sights and sounds of the city through the mesmerizing cinematic flickerings of its physical form.

Bamboo Cinema (detail), 2001
Acrylic tubing
Madison Square Park, Manhattan,
May 31–September 30, 2001

↘ TERESITA FERNÁNDEZ

Born in Miami, Florida, 1968.
Studied at Virginia Commonwealth University, Richmond (MFA, 1992), and Florida International University, Miami (BFA, 1990).

SELECTED EXHIBITION HISTORY

Teresita Fernández has recently had solo exhibitions at Lehmann Maupin Gallery, New York (2002); MoMA, New York (2000); SITE Santa Fe, New Mexico (2000); Berkeley Art Museum, California (1999); and Institute of Contemporary Art, Philadelphia (1999). Recent group exhibitions include *Outer City, Inner Space: Teresita Fernández, Stephen Hendee, and Ester Partegás*, Whitney Museum of American Art at Philip Morris, New York (2002); *The Young Latins*, Nassau County Museum of Art, Long Island (2002); *Hortus Conclusus*, Witte de With, Rotterdam, The Netherlands (2001); *Inside Space*, List Visual Arts Center, Massachusetts Institute of Technology, Cambridge, Massachusetts (2001); *Reading the Museum*, National Museum of Modern Art, Tokyo (2001); *La Ville, le Jardin, la Memoire*, Villa Medici, Rome (2000); *Greater New York: New Art in New York Now*, P.S. 1 Contemporary Art Center, Long Island City, Queens (2000); *Seamless*, De Appel, Amsterdam (1998); and *X-Site*, Contemporary Museum, Baltimore (1997).

FURTHER READING

Harris, Jane, "Intimate Immensity," *Art/Text*, no. 64, Feb.–April 1999, pp. 39–41

Lloyd, Anne Wilson, "From an Architect of Desire, Many-Layered Constructions," *The New York Times*, March 21, 1999, Arts & Leisure section 2, p. 41

Morgan, Anne Barclay, "Focus: Teresita Fernández," *Sculpture*, 18, Jan.–Feb. 1999, pp. 8–9

Sheets, Hilarie M., "Gardens of Earthly Delights," *ARTnews*, 100, Sept. 2001, pp. 138–41

Smith, Roberta, "Teresita Fernández, Borrowed Landscape," *The New York Times*, June 4, 1999, p. E33

Teresita Fernández, exhib. cat. by Teresita Fernández *et al.*, Philadelphia, Institute of Contemporary Art, 1999

Teresita Fernández, exhib. cat. by Marcella Beccaria, Rivoli, Castello di Rivoli, 2001

Teresita Fernández, exhib. cat. by Teresita Fernández *et al.*, Santa Fe NM, SITE Santa Fe, 2001

Williams, Gilda (ed.), *Cream: Contemporary Art in Culture*, London (Phaidon Press) 1998, pp. 116–19

Williams, Gregory, "Into the Void," *World Art*, no. 20, 1999, pp. 58–61

LEFT:

Bamboo Cinema, 2001

RIGHT, TOP:

Untitled, 1997
Wood, scrim, mirror, pencil

RIGHT, BOTTOM:

Borrowed Landscape, 1998
Wood, fabric, oculus light, pencil, paint
Installation view at ArtPace, San Antonio

Seen from a distance, the seductively undulating black rubber surface of Maria Elena González's *Magic Carpet/Home*, created in the Red Hook neighborhood of Brooklyn in 1999, suggested a piece of rogue pavement, buckled from the heat perhaps, and mysteriously plunked in the middle of Coffey Park's grassy commons. Up close, however, the white markings told a different story—not lane dividers or crosswalks, the painted image on the spongy surface of the raised wooden platform was actually the floor plan of one of the six-room units from the Red Hook East Houses, a nearby housing project. The precise size (27 ft x 39 ft/8.2 x 11.8 m) of one of the apartments it depicted, the schematic faithfully detailed the confines of these modest homes, down to the closets. Yet just as González's image evoked a kind of urban claustrophobia, the springy surface of her rippling magic carpet form also suggested escape, via the enchanted aerial conveyance familiar from folktales.

The Cuban-born González often employs tactile materials in her gallery works, imbuing Minimalist forms with compelling narrative allusion. For her memorable *The Persistence of Sorrow* (1996–97), for example, she printed the names of friends and loved ones who had recently died, including her parents, in Braille on a black rubber panel, and then covered the entire surface in Vaseline so that attempts to "read" the names would leave visible traces on both the surface of the piece and the fingers of the viewers. Yet González is also capable of lighter modes of address, as in her work *Basebowl* (2001), an installation designed to honor her father's memory via his favorite game. For the work, the middle of a large shallow bowl was mounded high with hundreds of baseballs; out of the center of this heap a thread of single balls rose some 45 feet (13.7 m) in the air like a fakir's charmed rope, a literal connection between heaven and earth that symbolized the daughter's connection with her departed parent.

In *Magic Carpet*, González consolidated elements of each of these two approaches, marrying social comment and social intervention in a resonant formal object. Juxtaposing interior and exterior, the domestic and the public, seriousness and deft humor, *Magic Carpet* was finally about optimism; about the idea, says González, that our hopes "can take us anywhere we choose."

Magic Carpet/Home (detail), 1999
Wood, rubber, paint
Coffey Park, Red Hook, Brooklyn,
May 16–November 1999

MARIA ELENA GONZÁLEZ
Magic Carpet/Home

MARIA ELENA GONZÁLEZ

Born in Havana, 1957.
Studied at San Francisco State University (MA, 1983) and Florida International University, Miami (BFA, 1979).

SELECTED EXHIBITION HISTORY

Maria Elena González has recently had solo projects and exhibitions at University of Memphis Art Museum, Tennessee (2003; traveled to Art in General, New York); The Project, New York (2003); Center for Art and Visual Culture, University of Maryland, Baltimore (2002); Bronx Museum of the Arts, New York (2002); and Ludwig Foundation of Cuba, Havana (2000). Recent group exhibitions include *Rudolf De Crignis, Maria Elena González, Ulrich Wellman*, Galerie Gisele Linder, Basel, Switzerland (2002); *Crossing the Line*, Queens Museum of Art (2001); *Maria Elena González, Paul Pfeiffer, Peter Rostovsky*, Gio Marconi Gallery, Milan, Italy (2001); *Greater New York: New Art in New York Now*, P.S. 1 Contemporary Art Center, Long Island City, Queens (2000); *Art Underfoot: Manhole Covers in NYC (The Past & Future of Manhole Cover Design)*, Urban Center Galleries, the Municipal Art Society, New York (1999); *Six Sculptors*, Long Island University, Brooklyn (1999); *Interpreting*, The Rotunda Gallery, Brooklyn (1998); *warming*, The Project, New York (1998); and *Home Is Where the Heart Is: Our Family Values*, White Columns, New York (1997).

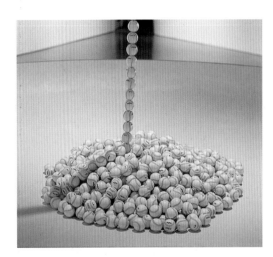

FURTHER READING

"Above and Beyond," *The New Yorker*, May 17, 1999, p. 22

Angeline, John, "Many Things for Many People: The Art of Maria Elena González," *Velvet Park Magazine*, Nov.–Dec. 2002, pp. 30–33

Auricchio, Laura, "Maria Elena González," *Time Out New York*, Oct. 24–31, 2002, p. 67

Brillembourg, Carlos, "Maria Elena González," *BOMB*, no. 82, Winter 2002–2003, pp. 40–47

Cotter, Holland, "Maria Elena González," *The New York Times*, Oct. 25, 2002, p. E35

Dawson, Jessica, "Maria Elena González at UMBC," *The Washington Post*, Oct. 24, 2002

Hammond, Harmony, *Lesbian Art in America: A Contemporary History*, New York (Rizzoli) 2000

Laster, Paul, "Fantastic Voyage," *One World*, Feb.–March 2003

Nadelman, Cynthia, "Maria Elena González," *ARTnews*, 102, Jan. 2003, pp. 122–23

Ostrower, Jessica, "Maria Elena González at The Project," *Art in America*, 91, April 2003, pp. 134–35

LEFT:

Magic Carpet/Home, 1999

RIGHT, TOP:

Basebowl, 2001
Wood, vinyl, baseballs
Installation view at Queens
Museum of Art

RIGHT, BOTTOM:

The Persistence of Sorrow
(detail), 1996–97
Wood, rubber, Braille,
Vaseline, tile

Dan Graham's pavilion for Madison Square Park was, as its straightforward name suggests, a roofless triangle-shaped structure bisected into two chambers by a curving piece of two-way reflective glass. It was made of solid, industrial materials, but *Bisected Triangle/Interior Curve* had an undeniably ethereal presence. In fact, at certain times of day, viewed from a distance, it appeared to vanish altogether—only the thin strip of aluminum along its top edge remained, like the Cheshire Cat's gleaming smile. Its tinted, reflective surface was always somewhat transparent—to what degree depended on how squarely the light was hitting it—so that one's image and surroundings faded in and out, merging in shifting fragments with the landscape on the other side of the pavilion.

Inside, the optical distortions continued. Each of the chambers in *Bisected Triangle/Interior Curve* had its own door, and moving from one chamber to the next required walking out and around the pavilion. People could see their own reflections, and possibly the reflections of those reflections, along with the faint figures of anyone in the adjoining chamber—not to mention passing pedestrians and traffic outside the structure. This layered, visual syncopation is not unlike the disconcerting effect produced by Graham's canonical video works of the 1970s, like *Opposing Mirrors and Video Monitors on Time Delay* (1974), an installation of two video monitors positioned on opposite sides of the gallery, each facing a mirror and each topped by a closed-circuit camera that feeds the other monitor. But the replay lags a few seconds behind, so that viewers often cross the room just in time to see themselves appear on screen. Graham's kaleidoscopic reshuffling of space amounts to a perceptual, social, and psychological ambiguity—in the case of either work, one can understand what causes the effect, and even anticipate it, but the palpable sense of disorientation lingers.

Graham, whose diverse oeuvre has shaped and pushed the boundaries of Conceptual art for more than four decades, has been creating quasi-architectural structures for parks, museums, and other places internationally since the 1970s. *Bisected Triangle/Interior Curve*—the first such work he has made for a public space in New York (although the Dia Center for the Arts has a well-known rooftop pavilion designed by the artist)—is neither sculpture nor architecture, neither public nor private. Using the traditional building materials of corporate office buildings, where mirrored glass is often used as a surveillance device, Graham creates what he has called an "intersubjective" space for human interaction. While some of Graham's environments, like *Star of David Pavilion for Schloß Buchberg* (1991–96), are rooted in social function or symbolism, *Bisected Triangle/Interior Curve* seems to be exactly what its name describes, nothing more and nothing less—a contemplative oasis in the center of Graham's hometown, where strangers encounter themselves, one another, and the world beyond.

Bisected Triangle/Interior Curve,
2002
Glass, wood, aluminum
Madison Square Park, Manhattan,
July 11, 2002–March 2003

DAN GRAHAM
Bisected Triangle/Interior Curve

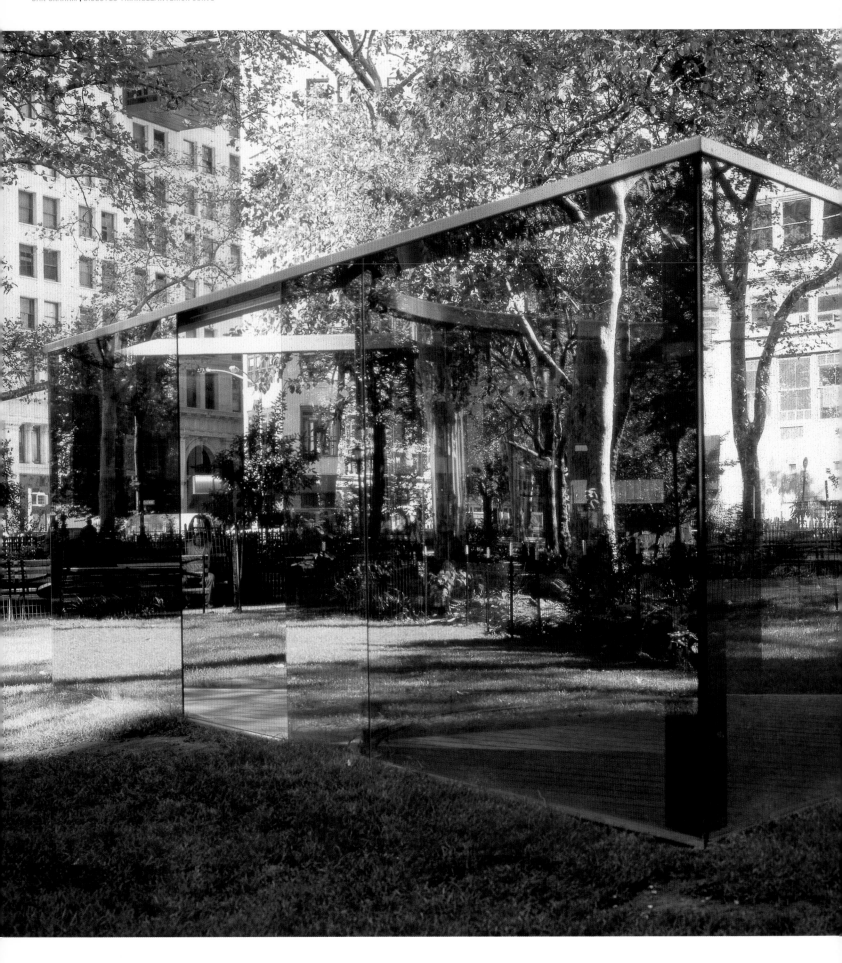

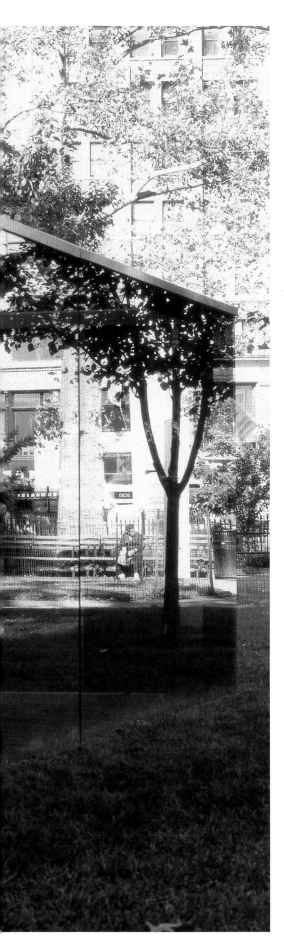

LEFT AND ABOVE:

Bisected Triangle/Interior Curve,
2002

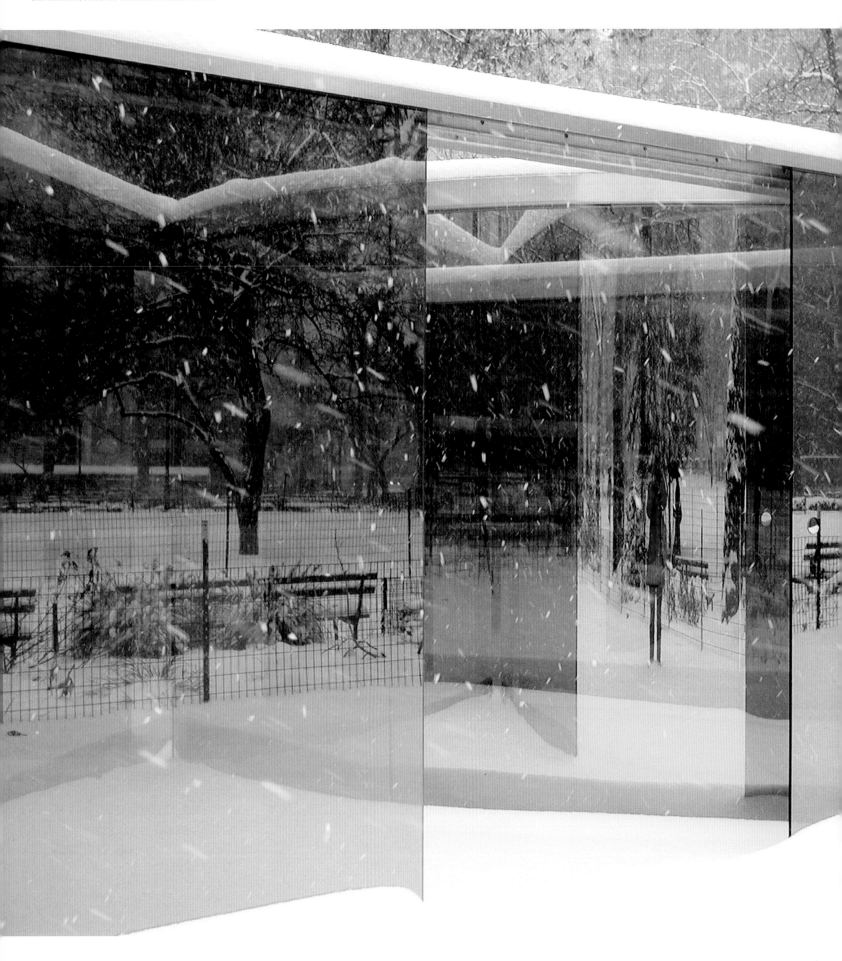

↘ DAN GRAHAM

Born in Urbana, Illinois, 1942.

SELECTED EXHIBITION HISTORY

Dan Graham has recently had solo exhibitions at Museu Serralves, Porto, Portugal (2002); Marian Goodman Gallery, New York (2002); and Centro Galego de Arte Contemporánea, Santiago de Compostela, Spain (1997). Over the past twenty-five years, he has realized pavilions in museums, sculpture parks, and public spaces all over the world; recent projects include *Curved Two-Way Mirror Triangle, One Side Perforated Steel*, Museum of Contemporary Art, Tokyo (2000); and *Two Different Anamorphic Surfaces*, a collaboration of the Wanås Foundation and the Kulturboro 2000 Foundation, Wanås Park, Knislinge, Sweden (2000).

FURTHER READING

Bader, Joerg, "Les kaleidoscopes de Dan Graham (the architecture of seeing)," *Art Press*, no. 231, Jan. 1998, pp. 20–25

Dercon, Chris, "Dan Graham" (interview), *Forum International*, 9, Sept.–Oct. 1991, pp. 73–80

Francis, Mark, *et al.*, *Dan Graham*, London (Phaidon Press) 2001

Gintz, Claude, "Beyond the Looking Glass," *Art in America*, 82, May 1994, pp. 84–88, 133

Graham, Dan, "My Works for Magazine Pages: A History of Conceptual Art," *Kunst & Museum Journaal*, 4, 1993, pp. 1–7

Graham, Dan, *et al.*, *Two Way Mirror Power*, Cambridge MA (MIT Press) 1999

Graham, Dan, *et al.*, *Dan Graham: Works 1965–2000*, Halle (Richter Verlag) 2001

Huber, Hans Dieter (ed.), trans. John S. Southard, *Dan Graham Interviews*, Ostfildern (Hatje Cantz Verlag) 1997

Kuspit, Donald, "Dan Graham: Prometheus Mediabound," *Artforum*, 23, May 1985, pp. 75–81

Thomson, Mark, "Dan Graham: Interview," *Art Monthly*, 162, Dec.–Jan. 1992, pp. 3–7

LEFT:

Bisected Triangle/Interior Curve (detail), 2002

RIGHT, TOP:

Opposing Mirrors and Video Monitors on Time Delay, 1974
Two mirrors, two video cameras, two video monitors with time delay, plywood, paint

RIGHT, BOTTOM:

Star of David Pavilion for Schloß Buchberg, 1991–96
Two-way mirror, aluminum, Plexiglas

On October 4, 1997, forty years to the day after the Soviet Union launched their orbiting satellite Sputnik I, and with it the space race, Brooklyn-based Conceptualist Gregory Green was "launching" his own salvo in an ongoing artistic battle with the established order. The second in a series of prototypes for a functional shortwave broadcast satellite modeled formally on the original Sputnik, Green's *Gregnik Proto II* was installed on a rooftop in the artist's Williamsburg neighborhood, from which it beamed low-frequency artist-created messages, twenty-four hours a day for an entire month, to local residents.

Throughout the 1990s, Green's practice frequently contested dominant sociopolitical power structures—specifically the relationship between the government and the individual around issues of security, technology, civil liberties, and control of the media. Given the forms his projects have taken, it is perhaps an understatement when the artist says that it's been "politically quite difficult" to work here in the U.S. He did, after all, first come to the attention of the art world in the 1990s with a series of works involving simulated terroristic WMDs—including a meticulously researched, carefully constructed, and fully functional (save for the fissionable material) cache of nuclear weapons in a variety of easily portable forms like books and suitcases, and a suite of operable guided missiles ready to receive chemical, biological, or conventional warheads. A consistent proponent of peaceful political change, Green sees the weapons as a conceptual vehicle to explore issues of domination, threat, and social control in the context of geopolitical conflict. Yet despite the aggressive boundary-testing implicit in this sub-violent sculptural arsenal, it was not the threat of total war but rather the war on drugs that brought Green to the attention of the authorities. A 1995 Chicago exhibition purporting to include some 10,000 doses of home-brewed LSD got the gallery closed down, Green's work confiscated, and his dealer thrown in jail.

Against this backdrop, the *Gregnik* satellite-broadcasting concept may seem comparatively low key. But as Green observed in an interview as he was beginning the project, the most successful strategy for change quite likely lies not in dramatic actions but in more subtle modes of influence, "in establishing control over information … . To insert a subversive message within the existing [media] structure is a much more efficient strategy." There's no doubt that Green's program has been affected by its eerie prescience—his decade-old conceptual interest in political extremism, catastrophic weapons, and the struggle between particular ideological positions for informational power today touches nerves that viewers might not even have known they had back then. Green said at the time that his ultimate goal was actually to launch his own satellite into space. That six years later, this notion seems just as subversive as it did then, if not more so, is a testament to the continuing currency of Green's controversial enterprise.

Gregnik Proto II, 1997
Mixed-media prototype radio
transmitter
Rooftop at Berry and North 11th
Streets, Williamsburg, Brooklyn,
October 4–November 4, 1997

GREGORY GREEN
Gregnik Proto II

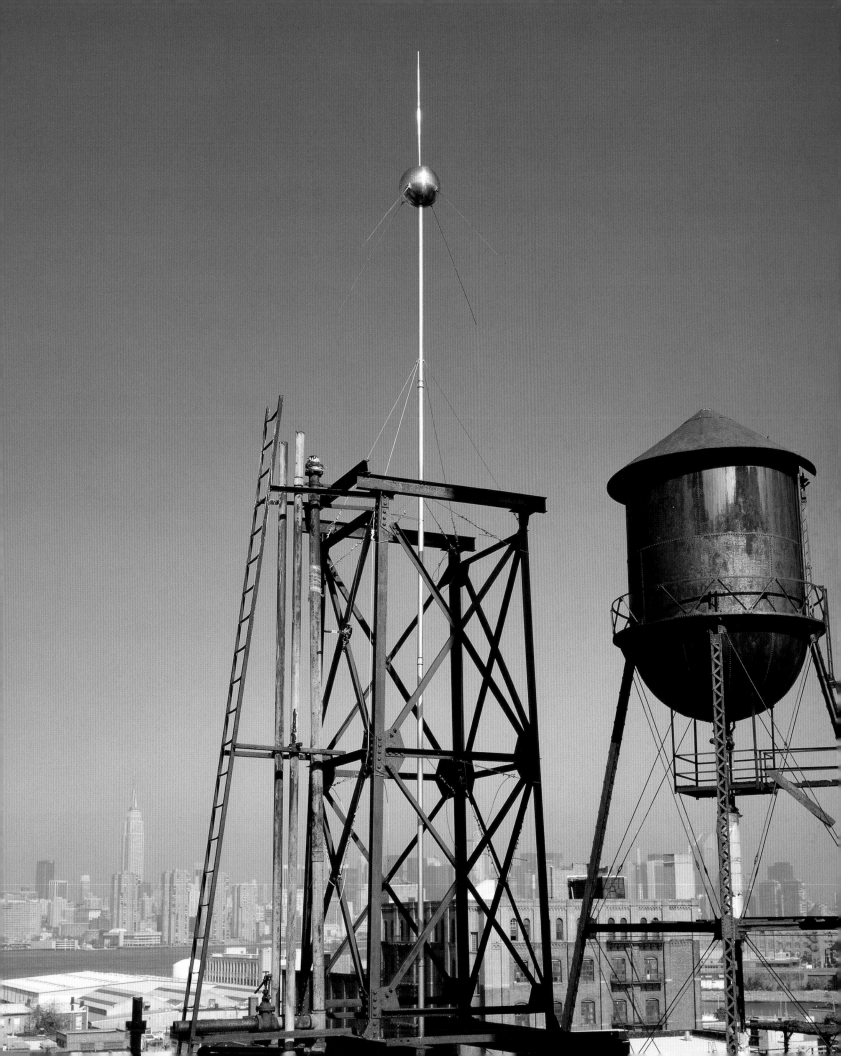

↘ GREGORY GREEN

Born in Niagara Falls, New York, 1959.
Studied at School of the Art Institute of Chicago (MFA, 1984) and Art Academy of Cincinnati (BFA, 1981).

SELECTED EXHIBITION HISTORY

Gregory Green has recently had solo exhibitions and projects at Stadsgalerij, Heerlen, The Netherlands (2003); Cultuur Centrum (Stadshallen), Bruges, Belgium (2001); Feigen Contemporary, New York (2000); and Ars Futura Galerie, Zurich, Switzerland (1997). Recent group exhibitions include *Away From Home*, Wexner Center for the Visual Arts, Columbus, Ohio (2003); *The Culture of Violence*, University Gallery, Fine Arts Center, University of Massachusetts, Amherst (2002); *Danger*, Exit Art, New York (2001); *Art at the Edge of the Law*, Aldrich Contemporary Art Museum, Ridgefield, Connecticut (2001); *Micropolitiques*, Magasin, Centre National d'Art Contemporain de Grenoble, France (2000); *Katastrofen und Desaster*, Folkwang Museum, Essen, Germany (2000); *High Red Center*, Centre for Contemporary Art, Glasgow, Scotland (1999); *Weird Science*, Cranbrook Art Museum, Detroit (1999); *Young Americans 2*, Saatchi Galley, London (1998); and *Art in Chicago, 1945–1995*, Museum of Contemporary Art, Chicago (1997).

FURTHER READING

Art at the Edge of the Law, exhib. cat. by Richard Klein and Jessica Hough, Ridgefield CT, Aldrich Contemporary Art Museum, 2001

Buck, Louisa, "Armed and Almost Dangerous," *The Independent*, Jan. 16, 1996, section 2, p. 8

Giovannotti, Micaela, "Gregory Green," *Tema Celeste*, no. 81, Summer 2000, p. 86

Jacobs, Karrie, "Satellite of Love: Brooklyn's Going-Nowhere Sputnik," *New York Magazine*, Oct. 20, 1997, p. 17

Jones, Jonathan, "Magic Mushrooms," *The Guardian*, Aug. 6, 2002, p. 18

Miller, John, "Gregory Green: Feigen Gallery, New York," *Frieze*, no. 54, Sept.–Oct. 2000, p. 134

O'Reilly, John, "Suspect Devices," *The Guardian*, Dec. 4, 1995, p. 8

Snodgrass, Susan, "Gregory Green at Feigen," *Art in America*, 84, Jan. 1996, p. 109

Weil, Benjamin, "After Terrorism" (interview), *Purple Prose*, 7, Fall 1994, pp. 76–79

Young Americans, exhib. cat. by Jeffrey Deitch, London, Saatchi Gallery, 1996

LEFT:

Gregnik Proto II (detail), 1997

RIGHT, TOP:

Nuclear Device # 1 (10 Kilotons, Plutonium 239, Chicago), 1995
Mixed media

RIGHT, BOTTOM:

RCSASM # 4 (MEGA-MAGNUM), 1995
Mixed media

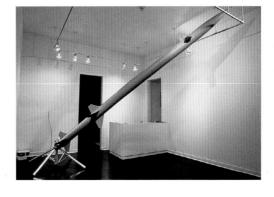

The advertisements first started appearing in New York City newspapers like the *Village Voice* and the Spanish-language *El Diario* in the summer of 1998: "Cops! Waitresses! Bartenders! Cabbies!" read one headline, "People who work at night set the stage for the rest of us to lead normal lives. Tell us your story" Placed by the artist team of Simon Grennan and Christopher Sperandio, this genial pitch represented the initial gesture of *The Invisible City*, their memorable pulp-style foray into the nighttime heart of the metropolis. The work—one in a series of inspired, quasi-anthropological comic-art projects that the two have produced since the late 1990s—took as its protagonists the graveyard-shift workers who keep the city operating while the average diurnal New Yorker dozes. After meeting with the various individuals who responded to their ads, Grennan and Sperandio selected a group for the final project, including a cleaner, a security guard, and a waiter. In full collaboration with their subjects, the artists then developed the various workplace stories they heard into illustrated individual narratives, often with a bittersweet tang.

Grennan, who lives in England, and Sperandio, a New Yorker, have consistently engaged with questions of work and identity during their fifteen-year collaboration, repeatedly contending with conventional notions of what constitutes "public" and "private" lives (the visible and the invisible) within contemporary society. In their early projects, the duo—conceptual descendants of 1960s art/work activists such as Mierle Laderman Ukeles—orchestrated a variety of generative participatory scenarios designed to probe issues of power, aspiration, and community. Their contribution to the much-discussed 1993 "Culture in Action" project in Chicago was *We Got It!*, a limited-edition candy bar they helped a group of chocolate factory workers design and produce on their own. For *Anyone in New York* (1993), meanwhile, the artists arranged for ten employees of New York University to have a "dream meeting" with the one New Yorker they most admired; news-style documentary photographs were taken of the encounters and exhibited along with short narrative accounts of them written by the employees.

The Invisible City—which debuted both as a freely distributed publication and on advertising-style placards in more than a thousand New York City subway cars in the spring of 1999—remained focused on the conditions that create community, using the conceptually loaded Pop form of the comic strip to interweave contextually real-life stories, unadorned and far from what is normally thought of as exceptional, into vivid symbols of the egalitarian impulse that informs their entire practice. In the artists' scheme, straightforward accounts like that of Khalil, the low-key security guard who gently urges sympathy for late-shift workers with mixed-up body clocks in *The Invisible City*'s "Night Watch" installment—"Laying in bed has become a great luxury to me," he wistfully allows—become persuasive arguments for visibility and respect: not necessarily greater than that accorded their fellow citizens, but certainly no less.

The Invisible City (detail), 1999
Publication and subway placard
series, April 15–May 15, 1999

GRENNAN AND SPERANDIO
The Invisible City

I WORK IN A GAY BAR IN *CHELSEA* AS A COCKTAIL WAITER. I START AT 9 PM AND FINISH AROUND 4AM, BUT, I LIVE IN *STATEN ISLAND* SO I DON'T GET HOME UNTIL 6AM.

THE BAR IS A VERY LAID BACK LOUNGE WHERE ALL PEOPLE COME FOR *COCKTAILS* BEFORE VENTURING OUT INTO THE DEPTHS OF CLUBLAND, OR TO HAVE A MARTINI AFTER WORK.

"CHELSEA NIGHTS STATEN ISLAND DAYS"

WE ALSO OFFER A LINE OF DRAG SHOWS SUCH AS CANDIS CANE, MONA FOOT, AND HEDDA LETUCCE. IT'S QUITE A DIFFERENT WORLD THAN WHAT I WAS EXPECTING, BEFORE THIS I WAS IN *CONSTRUCTION*.

IN THIS JOB YOU GET TO PLEASE PEOPLE, THE "DAYPEOPLE" COME OUT TO PLAY AND I HELP PROVIDE A *WONDERFUL* PLAYLAND FOR THEM TO FEEL COMFORTABLE AND BE THEMSELVES.

T THAT GUY WOULD N *THINK* TO COME DRUNK OR TIP HIS DURING HIS NORMAL E. ONLY AT NIGHT*!!*

AND IT'S ALWAYS *CHANGING.* YOU'LL NEVER KNOW WHAT TO EXPECT LIKE THE CRACK KID WHO BROKE THE GLASS WINDOW THAT EVEN AN ELEPHANT COULDN'T CRACK, OR IF THELMA HOUSTON WOULD GET UP AND PERFORM AN IMPROMPTU NUMBER WITH A DRAG QUEEN.

↘ GRENNAN AND SPERANDIO

Simon Grennan was born in London, 1965. He studied at University of Illinois at Chicago (MFA), Reading University, England (BA), and Brighton Polytechnic, England.
Christopher Sperandio was born in Kingwood, West Virginia, 1965. He studied at University of Illinois at Chicago (MFA) and West Virginia University (BFA).

SELECTED EXHIBITION HISTORY

Simon Grennan and Christopher Sperandio have recently had joint exhibitions at Manchester Art Gallery, England (2002); Gallery of Modern Art, Glasgow, Scotland (2001); Yerba Buena Center for the Arts, San Francisco (2000); Seattle Art Museum (1998); and American Fine Arts, New York (1998). Recent group exhibitions include *Comic Release: Negotiating Identity for a New Generation*, Regina Gouger Miller Gallery, Carnegie Mellon University, Pittsburgh (2003); *Tele[visions]*, Kunsthalle Wien, Vienna (2001); 24th Biennale of Graphic Arts, Ljubljana (2001); *Animations*, P.S. 1 Contemporary Art Center, Long Island City, Queens (2001); *Up in the Air*, Liverpool Biennale, England (2000); *Super Freaks: Post Pop and the New Generation, Part 1: Trash*, Greene Naftali Gallery, New York (1998); *Art Transpennine '98*, Tate Gallery Liverpool with the Henry Moore Institute, England (1998); and *Revenge*, Ikon Gallery, Birmingham, England (1998).

FURTHER READING

Decter, Joshua, "Grennan and Sperandio," *Artforum*, 35, Jan. 1997, pp. 86–87

Goodman, Jonathan, "G & S: Moralists in Paradise," *Parachute*, no. 100, Oct. 2000, pp. 112–21

Grennan, Simon, and Christopher J. Sperandio, *The Ghost on the Stair*, Liverpool (Tate Gallery Liverpool and the Henry Moore Institute) 1998

Grennan, Simon, and Christopher J. Sperandio, *The Peasant and the Devil*, Seattle (Seattle Art Museum and Fantagraphics Books) 1998

Grennan, Simon, and Christopher J. Sperandio, *The Invisible City*, New York (Public Art Fund) 1999

Grennan, Simon, and Christopher J. Sperandio, *Modern Masters*, Queens, New York (Museum of Modern Art, DC Comics, and P.S. 1 Contemporary Art Center) 2002

Grennan, Simon, and Christopher J. Sperandio, *What in the World?* Manchester (Arts About Manchester) 2002

Krainak, Paul, "Lay Miserables: Grennan and Sperandio's Art for Them Asses," *Art Papers*, 26, Oct.–Nov. 2002, pp. 29–33

Smith, Roberta, "Grennan and Sperandio," *The New York Times*, April 5, 1996, p. C28

Wadler, Joyce, "Graphic Vision: Art for People, Not Artists," *The New York Times*, May 6, 1999, p. B2

LEFT:

The Invisible City (installation view of subway placards), 1999

RIGHT, TOP:

We Got It!, 1993
Sperandio (left) and Grennan (right) pose with a stack of *We Got It!* boxes in a Chicagoland grocery store

RIGHT, BOTTOM:

Anyone in New York, 1993
Thomas L. Blum (left) meets Police Commissioner Raymond Kelly (right)

A characteristically fluid example of the participatory performance work for which she is best known, Christine Hill's *Tourguide?* carried the artist's productive conceptual ambiguity in its very punctuation. By attaching a question mark to the title of her 1999 Public Art Fund project, Hill hinted at the complex ambivalences always present in the public scenarios she creates—installations and activities that tread the boundaries between calculation and improvisation, between the performer and the audience, between art and life. Providing customers with highly personalized $12 walking tours of Lower Manhattan meant to counter the well-worn visitor bureau-approved paths, Hill's *Tourguide?* gave new meaning to the idea of "interpersonal commerce."

Since the mid-1990s, Hill has developed an artistic identity so diverse and multivalent that it almost defies categorization. Yet through all the various guises she has adopted for her projects—masseuse, waitress, shopkeeper, rock star, talk-show host—the work is always focused on the slippery distinctions between artistic (read: artificial) and non-artistic (read: real) activities. For her 1996 *Volksboutique*, for example, Hill opened and operated a temporary used-clothing store in the East Berlin neighborhood where she had been living during the mid-1990s. Playing the East German system of state-subsidized commercial activity against the tradition of civic-minded activist theater, Hill collected cast-off clothing and then worked in the store each day, where she interacted with customers attracted by her cut-rate prices. (She later reprised the piece for *Documenta X* in Kassel.) And the artist—who once fronted her own rock band and studied improvisation with New York's celebrated Upright Citizens' Brigade troupe—brought the theatrical even further to the foreground in 2000 with *Pilot*, a one-off hour-long talk show, featuring her as host, performed before a live audience on a sprawling stage set she created in a SoHo gallery space. Inspired by what she acknowledges as a persistent "obsession" at the time with late-night TV host Conan O'Brien, *Pilot* also highlighted another central aspect of her adventurous program—by relying on the extemporaneous interaction between herself and her invited guests, Hill laid open the process of her art-making to input beyond her control, a conceptually generous gesture full of potential risk but also promising unusual rewards.

A regular presence on the streets of SoHo throughout the summer of 1999, Hill's *Tourguide?* groups—identifiable by their name tags and smiles—followed the artist through the neighborhood as she told stories about its people and places, visiting shops and building lobbies, pausing at interesting vendor displays along Canal Street, and just generally soaking in the area's ambience. Cheerfully acknowledging the tours' "huge capacity for randomness" to a reporter at the time, Hill encapsulated the conceptual challenge at the core of her disarmingly appealing program: "I'm trying to make artwork, but I'm trying hard so that it doesn't look like art."

OPPOSITE:

Tourguide?, 1999
Performance and storefront
installation at Deitch Projects,
76 Grand Street, Manhattan,
June 18–September 18, 1999

FOLLOWING PAGES:

Tourguide? (performance and
installation details), 1999

CHRISTINE HILL
Tourguide?

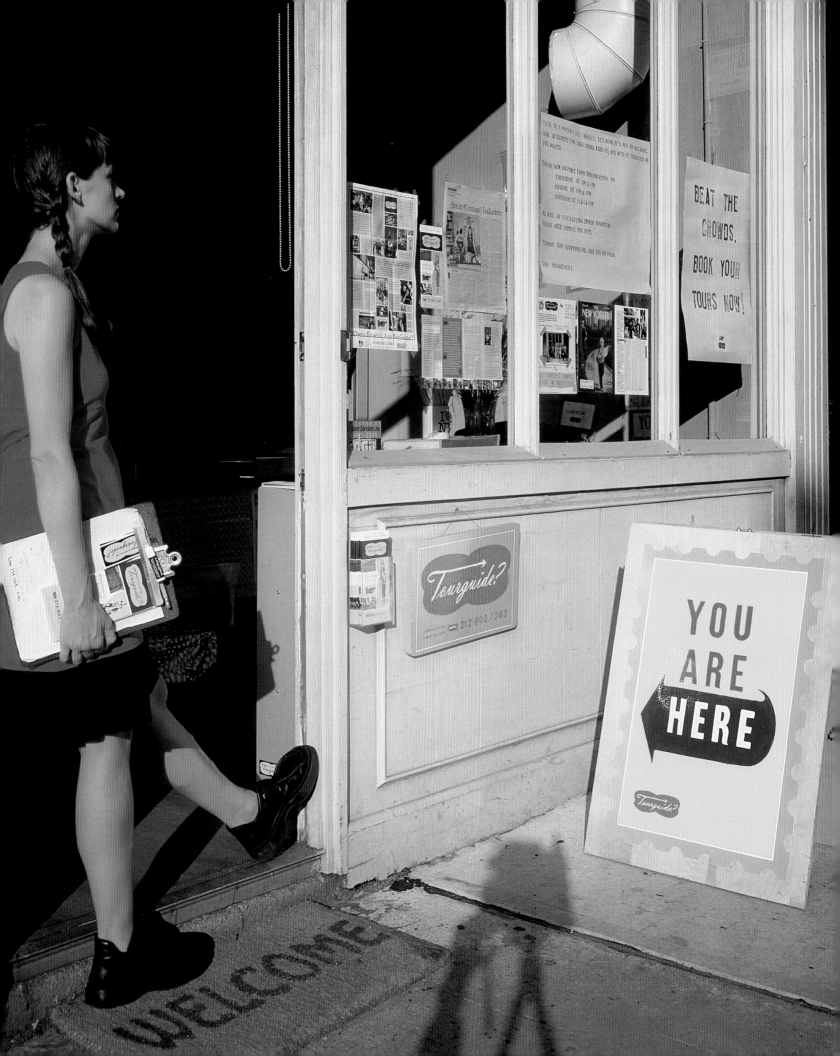

↘ CHRISTINE HILL

Born in Binghamton, New York, 1968.
Studied at Maryland Institute College of Art, Baltimore (BFA, 1991).

SELECTED EXHIBITION HISTORY

Christine Hill has recently had solo exhibitions at Museum of Contemporary Art, Cleveland (2003); Kunsthalle Bern, Switzerland (2002); Migros Museum, Zurich, Switzerland (2001); Galerie EIGEN + ART, Berlin (2000); and Ronald Feldman Fine Arts, New York (2000). Recent group exhibitions include *The Republics of Art: Germany*, Palazzo delle Papesse Centro Arte Contemporanea, Siena, Italy (2001); *Tele[visions]*, Kunsthalle Wien, Vienna (2001); *Children of Berlin*, Folkwang Museum, Essen, Germany (2000); *Snapshot*, Baltimore Museum of Art (2000); *Kunstraum Deutschland*, University of Tel Aviv Art Gallery, Israel (2001); *Talk Show*, Von der Heydt Museum, Wuppertal, Germany, and Haus der Kunst, Munich, Germany (1999); *Wish You Luck*, P.S. 1 Contemporary Art Center, Long Island City, Queens (1998); and *Documenta X*, Kassel, Germany (1997).

FURTHER READING

Ayers, Robert, "Christine Hill, *Tourguide?*," *Contemporary Visual Arts*, 25, Oct. 1999, p. 64

Carr, C., "Art et (Cottage) Industrie," *The Village Voice*, July 6–12, 1999, p. 61

Felty, Heather, "Christine Hill," *Flash Art*, no. 215, Nov.–Dec. 2000, pp. 107–108

Hill, Christine, Lucy R. Lippard, Barbara Steiner, and Doris Berger, *Inventory: The Work of Christine Hill and Volksboutique*, Ostfildern (Hatje Cantz Verlag) 2004

Kaplan, Janet A., "Christine Hill's *Volksboutique*," *Art Journal*, no. 57, Summer 1998, pp. 38–45

Lloyd, Ann Wilson, "Transactions," *Sculpture*, 16, Nov. 1997, pp. 28–33

Schwabsky, Barry, "Businesslike," *Art/Text*, 63, Nov. 1998, pp. 74–81

Steiner, Barbara, "Being a Tourist in Society," *Documents*, 6, Summer 1996, pp. 118–23

Stivers, Valerie, "The Accidental Tourguide," *Time Out New York*, July 1–8, 1999, p. 47

Zeller, Ursula, "Christine Hill" (interview), *Flash Art*, no. 224, May–June 2002, p. 117

LEFT:

Tourguide? (interior installation view), 1999

RIGHT, TOP:

Volksboutique Franchise, 1997 Installation view at *Documenta X*, Kassel, Germany

RIGHT, BOTTOM:

Pilot (detail of set), 2000 Installation at Ronald Feldman Fine Arts, New York

ILYA KABAKOV
Monument to the Lost Glove
ILYA AND EMILIA KABAKOV
The Palace of Projects

Ilya and Emilia Kabakov's *The Palace of Projects* balanced visual drama with abjection, enthusiasm with psychological disorientation. Set within the cavernous main hall of the 69th Regiment Armory on Manhattan's Lexington Avenue in the summer of 2000, the spiraling, 40 foot by 80 foot (12.1 x 24.3 m) multi-chamber structure—a wood frame covered with translucent white fabric and lit from within like an enormous, glowing nautilus shell—contained some sixty-five individual "projects." Attributed to invented Soviet citizens, the various projects offered helpful, if often outlandishly absurd, suggestions on ways for viewers to improve themselves and, by extension, the world around them.

Though the elegant, curving shape and celestial, white radiance of *Palace*'s exterior were designed to suggest the socio-spiritual utopianism of structures like Vladimir Tatlin's *Monument to the Third International*, its contents, like much of Ilya Kabakov's work (this project was created with his wife and frequent collaborator Emilia), suggested a reality that was far more mundane and dystopian. Reminiscent of a surreal display at a Stalinist state fair, the projects—represented by small, crude models set on tables, surrounded by chairs in which viewers were meant to sit while reading the dense explanatory texts that accompanied them—demonstrated a dizzying range of preposterous though well-intentioned proposals, from a suggestion that urbanites arrange potted plants around their beds to re-establish fulfilling contact with nature,

to a treatment for anxiety that involved sitting on a tiny chamber pot in order to reconnect with one's childhood.

Born and raised in Soviet-era Russia, Ilya Kabakov was labeled a "nonconformist" and barred from exhibiting in his native country. It's not surprising, then, that the artist is ambivalent toward those who peddle Pollyanna-ish encomiums about self-betterment and shared futures. Yet while his installations, such as *The Palace of Projects*—or his first Public Art Fund project, *Monument to the Lost Glove* (1997)—often exhibit an intensely mordant world view, they are typically leavened with humor and even occasional glimmers of gently lyrical optimism. For *Monument*, Kabakov made a life-size glove, cast in red resin, that he placed in the middle of a traffic triangle next to the famous Flatiron Building. Accompanied by a series of translated poetic Russian texts dealing with aesthetics, loss, and nostalgia, the abandoned glove was like a tiny pebble dropped into the onrushing flow of the city, something almost unnoticed at first that nevertheless created poignant ripples. For *Palace*, one of the first projects viewers encountered once inside—designed by one N. Solomatkin, a chauffeur from Kishinev—used similar understatement, suggesting that visitors fashion themselves angels' wings of "white tulle," strap them on their backs and sit "without anything to do and in silence" for several minutes each day in order to make themselves "better, kinder, more decent."

ILYA KABAKOV

Monument to the Lost Glove, 1997
Cast resin
Traffic triangle at intersection
of Broadway and Fifth Avenue,
Flatiron District, Manhattan,
March 17, 1997–June 1998

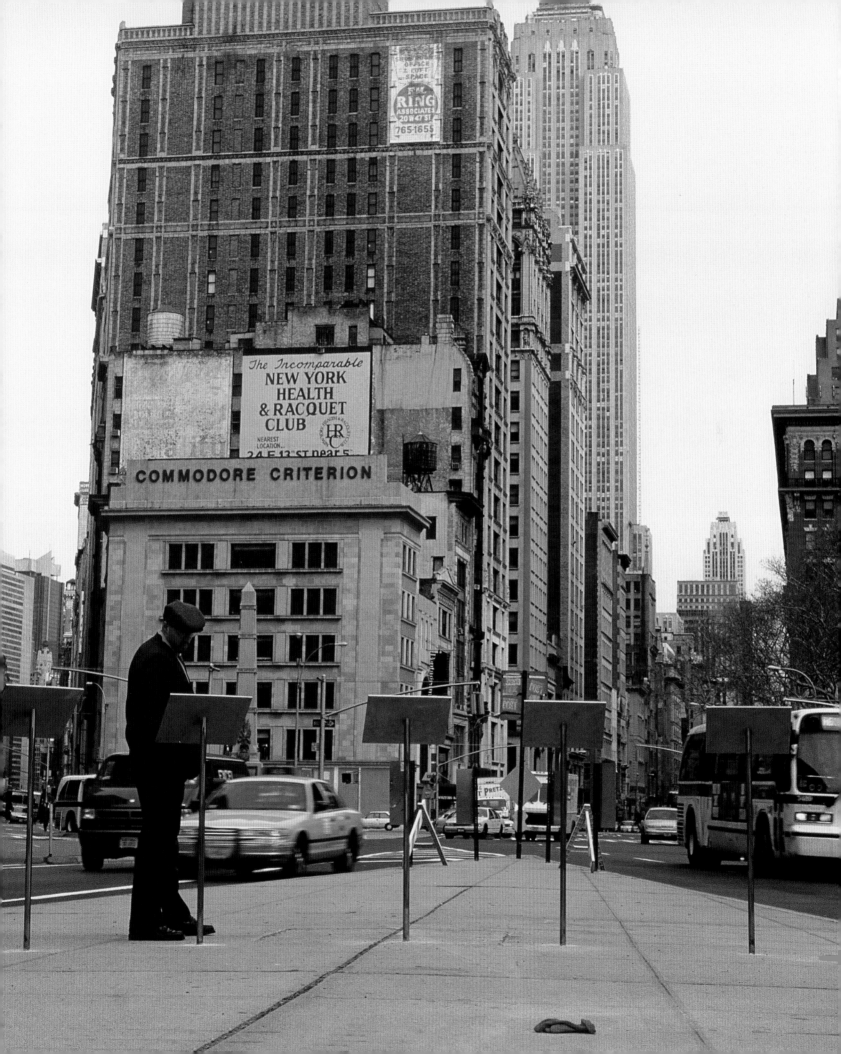

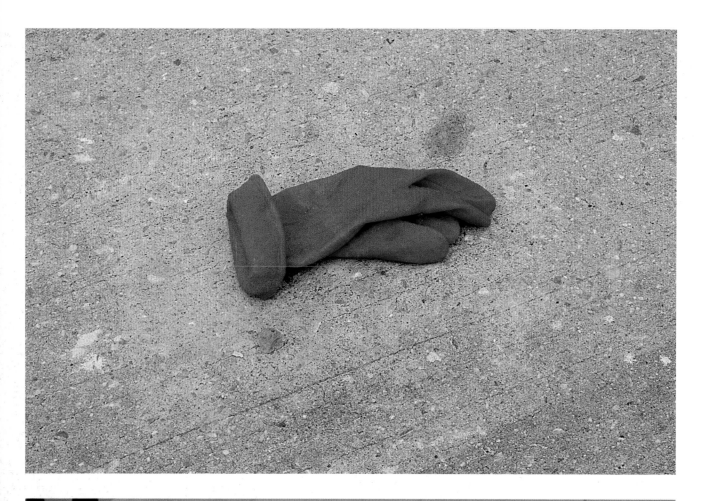

The red spot on gray — it's a strong, vivid stroke, what harmony!

Oh how the entire gray, depressing landscape has resounded from this spot on the asphalt!

All the colors immediately came to life, began to speak, the entire color palette all around can be seen:

The blue letters of the advertisements, the yellow spots of the taxis, the dull green of the trees.

Only one small red spot — but it shimmers so

Against the background of the gray earth, the gray buildings, the light gray sky!

Monet, Pissaro, Renoir — they could really place

Such a stroke so perfectly in the landscape!

The wonderful harmony of colors played on their canvasses

It's a shame that the time of depicting reality, of drawing from real life has passed irrevocably,

No one needs it now — there are only "concepts" all around,

Abstractions, "installations" and other talentlessness and stupidity.

¡La mancha roja sobre gris — es un trazo fuerte, intenso, qué armonía!

¡Cómo ha resonado todo el deprimente paisaje gris con esta mancha en el asfalto!

Todos los colores cobraron vida de inmediato, comenzaron a hablar, se puede ver toda la paleta de colores a nuestro alrededor:

Las letras azules de los anuncios, las manchas amarillas de los taxis, el verde opaco de los árboles.

¡Sólo una pequeña mancha roja — pero cómo resplandece

Contra el fondo de la tierra gris, los edificios grises, el cielo gris claro!

¡Monet, Pissaro, Renoir — ellos verdaderamente sabían poner

un trazo con perfección en el paisaje!

La hermosa armonía de los colores bailaba en sus lienzos

Es una pena que el momento de representar la realidad, de dibujar de acuerdo a la vida real ha pasado irrevocablemente,

Nadie lo necesita ahora — tan sólo hay "conceptos" por todas partes,

Abstracciones, "instalaciones" y otras estupideces sin talento.

Красное пятно на сером — сильный, яркий удар, какая гармония!

Как зазвучал весь серый, унылый пейзаж от этого пятна на асфальте!

Сразу ожили, заговорили все цвета, видна стала вся цветная палитра вокруг:

Синие буквы реклам, жёлтые пятна такси, тусклая зелень деревьев.

Только маленькое, красное пятно — но как оно сверкает

На фоне серой земли, серых домов, светло-серого неба!

Моне, Писсаро, Ренуар — как они могли точно поставить

Такую же точку в пейзаже!

Жемчужная гармония цветов играла на их полотнах

Жалко, что прошло безвозвратно время изображать реальность, писать с натуры,

Никому это не нужно теперь — кругом одни «концепты»,

Абстракции, «инсталляции» и другая бездарность и глупость.

灰色中的紅點——它是強烈、鮮明的一劃，即麼和諧！

呵，這整個灰色、令人感到壓抑的場根竟如此從柏油路的這一點傳播開來！

所有的顏色立刻充滿活力，開始言語，我們四周的大調色板全部展現出來：

廣告的綠色字母、出租車的黃點、樹木的墨綠色

只有小小一點紅——而它

在灰色大地的背景，灰色建築、青灰色天空的襯托下卻如此閃煉著！

莫奈、畢加索、雷諾——他們的確可以將

這樣一劃完美地置於自然景色之中！

色彩在他們的畫板上構成了美妙的和諧

可惜描述現實、寫生繪畫的歲月已經一去不複返，

現在沒有人需要這種歲月——現在到處只有 "概念"

抽象的、"人爲的" 和其它有才氣的及愚蠢的。

LEFT, TOP AND BOTTOM:

ILYA KABAKOV
Monument to the Lost Glove
(details), 1997

OPPOSITE:

ILYA AND EMILIA KABAKOV
The Palace of Projects, 1998
Mixed-media installation
69th Regiment Armory, 26th Street
and Lexington Avenue, Manhattan,
June 15–July 10, 2000

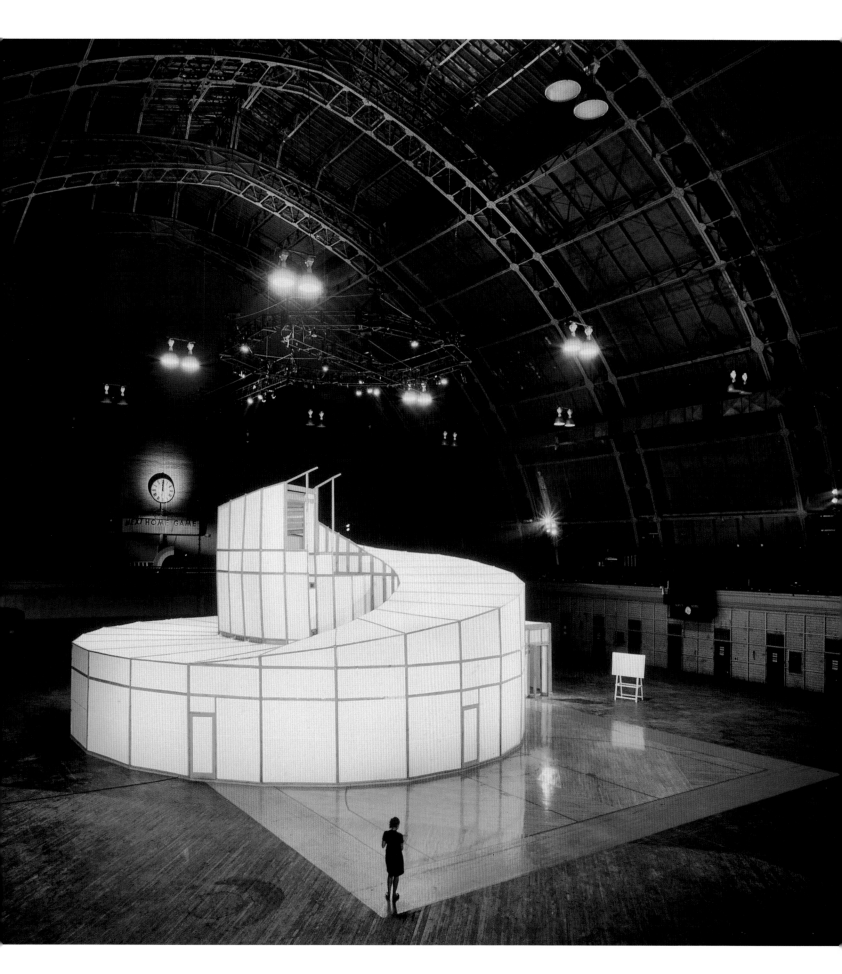

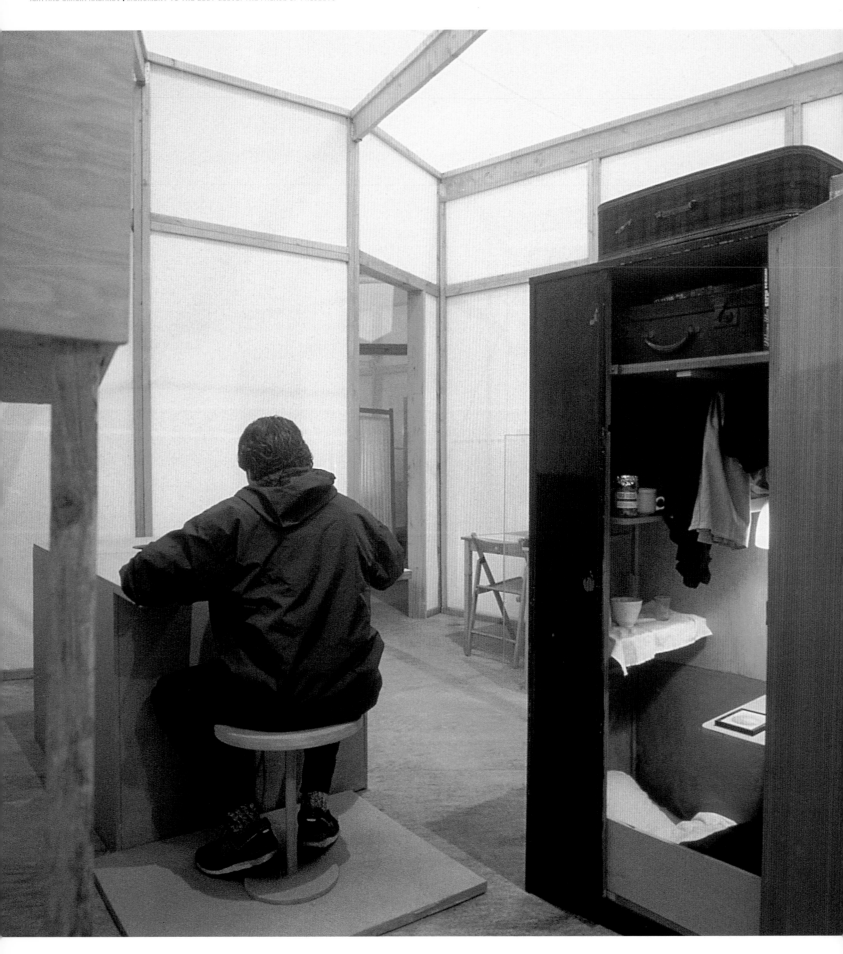

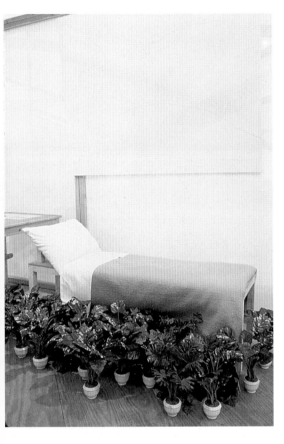

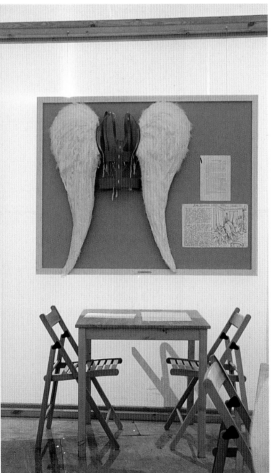

OPPOSITE AND LEFT,
TOP AND BOTTOM:

ILYA AND EMILIA KABAKOV
The Palace of Projects
(interior details), 1998
(presented in 2000)

RIGHT, TOP:

ILYA KABAKOV
How can one change oneself?
(detail), 2000
Hand-painted lithograph

RIGHT, BOTTOM:

ILYA KABAKOV
School # 6, 1993
Installation view at the
Chinati Foundation,
Marfa, Texas

↘ ILYA AND EMILIA KABAKOV

Ilya Kabakov was born in Dnipropetrovs'k, Ukraine, 1933. He studied at V.I. Surikov State Art Institute, Moscow (1957), and Art School, Moscow (1951).
Emilia Kabakov was born in 1945.

SELECTED EXHIBITION HISTORY

Ilya Kabakov has recently had solo exhibitions and projects at Galerie im Traklhaus, Salzburg, Austria (2002, with Emilia Kabakov; traveled to Galerie Thaddaeus Ropac, Paris); Kunstmuseum Bern, Switzerland (2000; traveled to Museum Wiesbaden, Germany, and Kunstsammlungen Chemnitz, Germany); Das Städelmuseum, Frankfurt, Germany (2000); Cantieri Culturali alla Zisa, Palermo, Italy (1999, with Emilia Kabakov); and the Roundhouse, London, organized by Artangel (1998; traveled to Museu Nacional Centro de Arte Reina Sofía, Madrid). Recent group exhibitions and projects include 49th Venice Biennale, Italy (2001, with Emilia Kabakov); *Here, Near, and There: Art in Singen*, Singen am Hohentwiel, Germany (2000, with Emilia Kabakov); *Over the Edges: the Corners of Ghent*, Stedelijk Museum voor Actuele Kunst, Ghent, Belgium (2000); *The Rice Fields*, Echigo-Tsumari Art Triennale, Japan (2000, with Emilia Kabakov); *Global Conceptualism: Points of Origin, 1950–1980*, Queens Museum of Art (1999); *The Edge of Awareness*, Palais des Nations, Geneva, Switzerland (1998; traveled); 1997 Biennial Exhibition, Whitney Museum of American Art, New York (1997); *Future Present Past*, 47th Venice Biennale, Italy (1997, with Emilia Kabakov); and *Skulptur: Projekte in Münster 1997*, Westfälisches Landesmuseum, Münster, Germany (1997).

FURTHER READING

Haden-Guest, Anthony, "Ilya Kabakov" (interview), *Paris Review*, 149, 1998, pp. 104–21

Halle, Howard, "The World Is a Stage: Ilya and Emilia Kabakov Build a Fun House of Pain," *Time Out New York*, July 16–23, 2000, p. 61

Kabakov, Ilya, *The Palace of Projects, 1995–1998*, London (Artangel) 1999

Kabakov, Ilya, *et al., Parkett*, no. 34, 1992, pp. 28–71 (including "'With Russia on Your Back': A Conversation Between Ilya Kabakov and Boris Groys," pp. 35–39; Robert Storr, "The Architect of Emptiness," pp. 42–45; Jan Thorn-Prikker, "On Lies and Other Truths," pp. 52–55; Claudia Jolles, "Kabakov's Twinkle," pp. 66–70)

Kabakov, Ilya, *et al., Ilya Kabakov*, London (Phaidon Press) 1998

Kabakov, Ilya, *et al., Ilya Kabakov: Installations: Catalogue Raisonné 1983–2000*, Halle (Richter Verlag) 2001

Kimmelman, Michael, "Ilya and Emilia Kabakov: The Palace of Projects," *The New York Times*, June 23, 2000, p. E33

Searle, Adrian, "Ministry of Silly Ideas," *Guardian*, March 24, 1998, p. 10

Torres, Ana Maria, "Ilya and Emilia Kabakov: The Palace of Projects, a Palace of Dreams" (interview), *NY Arts*, 5, July–Aug. 2000, pp. 7–10

Wallach, Amei, "Ilya Kabakov Flies into His Picture," *Art in America*, 88, Nov. 2000, cover, pp. 145–53

KIM SOOJA
Deductive Object

The cast-off bedcovers that Kim Sooja brings back from her native Korea to use in her installations and performative works—hand-woven, brightly colored textiles embroidered with symbolic patterns—carry an emotional potency not unlike discarded family snapshots found at a flea market. Traditionally given to newlywed couples, the bedcovers symbolize intertwined lives, the unification of yin and yang, long life, happiness, and protection. And they represent domesticity outside the home as well: they are often wrapped around clothing or household objects to form *bottari*, flexible bundles that serve as ad hoc suitcases or laundry baskets. For Kim, the bedcovers are powerful objects, profound yet familiar, that witness life's most intimate moments of love, pain, birth, death, sex, sleep, and dreams—they are, in Kim's words, "frames of our bodies and lives." She has worked with them for more than a decade, laying them out in colorful grids on museum floors, hanging them on clotheslines, or piling *bottari* into a gallery corner. Balancing formal beauty with functionality, Kim's installations retain the poignant association between the bedcovers and the anonymous personal histories of those who once used them.

For her installation *Deductive Object* (2002) at the Leaping Frog Café in Central Park, Kim covered the outdoor tables with bedcovers, resulting in a vibrant display that dramatically altered the café's otherwise understated atmosphere. Placing such inherently private objects into a very public realm wasn't merely a decorative touch. For Kim, the simple act of wrapping the textiles over the table—in a space where people come to eat, relax, meet, and chat—is also a symbolic way of enveloping those myriad interactions. The bedcover becomes a platform for conversations and exchanges, which in turn become part of the rich fabric of the object's history. Furthermore, it is considered taboo in Korea to eat on the bedcovers, so installing them in a café is a quietly provocative gesture as well.

Kim first envisioned the emotional and artistic potential of bedcovers when she sat sewing one with her mother one day in 1983. Since that time, the idea of stitching has been a consistent current in her wide-ranging conceptual practice. In a recent video installation, *A Needle Woman* (1999–2001)—which shows Kim standing motionless in busy streets around the globe, always with her back to the camera—she imagines her own body as a needle, linking distinct places and peoples with her own unchanging presence. With *Deductive Object* in Central Park, Kim proposed a different but equally intangible type of stitching: using the bedcovers as a medium, she sought to create an invisible, tacit connection between the artist and the viewer, and among the viewers themselves.

Deductive Object, 2002
Traditional Korean bedcovers
Leaping Frog Café, Central Park,
Manhattan, March 7–May 26, 2002

↘ KIM SOOJA

Born in Taegu, South Korea, 1957.

SELECTED EXHIBITION HISTORY

Kim Sooja has recently had solo exhibitions at Le Musée d'Art Contemporain Lyon, France (2003); Peter Blum Gallery, New York (2002); Kunsthalle Wien, Vienna (2002); P.S. 1 Contemporary Art Center, Long Island City, Queens (2001); and Rodin Gallery, Seoul (2000). Recent group exhibitions include *The Ideal City: Solare*, 2nd Valencia Biennale, Spain (2003); 2002 Biennial Exhibition, Whitney Museum of American Art, New York (2002); *Tempo*, MoMA QNS, Long Island City, Queens (2002); *Memory of Water*, Spoleto Festival USA, Charleston, South Carolina (2002); *ARS 01*, Kiasma, Helsinki (2001); *Sharing Exoticisms*, 5th Lyon Biennale, France (2000); *d'APERTutto*, 48th Venice Biennale, Italy (1999); *ArtWorlds in Dialogue*, Global Art Rhineland 2000, Museum Ludwig, Cologne, Germany (1999); 24th São Paulo Bienal, Brazil (1998); and *Cities on the Move*, Secession, Vienna (1997; traveled).

FURTHER READING

Ardenne, Paul, "Kim Sooja: Coudre des corps dans le tissu du monde," *Art Press*, no. 286, Jan. 2003, pp. 27–31

Echolot, exhib. cat. (Kim Ai-Ryung, "Kim Sooja: A Solitary Performance with Old Fabric"), Kassel, Kunsthalle Fridericianum, 1998, pp. 25–28

Kim Sooja: A Laundry Woman, exhib. cat. by Gerald Matt *et al.*, Vienna, Kunsthalle Wien, 2002

Kim Sooja's A Needle Woman, exhib. cat. by Keiji Nakamura, Tokyo, InterCommunication Center Tokyo, 2000

Kim Sooja: A Needle Woman, A Woman Who Weaves the World, exhib. cat. by Hyunsun Tae, Seoul, Samsung Museum, 2000

Morgan, Robert, "The Persistence of the Void," *Sculpture*, 21, Jan.–Feb. 2002, pp. 30–35

Obrist, Hans-Ulrich, "Kim Sooja: Wrapping Bodies and Souls," *Flash Art*, no. 192, Jan.–Feb. 1997, pp. 70–72

Obvious but Problematic, Kim Sooja: A Needle Woman, exhib. cat. by Bernhard Fibicher, Kunsthalle Bern, 2001

One Woman's Serenity in the Thick of Things, exhib. cat. by Ken Johnson, Long Island City, Queens, P.S. 1 Contemporary Art Center, 2001

Schwabsky, Barry, "Fold and Lose," *Art/Text*, no. 65, May–July 1999, pp. 36–39

LEFT:

Deductive Object, 2002

RIGHT, TOP:

A Mirror Woman, 2002
Traditional Korean bedcovers, mirror, steel cables, clothespins, electric fans, soundtrack

RIGHT, BOTTOM:

A Needle Woman (Cairo), 1999–2001
Video still

One of the few recent works of contemporary art that could legitimately be called iconic, Jeff Koons's extraordinary *Puppy* took up residence at Rockefeller Center in the summer of 2000. The work—an ambitious and startlingly appealing 43 foot tall (13 m) West Highland terrier, made out of some 70,000 live flowering plants—had by then already become a kind of globe-trotting symbol of the artist's eminently seductive brand of polished Pop production. First created for the German city of Arolsen in 1992, *Puppy* logged time in both Sydney and Bilbao before settling into its almost four-month residency in midtown Manhattan. Its typically meticulous (and extravagant) production values, along with an unexpectedly ingenuous mode of address, immediately connected with local viewers—confirming New Yorkers' preference for big gestures, as well as perhaps going some way to belie their reputation as jaded urban sophisticates beyond the reach of cuddliness.

Like Koons himself, an artist who honed his larger-than-life persona during New York's 1980s art boom, *Puppy* had a style that somehow seemed perfectly suited to the outsized civic ambience of its adopted city. A stainless steel armature overlaid with 25 tons (25.4 tonnes) of soil continuously watered by an internal irrigation system, the sculpture was an engineering feat that echoed the architectural context of the metropolitan core. Yet for all its size and mechanical complexity, the Westie's charmingly evocative silhouette—a multi-colored riot of marigolds, begonias, impatiens, petunias, and lobelias that, like a dog's coat, grew shaggier as the summer months passed—managed to convey all the sincerity, simplicity, and pure crowd-pleasing exuberance that Koons had so often cited as central goals of his practice.

A skilled appropriationist who first came to attention for his beautiful, if standoffish, vitrine pieces of the 1980s, in which he displayed low objects such as vacuum cleaners and basketballs like works of high art, Koons, with his strategically ambiguous stance toward consumer culture, long ago marked himself as a descendant of both Marcel Duchamp and Andy Warhol. A flamboyant figure with a wicked sense of conceptual humor, the artist spent much of his career unapologetically engaged with the business of art world celebrity, most notably in the memorably controversial series of explicit images he produced of himself having sex with his then-wife, the Italian porn star Cicciolina. Yet to associate Koons only with such broad gestures would be to overlook the often delicate pleasures to be found in more low-key works such as *Rabbit* (1986), one of his classic series of stainless steel sculptures that crossed novelty-store kitsch with a degree of technical perfection worthy of Brancusi. Like an enlarged organic companion for its high-gloss lapin predecessor, *Puppy* reimagined a familiar object in an implausibly beautiful new guise—altering it not to diminish it but rather to highlight what the artist once called, with a surprisingly convincing lack of irony, its symbolic message of "love, warmth, and happiness."

Assistant working on
Jeff Koons's *Puppy* at
Rockefeller Center in 2000

JEFF KOONS
Puppy

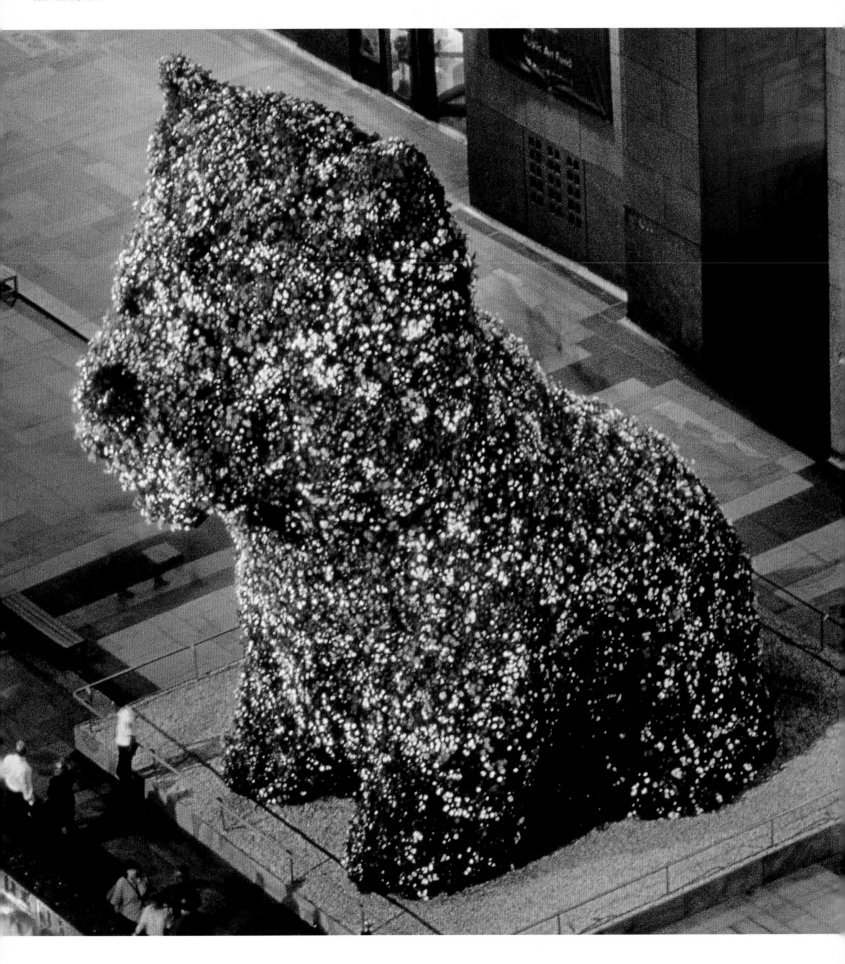

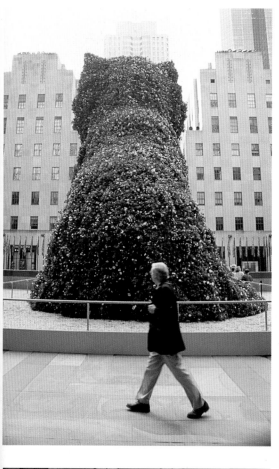

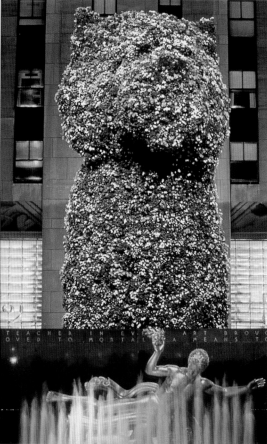

JEFF KOONS

Born in York, Pennsylvania, 1955.
Studied at Maryland Institute College of Art, Baltimore (BFA, 1976), and School of the Art Institute of Chicago (1976).

SELECTED EXHIBITION HISTORY

Jeff Koons has recently had solo exhibitions at Sonnabend Gallery, New York (2002); Kunsthalle Bielefeld, Germany (2002); Deutsche Guggenheim, Berlin (2000; traveled to Fruitmarket Gallery, Edinburgh, and Solomon R. Guggenheim Museum, New York); Kunsthaus Bregenz, Austria (2001); and Anthony d'Offay Gallery, London (1998). Recent group exhibitions include *From Pop to Now: Selections from the Sonnabend Collection*, Tang Teaching Museum and Art Gallery at Skidmore College, Saratoga Springs, New York (2002; traveled to Wexner Center for the Arts, Ohio State University, Columbus); *Give and Take*, Serpentine Gallery and Victoria and Albert Museum, London (2001); *Open Ends*, MoMA, New York (2000); *Apocalypse: Beauty and Horror in Contemporary Art*, Royal Academy of Arts, London (2000); *Almost Warm and Fuzzy: Childhood and Contemporary Art*, organized by Independent Curators International, Des Moines Art Center (2000; traveled); *Around 1984: A Look at Art in the Eighties*, P.S. 1 Contemporary Art Center, Long Island City, Queens (2000); *The American Century: Art & Culture 1900–2000, Part II 1950–2000*, Whitney Museum of American Art, New York (1999); *A Portrait of Our Times: An Introduction to the Logan Collection*, San Francisco Museum of Modern Art (1998); *Future Present Past*, 47th Venice Biennale, Italy (1997); and *Objects of Desire: The Modern Still Life*, MoMA, New York (1997).

OPPOSITE AND LEFT,
TOP AND BOTTOM:

Puppy, 1992
Stainless steel, soil,
flowering plants
Rockefeller Center,
June 6–September 5, 2000

RIGHT, TOP:

Rabbit, 1986
Stainless steel

RIGHT, BOTTOM:

New Hoover Deluxe Shampoo Polishers, 1980–86
Three shampoo polishers,
Plexiglas, fluorescent lights

FURTHER READING

Dewan, Shaila K., "No Walking, Just Watering for This Puppy," *The New York Times*, June 6, 2000, Metro section, p. 5

Jeff Koons, exhib. cat. by Eckhard Schneider *et al.*, Kunsthaus Bregenz, 2002

Jeff Koons: Easyfun – Ethereal, exhib. cat. by Robert Rosenblum, Berlin, Deutsche Guggenheim, 2000

Jeff Koons: Pictures 1980–2002, exhib. cat. by Jeff Koons and Thomas Keillen, Kunsthalle Bielefeld, 2003

Koons, Jeff, *et al.*, *Parkett*, 19, 1989, pp. 28–69 (including Klaus Kertess, pp. 1, 2, 28–43; Burke & Hare, "From Full Fathom Five," pp. 44–52; Jean-Christophe Ammann, "Jeff Koons: A Case Study," pp. 53–61; Glenn O'Brien, "Koons Ad Nauseum," pp. 62–65; and Jeff Koons, "Edition for Parkett," pp. 68–69)

Saltz, Jerry, "Jeffersonian Koons," *The Village Voice*, June 27–July 4, 2000, p. 12

Schjeldahl, Peter, "The Blooming Beast," *The New Yorker*, July 3, 2000, p. 59

Siegel, Katy, "Jeff Koons Talks to Katy Siegel," *Artforum*, 41, March 2003, pp. 252–53, 283

Smith, Roberta, "A New Dog in Town, Steel and Sprouting," *The New York Times*, June 8, 2000, Arts section, pp. 1, 3

Solomon, Deborah, "Puppy Love: Questions for Jeff Koons" (interview), *The New York Times Magazine*, June 25, 2000, p. 15

Barbara Kruger's iconic, red-on-black graphic aphorisms have appeared in New York's cityscape several times over the past few decades, as billboards, bus shelter posters, and building banners, and in other public modes of address. More often than not, these have been Public Art Fund projects— in fact, there's no other artist with whom the institution has worked more frequently. In 1983, Barbara Kruger made an untitled text-based work for the Times Square Spectacolor Board, one of the earliest pieces in the Public Art Fund's "Messages to the Public" series and also the first time that Kruger's savvy, topical works were broadcast to a mass audience. "I'm not trying to sell you anything," read one message. "I just want you to think about what you see when you watch the news on TV," read another. At the time, the Spectacolor Board was New York's preeminent forum for advertisers, a place where Kruger's faculty for appropriating media strategies to critique them found resonant form.

In the sixteen years between Kruger's first Public Art Fund piece and her 1997 project, *Bus*, urban marketing strategies became infinitely more ubiquitous and sophisticated, fanning out to annex countless available outdoor surfaces. At the time of *Bus*, the bus wrap was a relatively new marketing strategy, which Kruger appropriated in vertiginous, characteristically relentless form. Using her signature color scheme, Kruger wrapped a local commuter bus from bumper to bumper in quotes, song lyrics, and literary excerpts, in a cacophony of font sizes and typefaces that graphically conveyed a diversity of twentieth-century voices. Kruger included assorted quotes from Billie Holiday, Karl Kraus, Virginia Woolf, H.L. Mencken, Jean-Paul Sartre, and others, including Malcolm X's advice to "give your brain as much attention as you give your hair," and Courtney Love's grunge-diva plea, "I want to be the girl with the most cake." Kruger's own chestnut, "I shop therefore I am," was even emblazoned across *Bus*'s back door. Taken together, the texts were in turn witty, suggestive, dry, and demanding.

On its daily journeys along Manhattan's Fifth Avenue and then out to eastern Queens, the bus was a moving, utterly eye-catching insertion into the urban scene, countering the city's exhaustive your-ad-here landscape with its flurry of concise texts. "Considering the difficulties and density of New York City traffic, these words met with a relatively captive audience and offered reading material that differed from the usual menu of hard-sell exhortations that meet our eyes during the course of a day in the city," she commented recently. Within her body of sociopolitical artwork—which, in some regards, is as familiar to the general public as it is within the art world—Kruger's *Bus* stands out, using statements to ask a question, prompting people to take a break from consumerism, at least for a moment.

Bus, 1997
Printed vinyl on bus
Commuter bus between
Queens and Manhattan,
November 1–30, 1997

BARBARA KRUGER
Bus

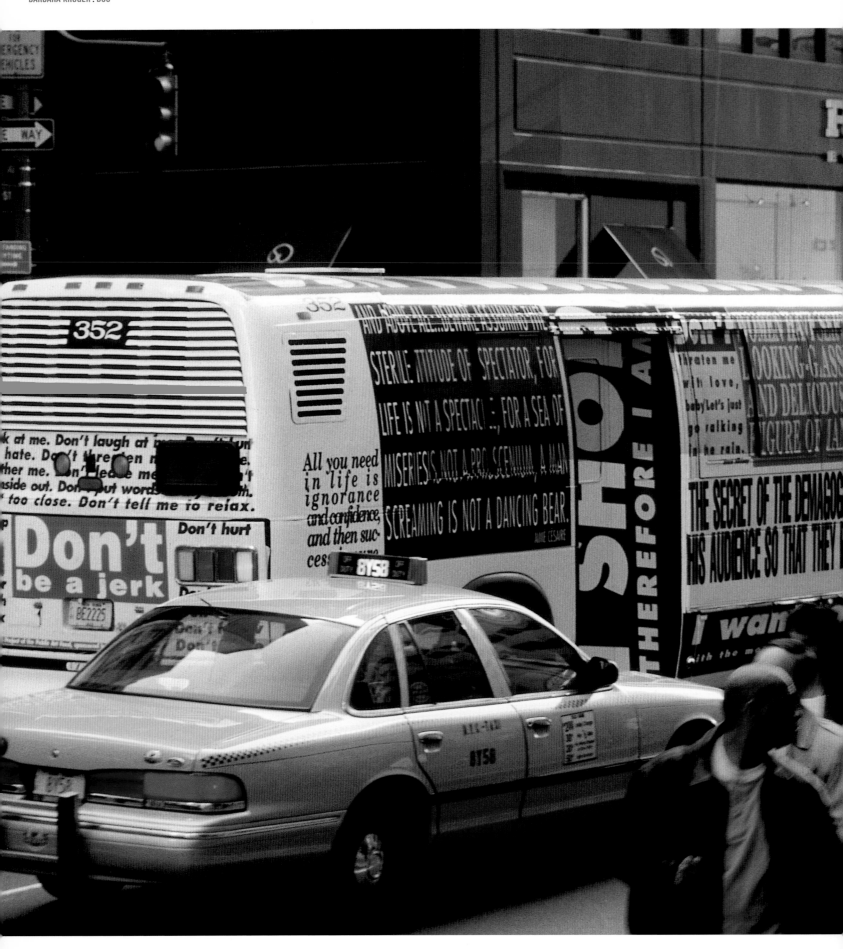

↘ BARBARA KRUGER

Born in Newark, New Jersey, 1945.
Studied at Parsons School of Design, New York (1966), and Syracuse University, New York (1965).

SELECTED EXHIBITION HISTORY

Barbara Kruger has recently had solo exhibitions at Palazzo della Papesse Centro Arte Contemporanea, Siena, Italy (2002); Whitney Museum of American Art, New York (2000); Museum of Contemporary Art, Los Angeles (1999); Deitch Projects, New York (1997); and Mary Boone Gallery, New York (1997). Recent group exhibitions include *Shopping*, Schirn Kunsthalle, Frankfurt, Germany (2002); *Sans Commune Mesure*, Musée des Beaux-Arts, Lille, France (2002); *Around 1984: A Look at Art in the Eighties*, P.S. 1 Contemporary Art Center, Long Island City, Queens (2000); *The American Century: Art and Culture 1900–2000, Part II 1950–2000*, Whitney Museum of American Art, New York (1999); and *Read My Lips: Jenny Holzer, Barbara Kruger, Cindy Sherman*, National Gallery of Australia, Canberra (1998).

FURTHER READING

Brown, David E., "Advertisements for Myself," *Metropolis*, 19, Feb.–March 1998, p. 49

Danto, Arthur C., "A Woman of Art & Letters," *The Nation*, Oct. 2, 2000, pp. 36–42

Deitcher, David, "Barbara Kruger: Resisting Arrest," *Artforum*, 29, Feb. 1991, pp. 84–91

Goodeve, Thyrza Nichols, "The Art of Public Address," *Art in America*, 85, Nov. 1997, pp. 92–99

Kimmelman, Michael, "Familiar Icons With a Bold Face," *The New York Times*, July 14, 2000, p. E25

Kruger, Barbara, and Kate Linker, *Love for Sale: The Words and Pictures of Barbara Kruger*, New York (Harry N. Abrams) 1996

Nakamura, Marie-Pierre, "Barbara Kruger," *Art Actuel*, no. 10, Sept.–Oct. 2000, pp. 68–71

Squiers, Carol, "Barbara Kruger," *Aperture*, no. 138, Feb. 1995, pp. 58–67

Thinking of You, exhib. cat. by Barbara Kruger et al., Los Angeles, Museum of Contemporary Art (MIT Press, Cambridge MA), 1999

Vogel, Carol, "Three Aphorism Shows Are Better Than One," *The New York Times*, Oct. 30, 1997, pp. E1, E7

LEFT:

Bus, 1997

RIGHT, TOP:

Untitled ("Messages to the Public" series), 1983
L.E.D. (light-emitting diode) sign in Times Square, Manhattan

RIGHT, BOTTOM:

We Don't Need Another Hero, 1988
Billboard series presented throughout New York City

Unlike the rural environments with which his work is usually associated, British artist Richard Long's two sculptural "New York Projects" of 2000—*White Quartz Ellipse* at Doris C. Freedman Plaza in Central Park and *Brownstone Circle*, installed at Seagram Plaza on nearby Park Avenue—were distinctly urban in both situation and inspiration. Taking their material cues from the stone used to create such New York icons as the Brooklyn Bridge and Grand Central Terminal in the case of the quartz (excavated from the very same Connecticut quarry), and the ubiquitous russet exteriors of the city's rowhouses for the brownstone, Long's two sculptural pieces isolated and gave new lyrical meaning to constituent elements of the built metropolitan fabric.

One of the pioneers of land-based artwork in Britain, Long first came to prominence in the mid-1960s for his resonant interventions, using indigenous materials in isolated countryside locations. In contrast to the often aggressively mechanized interruptions of natural environments characteristically carried out by their American counterparts, the British artists who worked in the landscape typically employed more organic, less physically emphatic modes of activity. Long's poetic practice—ranging from modest, sculptural-based methodologies involving found stone or wood to structured walking tours and ritualistic actions conducted by the artist in private, and then later recounted through photographic documentation, maps, and/or haiku-like descriptive texts—takes the earth as a stage for activities designed to elicit moments of heightened spatial and temporal perception. The images and maps serve as documents of Long's usually clandestine gestures, while the words add context. His related series of prose pieces for New York City subways, commissioned in conjunction with his pair of sculptures for the "New York Projects,"

include examples of two characteristic approaches—from the straightforwardly descriptive recitation of facts in *A Trail of Water Circles*, 2000 (in which he recounts the experience of "FOURTEEN NIGHTS CAMPING ALONG A WILDERNESS WALK/ INYO NATIONAL FOREST CALIFORNIA 2000/ EACH MORNING AFTER BREAKING CAMP A CIRCLE OF WATER POURED/AROUND MY SLEEPING PLACE BEFORE WALKING ON") to his economically poetic *A Walk Across Ireland* (1998), a journey that takes him "FROM WAVES POUNDING BOULDERS IN POURING RAIN TO THE SMELL OF A TURF FIRE/ TO WALKING THROUGH SPRAY BLOWING OFF KYLEMORE LOUGH TO LOW TIDE LINE/ TO THE HIGHEST POINT OF THE WALK TO A CAMP UNDER FAST CLOUDS AND A FULL MOON/TO THE FIRST SUN AT 76 MILES TO THE FLASH OF AN ELLIPTICAL CLOUD OF/ STARLINGS... ." Together, Long's images and words build a lyrical picture of a place, and of the artist's temporary presence within it.

In parallel with the gallery-based artifacts of his outdoor works, Long has also produced numerous projects where the gesture itself, rather than its documentation, is located indoors. Usually floor-based arrangements utilizing specific types of quarried stone, these pieces produce yet another layer of transactions between different locales and activities. In many respects, then, Long's "New York Projects" represent a compellingly multivalent hybrid mode for the artist. In their form and materials, *White Quartz Ellipse* (30 feet/9.1 m long) and *Brownstone Circle* (23 feet/7 m diameter) suggest his gallery works, yet they are sited outside; though they are in the landscape, it is an environment very unlike that in which one expects to find the artist's work. Because of this, they are available in a way that Long's actual physical gestures rarely are—and are among the most specifically "public" examples of his practice.

Brownstone Circle, 2000
Presented as part of
"New York Projects"
Brownstone
Seagram Plaza, Manhattan,
April 21–June 2000

RICHARD LONG
New York Projects

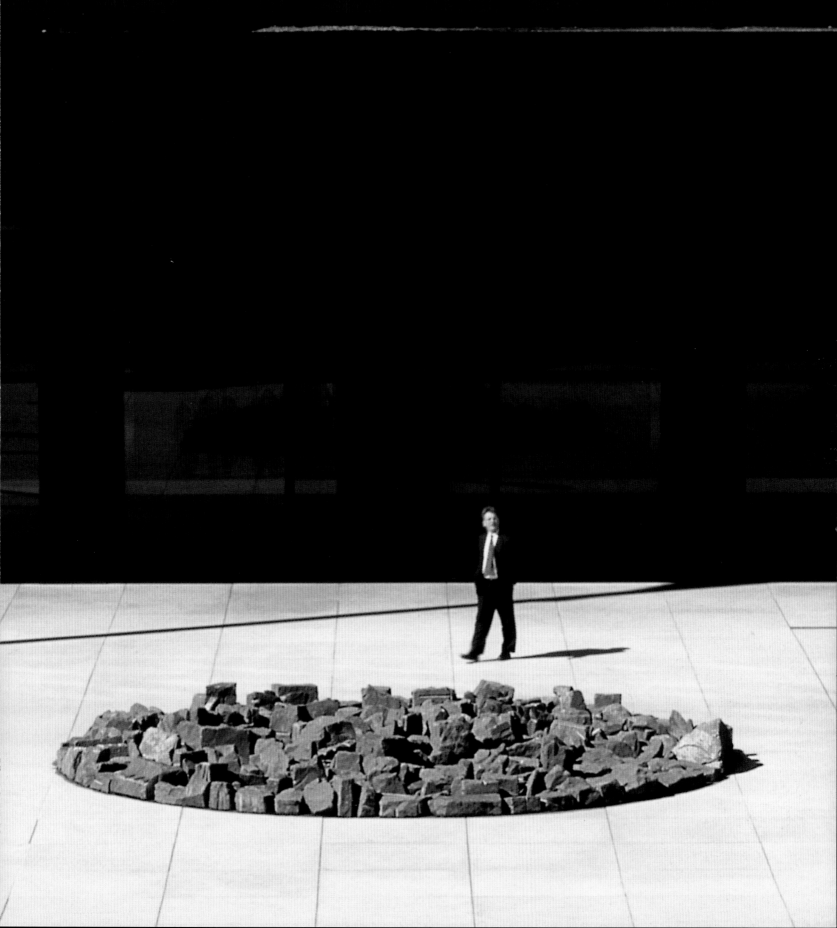

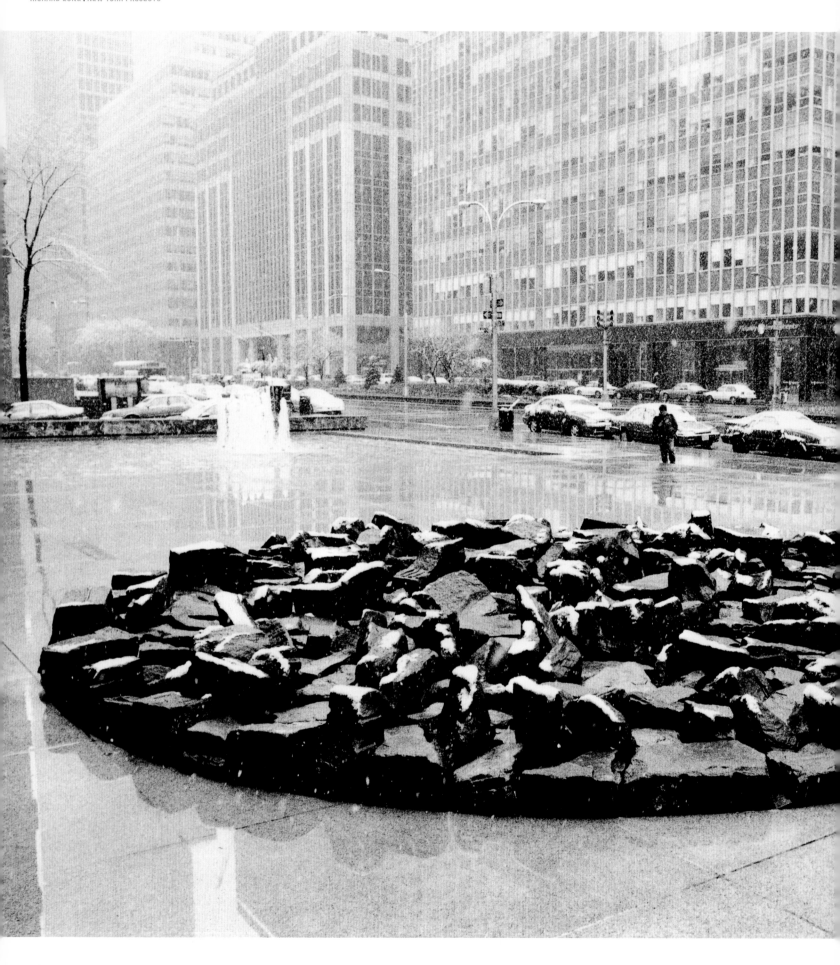

↘ RICHARD LONG

Born in Bristol, England, 1945.
Studied at St. Martin's School of Art, London (1968) and West of England College of Art, Bristol, England (1965).

SELECTED EXHIBITION HISTORY

Richard Long has recently had solo shows at James Cohan Gallery, New York (2002); Anthony d'Offay Gallery, London (2000); Yorkshire Sculpture Park, Wakefield, England (1998); and Spazio Zero, Cantieri Culturali Alla Zisa, Palermo, Italy (1997). Recent group exhibitions include *Conceptual Art*, Stedelijk Museum, Amsterdam (2002); *Measure of Reality*, Kettle's Yard Gallery, Cambridge, England (2002); *At Sea*, Tate Liverpool, England (2001); *Live in Your Head*, Whitechapel Art Gallery, London (2000); *De Re Metallica*, Anthony d'Offay Gallery, London (1997); and *Treasure Island*, Centro de Arte Moderna, Lisbon (1997).

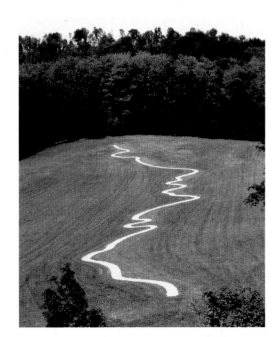

FURTHER READING

Every Grain of Sand: Richard Long, exhib. cat. by Richard Long, Kunstverein Hannover, 1999

Henry, Clare, "Richard Long," *ARTnews*, 99, Summer 2000, p. 211

Long, Richard, *Richard Long: A Walk across England*, London (Thames & Hudson) 1997

Long, Richard, *Richard Long: Mountains and Waters*, New York (George Braziller) 2001

Moorhouse, Paul, *et al.*, *Richard Long: Walking the Line*, London (Thames & Hudson) 2002

Richard Long: Here and Now and Then, exhib. cat. by Christiane Schneider, London, Haunch of Venison Yard, 2003

Richard Long: A Moving World, exhib. cat. by Paul Moorhouse, Tate St. Ives, 2003

Smith, Roberta, "Richard Long," *The New York Times*, April 28, 2000, p. E38

Tromp, Ian, "From Walk to Text: On Richard Long," *Sculpture*, 19, March 2000, pp. 26–35

LEFT:

Brownstone Circle, 2000
Photograph by Richard Long

RIGHT, TOP:

River Po Line, Northern Italy, 2001
White marble

RIGHT, BOTTOM:

White Quartz Ellipse, 2000
Quartz stone
Doris C. Freedman Plaza,
Central Park, Manhattan,
April 21–June 2000

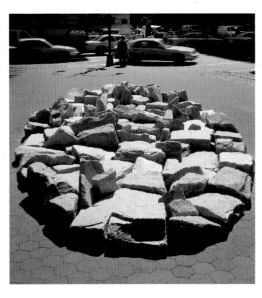

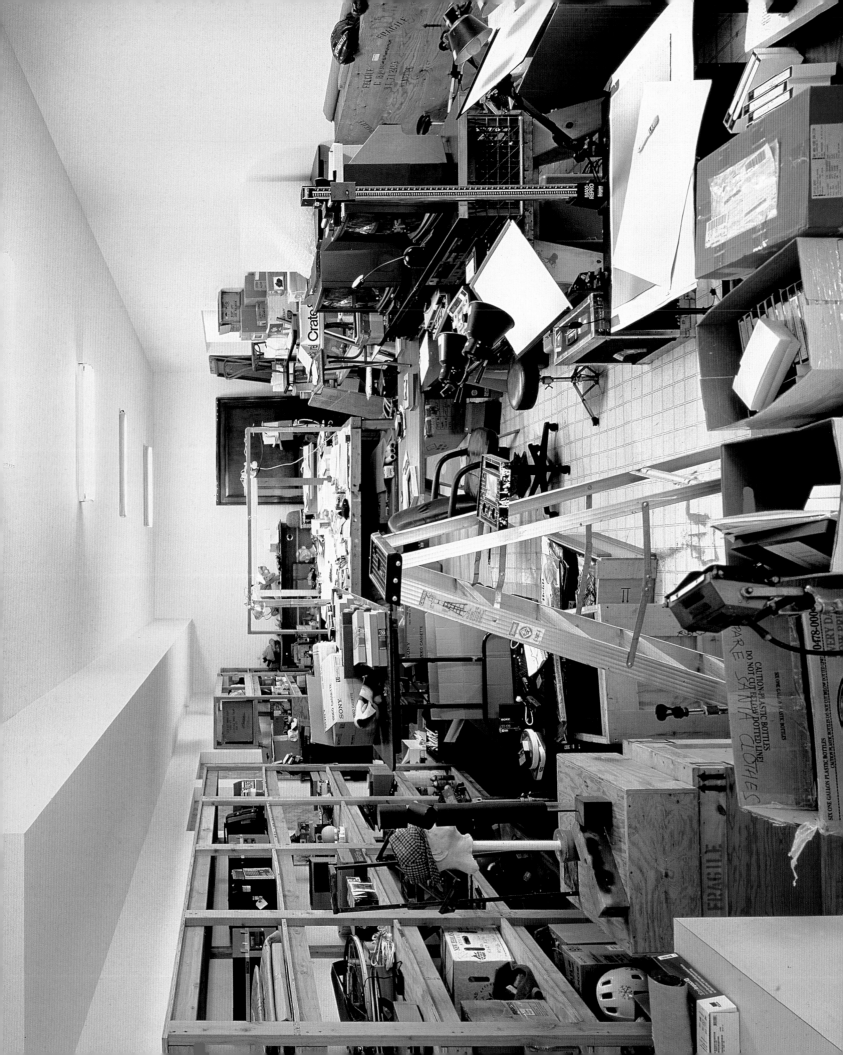

PAUL McCARTHY
The Box

Paul McCarthy's *The Box*—a full-scale replica of the artist's Pasadena studio turned dramatically on its side—combined chaos with obsessive order, disorientation with familiarity. A giant plywood crate, *The Box* was filled with the actual contents of McCarthy's studio at the time that he conceived the project: furniture, boxes of videotapes, piles of paper, McCarthy's artwork, other people's artwork, and so on, down to the white walls, wooden shelving, and stark fluorescent lighting. These things were carted out of his studio en masse, with utter disregard for their future necessity, and pressed into service as part of what was to become the artist's most intimate work to date. A relatively simple concept with drastic personal and professional implications (McCarthy had to completely restock his studio, and half-completed works were effectively gone forever, to the dismay of friends and collectors), *The Box* was constructed with meticulous fidelity to both the studio's architectural detail and the original placement of the objects inside. After an initial showing in Zurich, it was installed inside the Modernist public atrium of a Manhattan office building, where it offered midtown passersby a glimpse through the studio's back window into dizzying, gravity-defying disarray.

McCarthy has become infamous over the past three decades for his no-holds-barred installations, videos, sculptures, body-art performances, and photographs. On its face, *The Box* seems to have little in common with much of his oeuvre—there's no visceral use of household materials, none of his trademark grotesqueries or kitschy icons. But it recalls some of his earliest works, including *Inverted Hallway* and *Inverted Room* (both 1970), in which he flipped one of a pair of images so that the space appears to have been built both right side up and upside down. McCarthy has often formulated an equation between architecture, the human body, and the human psyche—he once described *Skull with a Tail* (1978), an early sculpture of a hollow black cube with a zigzagging appendage, as "a head that you wanted to look into but couldn't." And in more recent installations such as *Santa Chocolate Shop* (1997), McCarthy has used rudimentary plywood structures as funhouse stage sets for his abject spectacles.

A similar current of extravagance and psychological exposure runs through *The Box*. McCarthy's topsy-turvy studio splits into two unequal parts: one side's dense clutter encroaches on a neutral white wall, punctuated only by a series of light fixtures that recall Dan Flavin's fluorescent constructions. This rare incidence of less-is-more in McCarthy's work recalls his early and ongoing fascination with Minimalist forms, which he appreciated not for the way they looked outside but instead for their hollowness within. The empty cube that he first used in *Skull with a Tail* has remained a staple in his sculptural practice, as has his penchant for penetrating the outside of something to lay bare whatever lies within.

The Box (detail), 1999
Mixed-media installation
590 Madison Avenue, Manhattan,
February 21–April 20, 2001

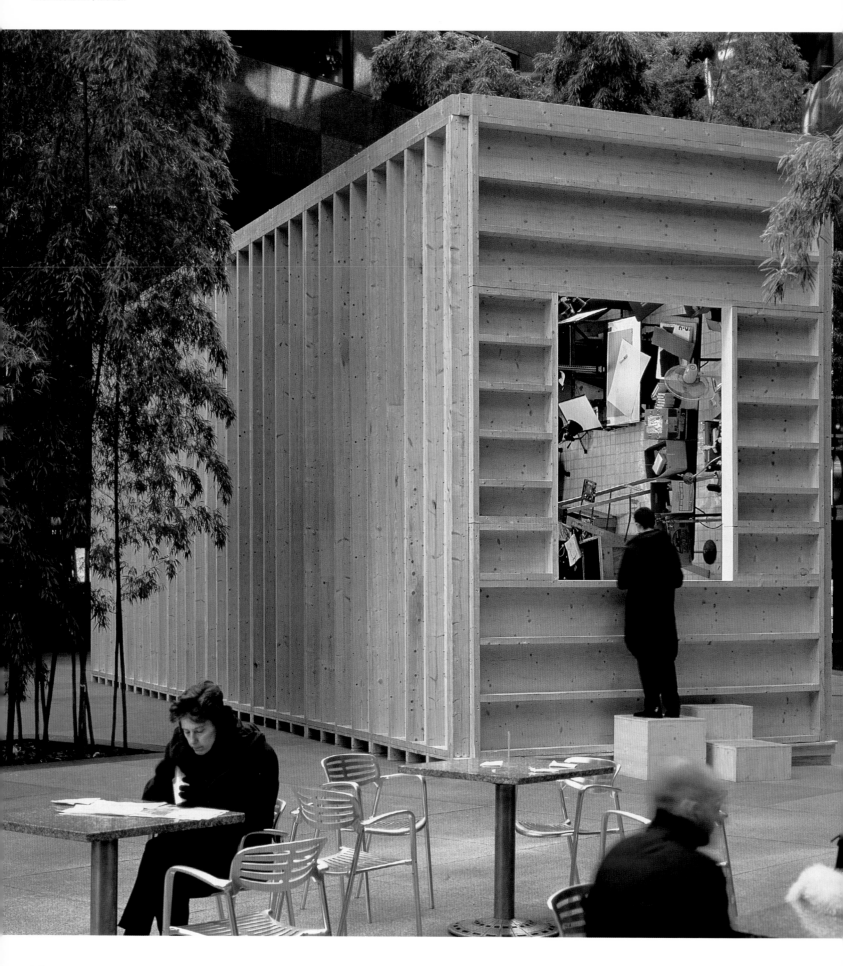

⬊ PAUL McCARTHY

Born in Salt Lake City, 1945.
Studied at University of Southern California, Los Angeles (MFA, 1973), San Francisco Art Institute (BFA, 1969), and University of Utah, Salt Lake City.

SELECTED EXHIBITION HISTORY

Paul McCarthy has recently had solo exhibitions at Tate Modern, London (2003); Luhring Augustine Gallery, New York (2002); New Museum of Contemporary Art, New York (2001); Sammlung Hauser und Wirth in der Lokremise, St. Gallen, Switzerland (1999); Secession, Vienna (1998); and Galerie Hauser und Wirth, Zurich, Switzerland (1997). Recent group exhibitions include *Imagine You Are Standing Here in Front*, Museum Boijmans Van Beuningen, Rotterdam, The Netherlands (2003); Lyon Biennale, France (2003); *Blind Mirror: Selections from a Contemporary Collection*, Museu de Arte Moderna de São Paulo, Brazil (2002); *Let's Entertain: Life's Guilty Pleasures*, Walker Art Center, Minneapolis (2000); *The American Century: Art and Culture 1900–2000, Part II 1950–2000*, Whitney Museum of American Art, New York (1999); 48th Venice Biennale, Italy (1999); *American Playhouse: The Theatre of Self-Presentation*, The Power Plant, Toronto, Canada; *Out of Actions: Between Performance and the Object, 1949–1979*, Museum of Contemporary Art, Los Angeles (1998); 1997 Biennial Exhibition, Whitney Museum of American Art, New York (1997); and *Sunshine and Noir: Art in LA 1960–1997*, Louisiana Museum for Moderne Kunst, Humlebaek, Denmark (1997).

FURTHER READING

Blockhead and Daddies Bighead: Paul McCarthy at Tate Modern, exhib. cat. by Frances Morris, David Thorp, and Sarah Glennie, London, Tate Modern, 2003

Hollert, Tom, "Schooled for Scandal," *Artforum*, 39, Nov. 2000, pp. 134–41

Kimmelman, Michael, "Thwack! It Sticks in the Brain," *The New York Times*, Feb. 23, 2003, p. E31

Paul McCarthy, exhib. cat. by Dan Cameron *et al.*, New York, New Museum of Contemporary Art, 2000

Plagens, Peter, "Another King of McCarthy Era," *Newsweek*, March 5, 2001, p. 60

Rugoff, Ralph, "Deviations on the Theme," *Artforum*, 32, Oct. 1994, pp. 80–83, 118

Saltz, Jerry, "Back Door Man: Surviving the McCarthy Invasion's Rabelaisian Excess," *The Village Voice*, March 20–27, 2001, p. 67

Selwyn, Marc, "Paul McCarthy: There's a Big Difference between Ketchup and Blood," *Flash Art International*, no. 170, May–June 1993, pp. 63–67

Turner, Grady, "Inside and Outside" (interview), *Flash Art International*, no. 217, March–April 2001, pp. 86–91

Yablonsky, Linda, "Gross Point-Blank," *Time Out New York*, March 8–15, 2001, p. 54

LEFT:

The Box, 1999 (presented 2001)

RIGHT, TOP:

Inverted Room, 1970
Black-and-white photograph

RIGHT, BOTTOM:

Skull with a Tail, 1978
Galvanized metal and paint

With its dovetailing interests in social behavior, cultural history, and modes of display, Josiah McElheny's complex conceptual practice in many ways found its apotheosis in his ambitious project *The Metal Party: Reconstructing a Party Held in Dessau on February 9, 1929*, a multipart participatory performance and installation created for two sites, San Francisco's Yerba Buena Center for the Arts, and Brooklyn Front, an exhibition space in Brooklyn's Dumbo neighborhood. A creative reimagining of a party held at the Bauhaus in Dessau, Germany, on February 9, 1929, McElheny's project, produced from late 2001 to early 2002, involved a wide range of interdisciplinary gestures and collaborative relationships, especially with the many guests who turned the opening nights at the two venues into memorable social events.

The artist's central action was represented by the kinetic, visually dazzling physical environments of the party. An accomplished glassblower, McElheny directed the fabrication of hundreds of reflective glass spheres that hung from the ceiling; he also co-designed the reflective mylar tunics that partygoers were encouraged to don at the entrance to the show, and worked closely with artists Soundlab to produce a mix of jazz, experimental music, and sound forms that created an uninhibitedly celebratory ambience—all elements present in the original event at the famous German art and design school. Yet that night in Brooklyn was just the first generative act of a six-week exhibition, the rest of which was addressed to the lyrically depleted space left in its aftermath. Only a few hundred people could actually attend the opening festivities, but *The Metal Party* was conceived to live on as a vivid remnant. Visitors to the installation weeks after the party would see the decorations, hear faint echoes of the music and voices, even step over debris that had been left scattered on the floor—an experience McElheny once likened to the way all history is experienced through the resonant material that others, long gone, have left behind.

This view of historical context is in keeping with McElheny's ongoing program, which has long concerned itself with the ways in which secondary information and tenuous memory shape our attitudes toward places and things. In his 1999–2000 project, *From an Historical Anecdote about Fashion*, for instance, McElheny created a series of elegant vases suggestive of female silhouettes, accompanied by texts detailing a fictitious history of their relationship to the wife of the owner of the glass studio that had supposedly created them a half-century earlier. With *The Metal Party*, McElheny took a historical event and produced another "mirroring" event of his own around it, a reflection of the way even the most vibrantly present moments eventually fade into the dimmer precincts of the past.

OPPOSITE:

The Metal Party: Reconstructing a Party Held in Dessau on February 9, 1929 (detail), 2001
Viewer participatory performance and mixed-media installation
Brooklyn Front, Dumbo, Brooklyn, November 29, 2001–January 13, 2002

FOLLOWING PAGES:

Photographs of *The Metal Party*, Dumbo, Brooklyn, November 29, 2001

JOSIAH McELHENY
The Metal Party

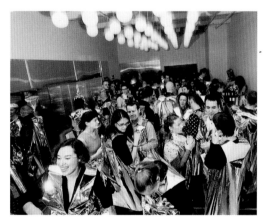

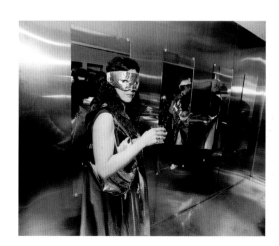

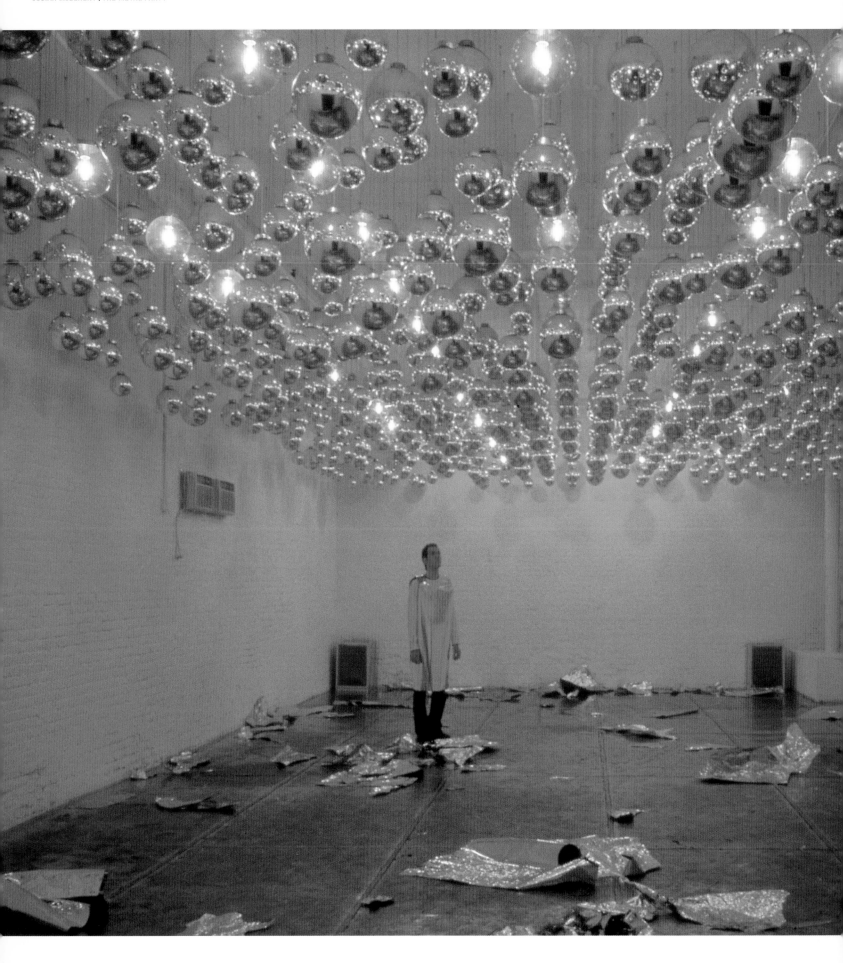

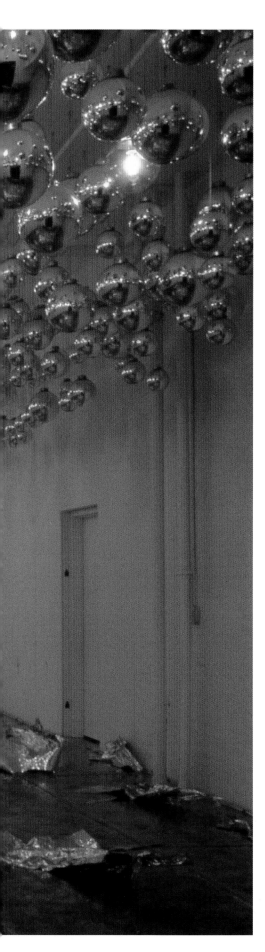

↘ JOSIAH McELHENY

Born in Boston, 1966.
Studied at Rhode Island School of Design, Providence (BFA, 1988), apprenticed to master glassblowers Lino Tagliapietra, Jan-Erik Ritzman, and Sven-Ake Carlsson.

SELECTED EXHIBITION HISTORY

Josiah McElheny has recently had solo exhibitions at Brent Sikkema, New York (2003); Centro Galego de Arte Contemporánea, Santiago de Compostela, Spain (2002; traveled to Artesia Center for the Arts, Brussels); Isabella Stewart Gardner Museum, Boston (1999); Henry Art Gallery, University of Washington, Seattle (1999); and AC Project Room, New York (1997). Recent group exhibitions include *Family*, Aldrich Contemporary Art Museum, Ridgefield, Connecticut (2002); *The Photogenic: Photography through Its Metaphors in Contemporary Art*, Institute of Contemporary Art, Philadelphia (2002); *Beau Monde: Toward a Redeemed Cosmopolitanism*, 4th Biennale, SITE Sante Fe, New Mexico (2001); *BodySpace*, Baltimore Museum of Art (2001); *2000 Biennial Exhibition*, Whitney Museum of American Art, New York (2000); *At Home in the Museum*, Art Institute of Chicago (1998); *Personal Touch*, Art in General, New York (1998); *Interlacings*, Whitney Museum of American Art at Champion, Stamford, Connecticut (1998); and *Young Americans: Part II*, Saatchi Gallery, London (1998).

FURTHER READING

Avgikos, Jan, "Josiah McElheny: The Art of Authentic Forgery," *Glass*, 54, Winter 1993, pp. 22–29

From an Historical Anecdote about Fashion, exhib. cat. by Josiah McElheny, Seattle, Henry Art Gallery, 1999

Israel, Nico, "Josiah McElheny: AC Project Room," *Artforum*, 36, March 1998, pp. 100–101

Josiah McElheny, exhib. cat. by Jennifer R. Gross and Dave Hickey, Boston, Isabella Stewart Gardner Museum, 1999

Josiah McElheny, exhib. cat. by Louise Neri *et al.*, Santiago de Compostela, Centro Galego de Arte Contemporánea, 2002

The Metal Party, exhib. cat. by Josiah McElheny *et al.*, Public Art Fund, New York, and San Francisco, Yerba Buena Center for the Arts, 2002

Scanlan, Joe, "Josiah McElheny: AC Project Room, New York," *Frieze*, no. 38, Jan.–Feb. 1998, p. 92

Smith, Roberta, "Multiple Realities Clash in a World of Shimmering Reflections," *The New York Times*, April 11, 2003, p. E36

Stern, Steven, "Josiah McElheny, Theories about Reflection," *Time Out New York*, April 10–17, 2003, p. 55

Volk, Gregory, "Josiah McElheny at AC Project Room," *Art in America*, 86, March 1998, pp. 106–107

LEFT:

The Metal Party: Reconstructing a Party Held in Dessau on February 9, 1929, 2001
Installation view after party, Dumbo, Brooklyn

RIGHT, TOP:

From an Historical Anecdote about Fashion (detail), 2000
Blown-glass objects, display case, five framed digital prints

RIGHT, BOTTOM:

Untitled (White), 2000
Painted wood shelf with blown-glass objects

Sandwiched between the imposing Neo-classical façade of the Brooklyn Public Library and the Beaux Arts arch at Grand Army Plaza, Anissa Mack's *Pies for a Passerby* was a little slice of Americana plunked down in one of Brooklyn's busiest intersections. The cottage's appearance on the Plaza—straight out of a storybook, with pale blue shutters, a swinging Dutch door, and petunia-filled flower boxes—was as sudden as Dorothy's touchdown in Oz, and, in many ways, no less wondrous. Inside was a kitchen, where Mack spent several hours a day baking apple pies, one at a time. She set each pie out on the window ledge to cool—at which point, presumably, some lucky, opportunistic passerby would stroll by and steal it, repeating three or four times a day the classic cliché of the pie-snatching thief. For Mack, the work began as an investigation of the way that such simple and iconic imagery—familiar from countless depictions in everything from *Little Rascals* to *The Simpsons* to *O Brother Where Art Thou?*—can have a powerful grasp on our collective imagination. But in bringing a bit of small-town nostalgia to the mean streets of New York, *Pies* quickly became a barometer of human behavior, as bystanders angled, conspired, and jostled for a pie. Mack told a *New York Times* reporter that "[One Saturday] an adult man ran across the plaza and stole the pie, right in front of a bunch of little kids who were waiting, and ran off. That was pretty satisfying—to get it the way I wanted it."

Within her diverse studio practice, Mack often explores the sculptural possibilities and nostalgic appeal of vernacular and handcrafted objects, as in *I'm Like You, Do You Like Me?* (2002), a quartet of leaded stained-glass windows made using bandanna designs. Mack's performance-based projects similarly employ familiar, appealing items to draw viewers into an open-ended interaction with the artist or the work: for *On Loan* (1999), an unsanctioned installation at the Smithsonian Institution's National Museum of American History in Washington, D.C., Mack set out a homemade pair of ruby slippers in front of the display case containing Judy Garland's *Wizard of Oz* originals and stood back as people tried them on. But, along with *Pies*, Mack's most direct and democratic project to date is *Traveling Salesman* (2003, ongoing), a homemade mail-order catalogue raisonné in which she offers to do "home parties," Tupperware-style sales presentations that provide an unassuming, intimate alternative to viewing art in a formal gallery or museum setting.

OPPOSITE:

Pies for a Passerby (detail), 2002
Performance and mixed-media installation
Brooklyn Public Library at Grand Army Plaza, Brooklyn,
May 17–June 23, 2002

FOLLOWING PAGES:

Pies for a Passerby (performance and installation details), 2002

ANISSA MACK
Pies for a Passerby

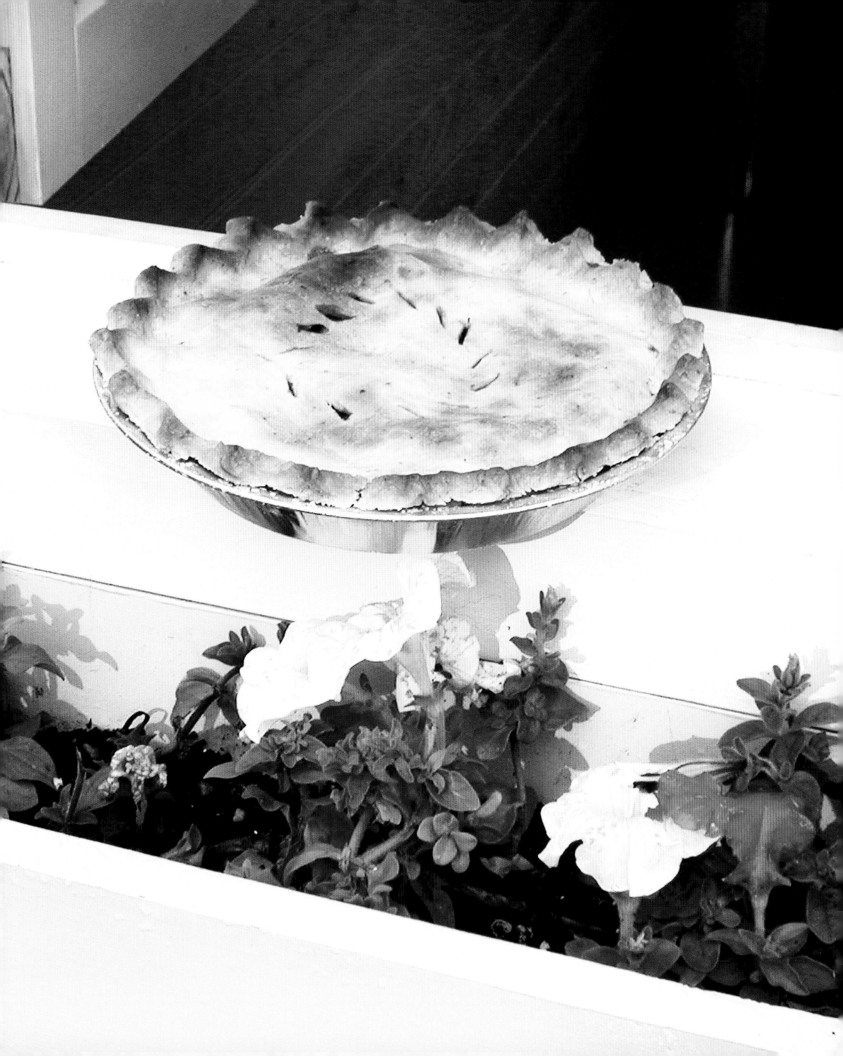

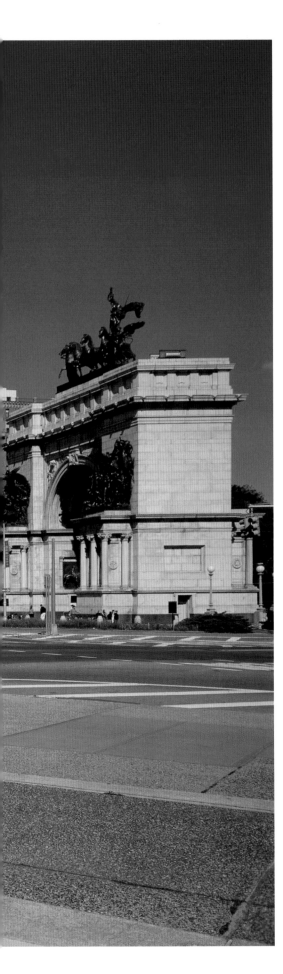

↘ ANISSA MACK

Born in Guilford, Connecticut, 1970.
Studied at Skowhegan School of Painting and Sculpture, Skowhegan, Maine (1999), Tyler School of Art, Temple University, Philadelphia (MFA, 1996), and Wesleyan University, Middletown, Connecticut (BA, 1992).

SELECTED EXHIBITION HISTORY

Anissa Mack has recently had solo projects and exhibitions that include *Harlem Postcards*, a multiple produced by Studio Museum in Harlem, New York (2002); *Typical Frankenstein*, Parlour Projects, Brooklyn; and *For Your Inspection*, Postmasters Gallery, New York (1998). Recent group exhibitions include *Heart of Gold*, P.S. 1 Contemporary Art Center, Long Island City, Queens (2002); and *Interval: New Art for a New Space*, SculptureCenter, Long Island City, Queens (2001).

FURTHER READING

Bell, Annie, "Steal This Pie," *Time Out New York*, May 16–23, 2002, p. 68

Burkeman, Oliver, "Mack the Pie," *Guardian*, June 12, 2002

Goodman, Christy, "Stolen Art: Challenging New Art Exhibits at the Central Library," *Brooklyn Heights Courier*, June 3, 2002, pp. 1, 7

Le Dracoulec, Pascale, "The Art of Baking," *The New York Daily News*, May 29, 2002, p. 5

Mack, Anissa, *Anissa Mack: Traveling Salesman*, New York (self-published) 2003

Newman, Andy, "Take These Pies, Please," *The New York Times*, May 31, 2002, pp. B1, B9

Sax, Irene, "Steal This Pie," *Food Arts*, Sept. 2002, pp. 12, 13

Wartofsky, Alona, "A Flaky Slice of Americana," *The Washington Post*, June 4, 2002, p. C1

LEFT:

Pies for a Passerby, 2002

RIGHT, TOP:

I'm Like You, Do You Like Me?, 2002
Stained-glass windows
Installation view at P.S. 1
Contemporary Art Center,
Long Island City, Queens

RIGHT, BOTTOM:

On Loan, 1999
Homemade ruby red slippers
Performance at the National
Museum of American History,
Smithsonian Institution,
Washington, D.C.

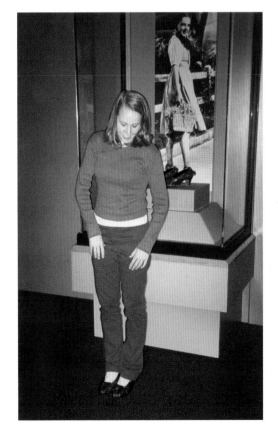

Two very different projects created by Tony Matelli for the Public Art Fund in the late 1990s demonstrate the formal and conceptual breadth of an artist best known for his lifelike sculptural figures set into surrealistic, often aggressively mordant situations. Together, they form a neat inversion, each presenting only a portion of their given scenarios—his *Stray Dog*, installed in 1998 at Brooklyn's MetroTech Center, featured a faithful model of a marooned seeing-eye Labrador, his owner nowhere to be found; meanwhile, the next year's audio piece, *Distant Party*, sent the sounds of a festive social event wafting over a Chelsea street, conspicuously minus the participants. Each work's poetry depended just as much on what was absent as on what was present—each short-circuited the expected relationships between interdependent elements in a given situation, making those relationships more affecting because of what was withheld.

There's more than a whiff of antiheroism, not to mention an often scabrous sense of humor, that runs through Matelli's work. His hyperrealistic sculptural installations have typically looked to gut the preconceived notions about bravery and honor with which monumental sculpture is infused—whether in the vomiting boy scouts cut off from their chaperones in *Lost and Sick* (1996–2001), or the comically pathetic scenario of *Very, Very First Man: Necessary Alterations* (1998–99), in which a pair of recently evolved australopitheci clumsily reattach each other's tails in a vain attempt to return to lower (and presumably less responsibility-burdened) life forms. Yet the artist also has a less acerbic side, one that deploys less spectacularized narrative structures—as in *Abandoned*, the clutch of delicately rendered plastic weeds he exhibited at London's Serpentine Gallery in 2000—to achieve his desired effects.

In its uncanny realism and unexpected solitude, *Stray Dog* drew on both strands of the artist's practice. Peering around the corner of a fence with that uniquely canine combination of anticipation and patience, Matelli's working dog seemed fully aware that something was wrong, yet appeared utterly determined to wait it out until his companion returned to once again take up the guide harness he wore on his back. It's a testament to Matelli's skill with both form and context that he managed to provoke a kind of odd compassion in the viewer for the ersatz animal, as well as for the person-in-need from whom it had been separated. *Stray Dog* featured Matelli's sculptural practice in an uncharacteristically empathetic, stripped-down mode; *Distant Party* had a similar poignancy, accomplished through even more economical means. Sited on the southern edge of Chelsea, a then-desolate area of warehouses along the margins of the gallery district, the audio work consisted of nothing but the sounds of a party, broadcast from hidden speakers to the street below. Tantalizingly present, yet fictitious and inaccessible, the faraway voices suggested one of the most vivid big-city emotions, and one of Matelli's most consistent fascinations—that feeling of being an outsider in society, alone amid the crowd.

Stray Dog, 1998
Resin (later recast in bronze)
MetroTech Center, Brooklyn,
ongoing since October 20, 1998

TONY MATELLI
Stray Dog and *Distant Party*

↘ TONY MATELLI

Born in Chicago, 1971.
Studied at Cranbrook Academy of Art, Bloomfield Hills, Michigan (MFA, 1995), Milwaukee Institute of Art and Design (BFA, 1993), and Alliance of Independent Colleges of Art, San Francisco (1991).

SELECTED EXHIBITION HISTORY

Tony Matelli has recently had solo exhibitions at Galerie Emmanuel Perrotin, Paris (2002); Gian Enzo Sperone, Rome (2002); Leo Koenig, New York (2002); Sies + Hoeke Gallery, Düsseldorf, Germany (2000); and Basilico Fine Arts, New York (1997). Recent group exhibitions include *The Fourth Sex*, Stazione Leopolda, Florence, Italy (2003); *The Americans*, Barbican Art Gallery, London (2001); *Greater New York: New Art in New York Now*, P.S. 1 Contemporary Art Center, Long Island City, Queens (2000); *Small World: Dioramas in Contemporary Art*, Museum of Contemporary Art, San Diego (2000); *Over the Edges: the Corners of Ghent*, Stedelijk Museum voor Actuele Kunst, Ghent, Belgium (2000); *The Greenhouse Effect*, Serpentine Gallery, London (2000); *Yesterday Begins Tomorrow*, Bard College for Curatorial Studies, New York (1998); *Pop Surrealism*, Aldrich Contemporary Art Museum, Ridgefield, Connecticut (1998); and *To Be Real*, Yerba Buena Center for the Arts, San Francisco (1997).

FURTHER READING

Avgikos, Jan, "The Shape of Art at the End of the Century," *Sculpture*, 17, April 1998, pp. 46–53

Galloway, Munro, "Tony Matelli," *Art Press*, 249, April 1999, p. 245

Hunt, David, "Tony Matelli," *Art/Text*, no. 66, Aug.–Oct. 1999, pp. 34–36

Hunt, David, "Tony Matelli," *Time Out New York*, Feb. 3–10, 2000, p. 61

Landi, Ann, "The Real Thing?," *ARTnews*, 101, June 2002, pp. 88–91

McCarthy, Gerard, "Tony Matelli at Basilico," *Art in America*, 87, July 1999, p. 90

Mahoney, Robert, "Tony Matelli, Sexual Sunrise," *Time Out New York*, Dec. 27, 2001–Jan. 3, 2002, p. 54

Maxwell, Douglas F., "Sexual Sunrise, Tony Matelli," *NY Arts*, 7, Feb. 2002, p. 69

Romeo, Filippo, "Tony Matelli: Gian Enzo Sperone," *Artforum*, 41, Nov. 2002, p. 193

Trainor, James, "Tony Matelli," *Tema Celeste*, no. 90, March–April 2002, p. 80

LEFT:

Distant Party, 1999
Sound installation
Ninth Avenue between 15th and 16th Streets, Chelsea, Manhattan, September 10–November 1999

RIGHT, TOP:

Lost and Sick, Winter Version, 2000–2001
Polyester, urethane, paint

RIGHT, BOTTOM:

Very, Very First Man: Necessary Alterations, 1998–99
Urethane, fiberglass, synthetic hair, acrylic paint

Nestled in between clusters of bamboo trees in the four-story atrium of a midtown Manhattan office building, and set against the incongruous backdrop of a giant American flag, Mariko Mori's *Wave UFO* was a futuristic spaceship—sleek, iridescent, and mysterious. Although it took Mori and an entire team of technical experts four years of research, artistic innovation, and engineering to realize it (Mori's acknowledgments read like the credits of a Hollywood blockbuster), *Wave UFO* remains true to Mori's first pencil drawing for the project, a curling, sideways teardrop sketched in her notebook during an airplane trip in 1999. Embodying Mori's dovetailing interests in technology and spiritualism, *Wave UFO* drew upon art, science, performance, sound, and architecture, using cutting-edge materials to explore fundamental elements of human consciousness and interconnectivity.

"All beings in this world may appear to exist independently," Mariko Mori wrote in a statement about *Wave UFO*. "But in reality, we are all interconnected … . There is an infinite relationship among us all, and a single life that unites the universe." These Buddhist underpinnings are at the heart of *Wave UFO*, which represents the culmination of an aesthetic and intellectual journey that, in the span of less than ten years, evolved from the exploration of self-image to the pursuit of shared experience. From her earliest photographic self-portraits, Mori has examined the relationship between biology and technology, and between humanity and divinity. Her first major sculptural installation, *Dream Temple* (1999)—also the first work in which she did not appear—was a recreation of the eighth-century Yumedono Temple in Nara, Japan. If *Dream Temple* was a reinterpretation of a Buddhist past, *Wave UFO* is its space-age, utopian counterpart.

Standing outside *Wave UFO*, one occasionally heard a low rumbling sound, as the video-and-sound piece inside ran its course, followed a few minutes later by the sliding swish as the convex door slid open and the participants emerged. Three people together experience Mori's immersive projection in the interior chamber of *Wave UFO*. The first few minutes of computer-generated imagery are controlled and altered by the brainwaves of the three participants—three pairs of jellybean-like shapes move and change color, indicating whether the participants are relaxed, solving math problems, or engaged in deep thought. And while it's enthralling to witness the activity of one's own brain, *Wave UFO* posits the possibility of the three participants entering a state of harmonious unity, which occurs when sets of shape-shifting, mercury-like blobs expand to form a ring. Such "coherence," as Mori calls it, is elusive. But after several minutes of real-time brain-wave activity, a second segment, "Connected World," begins, combining Mori's embryonic graphics with an otherworldly sound composition. This three-and-a-half-minute segment is an aesthetic voyage to the cosmos and back to inner space, where, in Mori's visionary embrace, each individual element of the universe exists as part of a larger whole.

OPPOSITE:

Wave UFO (detail), 2003
Mixed-media installation with
digital projection
590 Madison Avenue, Manhattan,
May 10–July 31, 2003

FOLLOWING PAGES:

Wave UFO, 2003

MARIKO MORI
Wave UFO

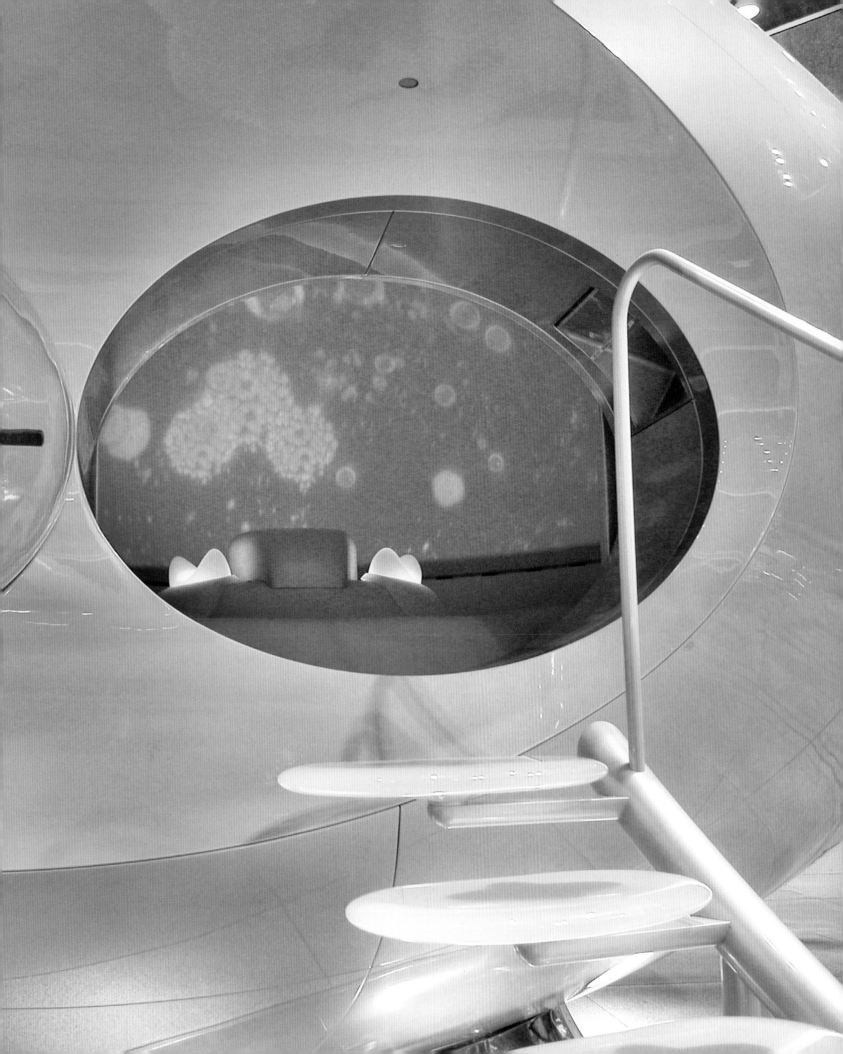

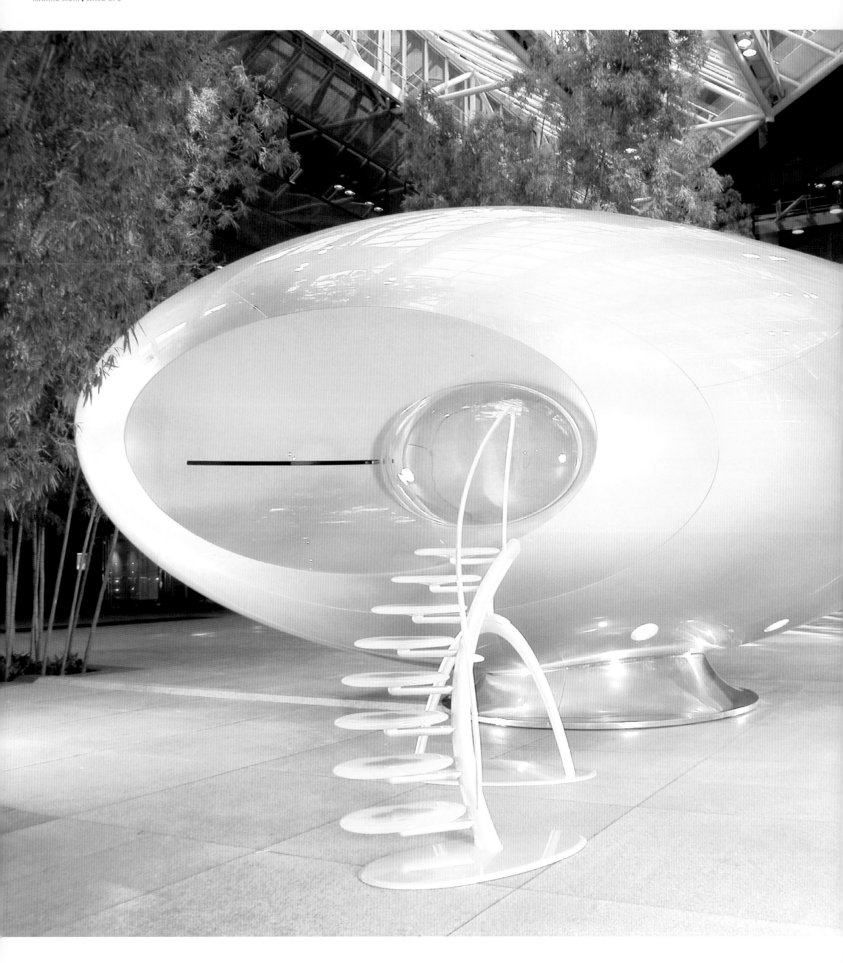

↘ MARIKO MORI

Born in Tokyo, 1967.
Studied at Whitney Museum of American Art Independent Study Program, New York (1992–93), Chelsea College of Art, London (1992), Byam Shaw School of Art, London (1989), and Bunka Fashion College, Tokyo (1988).

SELECTED EXHIBITION HISTORY

Mariko Mori has recently had solo exhibitions at the Museum of Contemporary Art, Tokyo (2002); Centre National de la Photographie, Paris (2000); Brooklyn Museum of Art, Brooklyn (1999); and Museum of Contemporary Art, Chicago (1999). Recent group exhibitions include *Life Death Love Hate Pleasure Pain: Selected Works from the MCA Collection*, Museum of Contemporary Art, Chicago (2002); *Form Follows Fiction*, Castello di Rivoli Museo d'Arte Contemporanea, Turin, Italy (2001); *Space Odysseys*, Art Gallery of New South Wales, Sydney, Australia (2001); *My Reality*, Brooklyn Museum of Art, Brooklyn (2001); *Contemporary Art from Japan: 1980 Until Now*, Kröller-Müller Museum, Otterloo, The Netherlands (2001); *Apocalypse: Beauty and Horror in Contemporary Art*, Royal Academy of Arts, London (2000); Sydney Biennale, Australia (2000); *Heaven: An Exhibition That Will Break Your Heart*, Tate Gallery, Liverpool, England (1999); *Seeing Time*, San Francisco Museum of Modern Art (1999); and *Future Present Past*, 47th Venice Biennale, Italy (1997).

FURTHER READING

Chen, Aric, "Cosmic Connection," *Interior Design*, 74, April 2003, pp. 160–63

Cotter, Holland, "Drawing on a Rich Lode of Shinto Buddhist Culture," *The New York Times*, April 16, 1999, p. 33

Heartney, Eleanor, "Dream Machine," *Art In America*, 91, Sept. 2003, pp. 52–53

Heartney, Eleanor, "Mariko Mori, In Search of Paradise Lost," *Art Press*, no. 256, April 2000, pp. 36–40

Iovine, Julie V., "If Martians Went to Design School," *The New York Times*, May 8, 2003, p. F4

Mariko Mori, exhib. cat. by Mariko Mori, Chicago, Museum of Contemporary Art; London, Serpentine Gallery, 1998

Mori, Mariko, *et al.*, *Mariko Mori: Dream Temple*, Milan (Fondazione Prada) 2000

Stern, Steven, "One Wild Ride," *Time Out New York*, June 5–12, 2003, p. 88

Wave UFO, exhib. cat. by Mariko Mori *et al.*, Bregenz, Austria, Kunsthaus Bregenz; New York, Public Art Fund, 2003

Yasuda, Sonoka, "Pure Land, Mariko Mori," *Harper's Bazaar*, April 2002, pp. 96–103

LEFT:

Wave UFO (interior detail), 2003

RIGHT, TOP:

Miko no Inori, 1996
Video still

RIGHT, BOTTOM:

Dream Temple, 1999
Mixed-media video installation

Kirsten Mosher once described herself as a "city planner gone astray," and with her 1998 Public Art Fund project, *Ballpark Traffic*, the artist brought her overlapping interests in urban space and social context together with a characteristic sense of humor and lightness of touch to reinvent a busy West Side intersection as a temporary zone for "play." Recognizing loose similarities in the architecture and traffic markings of the Chelsea corner and the physical parameters of a sandlot baseball field, Mosher coaxed these formal adjacencies into harmonization, unifying the two different pattern sets and rule systems into a hybrid that wryly subverted both.

Since the outset of her career, Mosher's multimedia practice has ranged widely but has often involved itself with aspects of the urban fabric—with the trajectories of communal life; with the physical ordering of public space and the character of public amenities; and with the signs and symbols that signify distinctions between nature and civilization. Many of Mosher's gestures emerge from skillful juxtapositions that take familiar forms out of their usual contexts. In works from the early 1990s, she used objects usually employed to exercise aspects of social control—such as parking meters, crowd barriers, and pedestrian path designations—to create public installations that interrogated and ultimately neutralized their function. In more recent projects such as *Local Park Express*, a version of which was featured as part of the Public Art Fund's 1999 exhibition at Brooklyn's MetroTech Center, she set a series of mobile park benches and planters on a small track, essentially allowing viewers to site themselves within the environment, providing them with a small measure of autonomy in the framing of the artificial experience of nature such furnishings present.

The lyrical potential available in subtle adjustments to familiar situations lies at the heart of *Ballpark Traffic*. Other than the embedded home plate and bases, the rest of Mosher's ball field was essentially insinuated—a temporary fence already in place around the Chelsea Garden Center inverted and augmented to create a backstop, the painted crosswalks extended up across the curbs to suggest base paths, a circular "pitcher's mound" simply rendered, in standard-issue Department of Transportation thermal paint, in the middle of the intersection. Filled with speeding cars and hurrying pedestrians each day during its two-month installation, *Ballpark Traffic* brought the space to life, slyly transforming citizens going about their daily business into unwitting players in a totally unexpected urban "sporting" event.

Ballpark Traffic, 1998
Mixed-media installation
Intersection at Ninth Avenue and
22nd Street, Chelsea, Manhattan,
January 15–March 15, 1998

KIRSTEN MOSHER
Ballpark Traffic

↘ KIRSTEN MOSHER

Born in New York, 1963.
Studied at Corcoran School of Art and Design, Washington, D.C. (BFA, 1985).

SELECTED EXHIBITION HISTORY

Kirsten Mosher has recently had solo exhibitions at Ten in One Gallery, New York (2003); Revolution Gallery, Ferndale, Michigan (2002); Achim Kubinski Gallery, Berlin (2001); Andrea Rosen Gallery, New York (2000); and Grand Arts, Kansas City, Missouri (1998). Recent group exhibitions include *Beyond City Limits*, Socrates Sculpture Park, Long Island City, Queens (2001); *Art in Public Spaces*, Singen, Germany (2000); *The Space Here Is Everywhere*, Villa Merkel, Esslingen, Germany (1999); *Cruise Control*, Christine Rose Gallery, New York (1999); Wanås Foundation, Knislinge, Sweden (1998); *Educating Barbie*, Trans-Hudson Gallery, New York (1998); *Home Screen Home*, Witte de With, Rotterdam, The Netherlands (1998; traveled to Museum of Contemporary Art, Barcelona, Spain, and Museo Nacional Centro de Arte Reina Sofía, Madrid); and *Young and Restless*, MoMA, New York (1997).

FURTHER READING

Faust, Gretchen, "Reconnaissance," *Arts Magazine*, 64, Sept. 1990, p. 104

Lohaus, Stella, "Kirsten Mosher," *Forum International*, 16, Jan.–Feb. 1993, p. 99

Mahoney, Robert, "Kirsten Mosher: Gutting Cycle & Around the Block," *Arts Magazine*, 65, Dec. 1991, p. 76

"The Most Dangerous Game," *Time Out New York*, Feb. 19–26, 1998, p. 42

Schwabsky, Barry, "Surrounded by Sculpture," *Art in America*, 87, Jan. 1999, pp. 56–59

Scott, Georgia, "Pedestrians Serve as Base Runners," *The New York Times*, Feb. 8, 1998, City section, p. 7

Vogel, Sabine, "Interventionen" (interview), *Kunst-Bulletin*, no. 10, Oct. 1992, pp. 18–23

Weil, Benjamin, "Remarks on Installations and Changes in Time Dimensions," *Flash Art International*, no. 162, Jan.–Feb. 1992, p. 107

Wollscheid, Achim, "Kirsten Mosher," *Artforum*, 29, Dec. 1991, p. 116

LEFT:

Ballpark Traffic, 1998

RIGHT, TOP:

Border Control, 1990
Mixed-media installation at Petrosino Park, Manhattan

RIGHT, BOTTOM:

Local Park Express, 1999
Wood and steel
Installation view of Public Art Fund project at MetroTech Center, Brooklyn

MUSIC

VIK MUNIZ
CandyBAM

Unlike many Public Art Fund projects, which are often conceived and sometimes even created before a location is chosen, Vik Muniz's *CandyBAM* was a site-specific work from its frosted cornice down to its jellybean base. Brazilian-born, Brooklyn-based Muniz was commissioned to make a work to cover the façade of the Brooklyn Academy of Music—usually known as "BAM"—as the building underwent a two-year face-lift. But the inspiration for *CandyBAM* had occurred to Muniz long before he ever actually made it: "Aside from going to shows at BAM, I drive past it almost everyday. I have always admired its architecture. The scale, architectural details, and color make me think of an alluring cake." With *CandyBAM*, Muniz transformed the building into a colossal, Italianate gingerbread house, its every terra-cotta feature lovingly recreated in icing, M&Ms, peppermint sticks, red licorice, and gummy bears. As with most of the artist's photographic works, *CandyBAM* was the result of a multilayered creative and technical process. It began with a cake 7 feet (1.2 m) long (made to match BAM's proportions exactly) that Muniz decorated and then photographed; that image was then enlarged and printed on a vinyl mesh banner at the actual size of the façade.

From his earliest works—such as "Relics," a series of playful sculptures that included *Precolumbian Coffee Maker*, a roughly hewn, anachronistic take on the modern household appliance—Muniz has irreverently explored the way we perceive familiar images and everyday objects. By the late 1980s, he had begun making the photographic works for which he's best known, beginning with "Best of Life" (1988–90), a group of photographs of drawings he made of photojournalism's timeless chestnuts: the VJ-Day kiss at Times Square, the tanks rolling into Tiananmen Square, and so on. Muniz drew the images from memory, and he inadvertently took artistic license, depicting them from different perspectives or omitting peripheral details. Few people notice what's missing or changed when they look at these works, and it's this space in between a picture, an image, and the thing itself, that interests Muniz. "My goal is not to create a really convincing version as much as it is to give you the worst possible illusion, but an illusion that is still possible and effective," Muniz has said. Since the mid-1990s, he has photographed drawings made on a light table using banal household substances—spaghetti sauce, dust, thread, garbage—pairing his medium and subjects in ways that prompt subtle shifts in perception as the viewer recognizes the image, then the material, and, finally, the relationship between the two. To recreate the famous Hans Namuth photograph of Jackson Pollock in action in *Action Photo I (After Hans Namuth)* (1997), Muniz used the suitably drippy medium of chocolate, capturing the messy id of Abstract Expressionism in visceral, virtuoso form. With *CandyBAM*, Muniz similarly used his low-tech alchemy to transform BAM into an amplified, fairy-tale version of itself, obscured but perhaps more visible than ever before.

CandyBAM
(detail of gingerbread cake),
2002

↘ VIK MUNIZ

Born in São Paulo, Brazil, 1961.

SELECTED EXHIBITION HISTORY

Vik Muniz has recently had solo exhibitions at Brent Sikkema, New York (2002); Brazil Pavilion, 49th Venice Biennale, Italy (2001); Whitney Museum of American Art, New York (2001); Tang Teaching Museum and Art Gallery, Skidmore College, Saratoga Springs, New York (2000); and International Center of Photography, New York (1998). Recent group exhibitions include *Tempo*, MoMA QNS, Long Island City, Queens (2002); *Moving Pictures*, Solomon R. Guggenheim Museum, New York (2002); *Visions from America: Photographs from the Whitney Museum of American Art, 1940–2001*, Whitney Museum of American Art, New York (2002); 2000 Biennial Exhibition, Whitney Museum of American Art, New York (2000); *Media/Metaphor*, 46th Corcoran Biennale, Corcoran Gallery of Art, Washington, D.C. (2000); *The Museum as Muse: Artists Reflect*, MoMA, New York (1999); 24th São Paulo Bienal, Brazil (1998); *Le Donné, le Fictif*, Centre National de la Photographie, Paris (1998); *New Photography XIII*, MoMA, New York (1997); and *New Faces and Other Recent Acquisitions*, Art Institute of Chicago (1997).

FURTHER READING

Aletti, Vince, "For Muniz, the Medium Is the Message," *The Village Voice*, May 23–30, 2000, p. 125

Anton, Saul, "Your 15 Minutes Are Up: Vik Muniz Pops Pop's Balloon," *Time Out New York*, June 1–8, 2000, p. 90

Baker, Kenneth, "Muniz Whets the Appetite for Images in Chocolate," *San Francisco Chronicle*, April 16, 1998, p. E1

Demby, Eric, "Desert Oasis," *Time Out New York*, Sept. 26–Oct. 3, 2002, p. 45

Goldberg, Vicky, "It's a Leonardo? It's a Corot? Well, No, It's Chocolate Syrup," *The New York Times*, Sept. 25, 1998, p. E1

Grosenick, Uta, and Burkhard Riemschneider (eds.), *Art Now: 137 Artists in the Rise of the New Millennium*, Berlin (Taschen) 2002, pp. 312–15

Saltz, Jerry, "Dust to Dust: Art from the Sweepings of a Museum Floor," *The Village Voice*, March 27–April 3, 2001, p. 75

Seeing Is Believing, exhib. cat. by Charles Ashley Stainback and Mark Alice Durant, New York, International Center of Photography (Arena Editions) 1998

Vik Muniz/Ernesto Neto, exhib. cat. by Germano Celant for Brazil Pavilion at 49th Venice Biennale (BrasilConnects) 2001

Vogel, Carol, "Academy of Music in the Land of Sweets," *The New York Times*, Sept. 30, 2002, Arts section, pp. 1, 5

LEFT:

CandyBAM, 2002
Digital ink-jet output
on vinyl mesh
Brooklyn Academy of Music,
Brooklyn, ongoing since
October 1, 2002

RIGHT, TOP:

*Action Photo I
(After Hans Namuth)*, 1997
From "Pictures of Chocolate"
series
Cibachrome

RIGHT, BOTTOM:

*Memory Rendering of Kiss at
Times Square*, from "Best of Life"
series, 1988–90
Gelatin silver print

Juan Muñoz's gracefully choreographed *Conversation Piece*—one of several works, all bearing the same title, made by the artist after 1990—is a quintet of bronze figures, each with a rounded, bulging base and on a slightly less-than-human-size scale. The figures' facial features are impassive and generalized, but their gestures, expressive and exaggerated, suggest a complicated group dynamic: one figure whispers in another's ear, as a third figure reaches out in supplication or possibly encouragement. A fourth figure tugs at the waist of another, and the last one simply looks on, standing a few feet away. Like many of Muñoz's gallery and museum installations, *Conversation Piece* annexed a discrete space and transformed it into a stage for an engaging, if enigmatic, series of interactions. Installed at the entrance to Central Park, the somber, suspended activities of Muñoz's group drew park-goers in—they circled and entered the sculpture, scrutinizing the various perspectives to a degree unusual for a work of public art. Falling somewhere between a riddle and a soap opera, *Conversation Piece* stopped people in their tracks.

Juan Muñoz gained international recognition in the early 1980s for his work as an artist, a curator, and a writer of art criticism and prose. Drawing upon a wide range of sources—from Diego Velázquez to Luigi Pirandello and Giorgio de Chirico—Muñoz investigated the ways in which architecture and sculpture can weave powerful but open-ended narratives that invite the viewer's participation on both a visceral and an intellectual level. His earliest sculptures were a series of tiny balconies, which he installed on gallery walls, where they precipitated a radical reevaluation of the room space by the viewer. In later installations, he began to involve the entire gallery, covering the floor with optical patterns, and placing sculpted figures within them, as if capturing characters in a theatrical matrix. Many of his *Conversation Piece* works—like the one shown here—made use of existing, unaltered gallery spaces or public venues. But for *Double Bind* (2001), his ambitious work at Tate Modern's massive Turbine Hall, Muñoz once again created an installation where his mysterious figures (and his viewers as well) were caught in a dramatically rendered multilevel space full of illusions and shifting perspectives. Muñoz completed *Double Bind* just two months before a fatal aneurysm cut short his life.

Conversation Piece takes its name from a style of European painting, particularly popular in eighteenth-century England, in which artists depicted social gatherings in fashionable domestic interiors, gardens, or other intimate settings. But here, as in other works, Muñoz boiled storytelling down to its bare minimum, foregoing the art-historical genre's precise, detailed iconography for his own psychologically charged ambiguity, and leaving his five characters to hash out a private drama in a very public setting.

JUAN MUÑOZ
Conversation Piece

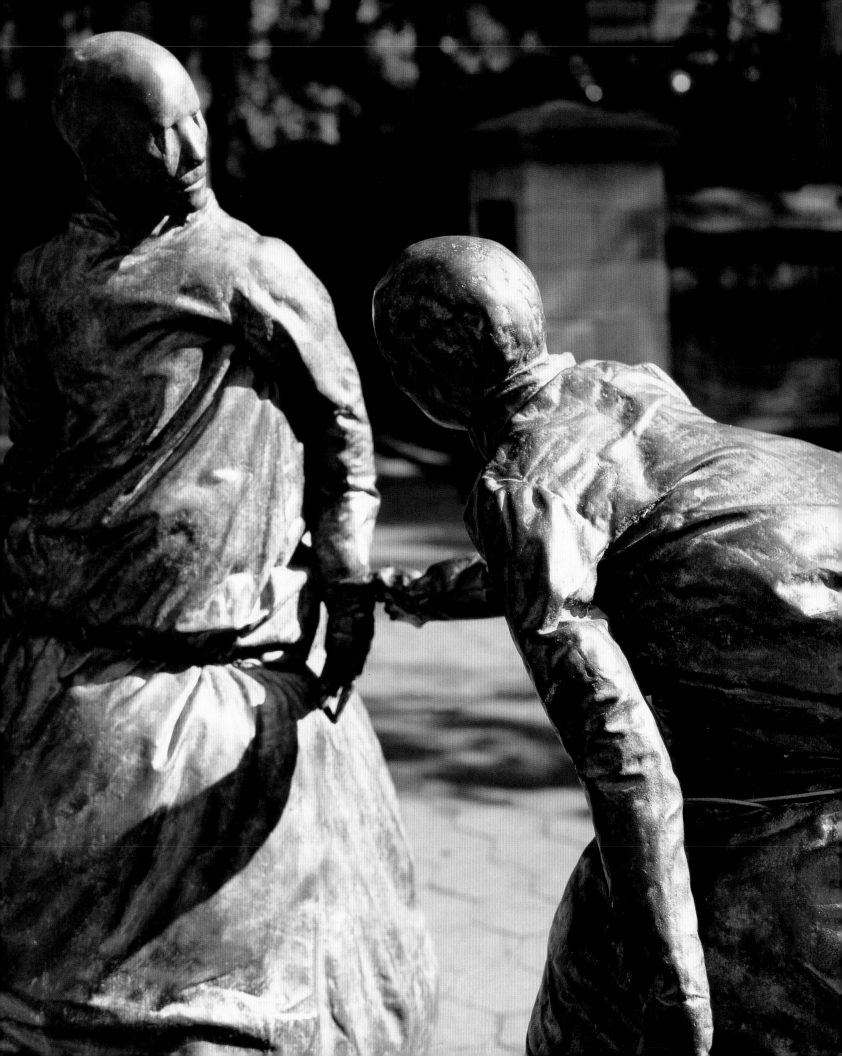

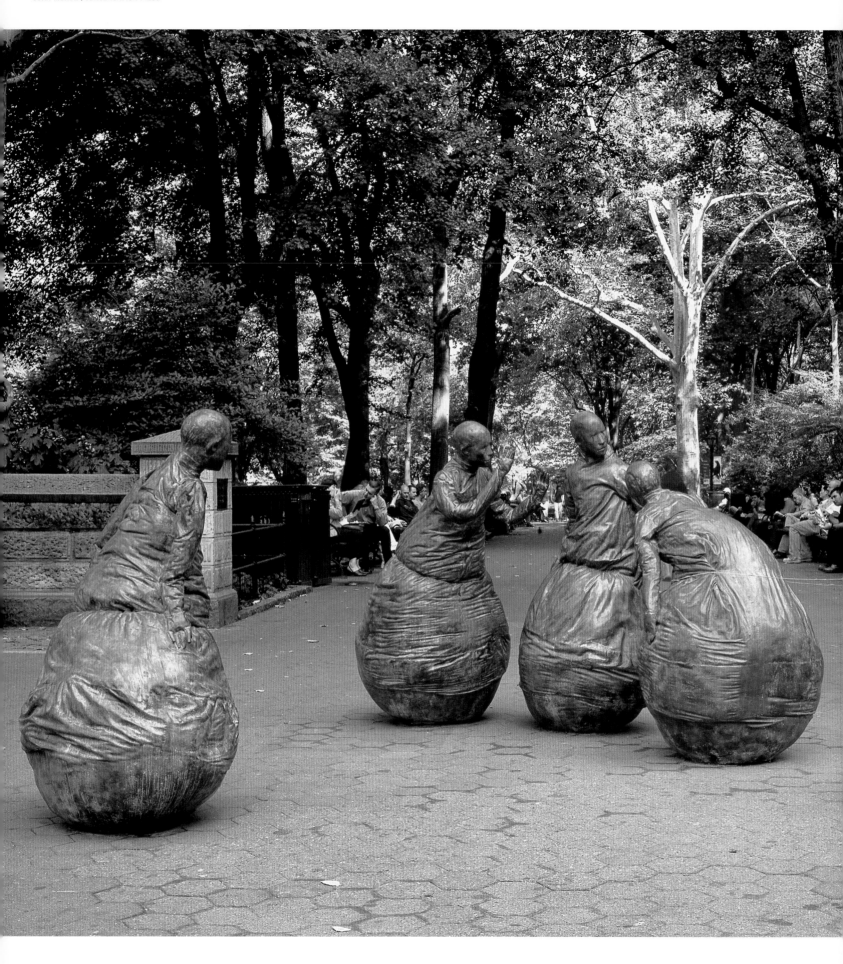

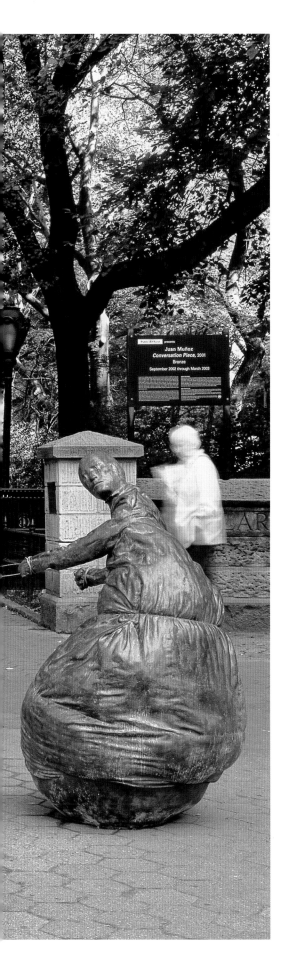

JUAN MUÑOZ

Born in Madrid, 1953. Died 2001.
Studied at Pratt Graphic Center, New York (1982), Croydon School of Art, London (1980),
and Central School of Art and Design, London (1977).

SELECTED EXHIBITION HISTORY

Juan Muñoz's recent solo exhibitions have taken place at Hirshhorn Museum and Sculpture Garden, Smithsonian Institution, Washington, D.C., (2002; traveled to the Museum of Contemporary Art, Los Angeles; Art Institute of Chicago; and Contemporary Arts Museum, Houston, Texas); Tate Modern, London (2001); Louisiana Museum for Moderne Kunst, Humlebaek, Denmark (2000); Marian Goodman Gallery, New York (1999); and Galleria Continua, San Gimignano, Italy (1997). Recent group exhibitions include *Collaborations with Parkett: 1984 to Now*, MoMA, New York (2001); *Around 1984: A Look at Art in the Eighties*, P.S. 1 Contemporary Art Center, Long Island City, Queens (2000); *Over the Edges: the Corners of Ghent*, Stedelijk Museum voor Actuele Kunst, Ghent, Belgium (2000); 12th Sydney Biennale, Art Gallery of New South Wales, Australia (2000); *Trace*, 1st Liverpool Biennale, Tate Gallery Liverpool, England (1999); 6th Istanbul Biennale (1999); *Dibujos germinales: 50 artistas espanoles*, Palacio de Velázquez, Museo Nacional Centro de Arte Reina Sofía, Madrid (1998); *Wounds: Between Democracy and Redemption in Contemporary Art*, Moderna Museet, Stockholm (1998); *Voice Over: Sound and Vision in Current Art*, Hayward Gallery, London (1998; traveled to Arnolfini Gallery, Bristol, England); and 47th Venice Biennale, Italy (1997).

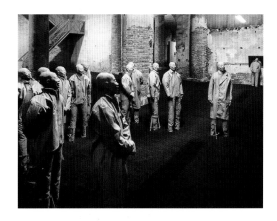

FURTHER READING

Ebony, David, "Fact and Fable: Juan Muñoz," *Art in America*, 90, Oct. 2002, pp. 116–22, 191

Juan Muñoz, exhib. cat. by Lynne Cooke, New York, Dia Center for the Arts, 1999

Juan Muñoz, exhib. cat. by Neal Benezra et al., Chicago, Art Institute of Chicago, in association with University of Chicago Press and Hirshhorn Museum and Sculpture Garden, 2001

Juan Muñoz: Monólogos y diálogos/Monologues and Dialogues, exhib. cat. by James Lingwood, Madrid, Museo Nacional Centro de Arte Reina Sofía, 1996

Juan Muñoz: The Nature of Visual Illusion, exhib. cat. by Adrian Searle and Asa Nacking, Humlebaek, Louisiana Museum for Moderne Kunst, 2000

Muñoz, Juan, et al., *Parkett*, no. 43, 1995, pp. 20–45 (including Lynne Cooke, "Juan Muñoz and the Specularity of the Divided Self," pp. 20–23; Alexandre Melo, "The Art of Conversation," pp. 36–41; Juan Muñoz and James Lingwood, "A Conversation, New York, 22 Jan. 1995," pp. 42–45)

Muñoz, Juan, et al., *Silence Please!: Stories After the Works of Juan Muñoz*, Zurich (Scalo Verlag) and Dublin (Irish Museum of Modern Art) 1996

Searle, Adrian, "Waiting for Nothing," *Frieze*, no. 2, Dec. 1991, pp. 24–29

The Unilever Series: Juan Muñoz, exhib. cat. by Susan May, London, Tate Modern, 2001

LEFT:

Conversation Piece, 2001
(presented in 2002–2003)

RIGHT, TOP:

Half Circle, 1997
Installation of 12 polyester resin figures at the 47th Venice Biennale, Italy

RIGHT, BOTTOM:

Double Bind, 2001
Installation of figures, elevator shafts, floor at the Turbine Hall, Tate Modern, London

Reversed Double Helix, the title of Takashi Murakami's exhibition at Rockefeller Center, refers to genetic reversal or, as the artist puts it, "an icon which emerges through a mutation." Murakami's best-known characters, such as Mr. DOB, are endlessly mutable, changing from friendly to fearsome in a manner associated with gods, monsters, aliens, or cartoons—all words that could describe Tongari-kun, one of several new sculptures made for the exhibition. Tongari-kun (Japanese for "Mr. Pointy")—a Buddha-like figure, 23 feet (7 m) tall, with a sweetly ambivalent smile, eighteen arms, and an oval head that tapers to a colorful spire—is a new addition to Murakami's coterie, whom the artist regards as "an alien as well as a religious icon." Inspired by both Buddhist iconography and the supernatural creatures of ancient animism, Tongari-kun is—according to Murakami—the spiritual embodiment of postwar Japan, a society that he says has had "no solid cultural core" since the nation's wartime defeat. "The culture that flowered in such an environment," he said recently, "is the culture of kawaii—that is, 'cuteness.' It's almost religious."

Since 1995, when he first created and trademarked Mr. DOB, Takashi Murakami has systematically developed a kaleidoscopic universe of happy flowers, fanged mushrooms, winking eyeballs, and other characters. Widely known for his exuberant, combinatory approach to art-making and mass-marketing, Murakami creates painting and sculpture, but also renders his characters as key chains, stuffed dolls, and other consumer products made by or produced under the supervision of Kaikai Kiki, the artist's studio and production company (an ambitious enterprise with more than forty staff members in Tokyo and New York). Murakami describes his work as "superflat," a term that serves double duty. On one hand, it acknowledges the historical primacy of two-dimensionality in Japanese visual art. But it also describes Murakami's nimble conflation of fine art, high-end products, and mainstream culture, which found a fitting home at Rockefeller Center, New York's most famous commercial public space.

Mystical and mischievous, Tongari-kun presided over a quartet of guards (collectively called Shitennoh) and two colorful patches of mushroom stools (Kinoko). But the first elements of the exhibition that most passersby noticed were the two massive black balloons, hovering motionless in a matrix of tethers as if caught in a giant spider's web. The balloons—as well as the mushroom seats and artist-designed flags—were covered in wide-open eyeballs, the artist's recurring reference to Hyakume ("Hundred Eyes"), a character who appeared in a Japanese comic book Murakami read during his childhood. Murakami has long acknowledged his debt to otaku, an underground culture of people who are fanatically devoted to manga and anime (Japanese comics and animation). Although otaku is an inherently Japanese phenomenon, a parallel can be drawn with the more global idea that movies and other forms of mass entertainment offer universal fantasy and escape. For Murakami, Reversed Double Helix was a spectacular fictional world, sized to complement and transform an iconic New York cityscape.

OPPOSITE:

Reversed Double Helix at Rockefeller Center, Manhattan, September 9–October 12, 2003

FOLLOWING PAGES:

PAGE 180, TOP LEFT AND BOTTOM:

Kinoko, 2003 Fiberglass with internal steel frame

PAGE 180, TOP RIGHT:

Koumo-kun, one of the four Shitennoh, 2003 Fiberglass with internal steel frame

PAGES 180–81:

Tongari-kun and Shitennoh, 2003 Fiberglass with internal steel frame

TAKASHI MURAKAMI
Reversed Double Helix

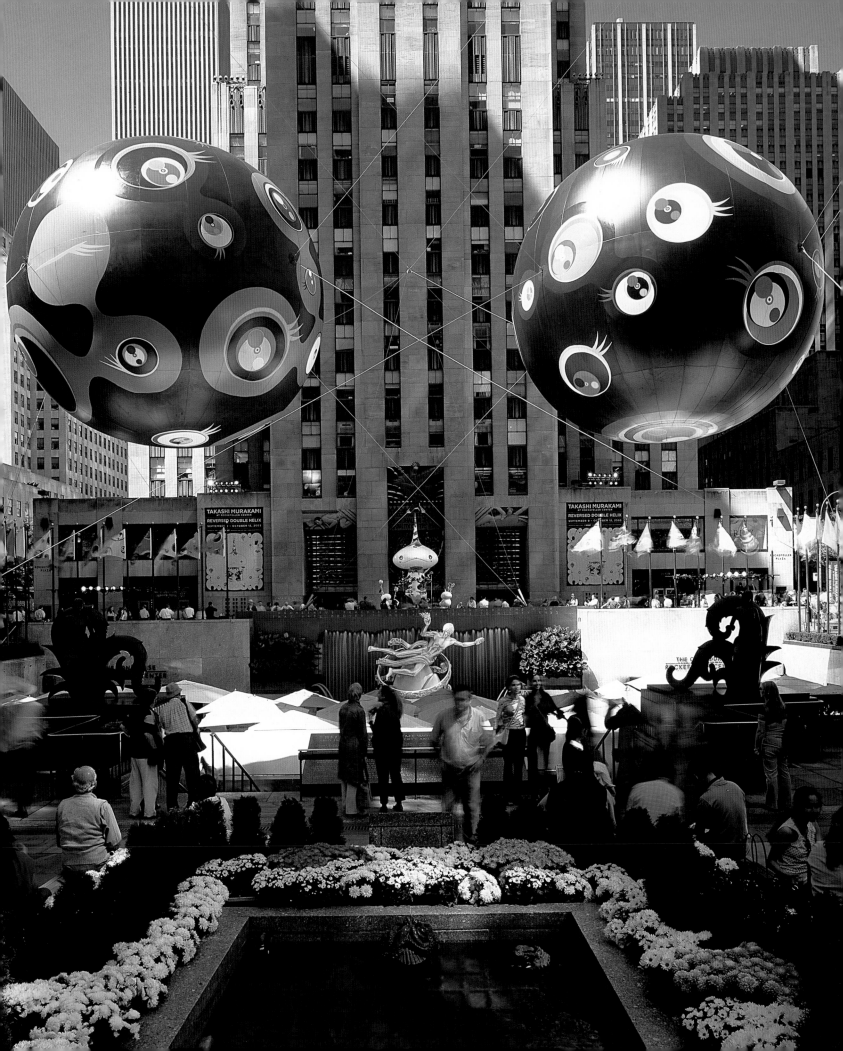

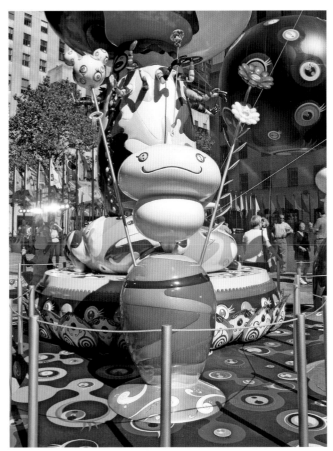

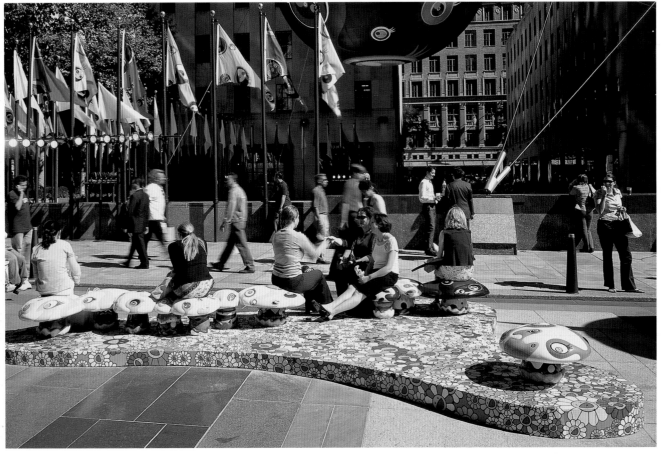

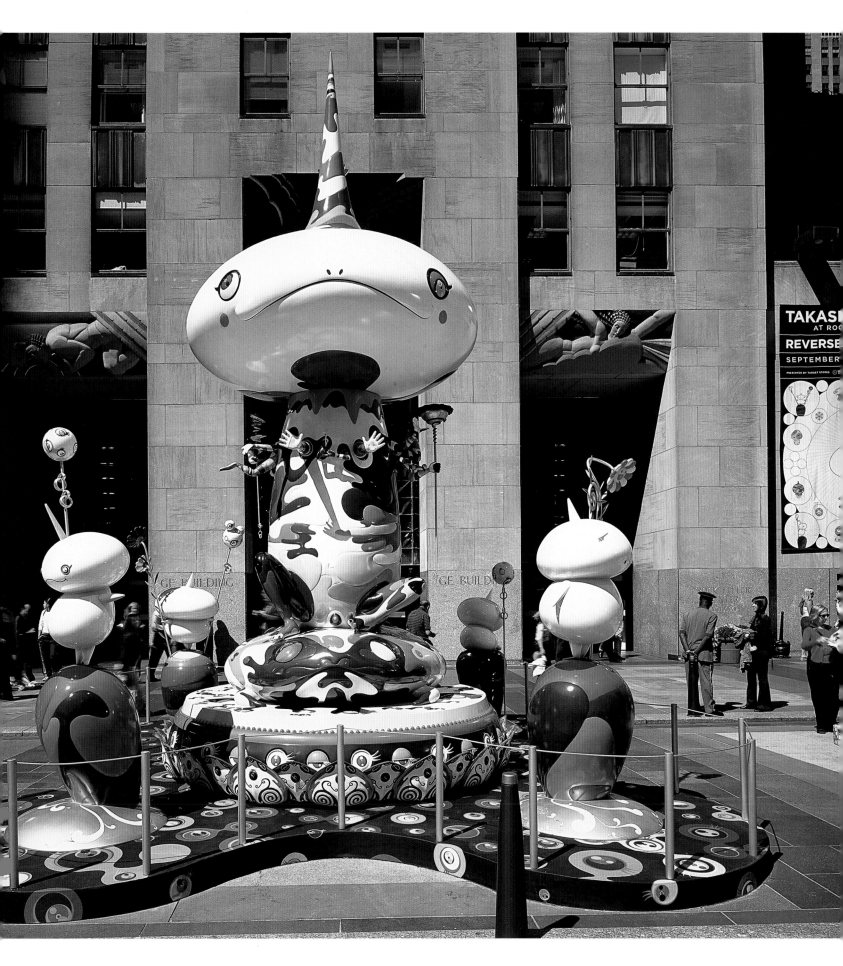

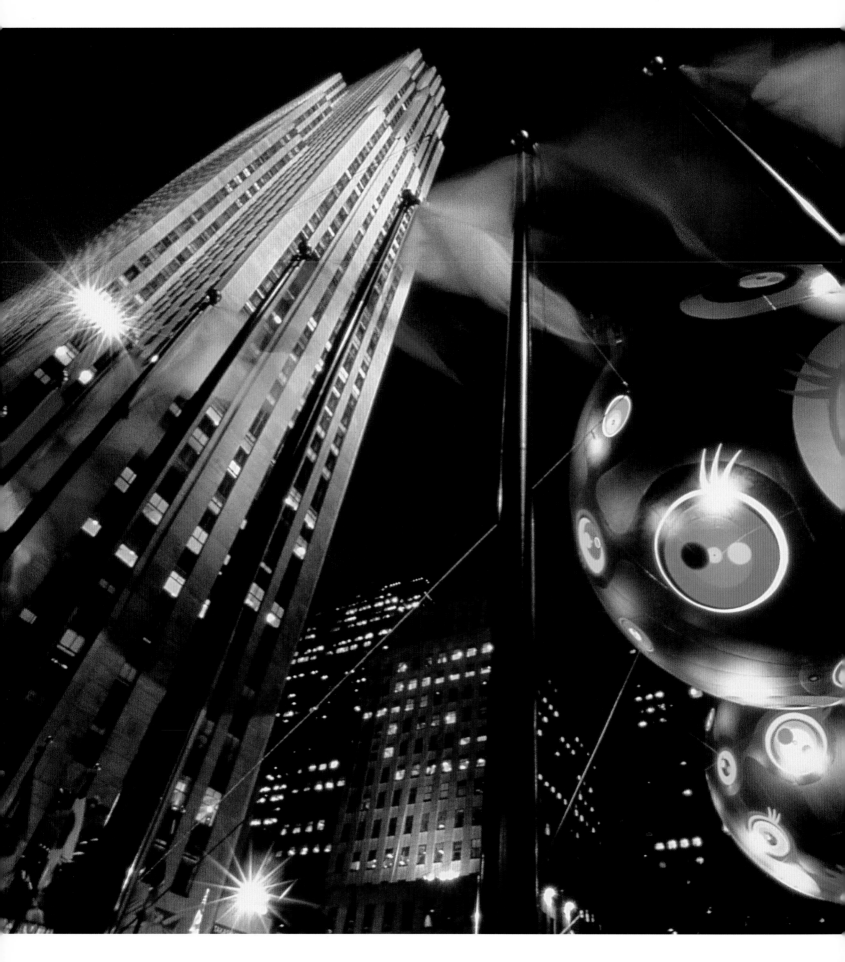

↘ TAKASHI MURAKAMI

Born in Tokyo, 1962.
Studied at Tokyo National University of Fine Arts and Music (PhD, 1993; MFA, 1988; BFA, 1986).

SELECTED EXHIBITION HISTORY

Takashi Murakami has recently had solo exhibitions at Marianne Boesky Gallery, New York (2003, 2001, 1999); Fondation Cartier pour l'art contemporain, Paris (2002); Museum of Fine Arts, Boston (2001); and P.S. 1 Contemporary Art Center, Long Island City, Queens (2000). Recent group exhibitions include *Drawing Now: Eight Propositions*, MoMA QNS, Long Island City, Queens (2002); *Form Follows Fiction*, Castello di Rivoli Museo d'Arte Contemporanea, Turin, Italy (2001); *Casino 2001: 1ˢᵗ Quadrennial*, Stedelijk Museum voor Actuele Kunst, Ghent, Belgium (2001); *Beau Monde: Toward a Redeemed Cosmopolitanism*, 4th Biennale, SITE Santa Fe, New Mexico (2001); *Painting at the Edge of the World*, Walker Art Center, Minneapolis (2001); *Let's Entertain*, Walker Art Center, Minneapolis (2000); Carnegie International, Pittsburgh (1999); *Fluffy*, Dunlop Art Gallery, Regina, Canada (2000; traveled); and *Cities on the Move*, Secession, Vienna (1997; traveled). Murakami also curated and participated in the exhibition *Superflat*, Museum of Contemporary Art, Los Angeles (2001; traveled).

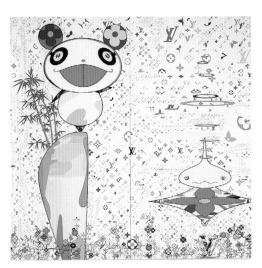

FURTHER READING

Adato, Allison, "Mr. Pointy," *People*, Sept. 15–22, 2003, pp. 75–76

Budick, Ariella, "Does Mr. Pointy Have a Point?" *New York Newsday*, Sept. 22, 2003, pp. B1, B6–B7, B16

Cotter, Holland, "Carving a Pop Niche in Japan's Classical Tradition," *The New York Times*, June 24, 2001, Arts & Leisure section 2, pp. 31–32

Itoi, Kay, "The Wizard of DOB," *ARTnews*, 100, March 2001, pp. 134–37

Maneker, Marion, "The Giant Cartoon Landing at Rockefeller Center," *The New York Times*, Aug. 24, 2003, Arts & Leisure section 2, p. 23

Marks, Peter, "A Japanese Artist Goes Global," *The New York Times*, July 25, 2001, pp. E1, E5

Roberts, James, "Magic Mushrooms," *Frieze*, no. 70, Oct. 2002, pp. 66–71

Siegel, Katy, "Planet Murakami," *ArtReview*, 54, Nov. 2003, cover, pp. 46–53

Takashi Murakami, exhib. cat. by Takashi Murakami, Paris, Fondation Cartier pour l'art contemporain; London, Serpentine Gallery, 2003

Takashi Murakami: Summon Monsters? Open the Door? Heal? Or Die? exhib. cat. by Takashi Murakami *et al.*, Museum of Contemporary Art Tokyo, 2001

LEFT:

Eyeball Balloons and *Eyeball Flags*, 2003
Nylon fabric

RIGHT, TOP:

DOB in a Strange Forest, 1999
FRP, resin, fiberglass, acrylic

RIGHT, MIDDLE:

Tan Tan Bo Puking— a.k.a. Gero Tan, 2002
Acrylic on canvas mounted on board

RIGHT, BOTTOM:

The World of Sphere, 2003
Acrylic on canvas

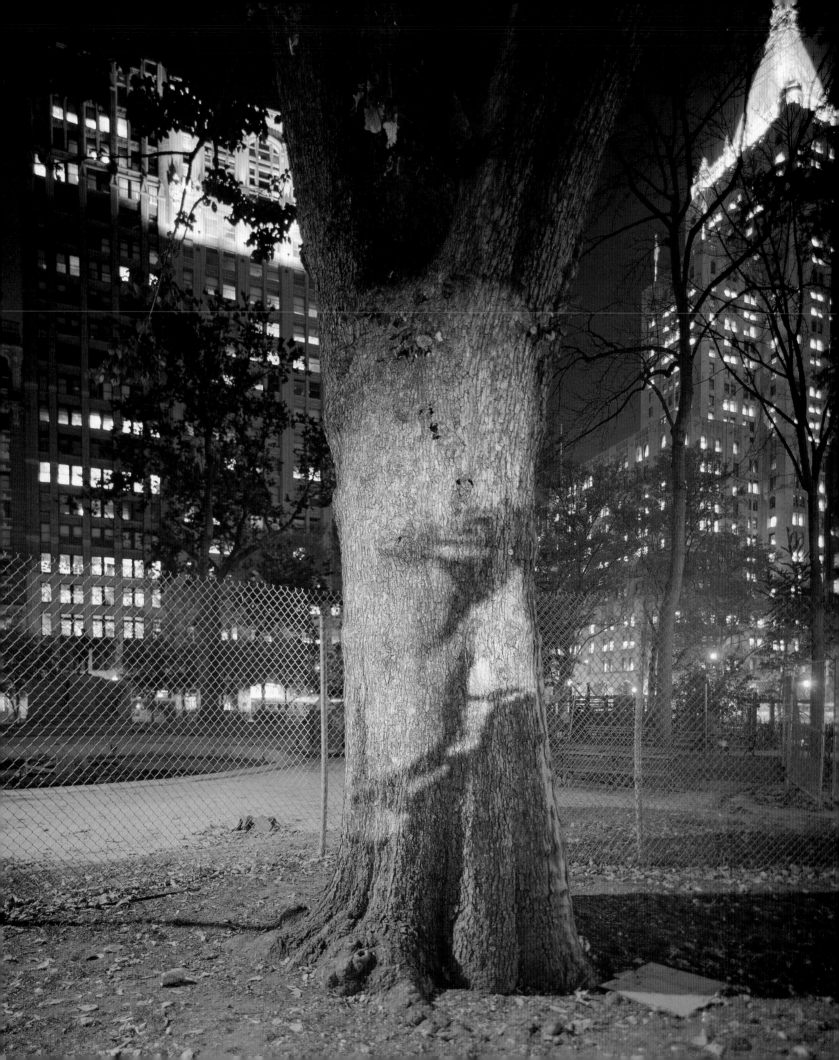

Tony Oursler's multifaceted nocturnal installation in Madison Square Park, *The Influence Machine*, ran for thirteen crisp autumn evenings in 2000, coming to a close on Halloween night. At the time, the nineteenth-century park was undergoing a drastic renovation, and Oursler took advantage of this rough-edged state of flux, transforming a zone of urban renewal into a macabre landscape filled with spirits and immaterial presences conjured from the technical beyond. Combining historical research with Oursler's trademark projections of the human form, *The Influence Machine* was a contemporary *son et lumière* (a public spectacle of sound and light) that turned an after-dark stroll into a sinister and entertaining journey through an astonishing maze of talking heads, garbled narratives, and knocking hands.

Oursler's darkly comic installations of murmuring, nervous, or anguished disembodied faces, projected on to cloth dummies, Plexiglas, and other platforms have been an art-world staple since his appearance at *Documenta IX* in 1992. In recent years, he has turned his attention to the history and psychology of his own medium, investigating how communication technologies—like radio, television, and most recently the Internet—are often perceived as extensions of human consciousness. At the time that he began *The Influence Machine*, Oursler was also working on *Timestream*, a timeline tracking 2500 years of scientific innovation and spiritual mysticism, two aspects of human history that have overlapped with surprising frequency, as each new media form has been used by quacks and believers alike to contact or transmit messages from the dead. In 1763, for example, French showman-scientist Etienne-Gaspard Robertson merged occult and optics in *Fantasmagoria*, a magic lantern show that terrified Parisian audiences by projecting eerie images on to the walls of a crypt in an abandoned Capuchin convent. Samuel Morse developed the Morse code in 1832 and, just over a decade later, Kate Fox—one of three sisters whose ghostly activities sparked the American spiritualist movement—famously communicated with the spirit world by rapping on walls, which Oursler has called "a folk appropriation of Morse code."

The Influence Machine invoked the names and fragmented stories of Robertson, Morse, the Fox Sisters, and others, drawing them into Oursler's elaborate exploration of the proverbial ghost in the machine, which balanced spectacular effects with an almost Brechtian exposure of the mechanisms involved in their production. Human heads, uttering disjointed narratives, materialized on treetops and on dissipating plumes of smoke. A black iron lamppost flashed in time with a voice that relayed a volley of stream-of-consciousness thoughts, which had been typed by unknown users into the project website. A hand rapped loudly on the wall of the nearby Metropolitan Life building, projected texts scrolled across a cyclone fence, and a man repeatedly bumped his head on a tree trunk—all to a soundtrack of radio feedback and eerie glass-harmonica music. Tapping into the mystical properties of familiar technology, *The Influence Machine* went bump in the night in the shadow of the Flatiron Building—and then, fittingly, vanished into thin air, rematerializing the following day in London's Soho Square, where it was presented by Artangel.

OPPOSITE:

The Influence Machine
(tree-trunk projections), 2000
Video, sound, and
mixed-media installation
Madison Square Park, Manhattan,
October 19–31, 2000

FOLLOWING PAGES:

The Influence Machine
(smoke projections), 2000

TONY OURSLER
The Influence Machine

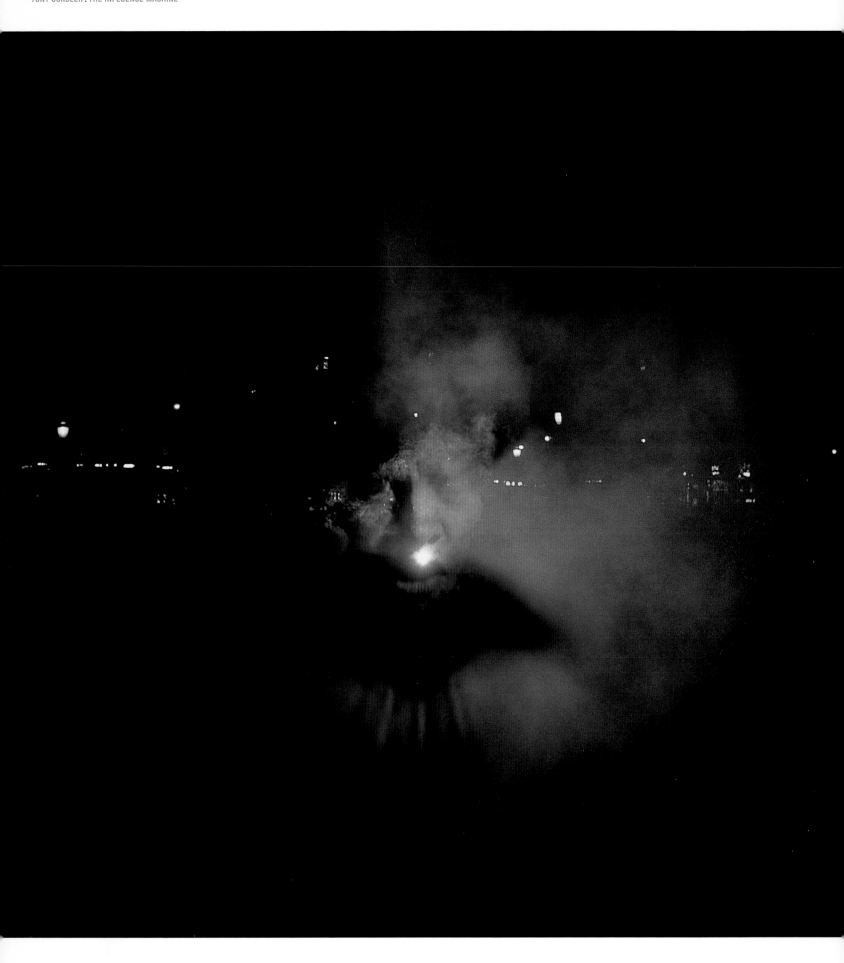

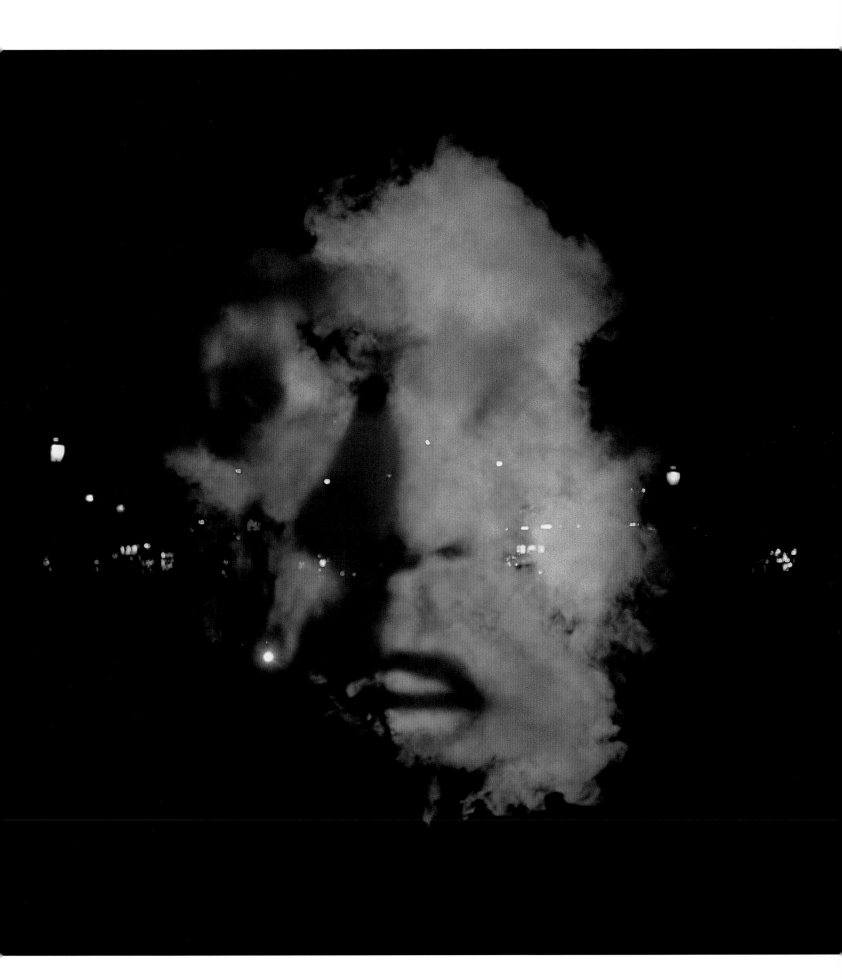

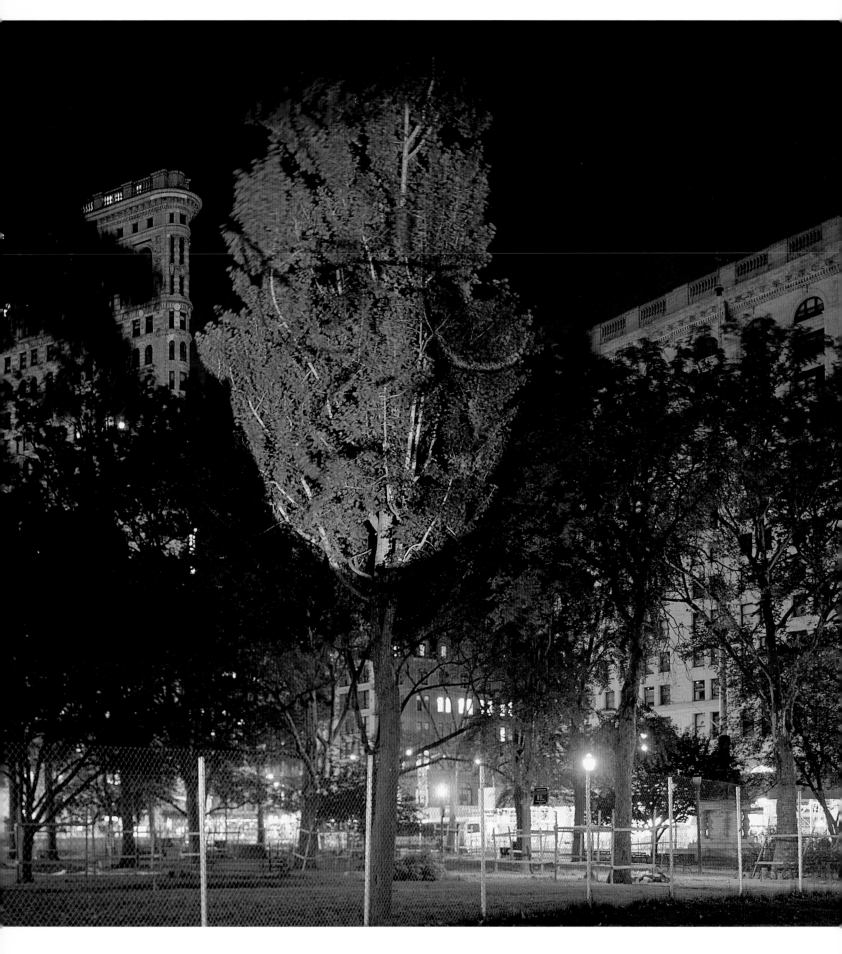

↘ TONY OURSLER

Born in New York, 1957.
Studied at California Institute for the Arts, Valencia (BFA, 1979).

SELECTED EXHIBITION HISTORY

Tony Oursler has recently had solo exhibitions at Magasin 3 Stockholm Konsthall, Sweden (2002); Institut Valencià d'Art Modern, Valencia, Spain (2001); Whitney Museum of American Art, New York (2000); Henry Art Gallery, University of Washington, Seattle (2000); and MASS MoCA (Massachusetts Museum of Contemporary Art), North Adams (1999; traveled to University Art Gallery, University of California, San Diego; Des Moines Art Center; Museum of Contemporary Art, Los Angeles; Contemporary Arts Museum, Houston, Texas; and Williams College, Williamstown, Massachusetts). Recent group exhibitions include *The First Decade: Video from the EAI Archives*, MoMA, New York (2002); *Tele[visions]*, Kunsthalle Wien, Vienna (2001); *Spectacular Bodies*, Hayward Gallery, London (2000); 6th Istanbul Biennale, Istanbul Foundation for Culture and Arts (1999); *The American Century: Art and Culture 1900–2000, Part II 1950–2000*, Whitney Museum of American Art, New York (1999); 24th São Paulo Bienal, Brazil (1998); *The Poetics Project: 1977–1997*, Watari Museum of Contemporary Art, Tokyo (1997); *Documenta X*, Kassel, Germany (1997); *Skulptur: Projekte in Münster 1997*, Westfälisches Landesmuseum, Münster, Germany (1997); and 1997 Biennial Exhibition, Whitney Museum of American Art, New York (1997).

FURTHER READING

Ardenne, Paul, "Tony Oursler's Cruel Theater," *Art Press*, no. 229, Nov. 1997, pp. 19–24

Bumpus, Judith, "Video's Puppet Master," *Contemporary Visual Arts*, 15, 1997, pp. 38–43

Kazanjian, Dodie, "Dark Star," *Vogue*, March 2000, pp. 518–22

Kimmelman, Michael, "A Sculptor of the Air with Video," *The New York Times*, April 27, 2000, pp. E27, E29

Oursler, Tony, *et al.*, *Parkett*, no. 47, 1996, pp. 21–41 (including Louise Neri, "Oursler/Leopold/Neri: A Conversation in the Green Room," pp. 21–37; Lynne Cooke, "Tony Oursler Alters," pp. 38–41)

Rosen, Carol, "What Are You Looking At?" *Sculpture*, 19, May 2000, pp. 34–39

Searle, Adrian, "Nowhere to Run," *Frieze*, no. 34, May 1997, pp. 42–47

Smith, Roberta, "Tony Oursler: 'The Influence Machine,'" *The New York Times*, Oct. 27, 2000, p. E38

Tony Oursler, exhib. cat. by Tony Oursler *et al.*, Valencia, Institut Valencia d'Art Modern, 2001

Tony Oursler: The Influence Machine, exhib. cat. by Tom Eccles, James Lingwood *et al.*, London (Artangel) 2002

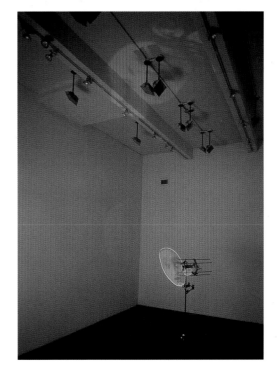

LEFT:

The Influence Machine
(treetop projection), 2000

RIGHT, TOP:

Getaway # 2, 1994
Video projector, VCR,
videotape, mattress, cloth

RIGHT, BOTTOM:

Endfire Array, 2001
Sony DPL CSE projector,
DVD player, DVD, metal

Nam June Paik opened his two-work exhibition at Rockefeller Center on a hot summer evening in 2002 with *Live Piano 20/21*, a short piano performance that activated *Transmission*, a new sculptural laser work made with his frequent collaborator Norman Ballard. Those in the audience familiar with the artist's legendary, iconoclastic multimedia performances and Fluxus actions of the 1960s and 1970s might have been surprised when Paik took the stage and began playing snippets of folk songs and popular standards like "Oh Susannah" and "The Battle Hymn of the Republic." But Paik's performance, characteristically free-form, was perfectly in tune with *Transmission*, a broadcast tower 33 feet (10 m) tall with neon-lined rungs that pulsed and rippled with each note he played, leading up to a trio of choreographed laser beams that emanated from the tower's tip to the far corners of the plaza. The visual patterns generated by the melodies, recorded by *Transmission*'s software system, were replayed and remixed throughout Paik's ten-week exhibition, eliciting a lyrical connection between the refrains of bygone American music and a vanishing icon of the twentieth-century media landscape.

From his earliest video work to his towering installations of flickering televisions, Nam June Paik has sought "new, imaginative and humanistic ways of using our technology," as he wrote in a 1969 gallery statement. The laser has been of interest to Paik since the late 1960s and has become the key element of his "post-video" work since the late 1990s; in his hands, it becomes its own medium, carving visible lines and shapes into space, interacting with its physical surroundings. Installed at 30 Rockefeller Plaza—the Art Deco building that famously houses the corporate headquarters of media giants NBC and RCA—*Transmission*'s radio tower sent direct visual information to passersby, rather than broadcasting an invisible volley of images, voices, and sounds to far-flung locations.

Transmission was joined on the plaza by the artist's elegiac sculptural installation *32 cars for the 20th century: play Mozart's Requiem quietly* (1997), a collection of classic examples of the American auto industry's heyday, from a 1929 Ford Model A to the infamously maligned 1959 Edsel. Dinged-up and damaged, each automobile was painted silver, stripped of its engine, and filled with defunct audiovisual equipment, transforming once-powerful vehicles into ghostly reliquaries of what Paik calls "machine-age junk." Near the cars, one could make out the strains of Mozart's Requiem (the composer's final, unfinished work), Paik's overt suggestion that a parallel can be drawn between the fleeting currency of technological innovation and the temporal nature of human existence. Set within the aptly symbolic terrain of Rockefeller Center, *32 cars* and *Transmission* balanced optimism and obsolescence, comprising an unsentimental ode to the twentieth century, an era that saw the rise and crisis of both the car culture and the media culture.

Installation view of two works:
32 cars for the 20th century: play Mozart's Requiem quietly, 1997
Vintage cars, silver paint, media equipment
Transmission, 2002
(made in collaboration with Norman Ballard)
Mixed-media laser installation

Jointly presented as *Transmission*, a two-work exhibition at Rockefeller Center, June 26–September 2, 2002

NAM JUNE PAIK
Transmission

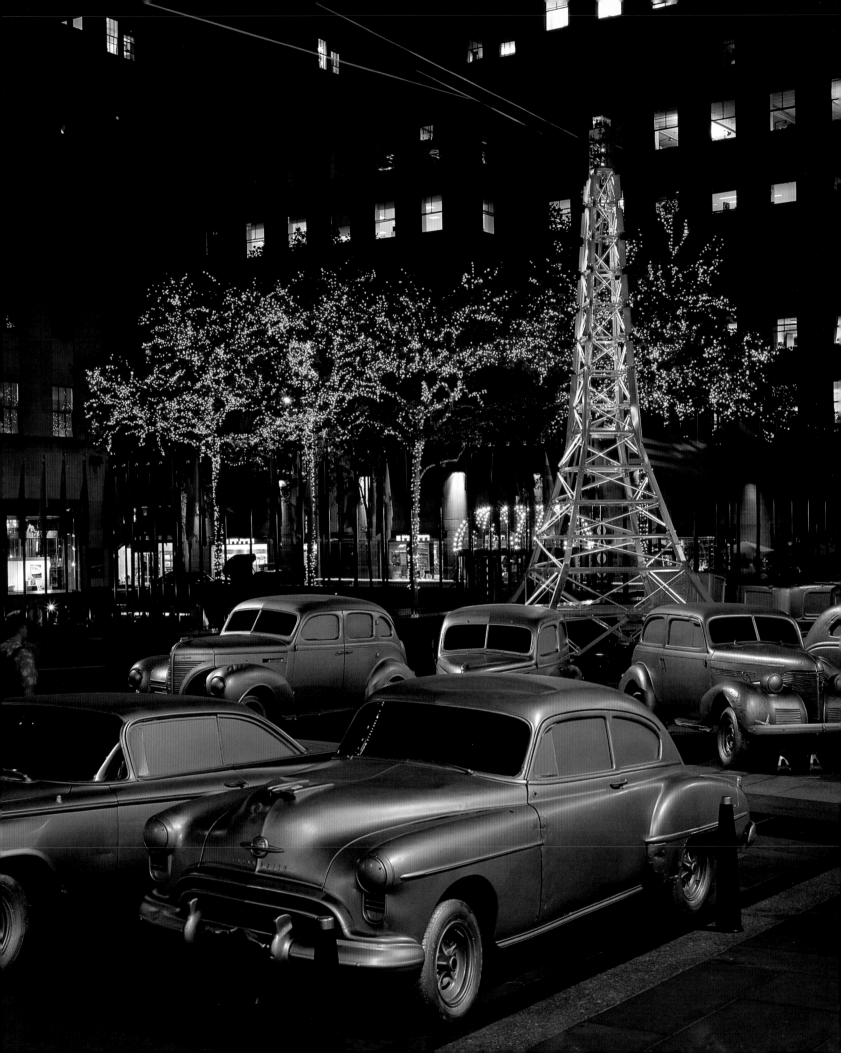

↘ NAM JUNE PAIK

Born in Seoul, 1932.

SELECTED EXHIBITION HISTORY

Nam June Paik has recently had solo exhibitions at Solomon R. Guggenheim Museum, New York (2000); Kunsthalle Bremen, Germany (1999); and Byron Cohen/Lennie Berkowitz Gallery for Contemporary Art, Kansas City, Missouri (1997). Recent group exhibitions include *Moving Pictures*, Solomon R. Guggenheim Museum, New York (2002); *The American Century: Art and Culture, 1900–2000, Part II 1950–2000*, Whitney Museum of American Art, New York (1999); *Jahrhundert: Ein Jahrhundert Kunst in Deutschland*, Hamburger Bahnhof, Berlin (1999); *Geometrie als Gestalt: Strukturen der modernen Kunst, Von Albers bis Paik, Werke der Sammlung DaimlerChrysler*, Nationalgalerie Berlin (1999); *Fluxus in Amerika*, Rafael Vostell, Berlin (1999); *Out of Actions: Between Performance and the Object, 1949–1979*, Geffen Contemporary at the Museum of Contemporary Art, Los Angeles (1998); and *Skulptur: Projekte in Münster 1997*, Westfälisches Landesmuseum, Münster, Germany (1997).

FURTHER READING

Cabutti, Lucio, Marisa Vescovo, and Henry Martin, *Il Giocoliere Elettronico: Nam June Paik e L'Invenzione della Videoarte*, Turin (Hopeful Monsters) 2003

Carr, C., "Into the Misty: Nam June Paik Lights Up Rockefeller Center," *The Village Voice*, July 16–23, 2002, pp. 72–78

Decker-Phillips, Edith, *Paik Video*, Cologne (DuMont Buchverlag) 1988

Joselit, David, "Planet Paik," *Art in America*, 88, June 2000, pp. 72–78

Mellenkamp, Patricia, "The Old and the New: Nam June Paik," *Art Journal*, 54, Winter 1995, pp. 41–47

O'Doherty, Brian, "The Worlds of Nam June Paik," *Artforum*, 38, April 2000, p. 135

Silver, Kenneth E., "Nam June Paik: Video's Body," *Art in America*, 81, Nov. 1993, pp. 100–107

Wadler, Joyce, "Public Lives: The Grandfather of Video Art, Still a Bit Naughty," *The New York Times*, July 10, 2002, p. B2

The Worlds of Nam June Paik, exhib. cat. by John G. Hanhardt, New York, Solomon R. Guggenheim Museum, 2000

Zurbrugg, Nicholas, "Nam June Paik: An Interview," *Visible Language*, 29, Spring 1995, pp. 122–37

LEFT:

Transmission (detail), 2002

RIGHT, TOP:

V-ramid, 1982
Single-channel video installation
with variable number of monitors

RIGHT, BOTTOM:

*Electronic Superhighway:
Continental U.S.*, 1995
47-channel and closed-circuit
video installation with 313
monitors, neon, and steel structure

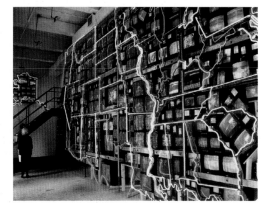

The elegant stainless steel tree that Roxy Paine "planted" in Central Park in the winter of 2002 was a showstopper. Fifty feet (15.2 m) high and weighing thousands of pounds, *Bluff* was a distinctly twenty-first-century paean to the delicately pitched balance between nature and artifice that is Frederick Law Olmsted and Calvert Vaux's nineteenth-century landscape masterpiece. Like an overgrown doppelgänger for the artist's trademark, technically dazzling sculptural fields of synthetic mushrooms, the project—one of the series of off-site components organized by the Public Art Fund for that year's Whitney Biennial—drew from and expanded on several of his long-standing strategies. A simple and succinct gesture, *Bluff* crystallized Paine's consistent engagement with both the technologies of organisms and the often organic character of technology.

Paine grew up in suburban Virginia and came to New York in 1987, following a consciousness-expanding half-decade spent traveling the United States; in the years since his arrival he's developed a diverse but interdependent practice. He's perhaps best known for his lifelike handcrafted installations in which meticulously simulated, often dangerously psychoactive, flora seem to proliferate on walls, floors, and tabletops. His *Crop* (1997–98), for instance, is a bed of crimson poppies, whose slender epoxy bodies and delicate blossoms seem to wave in some undetectable breeze. Paine's engagement with the natural world finds often lyrical expression in these biological forms, but it also emerges from within his more industrial modes of address. One in a series of complex automated machines able to fabricate their own drawings, paintings, and sculptural objects, his *PMU (Painting Manufacture Unit)* (1999–2000) is designed to jet white paint on to canvases over long periods of time, creating richly textural surfaces that suggest geological accretions even as they broadcast their mechanical origins. Like a classical philosopher–scientist of nature armed with the technical capabilities of a space-age fabricator, Paine uses the scientific products of post-industrial society to probe natural systems, looking to identify the many consonances between their operative patterns.

The monumental undertaking involved in the making of *Bluff*—a multi-ton network of upswept branches, composed of two dozen different sizes of steel piping, welded together and then cantilevered over a metal-plate "trunk" 2 feet (60 cm) wide—was belied by the piece's spartan delicacy. Although its bare limbs suggested it was an integral part of the leafless landscape of a Manhattan winter, the remarkable effects of changing light conditions on its reflective surface (like an oak designed by Frank Gehry) announced Paine's sculpture as an uncanny visitor, a temporary and resonant incursion across the boundary between the manufactured and the naturally occurring.

OPPOSITE:

Bluff, 2002
Stainless steel
Central Park, between the
Mall and the Sheep Meadow,
March 7–May 30, 2002

FOLLOWING PAGES:

PAGE 196, LEFT, TOP TO BOTTOM:

Process of making *Bluff*, 2002

PAGES 196–97:

Bluff (detail), 2002

ROXY PAINE
Bluff

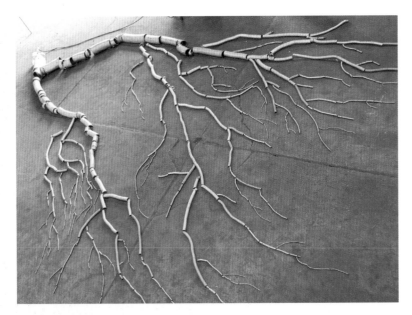

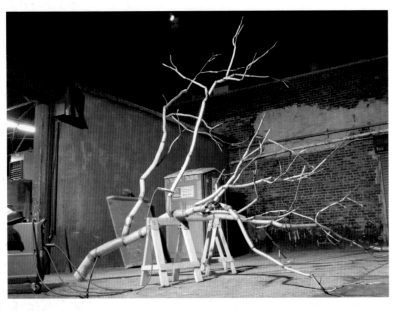

↘ ROXY PAINE

Born in New York, 1966.
Studied at Pratt Institute, New York, and College of Santa Fe, New Mexico.

SELECTED EXHIBITION HISTORY

Roxy Paine has recently had solo exhibitions at James Cohan Gallery, New York (2002); Bernard Toale Gallery, Boston (2002); Rose Art Museum, Brandeis University, Waltham, Massachusetts (2002); Museum of Contemporary Art, North Miami, Florida (2001); Grand Arts, Kansas City, Missouri (2001); Musée d'Art Americain, Giverny, France (1998); and Temple Gallery, Tyler School of Art, Temple University, Philadelphia (1997). Recent group exhibitions include *Early Acclaim: Emerging Artist Award Recipients 1997–2001*, Aldrich Contemporary Art Museum, Ridgefield, Connecticut (2002); 2002 Biennial Exhibition, Whitney Museum of American Art, New York (2002); *Brooklyn!*, Palm Beach Institute of Contemporary Art, Lake Worth, Florida (2001); *Arte y Naturaleza*, NMAC Foundation, Montenmedio Arte Contemporáneo, Cadiz, Spain (2001); *01.01.01: Art in Technological Times*, San Francisco Museum of Modern Art (2001); *Give and Take*, Serpentine Gallery in collaboration with the Victoria and Albert Museum, London (2001); 5th Lyon Biennale (2000); *Greater New York: New Art in New York Now*, P.S. 1 Contemporary Art Center, Long Island City, Queens, in collaboration with MoMA, New York (2000); *Interlacings: The Craft of Contemporary Art*, Whitney Museum of American Art at Champion, Stamford, Connecticut (1998); and *Nine International Artists at Wanås*, Wanås Foundation, Knislinge, Sweden (1998).

FURTHER READING

Bluff, exhib. cat. by Roxy Paine et al., New York, Public Art Fund, 2004

Fineberg, Jonathan, *Art Since 1940: Strategies of Being*, 1995; 2nd edn. New York (Harry N. Abrams) 2000

Johnson, Ken, "Roxy Paine," *The New York Times*, Jan. 15, 1999, p. E42

Landi, Ann, "The Big Dipper," *ARTnews*, 100, Jan. 2001, pp. 136–39

Madoff, Steven Henry, "Nature vs. Machines? There's No Need to Choose," *The New York Times*, June 9, 2002, p. A33

Roxy Paine, exhib. cat. by Scott Rothkopf, New York, James Cohan Gallery, 2001

Roxy Paine: Second Nature, exhib. cat. by Lynn Herbert, Joseph Ketner, and Gregory Volk, Houston, Contemporary Arts Museum, 2002

Vogel, Carol, "Sometimes, Man Can Make a Tree," *The New York Times*, Feb. 27, 2002, pp. A1, B1, B6

Wachtmeister, Marika, *et al.*, *Art at Wanås*, Knislinge (Wanås Foundation) 2001

Yablonsky, Linda, "Roxy Paine: New Work," *Time Out New York*, April 26–May 3, 2001, p. 63

LEFT:

Bluff, 2002

RIGHT, TOP:

Crop, 1997–98
Lacquer, epoxy, oil paint, pigment

RIGHT, BOTTOM:

PMU # 8, 2002
Acrylic on canvas

PAUL PFEIFFER
Orpheus Descending

When Paul Pfeiffer created *Orpheus Descending*, his project sited at the World Trade Center and the adjacent World Financial Center in the spring of 2001, he couldn't have imagined the resonance that the events of half a year later would lend it. The video work, taped over the course of more than ten weeks and shown in real time, twenty-four hours a day, on small monitors positioned at several locations in the complex, documented the life cycle of a flock of chickens raised by the artist and several friends on an upstate New York farm. Starting with a clutch of eggs being warmed by an incubator, the video followed the birds for seventy-five days, from the moment of their hatching through their growth to maturity, ending when Pfeiffer and his collaborators began culling them for the farmhouse table.

Designed to be viewed in snippets, out of the corner of the commuter's eye, *Orpheus Descending* evoked comparisons between the artificial, highly structured urban atmosphere of the World Trade Center and the natural, pastoral environment of the birds' free-range farm home. In an interview published in the Public Art Fund's *Orpheus Descending* catalog, Pfeiffer described the work as a meditation on temporality and routinization, and as being "very much about death—death being synonymous with the consciousness of the passing of time." The project concluded on June 28, 2001—its last image was the sunset on the final day all the chickens were together—just over two months before terrorist attacks destroyed the towers that housed it.

Pfeiffer, a native of Honolulu based in New York, is best known for his elegant, uncanny digital manipulations of appropriated film and video— ranging from his *John 3:16* (2000), where a levitating basketball built from thousands of video stills seems to beat in its small frame like a sacred heart, to his 2001 video triptych *The Long Count (I Shook Up the World)*, for which he "erased" the bodies of Muhammad Ali and his opponents from films of three of his title bouts, leaving only phantasmal ripples, watched by an avid crowd, in their place. Although it deploys a wide range of formal and conceptual approaches, Pfeiffer's work consistently pursues the lyrical potential to be discovered in blurring distinctions between time, place, and activity, crystallizing the myriad ways in which what is present is shaped by what is absent.

OPPOSITE:

Orpheus Descending, 2001
Video installation
World Trade Center and
World Financial Center,
April 15–June 28, 2001

FOLLOWING PAGES:

Orpheus Descending (details),
2001

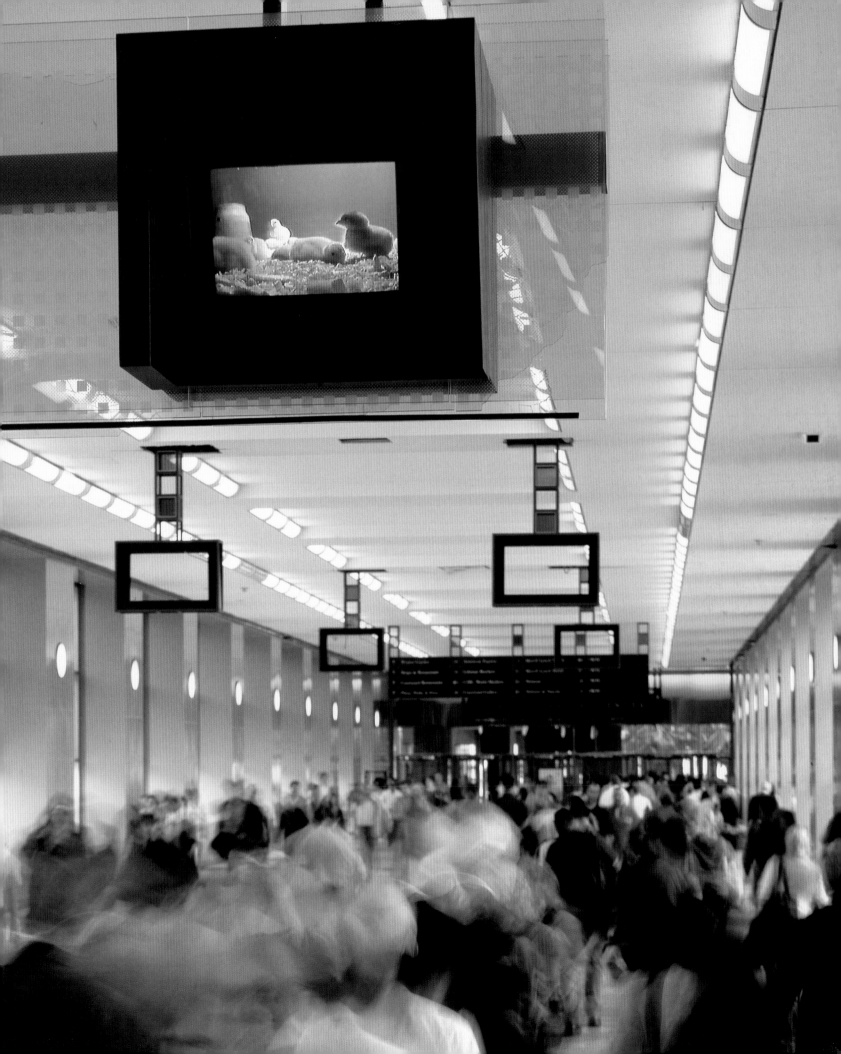

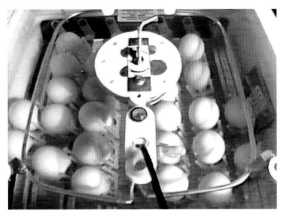

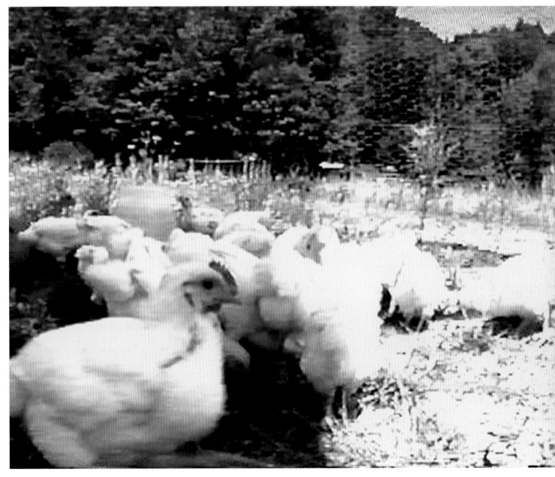

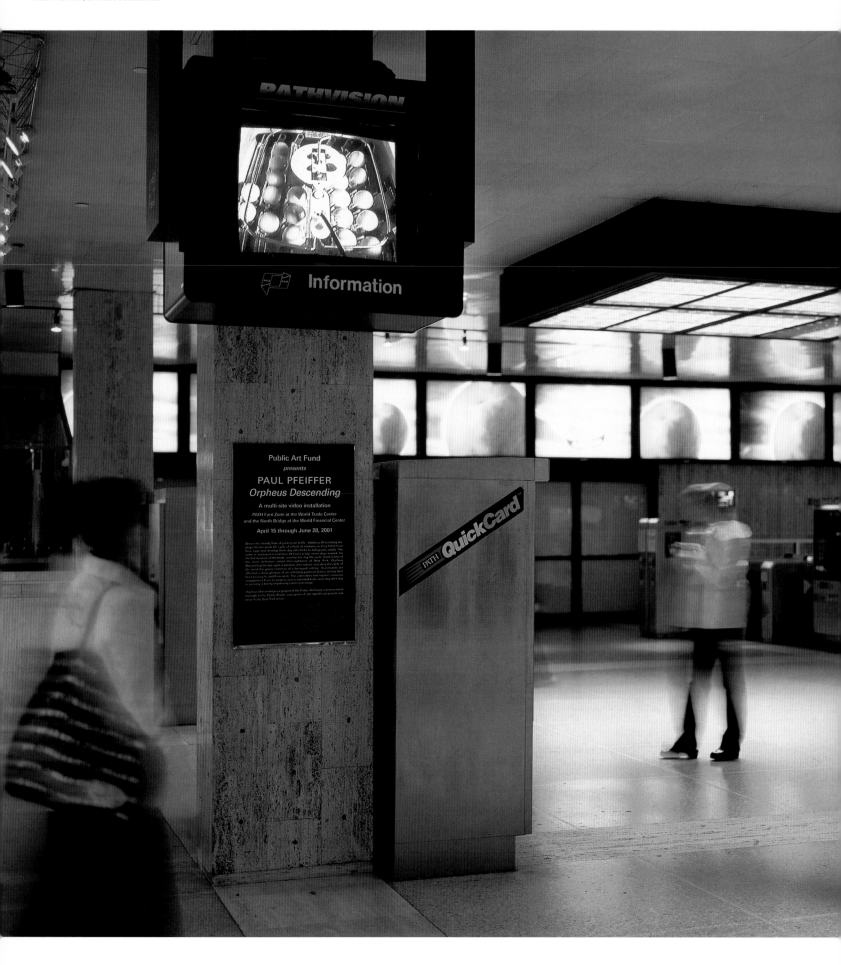

↘ PAUL PFEIFFER

Born in Honolulu, 1966.
Studied on Whitney Museum of American Art Independent Study Program, New York (1997–98),
and at Hunter College, New York (MFA, 1994), and San Francisco Art Institute (BFA, 1987).

SELECTED EXHIBITION HISTORY

Paul Pfeiffer has recently had solo exhibitions at Museum of Contemporary Art, Chicago (2003); List Visual Art Center, Massachusetts Institute of Technology, Cambridge (2003; traveled to SITE Santa Fe, New Mexico); UCLA Hammer Museum, Los Angeles (2001); Whitney Museum of American Art, New York (2001); and The Project, New York (1998). Recent group exhibitions include *Tempo*, MoMA QNS, Long Island City, Queens (2002); 49th Venice Biennale, Italy (2001); *BitStreams*, Whitney Museum of American Art, New York (2001); Maze Gallery, Turin, Italy (2001); *Casino 2001*, Stedelijk Museum voor Actuele Kunst, Ghent, Belgium (2001); *The Americans*, Barbican Art Gallery, London (2001); 2000 Biennial Exhibition, Whitney Museum of American Art, New York (2000); and *Greater New York: New Art in New York Now*, P.S. 1 Contemporary Art Center, Long Island City, Queens (2000).

FURTHER READING

Basilico, Stefano, "Just Another Day on the Farm," *Time Out New York*, June 7–14, 2001, p. 58

Cotter, Holland, "Art in Review: Paul Pfeiffer at the Whitney Museum of American Art," *The New York Times*, Jan. 18, 2002, p. E44

Halle, Howard, "Prize Fighter," *Time Out New York*, Jan. 10–17, 2002, pp. 60–61

Hunt, David, "Man Trap," *Frieze*, no. 53, June–Aug. 2000, pp. 98–99

Paul Pfeiffer, exhib. cat. by Hilton Als, Los Angeles, UCLA Hammer Museum, 2001

Paul Pfeiffer: Orpheus Descending, exhib. cat. by Jeffrey Kastner *et al.*, New York (Public Art Fund) 2001

Piene, Chloe, "Paul Pfeiffer: Eating and Excreting," *Flash Art*, no. 214, Oct. 2000, pp. 84–86

Sheets, Hilarie M., "Making DeMille Dance," *ARTnews*, 99, Nov. 2000, pp. 200–202

Siegel, Katy, "Openings: Paul Pfeiffer," *Artforum*, 38, Summer 2000, pp. 174–75

Yablonsky, Linda, "Making Microart That Can Suggest Macrotruths," *The New York Times*, Dec. 9, 2001, Arts & Leisure section, p. 39

LEFT:

Orpheus Descending, 2001
PATH station in World Trade
Center, April 15–June 28, 2001

RIGHT, TOP AND MIDDLE:

John 3:16, 2000
Digital video still and installation
view
LCD monitor, armature, DVD,
DVD player

RIGHT, BOTTOM:

*The Long Count (I Shook Up the
World)*, 2000
Digital video still

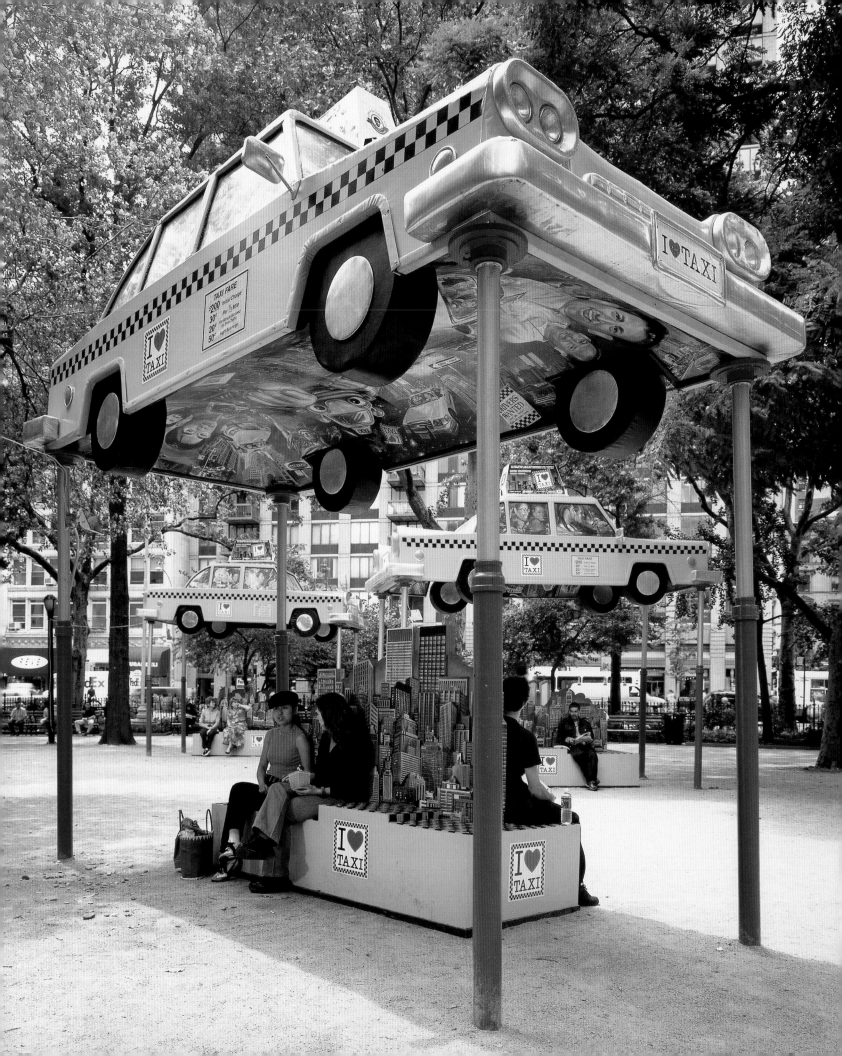

An artist with a truly global outlook, Thai-born Navin Rawanchaikul spent half a dozen years traveling the world to develop his sprawling *Taxiscope* project. *I ♥ Taxi*, the artist's contribution to the *Target Art in the Park* exhibition in the summer of 2001, followed previous versions created in Australia, Japan, and Europe. Rawanchaikul's thesis—that the taxicab represents a particularly intriguing example of socially constructed space, and one that has been overlooked—was inspired by his native Chiang Mai, a city where a huge population of taxis plies one of the world's most notoriously congested urban traffic grids. Conceived as a constellation of gestures highlighting the connections between this mode of transportation and our increasingly atomized twenty-first-century lifestyles, the project was presented in collaboration with P.S. 1 Contemporary Art Center, and planned for a variety of media, in multiple contexts, and at several locations.

At Madison Square Park and at P.S. 1 Contemporary Art Center in Long Island City, Rawanchaikul created taxi-themed environments—in the city, the artist produced canopied seating areas around a hot-dog stand that became a popular lunchtime destination for area workers. At the museum, he renovated the existing café, covering the walls with pages from his *manga*-style comic book featuring the adventures of Taximan—an innocent hero dedicated to seeking the "meaning of Taxi"—hanging hand-painted taxi shells from the ceiling, and fabricating new seating out of old cab tires. And despite (or, indeed, because of) the unexpected last-minute denial of a permit for the most wide-ranging element of *I ♥ Taxi* by the city's Taxi and Limousine Commission—the outfitting of two hundred yellow cabs with special artist-designed seats and pillows, as well as thousands of free copies of the Taximan comic—Rawanchaikul's project managed to provoke precisely the effect it intended. As it played out, the controversy over *I ♥ Taxi* turned attention even more acutely toward the nature of interpersonal exchange in the oddly depersonalized close quarters of a cab, and the ways it is governed by social, political, and commercial conventions.

Despite the loss of his fleet of mobile aesthetic environments, Rawanchaikul did manage to retain one altered cab, based at Madison Square Park, as a unique test environment: "riders" in the stationary vehicle were asked their opinions of the decor and concept. But in keeping with his engagement with issues around the nature of labor, social hierarchy, and community dynamics—a central aspect of the artist's work, just as it is of the work of his fellow-countryman and sometimes collaborator Rirkrit Tiravanija—his focus was as much on the occupant of the driver's seat as on the passenger–viewer. As he told a journalist at the time, "The taxi drivers don't feel they're important. I wanted them to feel happiness about their everyday experience." A sly intervention into a ubiquitous but rarely interrogated aspect of city life, *I ♥ Taxi* represented another important step in Rawanchaikul's epic examination of the relationships between those who drive and those who get driven.

I ♥ Taxi, 2001
Mixed-media installation, taxi,
and comic book
Madison Square Park, Manhattan,
May 31–September 30, 2001

NAVIN RAWANCHAIKUL
I ♥ Taxi

↘ NAVIN RAWANCHAIKUL

Born in Chiang Mai, Thailand, 1971.

SELECTED EXHIBITION HISTORY

Navin Rawanchaikul has recently had solo exhibitions at Palais de Tokyo, Paris (2002); P.S. 1 Contemporary Art Center, Long Island City, Queens (2001); Eurovespa 2001, Fourchambault, France (2001); About Studio/About Café, Bangkok (2000); and Contemporary Art Gallery, Vancouver, Canada (1997). Recent group exhibitions include *Traffic: Art Exchange between Fukuoka and Kitakyushu*, Fukuoka Art Museum and Kitakyushu Municipal Museum of Art, Fukuoka, Japan (2003); Shanghai Biennale, Shanghai Art Museum, China (2002); *Facts of Life: Contemporary Japanese Art*, Hayward Gallery, London (2001); 2nd Berlin Biennale (2001); 2nd Taipei Biennale, Taipei Fine Arts Museum (2000); 5th Lyon Biennale, France (2000); *Media City Seoul*, Seoul Biennale (2000); 11th Sydney Biennale, Australia (1998); *Cities on the Move*, Secession, Vienna (1997; traveled); and *Out of India: Contemporary Art of the South Asian Diaspora*, Queens Museum of Art (1997).

FURTHER READING

Comm...: Navin Rawanchaikul, Individual and Collaborative Projects 1993–1999, exhib. cat. by Helen Michaelson, Tokyo, S by S Co.; and Vancouver, Contemporary Art Gallery, 1999

Farquharson, Alex, *Navin Rawanchaikul: Visual Artist*, Paris (Editions de l'oeil) 2002

Kirker, Anne, "Navin Rawanchaikul's Social Research," *ART Asia Pacific*, 3, Oct.–Dec. 1996, pp. 70–77

McEvilley, Thomas, "Tracking the Indian Diaspora," *Art in America*, 86, Oct. 1998, pp. 74–79

Obrist, Hans Ulrich, "Navin Rawanchaikul: Temples, Streets, and Taxicabs," *Flash Art*, no. 210, Jan.–Feb. 2000, pp. 98–100

Phataranawik, Phatarawadee, "Behind the Wheel," *The Nation*, Feb. 9, 1998, p. C8

Poshyananda, Apinan, "Navin Rawanchaikul," in *Fresh Cream*, London (Phaidon Press) 2000, pp. 496–501

Rawanchaikul, Navin, *I ♥ Taxi*, New York (Public Art Fund) 2001

Rubinstein, Raphael, "Art by the (Taxi) Meter," *Art in America*, 85, Jan. 1997, p. 23

Scherr, Apollinaire, "Trying to Provide Art for $2 Plus $1.50 a Mile," *The New York Times*, June 10, 2001, Arts & Leisure section, p. 29

OPPOSITE:

I ♥ Taxi (detail of taxi interior), 2001

LEFT:

I ♥ Taxi
(detail of hot-dog cart), 2001

RIGHT, TOP:

NAVIN RAWANCHAIKUL
(in collaboration with Rirkrit Tiravanija)
Cities on the Move, 1997
Installation view at Secession, Vienna

RIGHT, MIDDLE:

A Blossom in the Middle of the Heart (City), 1997
Navin Gallery Bangkok
(Taxi Gallery), 1997

RIGHT, BOTTOM:

I ♥ Taxi café at P.S. 1
Contemporary Art Center,
Long Island City, Queens, 2001

A kind of urban mirage promising (conceptual, at least) counterpoint to the heat of a New York City summer, Tobias Rehberger's *Tsutsumu N.Y.* represented a lyrical rupture in both local cultural and meteorological patterns. A small Japanese formal garden plopped into the leafy precincts of Manhattan's Madison Square Park as part of the 2001 installment of the *Target Art in the Park* exhibition series, *Tsutsumu N.Y.* was a cheerful anachronism, made to seem even more out of place by the minute, localized blizzard—produced by one of the only mechanisms in the world capable of generating "snow" at temperatures above freezing—that engulfed it at 6 a.m. every day. After the flurry, the machine would be put away, but the snow sometimes remained for over an hour—more than enough time for it to be seen by workers arriving at nearby offices, for whom it must have seemed like a bit of rogue holiday spirit arrived to cool down the very worst of the dog days.

The trajectory of German-born Rehberger's work over the years leading up to his Public Art Fund project describes an artist with a wide range of both conceptual interests and stylistic facility. His "Performance" series from the mid-1990s, for instance, jumbled the tropes of haute couture and high-end interior decoration in a series of theatrical, room-sized installations featuring actual bits of designer clothing casually strewn over the artist's own furniture designs; by 2000, he was engaged in more broadly public gestures involving natural systems, such as his gardens for museum sites in places like MCA Chicago and the Berkeley Art Museum in California, from which viewers were encouraged to harvest vegetables planted by the artist. *Tsutsumu N.Y.* clearly drew on both precedents. Its gracefully restrained arrangement of a wooden bench, a single rock, and a small pine tree within the elegantly plotted garden space suggested both Rehberger's flair for set decoration and his green thumb, as well as his interest in the manicured, sculptural presence of Asian garden design. The addition of the snow provided literally another layer—a reminder that the artist's interest in such scenarios extends beyond mere formal aesthetics and into the realm of narrative potential, where his manufactured spatial settings provide a kind of endlessly mutable stage for social interactions and the types of stories and behaviors they imply.

As with the architectural interiors he created for his "Furniture" works of 1996—based on friends' descriptions of what they thought would be "pleasant" environments—*Tsutsumu N.Y.* was Rehberger's attempt to bring to life an idealized setting, yet it was an attempt well aware of its own limitations, and one that openly balanced verisimilitude with vivid artificiality. No more likely in reality than a deep, palm-lined pool of cool water in a barren desert, the space of introspective calm and wintry refreshment offered by *Tsutsumu N.Y.* was nevertheless a welcome enticement for the imaginations of hot and harried New Yorkers.

Tsutsumu N.Y., 2001
Mixed-media installation
Madison Square Park, Manhattan,
May 31–September 30, 2001

TOBIAS REHBERGER
Tsutsumu N.Y.

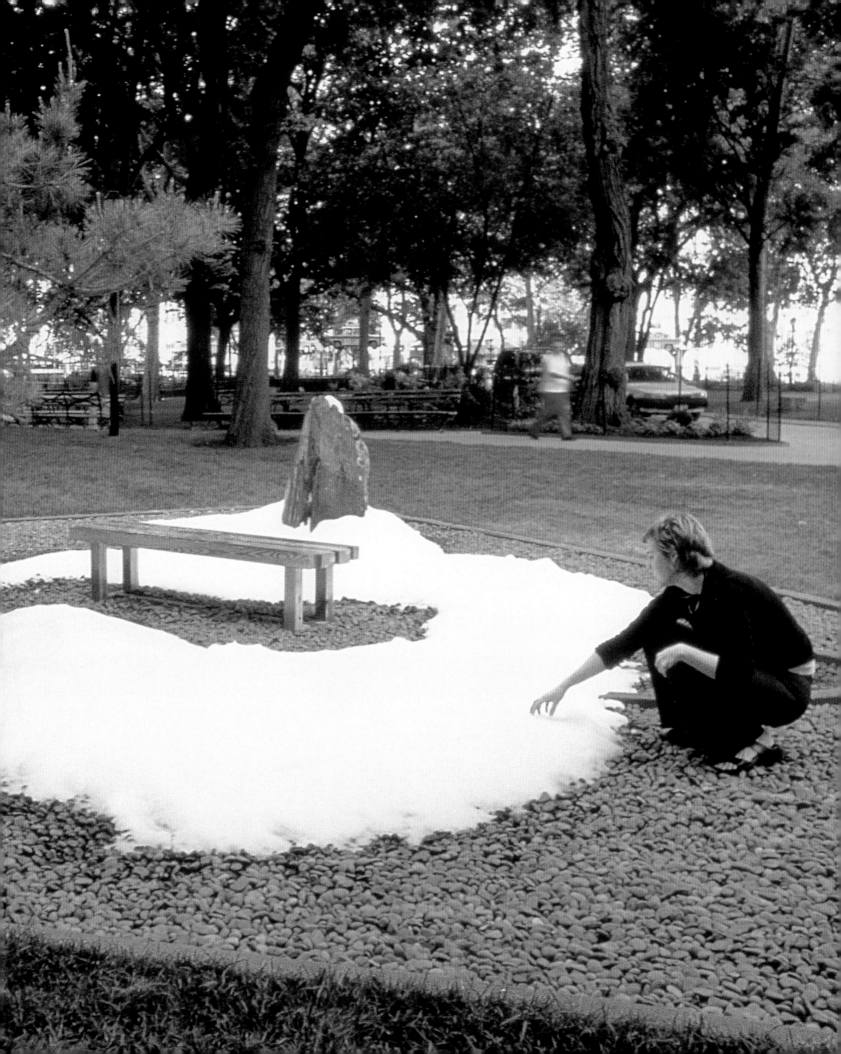

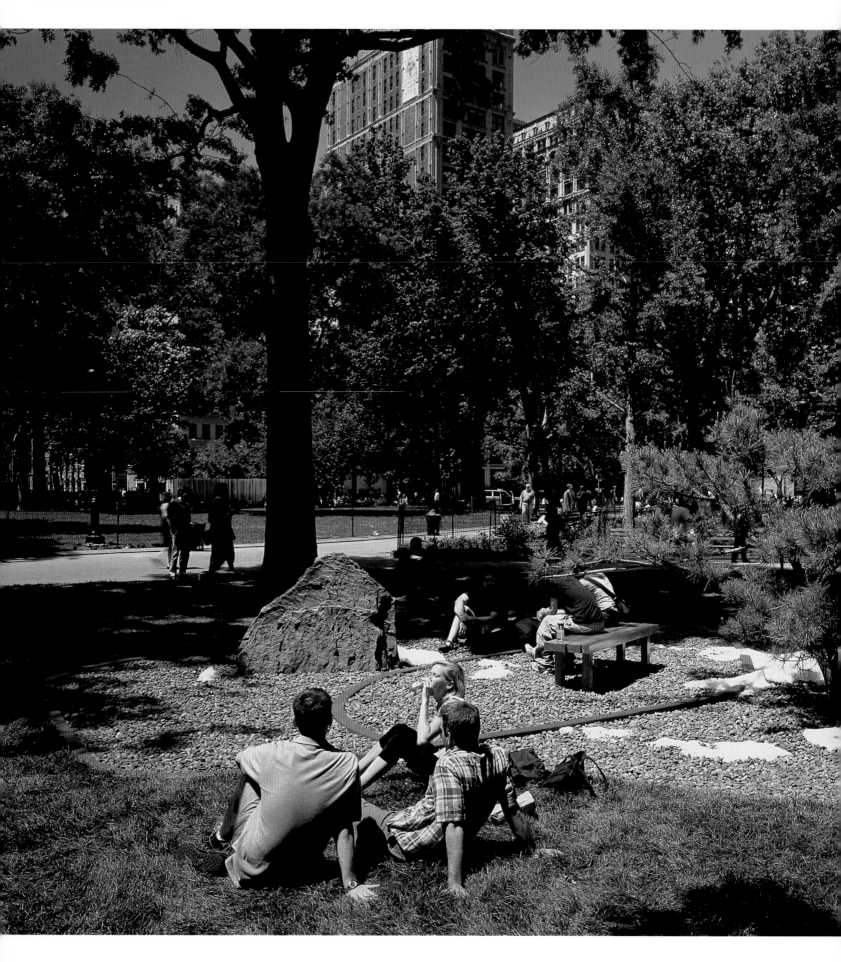

↘ TOBIAS REHBERGER

Born in Esslingen, Germany, 1966.
Studied at Staatliche Hochschule für Bildende Künste, Frankfurt, Germany.

Tobias Rehberger has recently had solo exhibitions at Galleria Civica d'Arte Moderna e Contemporanea, Turin, Italy (2002); Museum für Neue Kunst, Karlsruhe, Germany (2002); Neugerriemschneider, Berlin (2000); Museum of Contemporary Art, Chicago (2000); and Kunsthalle Basel, Switzerland (1998). Recent group exhibitions include *Hossa: Arte Alemán del 2000*, Centro Cultural Andratx, Mallorca, Spain (2002); *Mínim Denominador Común*, Sala Montcada de la Fundación "La Caixa," Barcelona, Spain (2001); *Hommage an Olle Baertling*, Kunsthalle Kiel, Germany (2001); *Raumkörper*, Kunsthalle Basel, Switzerland (2000); *German Open*, Kunstmuseum Wolfsburg, Germany (1999); *kraftwerk BERLIN*, Aarhus Kunstmuseum, Denmark (1999); Sculpture Biennale 1999, Münsterland, Germany (1999); *Dad's Art*, Neugerriemschneider, Berlin (1998); *Manifesta 2*, Luxembourg (1998); and *M&M*, Fondazione Sandretto Re Rebaudengo, Turin, Italy (1997).

FURTHER READING

Birnbaum, Daniel, "A Thousand Words: Tobias Rehberger Talks about His Garden," *Artforum*, 36, Nov. 1998, pp. 100–101

Bonetti, David, "Two Artists, Two Starkly Different Intentions," *The San Francisco Examiner*, Oct. 22, 1999, p. C16

Casadio, Mariuccia, "Rehberger by Tobias Rehberger," *L'Uomo Vogue*, Oct. 2000, pp. 130–37, 221

Decter, Joshua, "Tobias Rehberger," *Artforum*, 36, Feb. 1998, pp. 93–94

Eichler, Dominic, "Tobias Rehberger," *Frieze*, no. 51, April 2000, pp. 102–103

Grosenick, Uta, and Burkhard Riemschneider (eds.), *Art Now: 137 Artists in the Rise of the New Millennium*, Berlin (Taschen) 2002, pp. 420–23

Krenz, Marcel, "Inside-out Art," *ArtReview*, 53, July–Aug. 2002, pp. 70–71

Schneider, Christiane, "Ouverture: Tobias Rehberger," *Flash Art*, no. 195, July–Sept. 1997, p. 129

Smith, Roberta, "Tobias Rehberger," *The New York Times*, June 2, 2000, p. 34

Wakefield, Neville, "Tobias Rehberger," *Elle Décor*, May 2000, pp. 72–76

LEFT:

Tsutsumu N.Y., 2001

RIGHT, TOP:

Performance (Frame Two), 1997
Wood, foam, various clothes by
Walter van Beirendonk

RIGHT, BOTTOM:

Sunny Side Up, 1999
Plants and mixed-media
Installation for the Matrix
Program for Contemporary Art,
University of California, at
Berkeley Art Museum and Pacific
Film Archive

Swiss-born video and installation artist Pipilotti Rist's *Open My Glade*, a series of sixteen one-minute-long video segments, was broadcast in the spring of 2000 on the Astrovision screen in Times Square. The famous urban zone, Rist wrote, was an "overwhelming space full of electric blossoms and electric twinkle" that, in her words, hits visitors like "a slap across the face." The energy of that slap, she noted, would come to serve as the fuel for her work.

Nine of the short films depicted the artist pressing her face against the square video screen as if trying to escape from the world of image into the real world of midtown Manhattan; several others were focused on abstracted close-up elements of her anatomy or her appearance within architectural settings. Taken together, the videos created the kind of irreverently oblique visual poetry for which Rist is best known—spirited and smart, savvy about the tropes of modern visual culture, and imbued with a kind of languid lyricism that often addresses issues of inhibition and liberation, both physical and psychological.

Although recognized in Europe since the late 1980s, Rist captured the international art world's attention at the 1997 Venice Biennale, where she debuted her award-winning video, *Ever Is Over All*. The work featured two screens—on one, a camera moves through a field of long-stemmed flowers; on the other, a cheerful young woman in a long blue dress is carrying what seems to be one of the blooms in her arms as she saunters in slow motion along a row of parked cars. All at once, as a sweet tune wafts on the sound track, the woman stops and with an enormous grin on her face swings the flower over her head and smashes it through a car window. Under the untroubled gaze of various pedestrians, including a passing policewoman, Rist's blissful vandal continues along destroying windows with her metal blossom, giddy in her unembarrassed freedom.

This sensuality and strategic unself-consciousness is typical of Rist's work, a practice organized around a sophisticated understanding of the rules of video narrative, and a mischievous enjoyment in subverting them. Bold, impertinent, canny, entertaining—an apt description of *Open My Glade* and the city into which it was so successfully interjected.

Open My Glade, 2000
Video presentation
One-minute segments shown on
NBC Astrovision by Panasonic,
Times Square, Manhattan,
April 6–May 20, 2000

PIPILOTTI RIST
Open My Glade

↘ PIPILOTTI RIST

Born in Rheintal, Switzerland, 1962.
Studied at Institute of Applied Arts, Vienna, and Basel School of Design, Switzerland.

SELECTED EXHIBITION HISTORY

Pipilotti Rist has recently had solo exhibitions at Shiseido Foundation, Tokyo (2002); Museo Nacional Centro de Arte Reina Sofía, Madrid (2001); Luhring Augustine Gallery, New York (2000); Musée d'Art Moderne de la Ville de Paris (1999); and Kunsthalle Zurich, Switzerland (1999). Recent group exhibitions include *Contemporary Art Project*, Seattle Art Museum (2002); *Moving Pictures*, Solomon R. Guggenheim Museum, New York (2002); *Video Acts*, P.S. 1 Contemporary Art Center, Long Island City, Queens (2002); *On Intimacy*, Paço das Artes, São Paulo, Brazil (2002); Urban Creation, Shanghai Biennale, China (2002); *Tempo*, MoMA QNS, Long Island City, Queens (2002); *Form Follows Fiction*, Castello di Rivoli Museo d'Arte Contemporanea, Turin, Italy (2001); *A Room of Their Own: From Arbus to Gober*, Museum of Contemporary Art, Los Angeles (2001); and *Wonderland*, St. Louis Art Museum (2000).

FURTHER READING

Apricots Along the Street, exhib. cat. by Pipilotti Rist, Madrid, Museo Nacional Centro de Arte Reina Sofía, 2001

Durand, Regis, "I Sing the Body Electronic," *Art Press*, no. 278, April 2002, pp. 19–24

Haye, Christian, "The Girl Who Fell to Earth," *Frieze*, no. 39, March–April 1998, pp. 62–65

Kazanjian, Dodie, "Caught on Tape," *Vogue*, Jan. 2003, pp. 160–63, 184

Kimmelman, Michael, "Open My Glade," *The New York Times*, April 21, 2000, p. E40

Lajer-Burcharth, Ewa, "Pipilotti Rist," *Artforum*, 39, Sept. 2000, p. 172

Myers, Terry R., "Grist for the Mill," *Art/Text*, no. 61, May–July 1998, pp. 32–35

Outer and Inner Space: Pipilotti Rist, Shirin Neshat, Jane and Louise Wilson, and the History of Video Art, exhib. cat. by John B. Ravenal, Richmond, Virginia Museum of Fine Arts, 2002

Phelan, Peggy, *et al.*, *Pipilotti Rist*, London (Phaidon Press) 2001

Rist, Pipilotti, *et al.*, *Parkett*, no. 48, 1996, pp. 82–120 (including Nancy Spector, "The Mechanics of Fluids," pp. 83–85; Philip Ursprung, "Pipilotti Rist's Flying Room," pp. 97–98; Marius Babias, "The Rist Risk Factor: When Dreams Twitch Like Dying Fish," pp. 104–107; Paolo Colombo, "Shooting Divas," pp. 112–13; "Laurie Anderson and Pipilotti Rist Meet Up in the Lobby of a Hotel in Berlin on Sept. 9, 1996" [interview], pp. 114–16)

LEFT:

Open My Glade
(details), 2000

RIGHT, TOP AND BOTTOM:

Ever Is Over All, 1997
Video stills from
double projection

Kiki Smith's *Sirens and Harpies* couldn't have found a more fitting home than the southern entrance to the Central Park Zoo, where Fifth Avenue's apartment buildings give way to a fairy-tale landscape of ivy-covered trees and two small, curious brick follies with sloping bell-shaped rooftops. A flock of *Sirens*—bronze sculptures with the winged bodies of birds, conical human breasts, and women's heads with mute, Classical features—perched with disconcerting attentiveness atop two large stones, looking as though they had just landed from flight. Inspired by the deadly temptresses of Greek mythology, the diminutive *Sirens* were paired with a trio of *Harpies*, the voracious legendary monsters, who beckoned from the top of three old brick columns. Standing, kneeling, and crouching like watchful gatekeepers, these larger fantastical figures had disproportionately sized human bodies and heads, with smooth bronze skin that gave way to a set of roughly rendered talons and equally scratchy, leaf-like wings.

At once familiar and extraordinary, *Sirens and Harpies* demonstrated Smith's signature ability to infuse figurative forms with compelling, often enigmatic narratives. In the early 1990s, she became widely known for her visceral examination of the anatomy of the human body, mapping its outer shape and inner organs in bronze, fabric, glass, wax, paper, ceramic, and other media. Since that time, she has created a cavalcade of powerful creatures, at once human and beastly, drawn from European folktales, ancient mythology, and biblical tales. Her 1999 mixed-media work *Daughter*—the child of Little Red Riding Hood and her wolf nemesis—is human and lupine, tame and wild, heroine and villain. This same duality exists in *Sirens and Harpies*, whose serene expressions and delicate features conceal their magical, destructive powers. According to Homeric legend, the sirens—whose name is derived from the Greek for "entangler"—sang so sweetly that passing sailors who heard them forgot everything and died of hunger or crashed their ships on the rocky islands in the sea. When the harpies, the personification of storm winds, first appeared in early Greek myths, they were described as beautiful maidens with wings. Later tales transformed them into "the robbers," winged monsters with the faces of old women and sharp, crooked talons for feet, who kidnapped people and carried them off to the underworld. In Smith's hands, the harpies fall somewhere in between: ageless and lovely at a glance, with a startling presence amplified by the contrast between their adult features and child-like size.

Smith has rarely exhibited her work outside of what she has referred to as "domestic space or museum space." Installed in Central Park, *Sirens and Harpies* played off its surroundings, melodramatically reminding park-goers of the possibility of a menagerie more magical than the familiar animals inside the zoo.

Sirens and Harpies
(detail of *Sirens*), 2002
Bronze
Entrance to Central Park Zoo,
Manhattan, March 7–May 26, 2002

KIKI SMITH
Sirens and Harpies

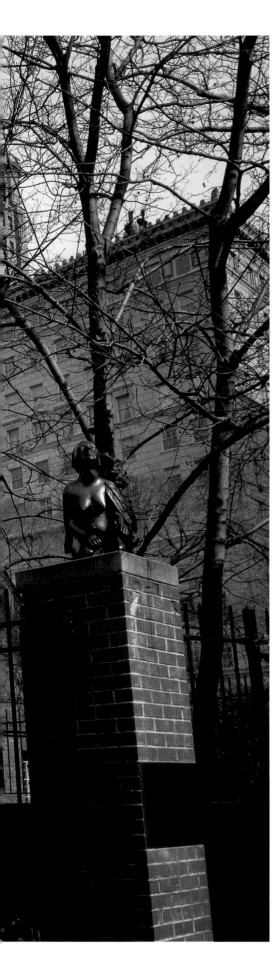

↘ KIKI SMITH

Born in Nuremberg, Germany, 1954.

SELECTED EXHIBITION HISTORY

Kiki Smith has recently had solo exhibitions at MoMA QNS, Long Island City, Queens (2003); Fabric Workshop and Museum, Philadelphia (2003); Pace Wildenstein, New York (2002); International Center of Photography, New York (2001); Hirshhorn Museum and Sculpture Garden, Smithsonian Institution, Washington, D.C. (1998); and Irish Museum of Modern Art, Dublin (1998). Recent group exhibitions include *The Smiths: Tony, Kiki, Seton*, Palm Beach Institute of Contemporary Art, Lake Worth, Florida (2003); *Unnatural Science*, MASS MoCA, North Adams, Massachusetts (2002); *2002 Biennial Exhibition*, Whitney Museum of American Art, New York (2002); *Over the Edges: the Corners of Ghent*, Stedelijk Museum voor Actuele Kunst, Ghent, Belgium (2000); *Regarding Beauty: A View of the Late 20th Century*, Hirshhorn Museum and Sculpture Garden, Smithsonian Institution, Washington, D.C. (2000; traveled); *The American Century: Art & Culture 1900–2000, Part II 1950–2000*, Whitney Museum of American Art, New York (1999); *Mirror Images: Women, Surrealism, and Self-Representation*, List Visual Arts Center, Massachusetts Institute of Technology, Cambridge (1998; traveled); *Then and Now and Later: Art Since 1945 at Yale*, Yale University Art Gallery, New Haven, Connecticut (1998); *Four Artists the Body/the Figure: Eric Fischl, Susan Rothenberg, Joel Shapiro, Kiki Smith*, Carpenter Center for the Visual Arts, Harvard University, Cambridge, Massachusetts (1998); and *Objects of Desire: The Modern Still Life*, MoMA, New York (1997; traveled).

FURTHER READING

Bollen, Christopher, "Outsider Art," *V Magazine*, no. 16, March–April 2002, pp. 57–60

Boodro, Michael, "Blood, Spit, and Beauty," *ARTnews*, 93, March 1994, pp. 126–31

Kertess, Klaus, "Kiki Smith: Elaborating a Language of the Body," *Elle Décor*, Feb.–March 1996, pp. 52–53, 56, 58

Kiki Smith: Telling Tales, exhib. cat. by Helaine Posner and Kiki Smith, New York, International Center of Photography, 2001

Kiki Smith: Realms 2002, exhib. cat., New York, Pace Wildenstein, 2002

Kimmelman, Michael, "Making Metaphors of Art and Bodies," *The New York Times*, Nov. 15, 1996, pp. C1, C22

Lebowitz, Cathy, "Rites of Passage," *Art in America*, 89, Dec. 2001, pp. 96–99

Schjeldahl, Peter, "Incorrigible: Kiki Smith," *The Village Voice*, Oct. 10–17, 1995, p. 85

Summerbelle, Deirdre, "Marrying Your Own Personal Nutty Trips with the Outside World" (interview), *Trans Magazine*, nos. 9–10, Fall–Winter 2001, pp. 202–19

Tallman, Susan, "Kiki Smith, Anatomy Lessons," *Art in America*, 80, April 1992, pp. 146–53, 175

LEFT:

Sirens and Harpies
(detail of *Harpies*), 2002

RIGHT, TOP:

Lilith, 1994
Silicon, bronze, glass

RIGHT, BOTTOM:

Daughter, 1999
Nepal paper, bubble wrap,
methyl cellulose, hair,
fabric, glass

From far away, Do-Ho Suh's *Public Figures* could easily be taken for a conventional monument, its massive, empty plinth awaiting a piece of oversized statuary of an army general or some famous citizen. But below, a motley regiment of diminutive men and women, arms outstretched, brace against the base of the faux-granite sculpture to lift it off the grass. One of Suh's earliest works employing vast numbers of Lilliputian figures to convey the power of the collective, *Public Figures* was later reworked in bronze for his exhibition at the Korean Pavilion at the 2001 Venice Biennale. In its original presentation on the grassy commons of MetroTech Center in Brooklyn—a 1 acre (0.4 hectare) corporate park bordered by businesses, schools, and the headquarters of the New York City Fire Department—Suh's simple inversion of a traditional monument seemed in keeping with the bustling anonymity of its quotidian surroundings. "When the eyes of the public look up they will encounter the void of the individual space," Suh said in an artist's statement. "As they look down, the stone of the pedestal will give way to the sight of the multiple, the diverse, the anonymous, and the tumultuous mass."

Much of Suh's sculptural work centers on the complex, ambiguous relationship between the individual and the crowd, a focus largely precipitated by his move from Korea to New York in the early 1990s. "In Korea, we refer to men as grains of sand," Suh has said, observing the vast cultural differences between East and West on matters of identity, conformity, and plurality. In *Floor* (1997–2000), an installation in which thousands of plastic figurines 2 inches (5 cm) tall stand under and support a glass floor, Suh utilized the gallery's architectural vocabulary to create a work that was both Minimalist and overwhelming. It's impossible to tell whether the figurines represent the strong proletarian masses or a herd of downtrodden underdogs who carry the weight of the art world on their shoulders. This ability to convey a visceral, open-ended message, all the while avoiding sociopolitical didacticism, is typical of Suh's work. In *Some/One* (2001)—a massive, imperial robe made of 100,000 military dog tags, evenly layered like scales on a body to form a measured, sweeping whole—Suh once again uses repetition, variation, and order to hint at the ways in which individuals collaborate to form a unified social fabric.

In his initial proposal for *Public Figures*, Suh suggested that he would come to move the sculpture every two weeks, so that over the course of the year-long exhibition the sculpture would traverse a straight line across the commons. This temporal/spatial dimension, although ultimately unrealized, underscores the sense that *Public Figures* was meant to echo the constant movement and displacement of individuals on the nearby walkways, an ambivalent yet lyrical ode to what Suh described as the area's "mobile anonymous collectivity."

Public Figures, 1998
Resin
MetroTech Center, Brooklyn,
October 20, 1998–September 1999

DO-HO SUH
Public Figures

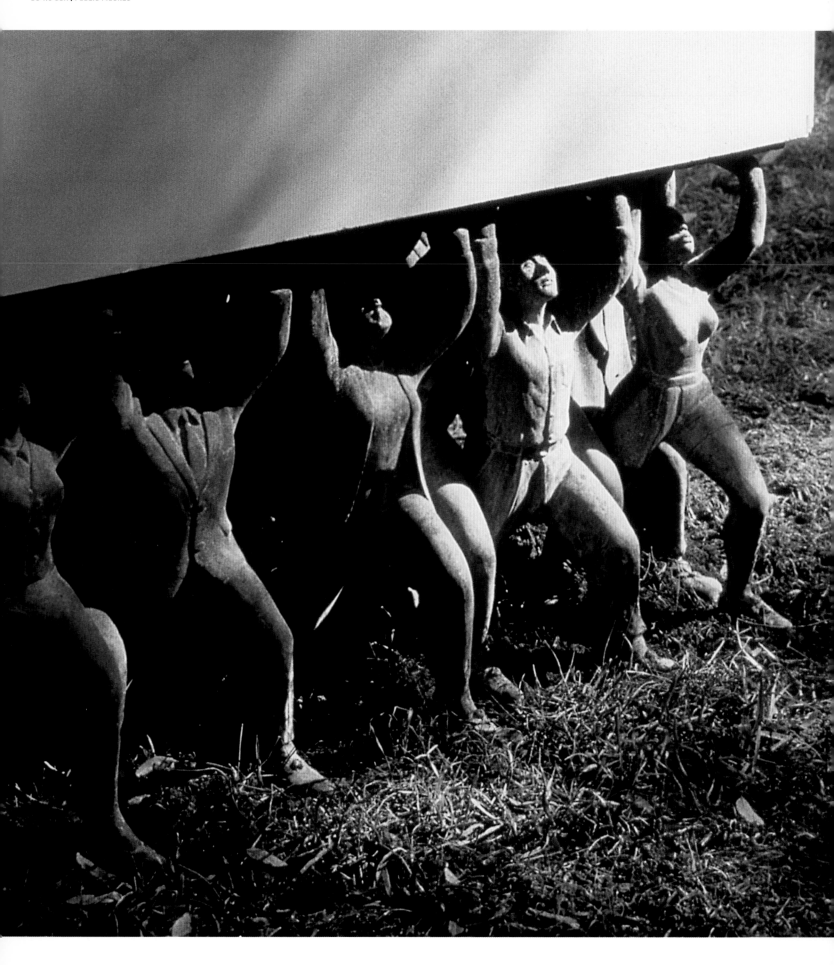

↘ DO-HO SUH

Born in Seoul, 1962.
Studied at Yale University School of Art, New Haven, Connecticut (MFA, 1997), Rhode Island School of Design, Providence (BFA, 1994), Skowhegan School of Painting and Sculpture, Maine (1993), and Seoul National University (MFA and BFA, 1987).

SELECTED EXHIBITION HISTORY

Do-Ho Suh has recently had solo exhibitions at Lehmann Maupin, New York (2003); ArtSonje Center, Seoul (2003); Serpentine Gallery, London (2002; traveled to Seattle Art Museum); Whitney Museum of American Art at Philip Morris, New York (2001); and Korean Cultural Center, Los Angeles (2000). Recent group exhibitions include *Living Inside the Grid*, New Museum of Contemporary Art, New York (2003); Sydney Biennale, Australia (2002); Korean Pavilion, 49th Venice Biennale, Italy (2001); *Uniform: Order and Disorder*, P.S. 1 Contemporary Art Center, Long Island City, Queens (2001); *Subject Plural: Crowds in Contemporary Art*, Contemporary Art Museum, Houston, Texas (2001); *BodySpace*, Baltimore Museum of Art (2001); *Greater New York: New Art in New York Now*, P.S. 1 Contemporary Art Center, Long Island City, Queens (2000); *Open Ends*, MoMA, New York (2000); and *Techno/Seduction*, Cooper Union School of Art, New York (1997).

LEFT:

Public Figures (detail), 1998

RIGHT, TOP:

Some/One, 2001
Stainless steel military dog tags, nickel-plated copper sheets, steel structure, glass-fiber reinforced resin, rubber sheets
Installation view at Whitney Museum of American Art at Philip Morris, New York

RIGHT, BOTTOM:

Floor (detail), 1997–2000
PVC figures, glass plates, phenolic sheets, polyurethane resin

FURTHER READING

Christov-Bakargiev, Carolyn, "and the winner is …," *Tema Celeste*, no. 86, Summer 2001, pp. 38–43

Clifford, Katie, "A Soldier's Story," *ARTNews*, 101, Jan. 2002, pp. 102–105

Cotter, Holland, "Do-Ho Suh," *The New York Times*, Sept. 29, 2000, p. E31

Do-Ho Suh: Some/One, exhib. brochure by Shamin Momin, New York, Whitney Museum of American Art at Philip Morris, 2001

Ellegood, Anne, "La Biennale de Venice," *Art Press*, no. 269, June 2001, pp. 34–39

Fehrenkamp, Ariane, "Commissions: Chakaia Booker, Tony Matelli, Valeska Soares, and Do-Ho Suh, *Beyond the Monument*, Brooklyn, New York," *Sculpture*, 18, March 1999, pp. 14–15

Kee, Joan, "The Singular Pluralities of Do-Ho Suh," *Art AsiaPacific*, no. 34, April–June 2002, pp. 45–51

Liu, Jenny, "Do-Ho Suh," *Frieze*, no. 56, Jan.–Feb. 2001, pp. 118–19

Malhorta, Priya, "Do-Ho Suh," *Tema Celeste*, no. 83, Jan.–Feb. 2001, pp. 52–55

Richard, Frances, "The Art of Do-Ho Suh: Home in the World," *Artforum*, 41, Jan. 2002, pp. 114–18

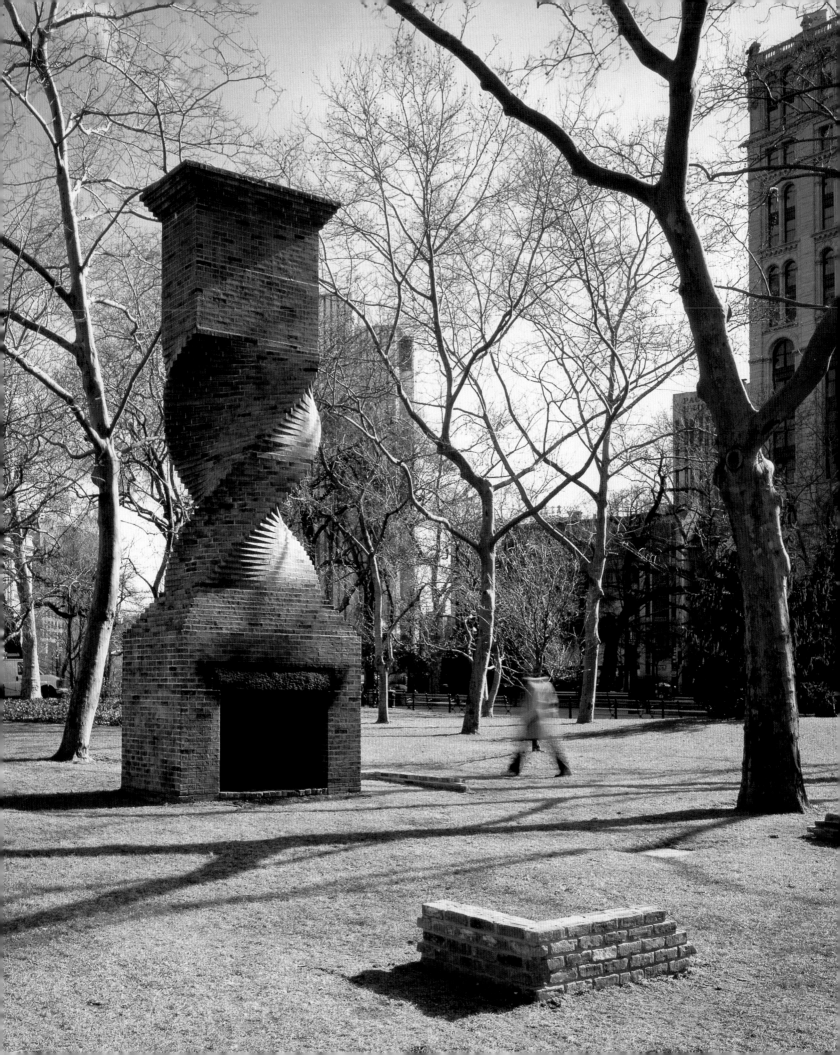

BRIAN TOLLE
Witch Catcher and *Waylay*

Although formally distinct, both of Brian Tolle's Public Art Fund projects were informed by one core conceptual element of the artist's practice—an interest in the ways in which historical information can be contained, elaborated upon, and even embellished within resonant objects and gestures. His 1997 sculpture *Witch Catcher*, installed as part of the fifth season of commissioned works for Brooklyn's MetroTech Center (and included in a second group exhibition at City Hall Park in 2003), was the artist's first-ever public project. Designed to suggest the remnants of a colonial homestead, the work was centered around an uncannily spiraling brick chimney that torqued gracefully some 25 feet (7.6 m) in the air, surrounded by low walls like the ruins of an old foundation—all made out of Styrofoam. Meanwhile, *Waylay*—Tolle's contribution to the Public Art Fund's off-site project set for the 2002 Whitney Biennial—was a delicate conceptual intervention in Central Park's lake. A version of *Dropped By* (2001), a work initially conceived for a pond in Sonsbeek, a park in the Dutch town of Arnhem, *Waylay* featured a series of small choreographed "disruptions" on the lake's surface, like the splashes of jumping fish or a skipped stone, generated by computer-controlled pumps hidden just beneath the water. Just as *Dropped By* was influenced by the World War II bombing of Arnhem, *Waylay* seemed to contain a gentle acknowledgment of the then-recent events of September 11 in New York City—both elegiac and celebratory, it was a small moment of surprise strategically pitched just above the threshold of perception.

Tolle's interest in the poetic potential of history—both factual and fictionalized—was apparent from his first solo exhibition in New York in 1996. Part of the inspiration for *Witch Catcher*, his *Overmounted Interior* filled a SoHo gallery space with exaggerated elements of an eighteenth-century architectural interior, such as a grand hearth, exposed beams, and casement windows. Improbably swollen and oversized, they loomed like a room remembered from a dream. This symbolically freighted reimagining of space and building elements also informed Tolle's celebrated Irish Hunger Memorial of 2002 in Lower Manhattan. Praised by *New York Times* critic Roberta Smith as expanding "the understanding of what a public memorial can be," the monument includes actual materials—a small, roofless, fieldstone cottage set in a quarter-acre tumulus evoking an Irish hillside, dotted with indigenous plantings and boulders—rather than the stage-set substitutes often employed by the artist. Yet despite its physical veracity, the project nevertheless manages to create that sense of lyrically mediated memory characteristic of all of Tolle's best work.

Commenting recently on *Waylay*, Tolle noted that the work "seemed to tap into people's imagination and allowed for them to invent their own narratives." This space for personal involvement is central to Tolle's practice, an approach that draws on the past to trigger memory and emotion, but scrupulously avoids the prescriptive limitations of simple historical re-creation.

Witch Catcher, 1997
Mixed-media installation
MetroTech Center, Brooklyn,
October 28, 1997–August 31, 1998
(seen here in second presentation
as part of *MetroSpective* in City
Hall Park, Manhattan, 2003)

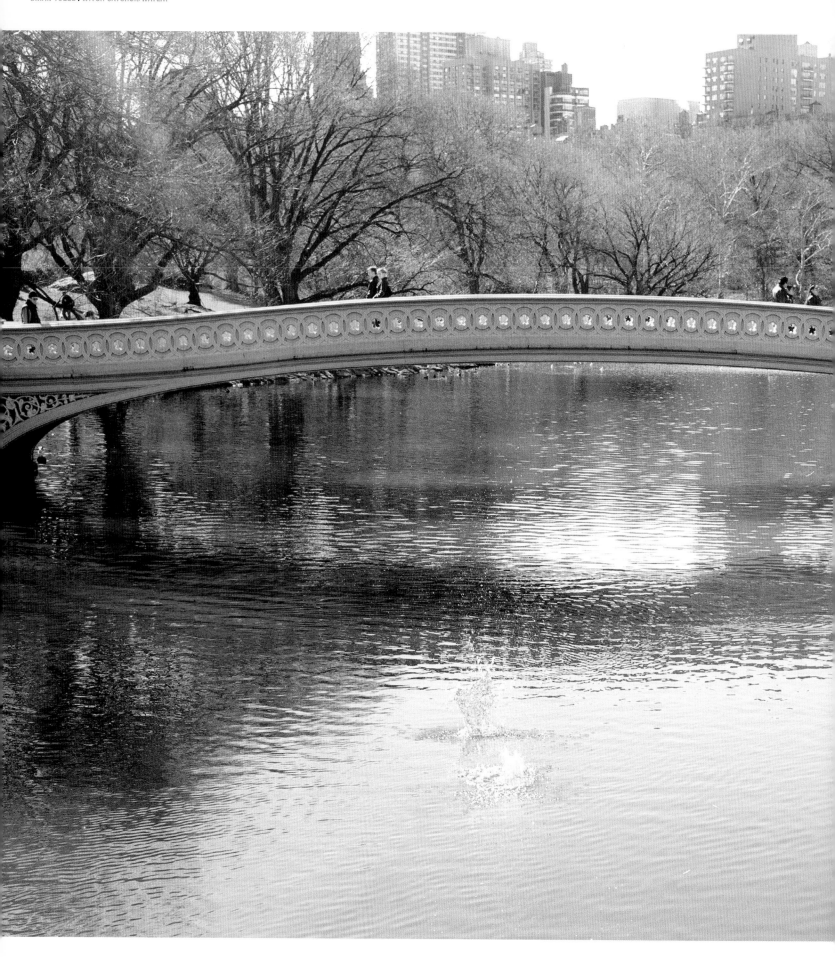

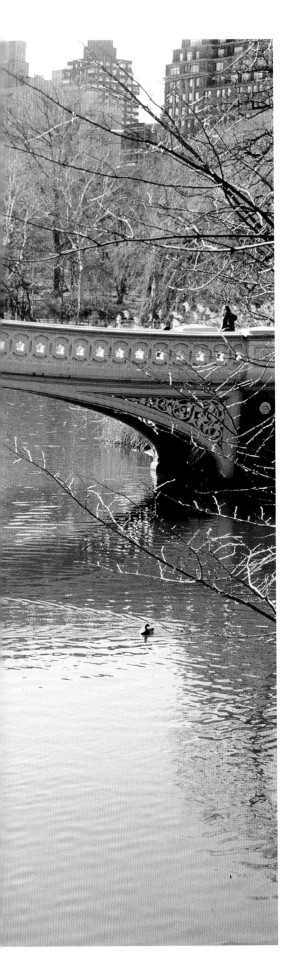

↘ BRIAN TOLLE

Born in Queens, New York, 1964.
Studied at Yale University School of Art, New Haven, Connecticut (MFA, 1994), Parsons School of Design, New York (BFA, 1992), and State University of New York at Albany (BA, 1986).

SELECTED EXHIBITION HISTORY

Brian Tolle recently completed the Irish Hunger Memorial in New York in 2002. He has had solo exhibitions at Shoshana Wayne Gallery, Santa Monica, California (2000); Schmidt Contemporary Art, St. Louis (1998); and Basilico Fine Arts, New York (1998). Recent group exhibitions include American Biennale, De Ponta-cabeça, Fortaleza, Brazil (2003); *Pursuit of Happiness*, Kunsthalle Bern (2003); *Eire/Land*, McMullen Museum of Art, Boston College, Chestnut Hill, Massachusetts (2003); 2002 Biennial Exhibition, Whitney Museum of American Art, New York (2002); *Crossing the Line*, Queens Museum of Art (2001); *Over the Edges: The Corners of Ghent*, Stedelijk Museum voor Actuele Kunst, Ghent, Belgium (2000); *Young Americans 2*, Saatchi Gallery, London (1998); *Here: Artists' Interventions at the Aldrich Museum*, Aldrich Contemporary Art Museum, Ridgefield, Connecticut (1998); and *Tableaux*, Museum of Contemporary Art, North Miami, Florida, and Contemporary Arts Museum, Houston, Texas (1997).

FURTHER READING

Avgikos, Jan, "Brian Tolle," *Artforum*, 37, Oct. 1998, pp. 123–24

Blackwell, Josh, "Brian Tolle at Shoshana Wayne," *Art Issues*, no. 63, Summer 2000, p. 49

Bollen, Christopher, "Outsider Art," *V Magazine*, 16, March–April 2002, pp. 57–58, 61

Dunlap, David W., "Memorial to the Hunger, Complete With Old Sod," *The New York Times*, March 15, 2001, p. E1

Frankel, David, "Hunger Artist," *Artforum*, 40, Summer 2002, p. 85

Kaizen, William R., "Brian Tolle," *BOMB*, no. 71, Summer 2001, pp. 56–63

Klinkenborg, Verlyn, "The Great Irish Hunger and the Art of Honoring Memory," *The New York Times*, June 21, 2002, p. 12

Over the Edges: The Corners of Ghent, exhib. cat. by Jan Hoet (Dieter Roelstraete, "Brian Tolle Talks to Dieter Roelstraete" interview), Ghent, Stedelijk Museum voor Actuele Kunst, 2000, pp. 345–49

Schama, Simon, "A Patch of Earth," *The New Yorker*, Aug. 15 and 22, 2002, pp. 58–60

Smith, Roberta, "A Memorial Remembers the Hungry," *The New York Times*, July 16, 2002, p. E1

LEFT:

Waylay, 2002
Mixed-media installation
The Lake in Central Park,
Manhattan, March 7–May 26, 2002

RIGHT, TOP:

Overmounted Interior, 1996
Mixed-media installation

RIGHT, BOTTOM:

Irish Hunger Memorial, 2002
Mixed-media work permanently
on view in Battery Park City,
Manhattan

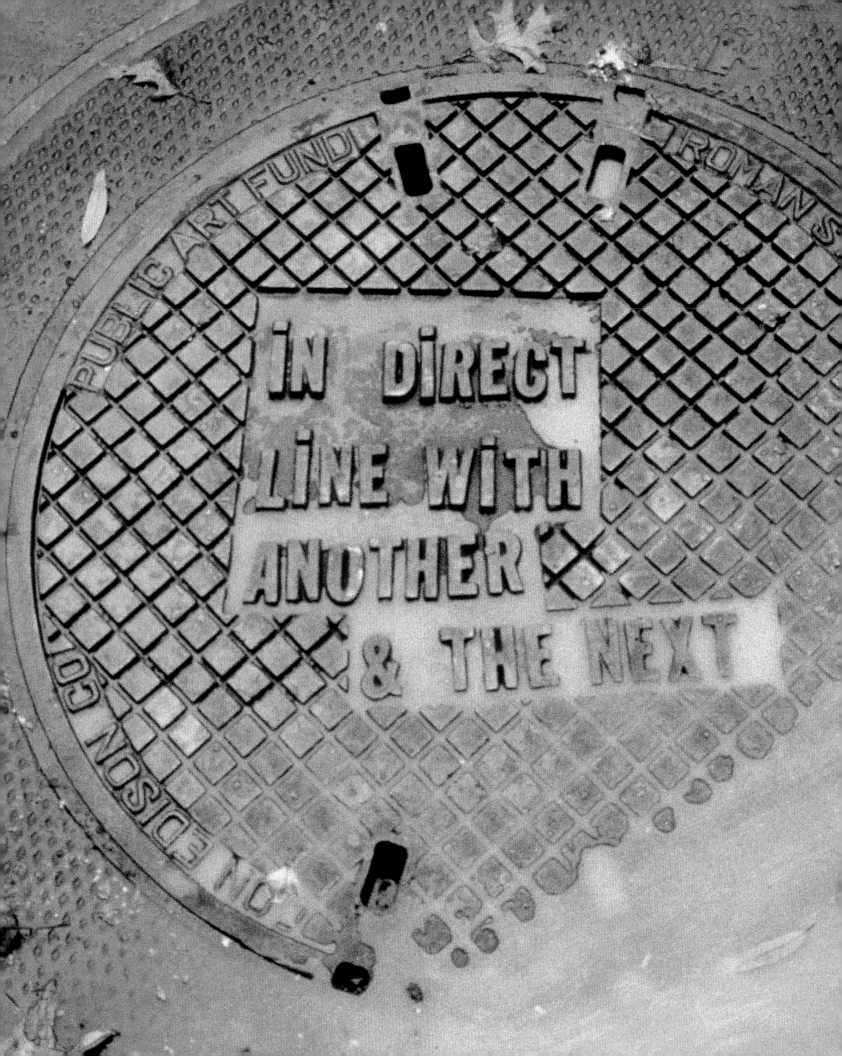

One of the only Public Art Fund projects commissioned to remain on view indefinitely, Lawrence Weiner's *NYC Manhole Covers* is also one of the easiest to overlook, noticeable only to those who happen to be looking down as they walk over one of the nineteen manhole covers that dot a cross-section of the city from 14th Street down to Greenwich Village. But all New Yorkers know that one must cast an occasional downward glance at the asphalt and concrete terrain to avoid potholes, curbs, puddles, and trash, and it is this reflexive act of locating oneself within the urban landscape to which Weiner pays tribute with *NYC Manhole Covers.* Or, as he put it in a statement for the book published as a companion to the project, "Given the light, urban people do not in fact have any means of determining where they are from looking to the stars." When charted on a map, the manhole covers indeed resemble a series of constellations clustered around Union Square, Washington Square Park, and the Bleecker Street Playground, linking the ground below with the world above.

Since the late 1960s, Conceptual artist Weiner has balanced his gallery and studio practice with frequent and varied outdoor interventions, stenciling or otherwise installing his simple, evocative texts on building façades, brick walls, and other urban surfaces. For one of his few public forays within the United States, Weiner settled on the utilitarian and ubiquitous city fixture of the manhole cover, a natural choice for a Bronx-born, Manhattan-based artist who has said that when working in a public context, he uses materials that are "not necessarily exotic." Collaborating with the city's gas–electric company Con Edison and fabricator Roman Stone, Weiner produced a functional manhole cover that bore the enigmatic text, "IN DIRECT LINE WITH ANOTHER & THE NEXT," a reference to the city's grid street-plan, and also a reminder of the myriad physical and personal relationships that are constantly reformulated within that grid. New York's streets and sidewalks are the most truly democratic aspect of the city, where rich and poor alike stand beside one another waiting for a light to change. Riding the subway, standing in line, or walking on the street, New Yorkers are always, quite literally, in direct line with another and the next.

For Weiner—who describes the project as "the placement within an urban context of a series of markers (sculptures) that participate within the relationships of objects to objects in relation to human beings"—the manhole covers are a relativist's take on the familiar "you are here" sign, offering a spontaneous triangulation between the object, the viewer, and the rest of the physical world. But *NYC Manhole Covers* is ultimately a personal gesture as well, retracing Weiner's footsteps through Manhattan's once-bohemian neighborhoods to parks, now-defunct bars, and other sites that he used to visit as a young artist coming of age in New York.

NYC Manhole Covers, 2000
Cast iron
19 manhole covers installed in street, Greenwich Village to Union Square, ongoing presentation since November 21, 2000

LAWRENCE WEINER
NYC Manhole Covers

↘ LAWRENCE WEINER

Born in the Bronx, New York, 1942.
Studied in the New York City public school system.

SELECTED EXHIBITION HISTORY

Lawrence Weiner has recently had solo exhibitions at Wexner Center for the Arts, Columbus, Ohio (2002); Birmingham Museum of Art, Alabama (2002); Palacio de Cristal, Museo Nacional Centro de Arte Reina Sofía, Madrid (2001); Kunstmuseum Wolfsburg, Germany (2001); and Deutsche Guggenheim, Berlin (2000). Recent group exhibitions include *A Minimal Future? Art as Object, 1958–1968*, Museum of Contemporary Art, Los Angeles (2001); *Get Together – Kunst als Teamwork*, Kunsthalle Wien, Vienna (2000); *The Work Shown in This Space Is a Response to the Existing Conditions and/or Work Previously Shown within the Space III*, Neugerriemschneider, Berlin (2000); *Présumés Innocents: l'Art Contemporain et l'Enfance*, CAPC Musée d'Art Contemporain, Bordeaux, France (2000); *Global Conceptualism: Points of Origin 1950s–1980s*, Queens Museum of Art (1999; traveled to Walker Art Center, Minneapolis; Miami Art Center, Florida; List Visual Arts Center, Massachusetts Institute of Technology, Cambridge; and Vancouver Art Gallery, Canada); *The American Century: Art & Culture 1900–2000, Part II 1950–2000*, Whitney Museum of American Art, New York (1999); *Circa 1968*, Museu Serralves, Porto, Portugal (1999); *Opening Program*, P.S. 1 Contemporary Art Center, Long Island City, Queens (1998); *Rendezvous: Masterpieces from the Centre Georges Pompidou and the Guggenheim Museums*, Solomon R. Guggenheim Museum, New York (1998); *Skulptur: Projekte in Münster 1997*, Westfälisches Landesmuseum, Münster, Germany (1997); and *The Red Carpet*, Van Abbemuseum, Eindhoven, The Netherlands (1997).

FURTHER READING

Alberro, Alexander (ed.), *Lawrence Weiner*, London (Phaidon Press) 1998

Holmes, Russell, "The Work Must Be Read," *Eye*, 8, Autumn 1998, pp. 36–45

Lawrence Weiner: Displacement, exhib. cat. by Lawrence Weiner and Gary Garrels, New York, Dia Center for the Arts, 1991

Lawrence Weiner: Nach Alles After All, exhib. cat. by Lawrence Weiner, New York, Dia Center for the Arts, 2000

Lawrence Weiner: NYC Manhole Covers, exhib. cat., New York (Public Art Fund) 2001

Lawrence Weiner: Until It Is, exhib. cat. by Lawrence Weiner, Columbus OH, Wexner Center for the Arts and Ohio State University, 2002

Weiner, Lawrence, *et al.*, *Parkett*, no. 42, 1994, pp. 24–72 (including Brooks Adams, "Weiner's Werkstätte," pp. 26–29; Frances Richard, "Providing Metaphor Needs: Lawrence Weiner's Specific & General Works," pp. 38–40; Dieter Schwarz, "Public Freehold," pp. 48–50; Danila Salvioni, "The Meaning that Comes Away from the Work of Art," pp. 52–55; Lawrence Weiner, "The Public Reacts," pp. 62–63; Lane Relyea, "But Can She Bake a Cherry Pie?" pp. 64–65; Edward Leffingwell, "& Vers Les Étoiles," pp. 71–72)

Weiner, Lawrence, *et al.*, *Lawrence Weiner: Bent and Broken Shafts of Light*, Ostfildern (Hatje Cantz Verlag) 2001

LEFT:

NYC Manhole Covers
(installation views), 2000

RIGHT, TOP:

*Placed Upon the Horizon
(Casting Shadows)*, 1990
Yellow cedar
Installation at the Vancouver Art
Gallery, Canada

RIGHT, BOTTOM:

*Bits & pieces put together to
present a semblance of a whole*,
1991
Anodized aluminum
Installation at the Walker Art
Center, Minneapolis

"What would site-unspecificity look like?" This was the rhetorical question behind Olav Westphalen's *E.S.U.S. (Extremely Site Unspecific Sculpture)*, an artwork made "to function equally well at almost any imaginable site at any time." With adjustable tripod legs, a cherry red fiberglass body that doubled as a flotation raft, and a self-contained lighting system powered by a solar panel, every element of *E.S.U.S.* was designed to guarantee its adaptability and survival in any given location. This unlikely cross between a Weber grill and a sci-fi spacecraft—designed with technical assistance from a NASA expert—seemed both alien and at home as it traveled to a variety of sites around New York City. Public interpretation of *E.S.U.S.* shifted with each location: at the opening night party at Lot 61 in Chelsea, and at the Whitney Museum's branch in midtown Manhattan, it was an art object; at Tompkins Square Park in the East Village it was thought to be a surveillance device; at Flushing Meadows–Corona Park it became a futuristic counterpart to the Unisphere, the iconic, stainless steel globe left over from the 1964 World's Fair.

In his wide-ranging comic Conceptual practice, German-born, California-educated Westphalen often takes aim at art-world gravitas and American culture in ways both spectacular (as in *Long Island City Blimp Derby*, a 2003 event in which individuals and art institutions raced personalized remote-controlled Mylar blimps) and cerebral (as in "Roadside Signs," 1998–99, a series of wry *New Yorker*-style cartoons that inserted Postmodern philosophers into the American drive-by landscape). *E.S.U.S.* was conceived as a response to the art world's dogmatic tug-of-war between site-specificity and so-called "Plop art," the derogatory term for public sculpture that asserts its modernity and pre-eminence without regard for context. "I realized how ubiquitous the notion of site-specificity had become, and how naïvely it was applied at times," Westphalen said. "My first impulse was to propose an artwork that would prove that attention to context doesn't inevitably have to lead to an illustration of place." *E.S.U.S.*, a sculptural oddity that could integrate with its surroundings without ever really belonging anywhere, occupied the blind spot between the two extremes. Extending the cartoonish forms of earlier sculptures such as *Smoke Stack* (2000)—a hand-carved Styrofoam smokestack with a smoke plume hovering above like a thought bubble in a comic book—Westphalen's *E.S.U.S.* was the deadpan solution to a theoretical problem, a super-engineered, utilitarian device whose only *raison d'être* was its perfect self-sufficiency.

E.S.U.S. (Extremely Site Unspecific Sculpture), 2000
Schematic computer rendering

OLAV WESTPHALEN
E.S.U.S. (Extremely Site Unspecific Sculpture)

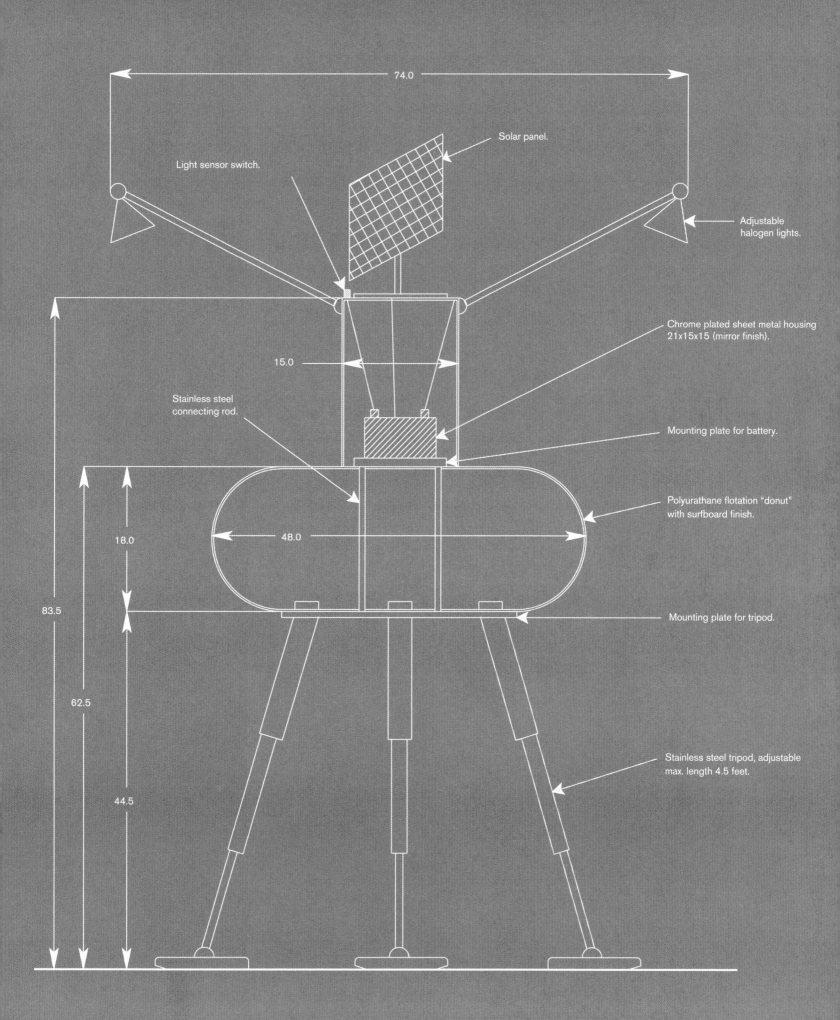

74.0

Light sensor switch.

Solar panel.

Adjustable
halogen lights.

Chrome plated sheet metal housing
21x15x15 (mirror finish).

15.0

Stainless steel
connecting rod.

Mounting plate for battery.

18.0

48.0

Polyurathane flotation "donut"
with surfboard finish.

83.5

62.5

Mounting plate for tripod.

Stainless steel tripod, adjustable
max. length 4.5 feet.

44.5

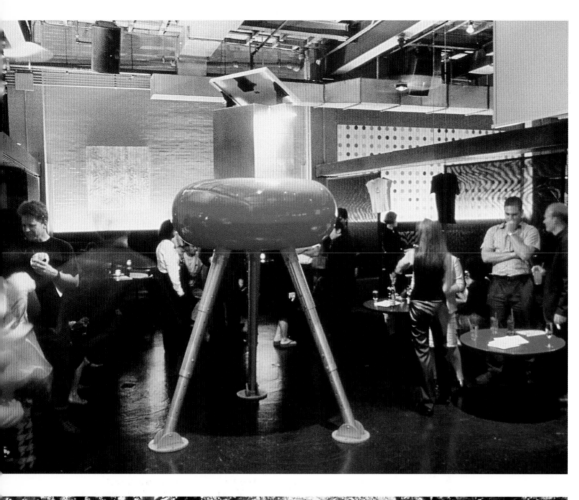
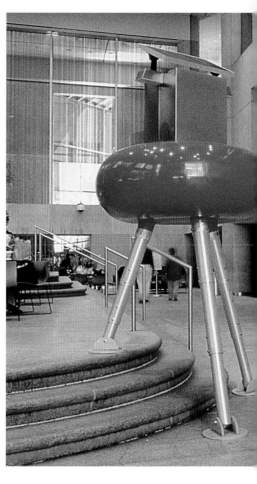

↘ OLAV WESTPHALEN

Born in Hamburg, Germany, 1963.
Studied at University of California, San Diego (MFA, 1993), and Fachhochschule für Gestaltung, Hamburg, Germany (MA, 1990).

SELECTED EXHIBITION HISTORY

Olav Westphalen has recently had solo exhibitions at SculptureCenter, Long Island City, Queens (2003); Maccarone Inc., New York (2002); Michael Neff Gallery, Frankfurt, Germany (2002); Museum Liljewalchs, IASPIS, Stockholm (2001); and Swiss Institute, New York (2001). Recent group exhibitions include *After Effect*, Centre d'Art Neuchâtel, Switzerland (2001); *Tele[visions]*, Kunsthalle Wien, Vienna (2001); *Out of Bounds*, Luckman Gallery, California State University, Los Angeles (2001); *Greater New York: New Art in New York Now*, P.S. 1 Contemporary Art Center, Long Island City, Queens (2000); *Fido*, Hunter College Gallery, New York (2000); *End Papers*, Neuberger Museum of Art, Purchase College, Purchase, New York (2000); *100 Drawings*, P.S. 1 Contemporary Art Center, Long Island City, Queens (1999); *Arrested Ambition*, Apex Art, New York (1999); *Sampling*, Ronald Feldman Fine Arts, New York (1999); and *Organically Grown*, Yerba Buena Center for the Arts, San Francisco (1997).

FURTHER READING

Ackermann, Franz, "Olav Westphalen," *Texte zur Kunst*, 5, May 1995, n.p.

Anton, Saul, "Olav Westphalen," *Frieze*, no. 56, Jan. 2001, p. 103

Anton, Saul, "Olav Westphalen," *Artforum*, 41, Sept. 2002, pp. 192–93

Baker, Kenneth, "Is Small Beautiful?" *San Francisco Chronicle*, April 5, 1997, p. E1

Burton, Johanna, "Olav Westphalen," *Time Out New York*, May 9, 2002, p. 68

Jenkins, Stephen, "Olav Westphalen," *Artweek*, 27, May 1997, p. 23

Johnson, Ken, "Olav Westphalen," *The New York Times*, May 3, 2002, p. E39

Östlind, Niclas, "Olav Westphalen," *INDEX*, no. 23, Fall 1998, pp. 62–63

Pincus, Robert L., "Art Imitates Guns," *San Diego Union Tribune*, Feb. 12, 1993

Wilson, Michael, "Olav Westphalen," *Frieze*, no. 70, Oct. 2002, pp. 83–85

LEFT:

E.S.U.S. (Extremely Site Unspecific Sculpture), 2000
Stainless steel, fiberglass

(top left) Opening night at Lot 61, Chelsea, Manhattan, September 20, 2000

(top right) Whitney Museum of American Art at Philip Morris, Manhattan, September 22–24, 2000

(bottom left) Tompkins Square Park, Manhattan, September 25–26, 2000

(bottom right) Flushing Meadows–Corona Park, Queens, September 27–October 27, 2000

RIGHT, TOP:

Smoke Stack, 2000
Mixed-media installation at P.S. 1 Contemporary Art Center, Long Island City, Queens

RIGHT, BOTTOM:

Crazy Jean's, 1999
Ink on paper

Since the late 1980s, Rachel Whiteread's signature sculptural gesture has involved conjuring presence from absence—giving body to the empty spaces contained within or secreted beneath other objects by creating casts of them, usually in plaster or concrete. Yet with *Water Tower*, the British artist added a subtle twist to this formula, transforming a tangible object—a roof-based water tank of the type so ubiquitous on the New York City skyline—into a kind of echo of itself, an anti-monumental phantom cast in translucent resin, whose physical character swam and altered in the ever-changing light conditions of its downtown Manhattan location.

"It's amazing," Whiteread told a journalist as the project was going up, "how much time it takes to make something look absolutely effortless." Despite its visual subtlety, *Water Tower* was a massive undertaking—at the time, the piece was the most ambitious project ever mounted by the Public Art Fund, involving more than four years of planning and development. When she was initially approached in 1994 to produce a public project—her first in the United States—Whiteread was less than a year removed from the controversy surrounding *House*, her concrete mold of the interior of a soon-to-be-razed row house in London's East End. Attacked in Britain's famously philistine tabloids and denounced by local government officials, *House*—an ambivalently elegiac symbol of memory and loss within the evolving landscape of the working-class neighborhood of Bow—was itself demolished against the artist's wishes less than three months after its creation. The work helped Whiteread win that year's Turner Prize, and while it might have been expected that the experience would have left her leery of starting another major public art project, she nevertheless agreed to take on the commission for New York, settling after a number of visits on the water tower as a shape that was "integral" yet also somehow still "anonymous," part of what she called "the furniture of the city."

It took more than two years to scout an appropriate site for the project. And once the particular rooftop was chosen—above the corner of West Broadway and Grand Street in SoHo—the project still had to overcome numerous obstacles related to the complex fabrication of the 9,500 pound (4,308 kg) resin volume. Yet when *Water Tower* was finally unveiled in the summer of 1998, it quickly became one of the most celebrated projects in the Public Art Fund's history. *Water Tower*—standing at the crossroads of a neighborhood that had once served as the center of New York's art world, but which had by then been forever altered by an exodus of both artists and galleries—served as a poetic reminder of something lost but not forgotten, an afterimage that suggested the inevitable process of change, and its equally inevitable costs.

OPPOSITE:

Water Tower, 1998
Cast resin
Rooftop at West Broadway and
Grand Street, SoHo, Manhattan,
June 10, 1998–September 1, 2000

FOLLOWING PAGES:

PAGE 240, LEFT, TOP TO BOTTOM:

Water Tower (views of the
installation in progress), 1998

PAGES 240–41:

Water Tower, 1998

RACHEL WHITEREAD
Water Tower

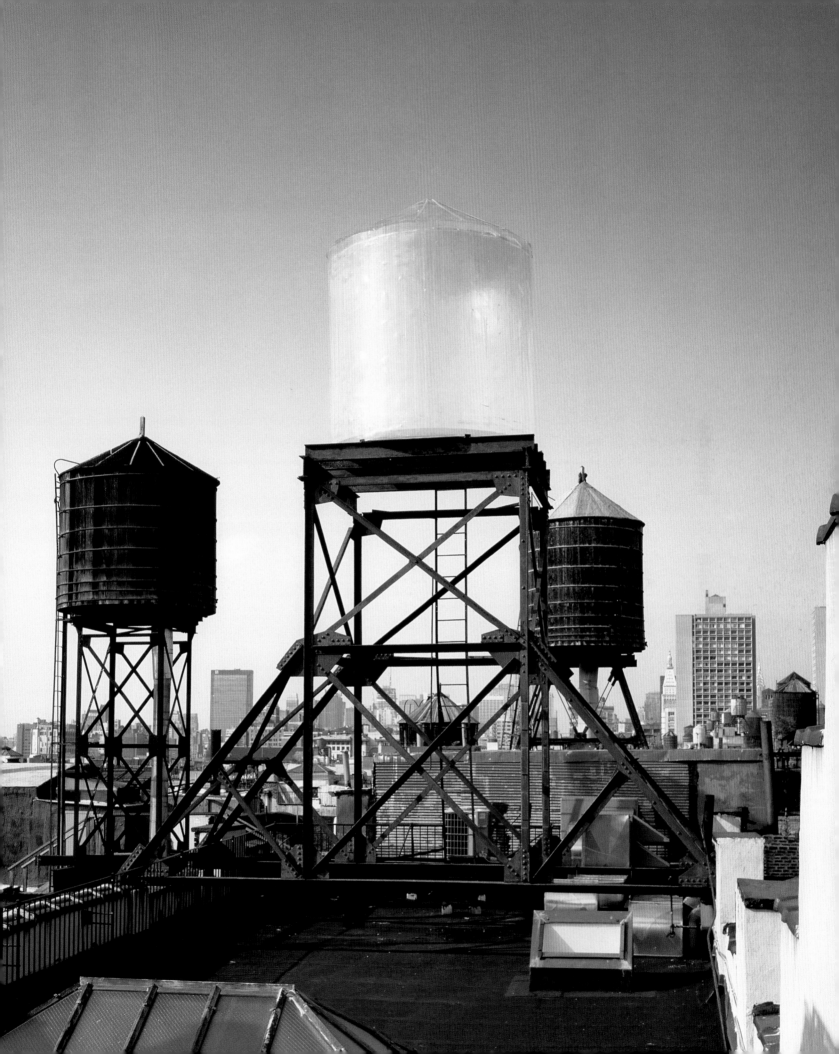

↘ RACHEL WHITEREAD

Born in London, 1963.
Studied at Slade School of Art, London (1987) and Brighton Polytechnic, England (1985).

SELECTED EXHIBITION HISTORY

Rachel Whiteread has recently had solo exhibitions at Luhring Augustine Gallery, New York (2003); Haunch of Venison, London (2002); Solomon R. Guggenheim Museum, New York (2002); Judenplatz, Jüdisches Museum Wien, Vienna (2000); and British Pavilion, 47th Venice Biennale, Italy (1997). Recent group exhibitions include *Days Like These*, Tate Triennial of Contemporary British Art 2003, Tate Britain, London (2003); *New to the Modern: Recent Acquisitions from the Department of Drawings*, MoMA, New York (2002); *Public Offerings*, Museum of Contemporary Art, Los Angeles (2001); *Field Day: Sculpture from Britain*, British Council and Taipei Fine Arts Museum (2001); *Trafalgar Square Plinth*, London (2001); *Amnesia*, Neues Museum, Westerburg, Bremen, Germany (2000); *Sensation: Young British Artists from the Saatchi Collection*, Brooklyn Museum of Art, New York (1999); *Displacements*, Art Gallery of Ontario, Toronto, Canada (1998); *Wounds: Between Democracy and Redemption in Contemporary Art*, Moderna Museet, Stockholm (1998); and *Longing and Memory*, Los Angeles County Museum of Art (1997).

FURTHER READING

Belcove, Julie, "Rachel Rachel," *W Magazine*, 28, Nov. 1999, pp. 344–49

Burton, Jane, "Concrete Poetry," *ARTnews*, 98, May 1999, pp. 154–57

Carr, C., "Going Up in Public," *The Village Voice*, June 23–30, 1998, p. 72

Kino, Carol, "Up on the Roof," *Time Out New York*, June 4–11, 1998, p. 67

Lingwood, James (ed.), *Rachel Whiteread: House*, London (Phaidon Press) 1995

Looking Up, exhib. cat. ed. by Louise Neri, New York (Public Art Fund) 1999

Rachel Whiteread: Transient Spaces, exhib. cat. by Rachel Whiteread *et al.*, New York, Solomon R. Guggenheim Museum, 2003

Smith, Roberta, "Critic's Notebook: The Ghosts of SoHo," *The New York Times*, Aug. 27, 1998, pp. E1–E2

Storr, Robert, "Remains of the Day," *Art in America*, 87, April 1999, pp. 104–109, 154

Vogel, Carol, "SoHo Site Specific: On the Roof," *The New York Times*, June 11, 1998, pp. E1, E4

LEFT:

Water Tower (detail), 1998

RIGHT, TOP:

Ghost, 1989
Plaster on steel frame

RIGHT, BOTTOM:

Untitled (Two Shelf Pieces), 1998
Plaster

CLARA WILLIAMS
The Price (Giving in Gets You Nowhere)

Clara Williams's understated, site-specific sculptural interventions tend to appear in unlikely locations—a New Haven church parking lot, a Manhattan office cubicle, or a weed-infested corner in a park. A resident of the South Bronx, Williams found inspiration in the boarded-up buildings that dotted her neighborhood and, in her project statement for the Public Art Fund, proposed a work that would utilize and activate one of those "neglected and under-appreciated sites." *The Price (Giving in Gets You Nowhere)*—a mechanized marionette production based loosely on Arthur Miller's play *The Price* (1968)—was ultimately set in the third-story windows of a dilapidated building near Fort Greene, one of Brooklyn's oldest residential communities. The building was undergoing renovations to become a home for arts organizations, a structural state-of-flux that dovetailed neatly with the plotline of *The Price*, Miller's acute portrayal of middle-aged brothers whose strained relationship falls apart in the attic of a soon-to-be-demolished New York brownstone.

On the hour, Williams's *The Price (Giving in Gets You Nowhere)* came to life, to the utter astonishment of anyone who happened to walk or drive by: the shutters swung open in unison and the marionettes rolled out of the windows on to platforms to enact an eight-minute automation drawn from *The Price*. As the play begins, the central character, Victor, and his wife, Esther, arrive to haggle with an antiques dealer over the price for an attic's worth of furniture and long-unused family treasures. When Victor's brother Walter arrives—late and unannounced—the already tense financial transaction builds into an airing of decades of unresolved family conflict. Using only body language, props, a painted stage set, and music—and dispensing altogether with dialogue—Williams's installation conveyed a basic narrative in a manner at once minimal and necessarily melodramatic. With their wide eyes, haunted expressions, and stooped shoulders, Williams's marionettes embodied the unsettling air of dissatisfaction and loss that characterizes *The Price*.

The Price (Giving in Gets You Nowhere) was the most high-profile and technically sophisticated of Williams's installations, but finding it nevertheless required careful observation. "I was attracted to the idea of a building that is sleeping, but that wakes up periodically," she commented. Williams often creates modest works that draw attention to their surroundings by blending in. In 2000, she made *deserving and undeserving*, a foam-and-plywood replica of a Madonna-and-child statue that sat in the parking lot of a Catholic church. She placed her low-end look-alike alongside the original, prompting parishioners to reexamine an overlooked element of their everyday environs. Nestled inside of one of New York City's many unremarkable brick buildings, *The Price (Giving in Gets You Nowhere)* emerged once an hour to offer a similarly unexpected glimpse into the architecture of the storied city.

The Price (Giving in Gets You Nowhere) (interior detail), 2003
Wooden marionettes, mechanical equipment, computer
Third-story windows of 80 Arts, 80 Hanson Place, Fort Greene, Brooklyn, September 15–October 26, 2003

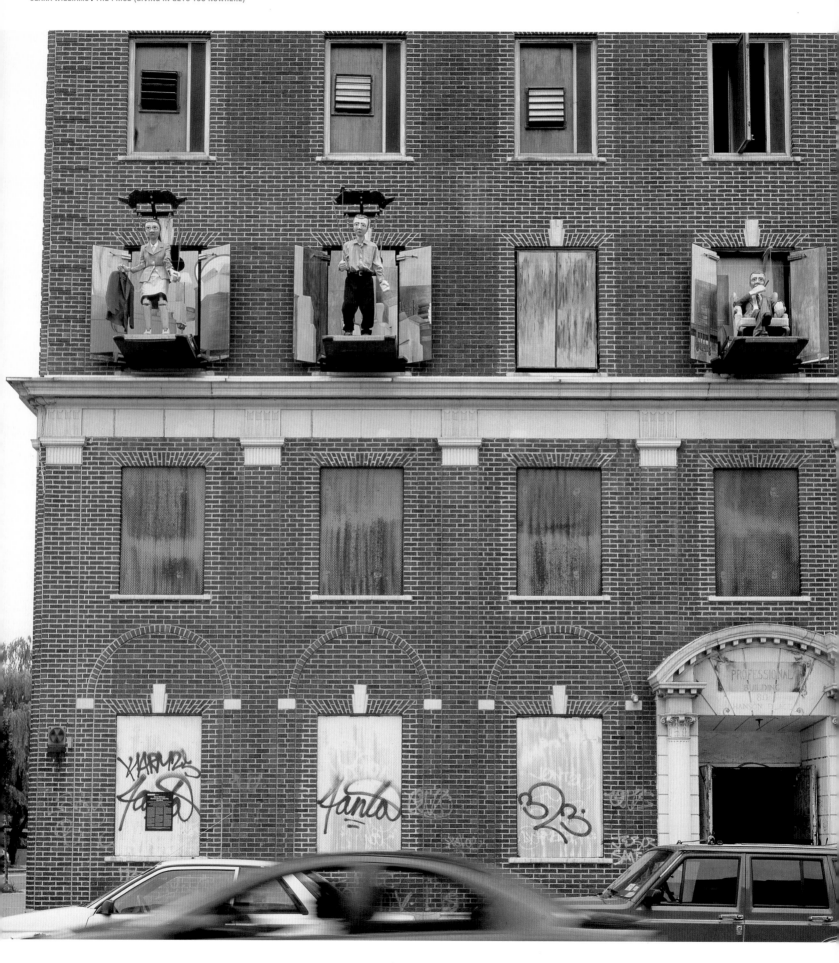

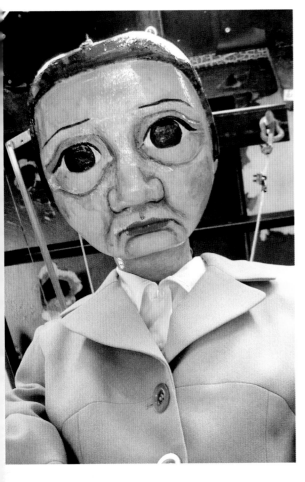

↘ CLARA WILLIAMS

Born in Nashville, Tennessee, 1972.
Studied at Yale University, New Haven, Connecticut (2000), and School of Visual Arts, New York (1995).

SELECTED EXHIBITION HISTORY

Clara Williams has recently had solo exhibitions at Nicole Klagsbrun Gallery, New York (2000, 2002) and at the Cheekwood Museum of Art, Nashville (2000). Recent group exhibitions include *Five Years of the Altoids Curiously Strong Collection, 1998–2002*, New Museum of Contemporary Art, New York (2003); *UnNaturally*, organized by Independent Curators International (2003; traveled); *Escape from New York*, New Jersey Center for Visual Arts, Summit (2003); *Past Tense: A Contemporary Dialogue*, Brigham Young University, Provo, Utah (2002); *Beyond City Limits*, Socrates Sculpture Park, Long Island City, Queens (2001); *Fresh: The Altoids Curiously Strong Collection*, New Museum of Contemporary Art, New York (2001); *Greater New York*, P.S. 1 Contemporary Art Center, Long Island City, Queens (2000); *Small World: Dioramas in Contemporary Art*, Museum of Contemporary Art, San Diego (2000); *True West*, PPOW Gallery, New York (1999); *All Terrain*, Friedrich Petzel Gallery, New York (1999).

FURTHER READING

Donadio, Rachel, "Arthur Miller Goes Cuckoo," *The New York Sun*, Sept. 2, 2003, p. 16

"Goings On About Town," *The New Yorker*, Oct. 20, 2003, pp. 47–48

Grega, Chris, "Darren Kraft and Clara Williams," *NY Arts*, 5, Dec. 2000, p. 79

Kastner, Jeffrey, "Land Acquisition 2: Queens County, New York," *Cabinet*, no. 10, Spring 2003, pp. 103, 105

Levin, Kim, "Voice Choices," *The Village Voice*, Sept. 17, 2003, p. C63

Mahoney, Robert, "Clara Williams: Something Like This," *Time Out New York*, January 17–24, 2002, p. 48

"Origin of Mary Replica a Mystery," *New Haven Register*, March 20, 2000, p. 1

Ranger, Abby, "New Public Art," *Brooklyn Free Press*, Sept. 18–25, 2003, pp. 1, 10

Smith, Roberta, "Art in Review: Clara Williams," *The New York Times*, Jan. 25, 2002, p. E45

Turner, Grady, "Wood at Lombard/Freid, New York," *Flash Art*, no. 205, March–April 1999, p. 53

OPPOSITE:

The Price (Giving in Gets You Nowhere), 2003

LEFT, TOP AND BOTTOM:

The Price (Giving in Gets You Nowhere) (details), 2003

RIGHT, TOP:

deserving and undeserving, 2000
Wood, foam, plaster

RIGHT, BOTTOM:

Very Gentle Protest, 2000
Office furniture, model-making supplies
Installation at P.S. 1 Contemporary Art Center, Long Island City, Queens

In the late spring of 1999, two unusual geological outcroppings appeared at the southeastern corner of Central Park, jutting directly out of the paved expanse of Doris C. Freedman Plaza. One of two temporary insertions into the park's landscape by Andrea Zittel, *Point of Interest* comprised two concrete-and-steel constructions, made to look exactly like the craggy stones found throughout New York's most famous man-made landscape. Inspired by Zittel's visit to the Berlin Zoo's monkey house—where she saw a highly stylized indoor environment built to facilitate climbing, perching, and reclining—*Point of Interest* became Zittel's attempt to create, as she noted recently, "a space that could likewise influence human postures and social interactions."

As it turns out, Zittel's intentions were not far removed from those of the park's original designers—Frederick Law Olmsted once noted that he had intended the Mall (the park's main pedestrian thoroughfare) to be a communal space that would inspire feelings of "rest, tranquility, deliberation, and maturity" among the city's diverse inhabitants. However, Zittel also looked beyond such nineteenth-century romantic musings, drawing upon the contemporary perception of nature as a place where people go to rock climb, mountain-bike, and engage in other thrilling, risk-taking adventures. The smaller of the two elements of *Point of Interest*—a narrow rock that emerged almost vertically from the ground as if forced out by some seismic event—addressed both modes: one side was a steep cliff-face, while the other gently stair-stepped downward, providing passersby with a small seating area structured to accommodate the human form, not unlike a well-worn rock along some popular hiking trail. *Point of Interest*'s larger rock had a slowly sloping shape that ended at an abrupt ledge (perhaps less dramatically inclined than Zittel might have preferred, had it not been for park safety regulations), forming a geological amphitheater and scenic vantage point of sorts. The formations appeared natural, as if they had been carted in from an upstate quarry or forest, but they each bore Zittel's trademark logo "A–Z Land Brand," a gentle dig at the way we often transform nature into a marketable, consumable experience.

From her early experiments in selective chicken breeding to her self-designed habitats, Zittel's art production has explored the external structures of contemporary living. Her second work in the park, *A–Z Deserted Islands*—installed in a small lake near *Point of Interest*—was a series of ten discrete sculptures, each resembling a tiny iceberg and each outfitted with a one-person seat. Acknowledging our occasional need for isolation and autonomy, these fiberglass buoys were intended to put some distance between individuals and their busy urban lifestyles. Zittel's modest intervention was first created for *Skulptur: Projekte in Münster 1997*, but it was well suited to Manhattan's built environment, where the buoys floated like tiny oases against the backdrop of the looming city.

A–Z Deserted Islands, 1997
Fiberglass and vinyl seats
South Lake at Central Park,
May 26–September 1999

ANDREA ZITTEL
A–Z Deserted Islands and *Point of Interest*

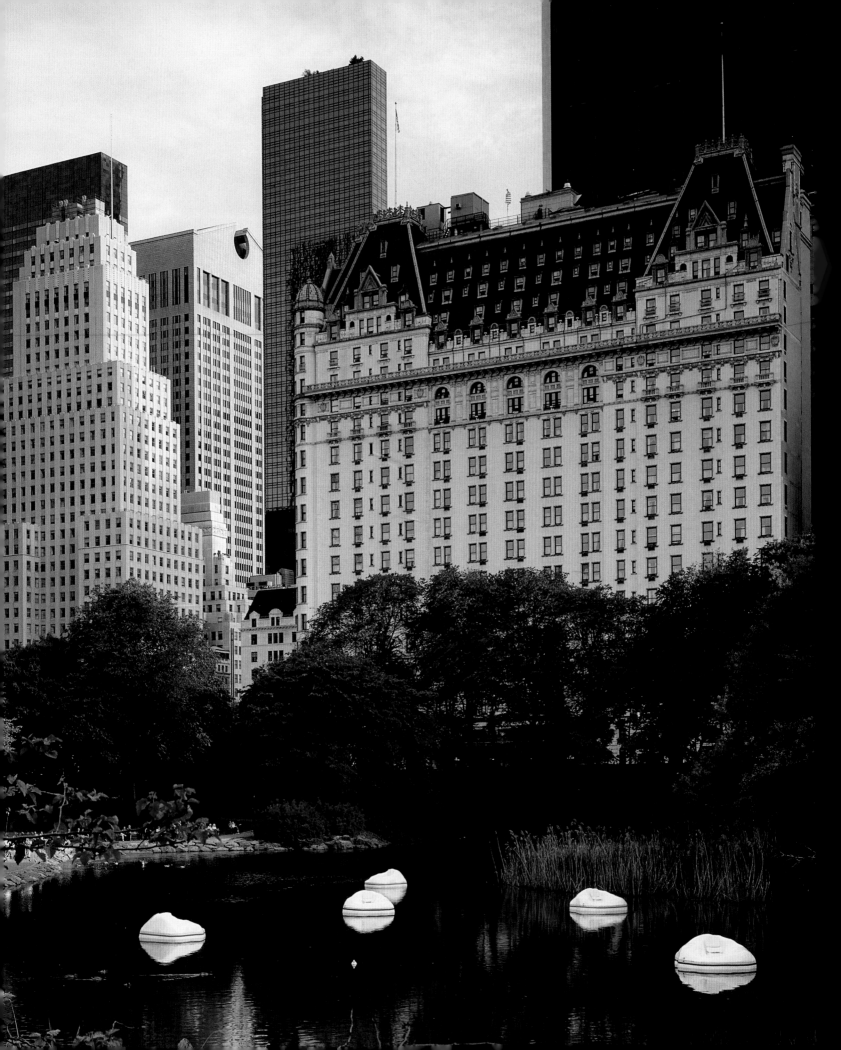

↘ ANDREA ZITTEL

Born in Escondido, California, 1965.
Studied at Rhode Island School of Design, Providence (MFA, 1990), and San Diego State University (BFA, 1988).

SELECTED EXHIBITION HISTORY

Andrea Zittel has recently had solo exhibitions at Sammlung Goetz, Munich, Germany (2003); Ikon Gallery, Birmingham, England (2001); Deichtorhallen, Hamburg, Germany (1999); Andrea Rosen Gallery, New York (1998); and Neue Galerie am Landesmuseum Joanneum, Graz, Austria (1997). Recent group exhibitions include *Tempo*, MoMA QNS, Long Island City, Queens (2002); *Intentional Communities*, Rooseum Center for Contemporary Art, Malmö, Sweden (2001); *What If: Art on the Verge of Architecture and Design*, Moderna Museet, Stockholm (2000); *Elysian Fields: Une Invitation au Purple Institute*, Centre Georges Pompidou, Paris (2000); *Against Design*, Institute of Contemporary Art, Philadelphia (2000); *Berlin/Berlin*, Berlin Biennale (1999); *Best of the Season*, Aldrich Contemporary Art Museum, Ridgefield, Connecticut (1998); *Skulptur: Projekte in Münster 1997*, Westfälisches Landesmuseum, Münster, Germany (1997); *Documenta X*, Kassel, Germany (1997); and *Selections from the Collection*, MoMA, New York (1997).

FURTHER READING

Basilico, Stefano, "Andrea Zittel," *Bomb*, no. 75, Spring 2001, pp. 70–76

Connelly, John, "A Corporate Affair," *Surface*, no. 24, Summer 2000, pp. 88–91

"Home of the Free: Artist Andrea Zittel Builds the New American Dream House," *V Magazine*, no. 14, Nov.–Dec. 2001

Pascucci, Ernest, "Andrea Zittel's Travel and Leisure," *Artforum*, 35, Oct. 1996, pp. 100–103

Princenthal, Nancy, "Andrea Zittel: The Comforts of Home," *Art/Text*, no. 56, Feb.–April 1997, pp. 64–69

Rowlands, Penelope, "At Home with Andrea Zittel," *Metropolis*, 17, May 1996, pp. 104–107, 141, 143

Storr, Robert S., *et al.*, *Art 21: Art in the 21st Century*, New York (Harry N. Abrams) 2001, pp. 186–94

Vendrame, Simona, *Diary # 01: Andrea Zittel*, New York (Tema Celeste Editions) 2002

Weil, Benjamin, "Home Is Where the Art Is," *Art Monthly*, no. 181, Nov. 1994, pp. 20–22

Zeiger, Mimi, "Living A-to-Z," *Dwell*, no. 61, Dec. 2002, p. 60

LEFT:

Point of Interest, 1999
Concrete and steel
Doris C. Freedman Plaza,
Central Park, Manhattan,
May 26, 1999–March 31, 2000

RIGHT, TOP:

Breeding Unit for Reassigning Flight, 1993
Steel and birch plywood

RIGHT, BOTTOM:

A–Z 1994 Living Unit II, 1994
Steel, wood, paint, mattress,
glass, mirror, lighting fixture,
oven range, upholstery,
utensils, saucepans, bowls,
towel, pillow, clock

PROJECT CREDITS

The Public Art Fund is extraordinarily indebted to our many exhibition sponsors and collaborators, whose generous support and involvement has made the projects in this book possible.

All artist entry texts were written by Jeffrey Kastner and Anne Wehr. Each author's contributions are noted with his or her initials.

VITO ACCONCI (JK)
Addition to MetroTech Gardens was made possible through the cooperation and support of the MetroTech Commons Associates. Special thanks to First New York Management.

FRANCIS ALŸS (AW)
The Modern Procession was presented in collaboration with *Projects: 76 Francis Alÿs*, an exhibition of The Museum of Modern Art, New York.

VANESSA BEECROFT (JK)
VB42/Intrepid: The Silent Service was presented in collaboration with Deitch Projects in cooperation with the Undersea Warfare Community and an off-site project of the 2000 Biennial Exhibition, Whitney Museum of American Art, New York. Special thanks to Captain James H. Barnes, USN (ret.) Naval Special Warfare, UDT Class 17 President, UDT-SEAL Museum Association, Inc., and H.T. Aldhizer III, Director, UDT-SEAL Museum Association, Inc.

CHRISTIAN BOLTANSKI (JK)
Lost: New York Projects was made possible by étant donnés, the French–American Endowment for Contemporary Art, with additional support from Goodwill Industries of Greater New York, Inc. Special thanks to Marian Goodman Gallery, Roberta Brandes Gratz, Susan Fine, the Reverend Canon Frederick B. Williams, and Betsy Gotbaum.

LOUISE BOURGEOIS (AW)
Spiders was presented in collaboration with Tishman Speyer Properties.

ALEXANDER BRODSKY (JK)
Canal Street Subway Project was presented in collaboration with MTA Arts for Transit, commissioned through the Public Art Fund program "In the Public Realm" and supported by the City of New York Department of Cultural Affairs, the Heathcote Art Foundation, The Silverweed Foundation, and friends of the Public Art Fund. Additional support was provided by United Aluminum, Joan Feeney and Bruce Philips, Ronald Feldman Fine Arts, A. Robert Towbin, and Robert Appleton.

MARTIN CREED (AW)
Everything is going to be alright was made possible through the cooperation and support of Forest City Ratner Companies. Special thanks to Let There Be Neon.

WIM DELVOYE (JK)
Gothic was presented in collaboration with the Madison Square Park Conservancy and made possible through the cooperation and support of the City of New York/Parks & Recreation.

MARK DION (AW)
Urban Wildlife Observation Unit was part of *Target Art in the Park*, an exhibition series sponsored by Target Stores and organized on behalf of the City Parks Foundation and the City of New York/Parks & Recreation.

CHRIS DOYLE (JK)
Commutable was made possible through the cooperation and support of the New York City Department of Transportation, commissioned through the Public Art Fund program "In the Public Realm" and supported by the City of New York Department of Cultural Affairs, the Heathcote Art Foundation, The Silverweed Foundation, and friends of the Public Art Fund.

KEITH EDMIER (AW)
Emil Dobbelstein and Henry J. Drope, 1944 was commissioned through the Public Art Fund program "In the Public Realm" and supported by the National Endowment for the Arts, the New York State Council on the Arts, a State Agency, the City of New York Department of Cultural Affairs, the Office of the Brooklyn Borough President, The Greenwall Foundation, The Silverweed Foundation, the JPMorgan Chase Foundation, and friends of the Public Art Fund. This project was part of the Whitney Biennial in Central Park, Organized by the Public Art Fund, which was made possible with the cooperation of the City of New York/Parks & Recreation and supported by Bloomberg, the City of New York Department of Cultural Affairs Cultural Challenge Grant 2002, Melissa and Robert Soros, and the Third Millennium Foundation. Special thanks to Friedrich Petzel.

TERESITA FERNÁNDEZ (JK)
Bamboo Cinema was part of *Target Art in the Park*, an exhibition series sponsored by Target Stores and organized on behalf of the City Parks Foundation and the City of New York/Parks & Recreation.

MARIA ELENA GONZÁLEZ (JK)
Magic Carpet/Home was made possible through the cooperation and support of the City of New York/Parks & Recreation, commissioned through the Public Art Fund program "In the Public Realm" and supported by the New York State Council on the Arts, a State Agency, the City of New York Department of Cultural Affairs, the Office of the Brooklyn Borough President, the Joyce Mertz-Gilmore Foundation, The Greenwall Foundation, The Silverweed Foundation, and friends of the Public Art Fund.

DAN GRAHAM (AW)
Bisected Triangle/Interior Curve was part of *Target Art in the Park*, an exhibition series sponsored by Target Stores and organized on behalf of the City Parks Foundation and the City of New York/Parks & Recreation.

GREGORY GREEN (JK)
Gregnik Proto II was commissioned through the Public Art Fund program "In the Public Realm" and supported by the New York State Council on the Arts, a State Agency, the City of New York Department of Cultural Affairs, The Greenwall Foundation, the Heathcote Art Foundation, The Silverweed Foundation, and friends of the Public Art Fund.

GRENNAN AND SPERANDIO (JK)
The Invisible City was made possible by the Lannan Foundation.

CHRISTINE HILL (JK)
Tourguide? was commissioned through the Public Art Fund program "In the Public Realm" and supported by the New York State Council on the Arts, a State Agency, the City of New York Department of Cultural Affairs Cultural Challenge 2000, the Office of the Brooklyn Borough President, the Joyce Mertz-Gilmore Foundation, The Greenwall Foundation, The Silverweed Foundation, and friends of the Public Art Fund. Special thanks to Jeffrey Deitch.

ILYA KABAKOV (JK)
Monument to the Lost Glove was presented in cooperation with the New York City Department of Transportation and Community Board Five.

ILYA AND EMILIA KABAKOV (JK)
The Palace of Projects was originally commissioned by Artangel, London, and Museo Nacional Centro de Arte Reina Sofía, Madrid. The Public Art Fund presentation was made possible through the support of Bloomberg, the National Endowment for the Arts, Melissa and Robert Soros, and The Silverweed Foundation.

KIM SOOJA (AW)
Deductive Object was part of the Whitney Biennial in Central Park, Organized by the Public Art Fund, which was made possible with the cooperation of the City of New York/Parks & Recreation and supported by Bloomberg, the City of New York Department of Cultural Affairs Cultural Challenge Grant 2002, Melissa and Robert Soros, and the Third Millennium Foundation.

JEFF KOONS (JK)
Puppy was presented in collaboration with Tishman Speyer Properties.

BARBARA KRUGER (AW)
Bus was sponsored by Beck's New York Arts Program.

RICHARD LONG (JK)
"New York Projects" was made possible through the cooperation and support of the City of New York/Parks & Recreation, Joseph E. Seagram & Sons, Inc., TIAA Realty, Inc., and Insignia/ESG, Inc. Special thanks to James Cohan, Gino Buzzio, and Mike Meehan. The quartz stones were generously donated by the Mine Hill Quarry, Roxbury CT, and the brownstone rocks were provided by Portland Brownstone Quarries, Inc., Portland CT.

PAUL McCARTHY (AW)
The Box was presented in collaboration with the New Museum of Contemporary Art, New York, and the Sculpture Garden at 590 Madison Avenue. The exhibition was made possible by The Silverweed Foundation and Melissa and Robert Soros; special thanks to Lawrence Luhring and Roland Augustine, Sammlung Hauser und Wirth, Minskoff Properties, and PaceWildenstein.

JOSIAH McELHENY (JK)
The Metal Party was sponsored by Banana Republic, presented in collaboration with the Yerba Buena Center for the Arts, San Francisco, and produced with the assistance of Brooklyn Front and Superfine. This project was commissioned through the Public Art Fund program "In the Public Realm" and supported by the National Endowment for the Arts, the New York State Council on the Arts, a State Agency, the City of New York Department of Cultural Affairs, the Office of the Brooklyn Borough President, The Greenwall Foundation, The Silverweed Foundation, the JPMorgan Chase Foundation, and friends of the Public Art Fund.

ANISSA MACK (AW)
Pies for a Passerby was commissioned through the Public Art Fund program "In the Public Realm" and supported by the National Endowment for the Arts, the New York State Council on the Arts, a State Agency, the City of New York Department of Cultural Affairs, the Office of the Brooklyn Borough President, The Greenwall Foundation, The Silverweed Foundation, the JPMorgan Chase Foundation, and friends of the Public Art Fund.

TONY MATELLI (JK)
Stray Dog was commissioned for *Beyond the Monument*, a group exhibition organized at MetroTech Center. This exhibition is part of an ongoing program sponsored by the MetroTech Commons Associates. Special thanks to First New York Management.

Distant Party was commissioned through the Public Art Fund program "In the Public Realm" and supported by the New York State Council on the Arts, a State Agency, the City of New York Department of Cultural Affairs, the Joyce Mertz-Gilmore Foundation, The Greenwall Foundation, The Silverweed Foundation, and friends of the Public Art Fund. Special thanks to Irwin Cohen of Chelsea Market.

MARIKO MORI (AW)
The Public Art Fund presentation of *Wave UFO* was sponsored by Bloomberg with additional support provided by Melissa and Robert Soros. Special thanks to Edward J. Minskoff Equities, Deitch Projects, and Marco Della Torre. Additional project support was provided by Shiseido Co. Ltd, Technogel, Lechler, and Zumtobel Staff/Das Licht. *Wave UFO* was first exhibited at Kunsthaus Bregenz, Austria.

KIRSTEN MOSHER (JK)
Ballpark Traffic was commissioned through the Public Art Fund program "In the Public Realm" and supported by the New York State Council on the Arts, a State Agency, the City of New York Department of Cultural Affairs, The Greenwall Foundation, The Silverweed Foundation, and friends of the Public Art Fund. Special thanks to David Protell of Chelsea Garden Center, Community Board #4, and the New York City Department of Transportation.

VIK MUNIZ (AW)
CandyBAM was sponsored by Target Stores and presented in collaboration with the Brooklyn Academy of Music.

JUAN MUÑOZ (AW)
The Public Art Fund presentation of *Conversation Piece* was made possible with the cooperation and support of the City of New York/Parks & Recreation. Special thanks to Marian Goodman Gallery, New York.

TAKASHI MURAKAMI (AW)
Reversed Double Helix was organized in collaboration with Tishman Speyer Properties and presented by Target Stores. Special thanks to Marianne Boesky Gallery.

TONY OURSLER (AW)
The Influence Machine was part of *Target Art in the Park*, an exhibition series sponsored by Target Stores and organized on behalf of the City Parks Foundation, New York, and the City of New York/Parks & Recreation. This project was developed in conjunction with Artangel, London.

NAM JUNE PAIK (AW)
Transmission was organized in collaboration with Tishman Speyer Properties and presented by Cingular Wireless. Additional support was provided by TAC Americas. *32 cars for the 20th Century: play Mozart's Requiem quietly* is in the collection of the Samsung Foundation of Culture.

ROXY PAINE (JK)
Bluff was part of the Whitney Biennial in Central Park, Organized by the Public Art Fund, which was made possible with the cooperation of the City of New York/Parks & Recreation and supported by Bloomberg, the City of New York Department of Cultural Affairs Cultural Challenge Grant 2002, Melissa and Robert Soros, and the Third Millennium Foundation. Special thanks to James Cohan Gallery.

PAUL PFEIFFER (JK)
Orpheus Descending was sponsored by Bloomberg, and was made possible with the assistance of the Lower Manhattan Cultural Council and the World Trade Center Arts & Events Program. Special thanks to the World Trade Center, the Port Authority Trans-Hudson Corporation, the Port Authority of New York and New Jersey, American Express, Merrill Lynch, Brookfield Financial Properties, and the Battery Park City Authority. This project was commissioned through the Public Art Fund program "In the Public Realm" and supported by the New York State Council on the Arts, a State Agency, the City of New York Department of Cultural Affairs Cultural Challenge Grant 2000, the Office of the Brooklyn Borough President, the Joyce Mertz-Gilmore Foundation, the Jerome Foundation, The Silverweed Foundation, The Greenwall Foundation, The Chase Manhattan Foundation, and friends of the Public Art Fund.

NAVIN RAWANCHAIKUL (JK)
I ♥ Taxi was part of *Target Art in the Park*, an exhibition series sponsored by Target Stores, and organized on behalf of the City Parks Foundation and the City of New York/Parks & Recreation.

TOBIAS REHBERGER (JK)
Tsutsumu N.Y. was part of *Target Art in the Park*, an exhibition series sponsored by Target Stores, and organized on behalf of the City Parks Foundation and the City of New York/Parks & Recreation.

PIPILOTTI RIST (JK)
Open My Glade was made possible by Panasonic, with major support from the Third Millennium Foundation, The Silverweed Foundation, and Agnes Gund and Daniel Shapiro.

KIKI SMITH (AW)
Sirens and Harpies was part of the Whitney Biennial in Central Park, Organized by the Public Art Fund, which was made possible with the cooperation of the City of New York/Parks & Recreation and supported by Bloomberg, the City of New York Department of Cultural Affairs Cultural Challenge Grant 2002, Melissa and Robert Soros, and the Third Millennium Foundation.

DO-HO SUH (AW)
Public Figures was commissioned for *Beyond the Monument*, a group exhibition organized at MetroTech Center. This exhibition is part of an ongoing program sponsored by the MetroTech Commons Associates. Special thanks to First New York Management.

BRIAN TOLLE (JK)
Witch Catcher was commissioned for *9 to 5*, a group exhibition organized at MetroTech Center. This exhibition is part of an ongoing program sponsored by the MetroTech Commons Associates. Special thanks to First New York Management, John Campagna of Architectural Wall Systems, Mike Lambrese of Dryvit Systems, Inc., and Jeff Nichols of Foam Systems, Inc.

Waylay was part of the Whitney Biennial in Central Park, Organized by the Public Art Fund, which was made possible with the cooperation of the City of New York/Parks & Recreation and supported by Bloomberg, the City of New York Department of Cultural Affairs Cultural Challenge Grant 2002, Melissa and Robert Soros, and the Third Millennium Foundation.

LAWRENCE WEINER (AW)
NYC Manhole Covers was made possible by Con Edison and Roman Stone. Special thanks to Lisa Frigand.

OLAV WESTPHALEN (AW)
E.S.U.S. (Extremely Site Unspecific Sculpture) was made possible with the cooperation and support of the City of New York/Parks & Recreation and the Whitney Museum of American Art at Philip Morris. This project was commissioned through the Public Art Fund program "In the Public Realm" and supported by the New York State Council on the Arts, a State Agency, the City of New York Department of Cultural Affairs Cultural Challenge Grant 2000, the Joyce Mertz-Gilmore Foundation, the Jerome Foundation, The Silverweed Foundation, The Chase Manhattan Foundation, and friends of the Public Art Fund. Special thanks to Diana and Roman de Salvo, Jerry McIntire and Alpine Metal in California, Jim and John Reed, and Randal Evans.

RACHEL WHITEREAD (JK)
Water Tower was sponsored by Beck's New York Arts Program and made possible through the support of the Charles Engelhard Foundation, Agnes Gund and Daniel Shapiro, Sarah-Ann and Werner H. Kramarsky, The Silverweed Foundation, the Andy Warhol Foundation for the Visual Arts, and the City of New York Department of Cultural Affairs Cultural Challenge Initiative 1998. The casting of Rachel Whiteread's *Water Tower* was made possible with the technical support and expertise of American Pipe and Tank Lining Co., Inc., Charles Hickok, Engineer, Hage Engineering, and resin manufacturers BJB Enterprises, Inc. Special thanks to Richard Silver, President of American Pipe and Tank Lining Co., Inc., Luhring Augustine Gallery, Anthony d'Offay Gallery, Brenna Beirne, Joe Beirne, Catherine Tice, and Ellen Weissbrod, building owners.

CLARA WILLIAMS (AW)
The Price (Giving in Gets You Nowhere) was presented in collaboration with the BAM Local Development Corporation. It was commissioned through the Public Art Fund program "In the Public Realm" and supported by the National Endowment for the Arts, the New York State Council on the Arts, a State Agency, the City of New York Department of Cultural Affairs, the Office of the Brooklyn Borough President, The Greenwall Foundation, The Silverweed Foundation, the JPMorgan Chase Foundation, and friends of the Public Art Fund.

ANDREA ZITTEL (AW)
A–Z Deserted Islands was first presented at *Skulptur: Projekte in Münster 1997. Point of Interest* was made possible through the cooperation and support of the City of New York/Parks & Recreation, and supported with public funds from the National Endowment for the Arts, the New York State Council on the Arts, a State Agency, and the City of New York Department of Cultural Affairs. Additional support was provided by The Silverweed Foundation, the Peter Norton Family Foundation, the Andy Warhol Foundation for the Visual Arts, The Fifth Floor Foundation, and Agnes Gund and Daniel Shapiro.

ABOUT THE AUTHORS AND PUBLIC ART FUND

DAN CAMERON has been Senior Curator at the New Museum of Contemporary Art in New York since 1995, where he has organized numerous exhibitions of artists from around the globe. He has also published extensively on new art, and was curator for the 8th Istanbul Biennial in 2003.

TOM ECCLES has been Director and Curator of the Public Art Fund since 1996.

JEFFREY KASTNER is a New York-based critic and journalist, and senior editor of *Cabinet* magazine. A frequent contributor to *The New York Times* and *Artforum*, Kastner's writing has appeared in magazines including *The Economist*, *Flash Art*, and *Frieze,* and in exhibition publications for such artists as Doug Aitken, Jeremy Blake, Willie Doherty, and Sarah Sze. Kastner was editor of *Land and Environmental Art* (1998).

KATY SIEGEL is a professor of art history and criticism at Hunter College, CUNY, and a contributing editor at *Artforum*. She has written on many contemporary artists, including exhibition catalog essays on Lisa Yuskavage, Bernard Frize, and Rineke Dijkstra. She is the co-author of the forthcoming *Money* (2004), and is currently working on a book on Abstract Expressionism.

ANNE WEHR is Communications Director at the Public Art Fund.

Public Art Fund

One East 53rd Street
New York, NY 10022
www.publicartfund.org

ACKNOWLEDGMENTS

The Public Art Fund is a non-profit arts organization supported by the New York State Council on the Arts, a State Agency, the City of New York Department of Cultural Affairs, and through generous contributions from corporations, foundations, and individuals.

We would like to acknowledge our Board of Directors and the following individuals and foundations for their sustaining contributions to the Public Art Fund over the years: The Lily Auchincloss Foundation, The Fifth Floor Foundation, Karen Freedman and Roger Weisberg, Nina Freedman and Michael Rosenbaum, The Horace W. Goldsmith Foundation, The Greenwall Foundation, Liz and Steve Gruber, Agnes Gund and Daniel Shapiro, The Marc Haas Foundation, Patricia E. Harris and Mark Lebow, the JPMorgan Chase Foundation, The Liman Foundation, the Joyce Mertz-Gilmore Foundation, Margaret T. Morris Foundation, May and Samuel Rudin Family Foundation, The Rudin Foundation, Inc., The Silverweed Foundation, Melissa and Robert Soros, Jerry Speyer and Katherine Farley, the Sussman Family Foundation, the Andy Warhol Foundation for the Visual Arts, and the Norman and Rosita Winston Foundation.

Plop is the result of the dedicated efforts of Anne Wehr and Jeffrey Kastner, who together have formed an invaluable team editing the Public Art Fund's publications. We are also grateful to Dan Cameron and Katy Siegel for both their contributions to this publication and their ongoing interest in and support of the activities of the Public Art Fund. *Plop* is designed by Evan Gaffney. We are always the beneficiaries of his singular vision.

This publication would not have been possible without the involvement of the staff and interns of the Public Art Fund who have maintained, researched, and organized the documentation of these projects. Special thanks to Malia Simonds, Mayuri Amuluru, Margaret Wray, Mary Kiplok, Katie Quillinan, Ginny Davis, Sara DeRose, Jessica Kuhn, and Brian Tovar. We are also grateful to the artists and their galleries for their frequent assistance with biographical and photographic material.

First published 2004 by
Merrell Publishers Limited

Head office:
42 Southwark Street
London SEI IUN

New York office:
49 West 24th Street
New York, NY 10010

www.merrellpublishers.com

in association with
Public Art Fund
One East 53rd Street
New York, NY 10022

www.publicartfund.org

A catalog record for this book is available from the Library
of Congress

British Library Cataloging-in-Publication Data:
Eccles, Tom
Plop : recent projects of the Public Art Fund
1.Public Art Fund (New York, N.Y.) 2.Public art – New York
(State) – New York 3.Art, American – 20th century
I.Title II.Wehr, Anne III.Kastner, Jeffrey
709.7'471'09045

ISBN 1 85894 248 9 (hardcover edition)
ISBN 1 85894 247 0 (softcover edition)

Edited by Tom Eccles, Anne Wehr, and Jeffrey Kastner
Designed by Evan Gaffney Design, New York
Copy-edited by Mary Scott
Produced by Merrell Publishers Limited
Printed and bound in China

PHOTOGRAPHY CREDITS

Pages 6, 9, 241, 242: Peter Fleissig; p. 11 (middle):
Timothy P. Karr; p. 11 (bottom): Stanley Greenberg;
p. 12 (bottom left and bottom right): courtesy Artangel,
photo by Stephen White; pp. 13, 23 (top), 55–58, 119,
120: Dorothy Zeidman; pp. 14 (left), 41, 42, 65, 66, 83, 84,
121: Andrew Moore; pp. 14 (right), 24 (left), 31, 47 (top),
87, 88, 125, 126, 195, 197, 198, 219, 220: Matthew Suib;
pp. 15 (top), 62, 236 (top left): Eileen Travell; pp. 15
(bottom), 146, 147: Eric Weiss; p. 16 (left): David Gahr;
p. 16 (right): photo by Daniel McPartlin, courtesy New
York City Parks Photo Archive; p. 17 (top): courtesy
Whitney Museum of American Art, New York; pp. 18
(bottom three), 32 (top), 33 (left), 68, 70, 94, 96, 133,
134, 156, 167, 168, 223, 224, 239, 240, 249, 250: Marian
Harders; pp. 18, 28, 61, 130, 131 (bottom left), 182, 192:
Bart Barlow; pp. 20, 27 (bottom), 48, 77–78, 91, 92, 99,
137, 139 (bottom), 142, 145, 148, 191, 201, 204, 206, 208,
211, 212, 214: Dennis Cowley; pp. 22 (bottom), 89 (left,
top to bottom), 161–64, 172, 179–81, 226: Tom Powel
Imaging; pp. 23 (bottom), 230, 232: Richard Griggs;
pp. 24 (right), 114–15: Brent Stirton; pp. 25, 151, 152:
Dave McKenzie; p. 26 (right): courtesy Hauser und
Wirth; pp. 27 (top), 74, 79, 80, 100, 101, 153, 154, 184,
186–88, 245–47: Aaron Diskin; pp. 30, 59 (bottom), 103
(bottom): courtesy Marian Goodman Gallery, New York;
pp. 32 (bottom), 72, 102: Anne Wehr; p. 34 (top left and
right): presented as "Projects 58: Rirkrit Tiravanija" at
The Museum of Modern Art, New York; p. 34 (middle):
presented as "Projects 65: Maurizio Cattelan" at The
Museum of Modern Art, New York; photo by Armin
Linke; p. 34 (bottom): courtesy The Public Building
Commission of Chicago; pp. 35 (top), 50, 52: Armin
Linke; pp. 35 (bottom), 44, 47 (bottom): Amy Elliot;
pp. 36, 71 (top and bottom): courtesy Gavin Brown's
Enterprise; p. 46: David Allison; p. 59 (top): courtesy of
Marian Goodman Gallery, New York; photo by Michael
Goodman; p. 67 (top): a project of The Pittsburgh
Cultural Trust, photo by C.E. Mitchell; p. 67 (bottom):
courtesy Ronald Feldman Fine Arts, New York, photo by
D. James Dee; p. 75 (top): Collection of UBS PaineWebber,
New York, courtesy Sperone Westwater, New York; p. 75
(bottom): courtesy Sperone Westwater, New York; p. 81
(top and bottom): courtesy Tanya Bonakdar Gallery,
New York; p. 85 (top): a project of Creative Time, New
York; pp. 89 (right top and right bottom), 213 (top and
bottom): courtesy Friedrich Petzel Gallery, New York;
pp. 93 (top and bottom), 225 (bottom): courtesy
Lehmann Maupin, New York; p. 97 (top): courtesy The
Project; p. 97 (bottom): courtesy El Museo del Barrio,
New York; pp. 113, 116: Lary Lamay; p. 117 (bottom):
courtesy Ronald Feldman Fine Arts, New York, photo
by Lary Lamay; pp. 122, 123 (left top and left bottom):
courtesy Artangel, London, photo by Dirk Pauwel;
p. 127 (top and bottom): courtesy Peter Blum, New
York; pp. 128, 131 (top left): Samuel Murray; p. 138:
Richard Long; pp. 139 (top), 199 (top and bottom):
courtesy James Cohan Gallery, New York; p. 140:
courtesy Hauser and Wirth, Zurich, photo by A. Burger;
p. 149 (top): courtesy Brent Sikkema Gallery, New York;
p. 159 (top and bottom): courtesy Leo Koenig, New
York; p. 165 (bottom): courtesy Deitch Projects, New
York, photo by Richard Learoyd; p. 169 (top): courtesy
Lower Manhattan Cultural Council, New York; p. 170:
Vik Muniz; pp. 175–76: Mauricio Alejo; p. 177 (top):
courtesy Marian Goodman Gallery, New York, photo
by Damian Andrus; p. 177 (bottom): courtesy Tate
Modern, London, and Marian Goodman Gallery, New
York; pp. 179–182: all works © 2003 Takashi Murakami.
All rights reserved; p. 183 (top and bottom): © Takashi
Murakami. All Rights Reserved. Courtesy Marianne
Boesky Gallery, New York; p. 183 (middle): © 2002
Takashi Murakami. All Rights Reserved. Courtesy
Kaikai Kiki; p. 189 (top and bottom): courtesy Metro
Pictures, New York; p. 193: Collection of the Whitney
Museum of American Art, New York, Purchase, with
funds from the Lemberg Foundation, Inc. in honor
of Samuel Lemberg, 82.11a-xx; p. 196 (top, middle,
bottom): Roxy Paine; p. 217 (top and bottom):
courtesy Luhring Augustine, New York, and Hauser
und Wirth, Zurich; p. 221 (top and bottom): courtesy
PaceWildenstein, New York, collection of the artist
© Kiki Smith/photo by Ellen Page Wilson; p. 225 (top):
courtesy Whitney Museum of American Art and
Lehmann Maupin, New York; p. 229 (bottom): Peter
Mauss © Esto/courtesy Battery Park City Authority,
New York; p. 233 (top): Collection of Vancouver Art
Gallery, Vancouver Art Gallery Acquisition Fund, VAG
90.49 a-jj, photo courtesy Marian Goodman Gallery,
New York; p. 233 (bottom): Collection of the Walker
Art Center, Minneapolis, T.B. Walker Acquisition Fund,
1993, photo courtesy Marian Goodman Gallery, New
York; p. 237 (top): Eileen Costa; p. 243 (top and bottom):
courtesy Luhring Augustine, New York; p. 251 (top and
bottom): courtesy Andrea Rosen Gallery, New York
© Andrea Zittel.